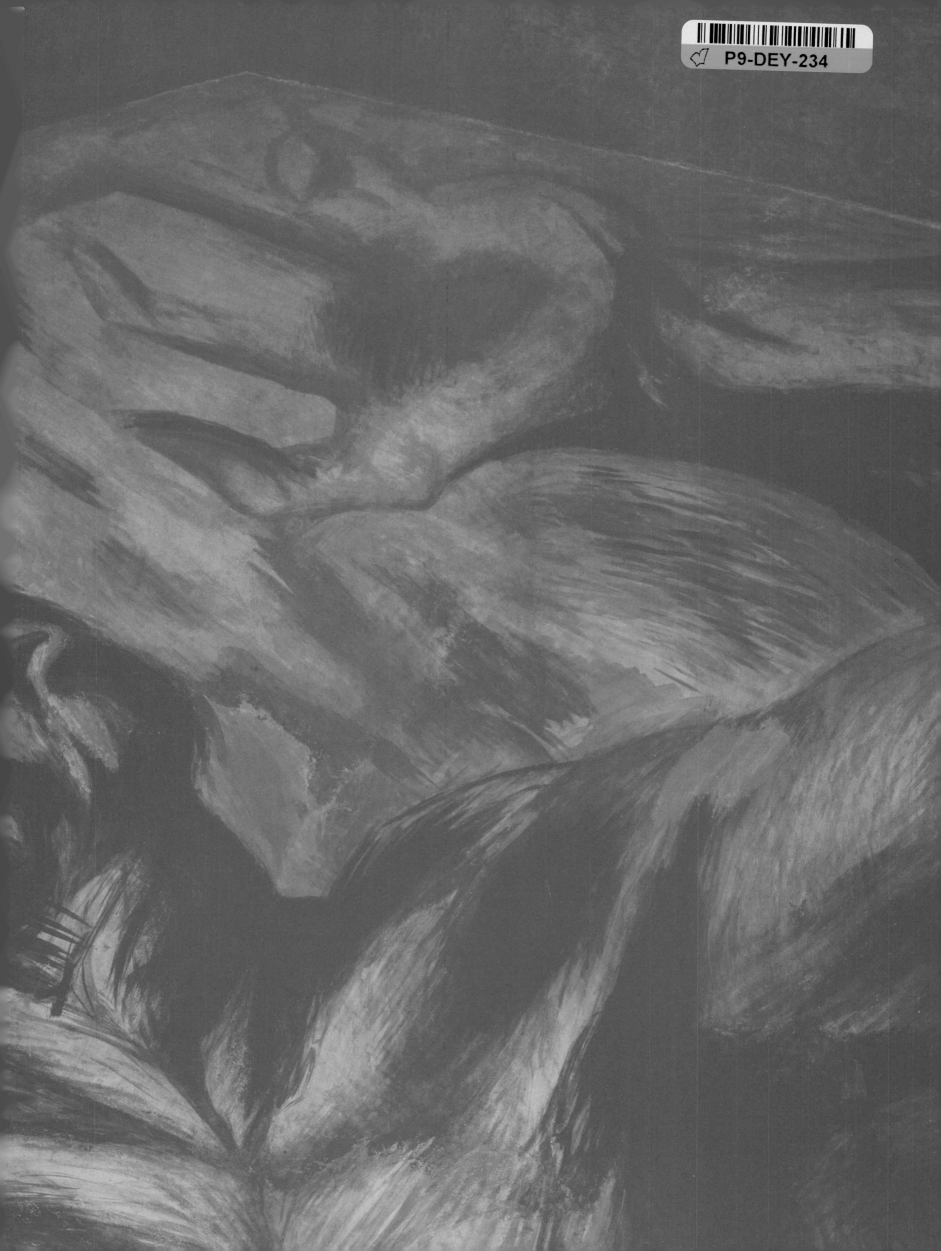

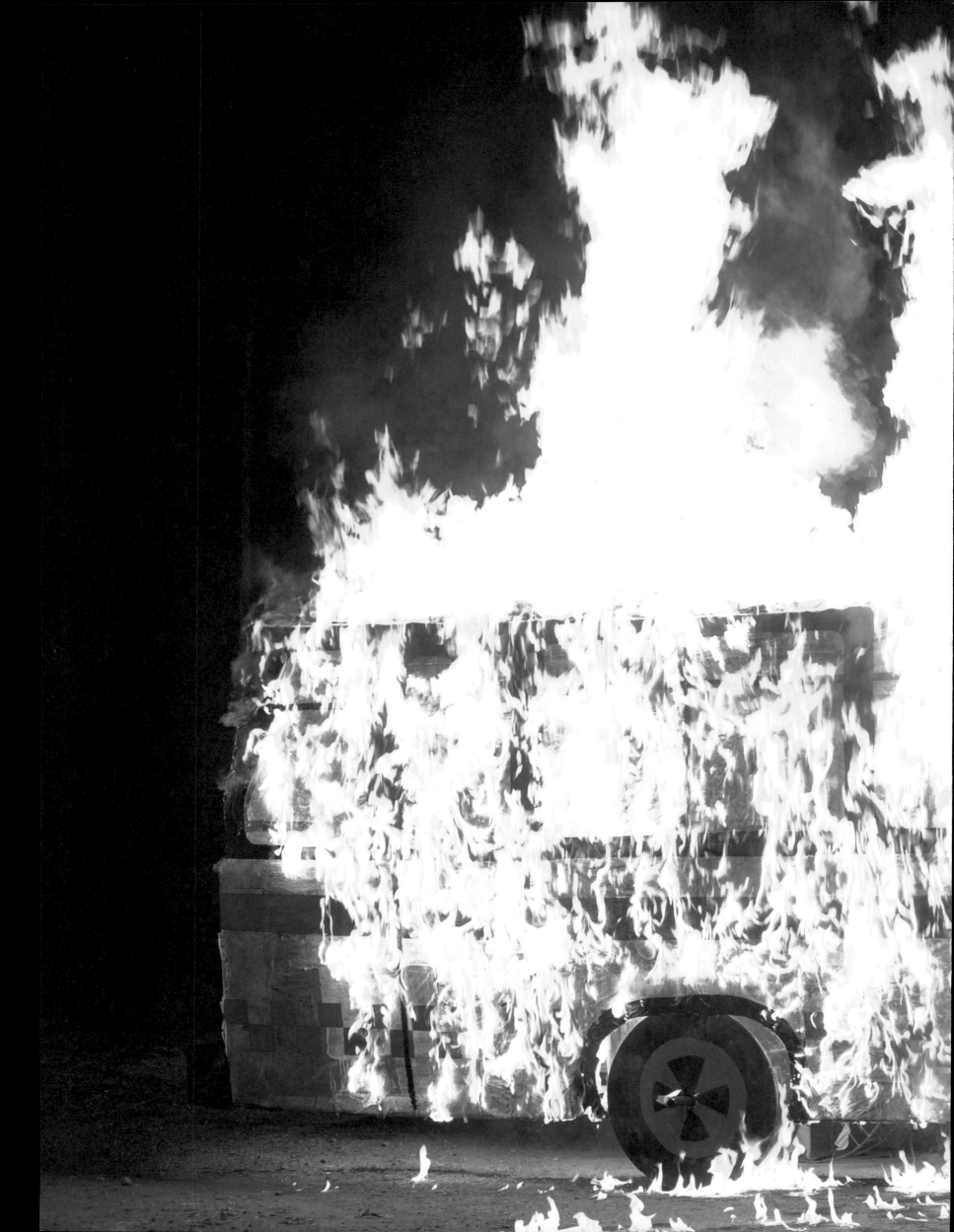

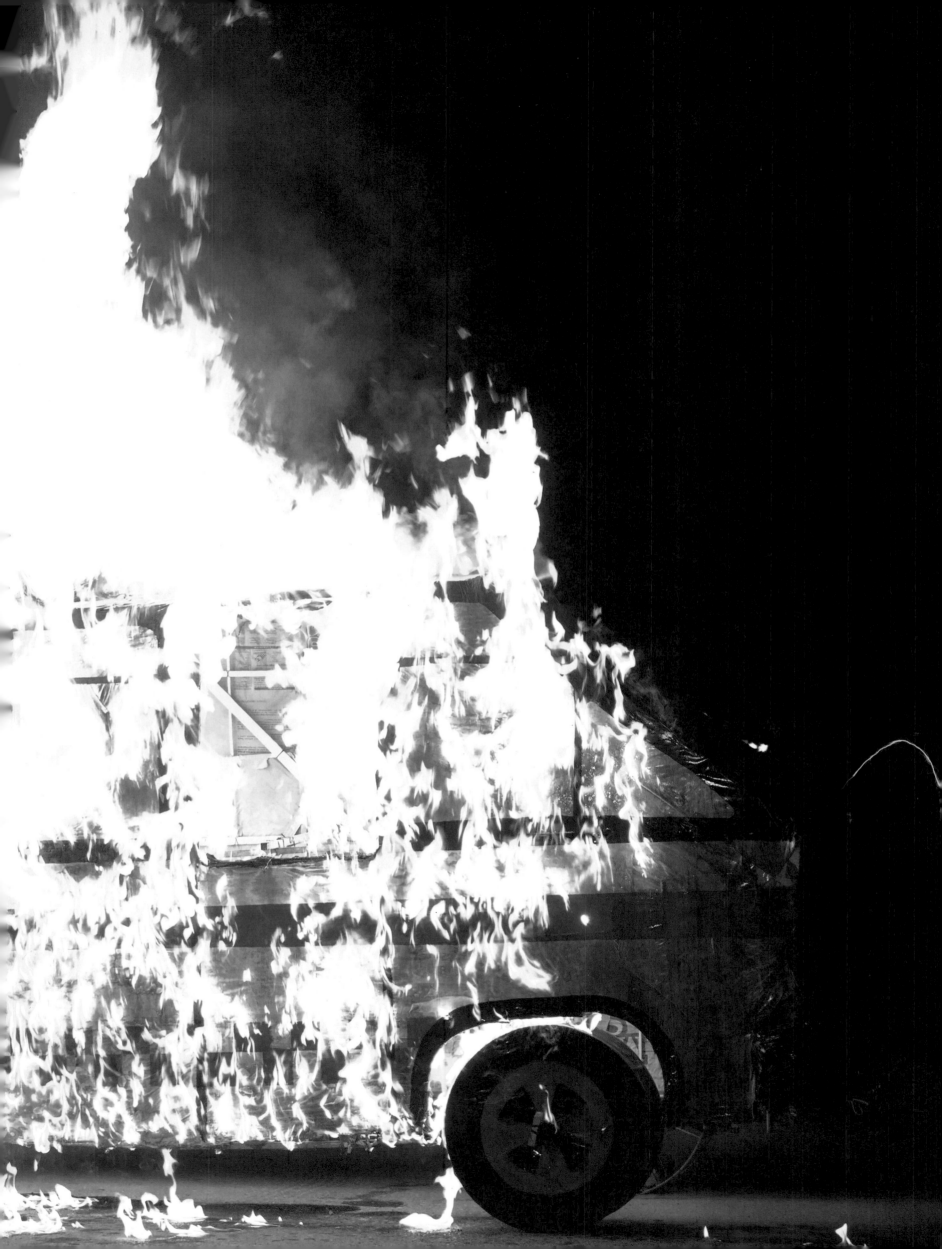

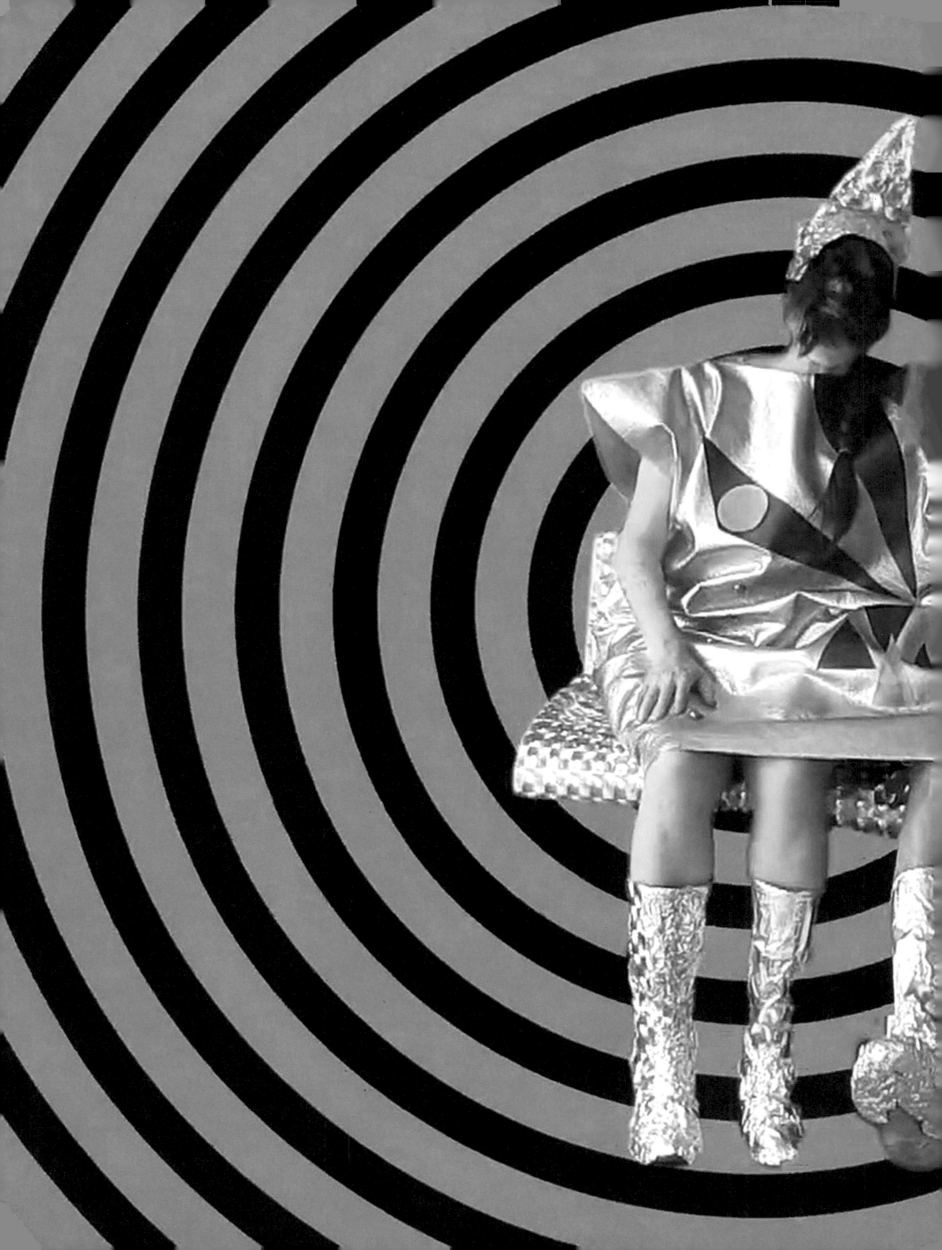

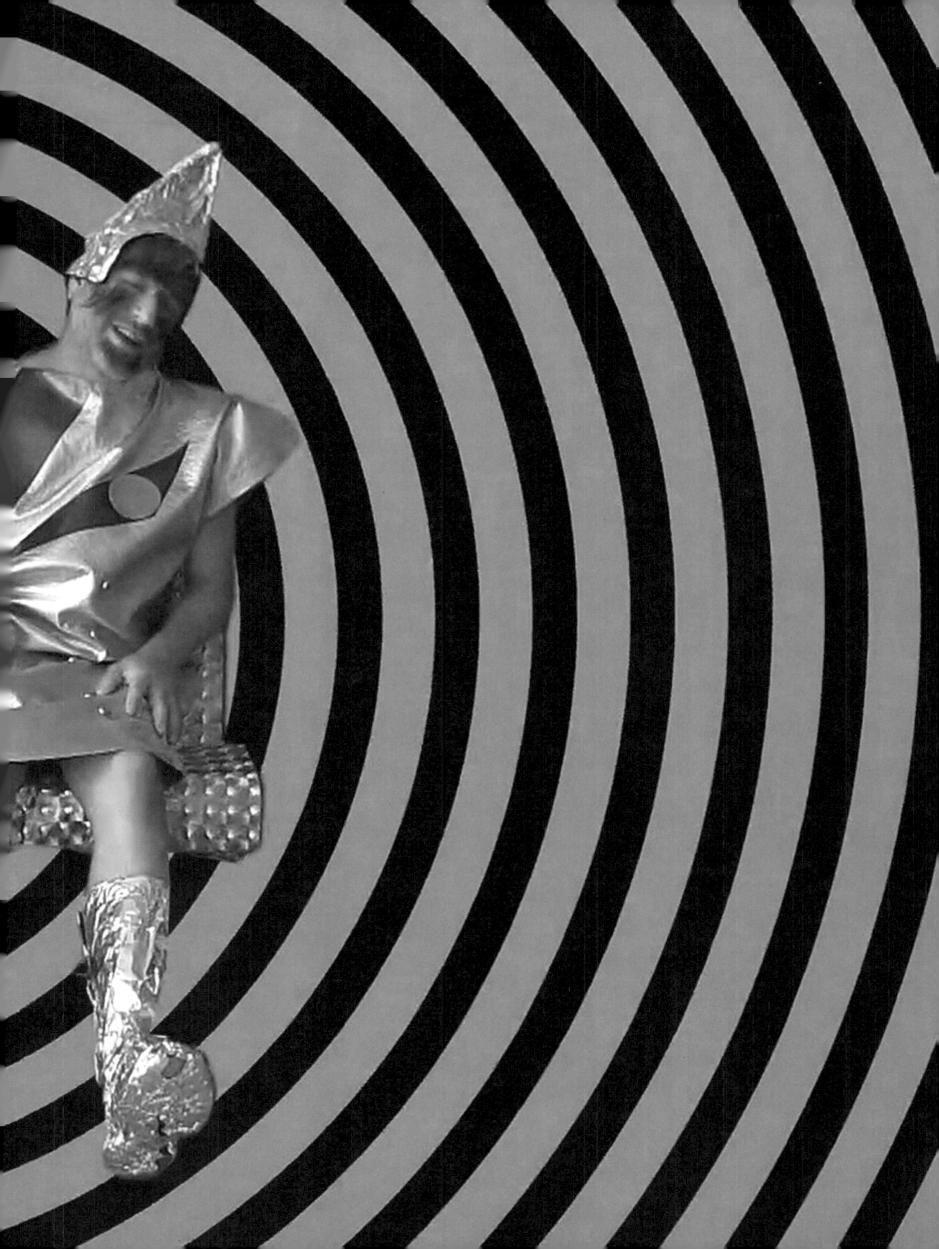

Prometheus
2017

ISA
CARRILLO

ADELA
GOLDBARD

RITA
PONCE DE LEÓN

NAOMI
RINCÓN-GALLARDO

FOUR
ARTISTS
FROM
MEXICO

REVISIT OROZCO

Published on the occasion of the exhibition "Prometheus 2017:
Four Artists from Mexico Revisit Orozco," organized by Rebecca
McGrew and presented at the Pomona College Museum of Art,
August 29–December 16, 2017.

Published with the assistance of the Getty Foundation.

Published by
Pomona College Museum of Art
333 North College Way
Claremont, CA 91711
www.pomona.edu/museum
Tel: 909-621-8283

in association with
Getty Publications
1200 Getty Center Drive, Suite 500
Los Angeles, CA 90049-1682
www.getty.edu/publications

Distributed in the United States
and Canada by the University of
Chicago Press

Distributed outside the United
States and Canada by Yale
University Press, London

"Prometheus 2017: Four Artists from Mexico Revisit Orozco" is
part of Pacific Standard Time: LA/LA, a far-reaching and ambitious
exploration of Latin American and Latino art in dialogue with Los
Angeles, taking place from September 2017 through January 2018
at more than 70 cultural institutions across Southern California.
Pacific Standard Time is an initiative of the Getty. The presenting
sponsor is Bank of America.

Publication Manager: Stephanie Emerson
Copy Editor: Elizabeth Pulsinelli
Designer: Kimberly Varella, Content Object Design Studio
Color Separations: Echelon Color, Santa Monica, California
Printing and Binding: Conti Tipocolor, Italy

(cover) Adela Goldbard, *Microbus*,
2014 (detail)

(endpapers) José Clemente Orozco,
Prometheus, 1930 (details)

(pages 1–2) Isa Carrillo, *Constelacíon
naciente III* (*Rising Constellation III*),
2015 (detail)

(pages 3–4) Adela Goldbard, *Microbus*,
2014 (detail)

(pages 5–6) Rita Ponce de León, *Sin
título 58* (*Untitled 58*), from *Es todo
gracias a ti* (*It Is All Thanks to You*), 2013

(pages 7–8) Naomi Rincón-Gallardo,
Salida del útero monacal (*Exit from the
Monastic Uterus*) from *Odisea Ocotepec
(Ocotepec Odyssey)*, 2014 (detail)

(page 244) José Clemente Orozco, *La ci-
udad en llamas* (*City in Flames*), 1937–39.
Fresco. Hospicio Cabañas, Guadalajara,
Jalisco, Mexico

ISBN: 978-1-60606-544-0

Library of Congress Cataloging-in-Publication Data

Names: McGrew, Rebecca, editor. | Geis, Terri, editor. | Pacific Standard
 Time: LA/LA (Project) | Pomona College (Claremont, Calif.). Museum of Art,
 host institution, issuing body. | Getty Foundation, sponsoring body.
Title: Prometheus 2017 : four artists from Mexico revisit Orozco / edited by
 Rebecca McGrew and Terri Geis ; with contributions by Mary K. Coffey,
 Daniel Garza Usabiaga, Terri Geis, Benjamin Kersten, Rebecca McGrew.
Description: Claremont, CA : Pomona College Museum of Art, [2017] |
 "Published on the occasion of the exhibition "Prometheus 2017: Four
 Artists from Mexico Revisit Orozco," organized by Rebecca McGrew and
 presented at Pomona College Museum of Art, August 29–December 16,
 2017."—ECIP data view. | "Pomona College Museum of Art, Claremont,
 published with the assistance of the Getty Foundation." | ""Prometheus
 2017: Four Artists from Mexico Revisit Orozco" is part of Pacific Standard
 Time: LA/LA, a far-reaching and ambitious exploration of Latin American
 and Latino art in dialogue with Los Angeles, taking place from September
 2017 through January 2018 at more than seventy cultural institutions across
 Southern California. Pacific Standard Time is an initiative of the
 Getty."—ECIP data view. | Includes bibliographical references.
Identifiers: LCCN 2017011560 | ISBN 9781606065440 (hardcover)
Subjects: LCSH: Orozco, José Clemente, 1883-1949. Prometheus—Exhibitions. |
 Orozco, José Clemente, 1883-1949—Influence—Exhibitions. | Mural
 painting and decoration, Mexican—Exhibitions.
Classification: LCC ND259.O7 A72 2017 | DDC 759.972—dc23
LC record available at https://lccn.loc.gov/2017011560

Presenting Sponsors

Prometheus
2017

FOUR ARTISTS FROM MEXICO

~~DELETED~~ REVISIT OROZCO

edited by

Rebecca McGrew

Terri Geis

with contributions by

Mary K. Coffey

Daniel Garza Usabiaga

Terri Geis

Benjamin Kersten

Rebecca McGrew

Pomona College Museum of Art, Claremont, California

Published with the assistance of the Getty Foundation

Contents

José Clemente Orozco, *Prometheus*, 1930.
Fresco, 240 × 342 in. (609.6 cm × 868.7 cm).
Pomona College

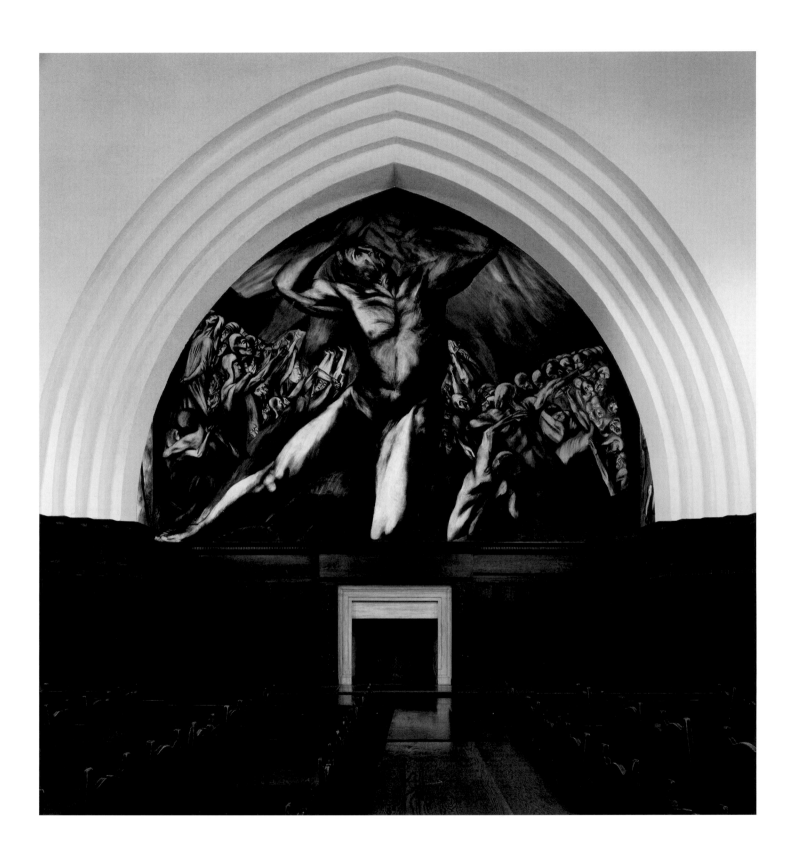

Foreword

José Clemente Orozco's *Prometheus* predates the founding of a museum on the Pomona College campus. Painted in a campus dining hall in 1930, the mural was the earliest and most important work of art acquired by Pomona College. It was and remains a truly public work of art, part of the lived experience of generations who make up the extended campus community. In the time since Orozco painted *Prometheus*, the college has established an art museum and formed an art collection, yet *Prometheus* remains the most significant and most frequently seen work of art on our campus. Over the years, it has acquired the stature of masterwork and historical artifact. In that time our appreciation of the radical nature of the college's invitation to Orozco has receded. Yet the fundamental questions Orozco posed in *Prometheus* remain pertinent: What is the nature of intellectual enlightenment, what are the burdens imposed by it, and how do we resolve conflicts among systems of knowledge and access to knowledge?

"Prometheus 2017: Four Artists from Mexico Revisit Orozco" asks today's generation to reflect on the issues that animated Orozco and the role of art as a vehicle for social change. This project, which insists on both the art of our time and the persistence of history, is the work of Senior Curator and Project Director Rebecca McGrew, former Curator of Academic Programming Terri Geis, and the team they assembled—scholars Mary K. Coffey and Daniel Garza Usabiaga. We thank them for enlarging our knowledge of Orozco's work and for introducing us to artists Isa Carrillo, Adela Goldbard, Rita Ponce de León, and Naomi Rincón-Gallardo. We are grateful to the artists for their generous engagement with *Prometheus* and with Pomona College. They exemplify the essential role of artists in our complex and politically contested world.

The Getty Foundation occasioned this opportunity to reappraise the riches of our past and to support artists working now. "Prometheus 2017: Four Artists from Mexico Revisit Orozco" is part of the Getty Foundation's Pacific Standard Time: LA/LA, which is a far-reaching and ambitious exploration of Latin American and Latino art in dialogue with Los Angeles. Pomona College is proud to be participating in this initiative, which promises to enrich the cultural life of our region and expand the history of art, and we thank the Getty Foundation for their support.

I would like to thank Professor Pijoán and the Pomona students who, more than 80 years ago, reacted to architect Sumner Spaulding's observation that his newly completed Frary Dining Hall should include fresco decoration, as was common to European refectories. Their vision and commitment brought José Clemente Orozco to our campus and endowed the college with a masterpiece. We also gratefully acknowledge all those who, over the decades, preserved and cared for *Prometheus*.

The Pomona College Museum of Art is able to undertake complex projects of this magnitude because of the many individuals who support or provided for the museum. We gratefully acknowledge: Dr. M. Lucille Paris Fund, Janet Inskeep Benton '79 Fund for Museum Programming, Merrill Francis '54 Fund for Public Art, Carlton and Laura Seaver Endowment, Edwin A. and Margaret K. Phillips Fund for Museum Publications, Matson Endowment for Exhibitions, and Louise and John Bryson. We extend our thanks to Pomona College outgoing President David Oxtoby, and the Pomona College Board of Trustees; their ongoing support and encouragement confirm the centrality of art within the liberal arts.

"Prometheus 2017: Four Artists from Mexico Revisit Orozco" is a continuation of both Pomona College's stewardship of the college's artistic heritage and its commitment to creating a platform for the art and ideas of our time. The benchmark for a teaching museum such as the Pomona College Museum of Art is the effectiveness of exhibitions, research, and programming in fostering a dialogue that connects past and present while acknowledging points of conflict and tension. We would like to recognize the members of our academic community who connect this project, and the broader PST: LA/LA initiative, with the ongoing academic mission of the college.

Kathleen Stewart Howe, PhD
Sarah Rempel and Herbert S. Rempel '23 Director
Pomona College Museum of Art

José Clemente Orozco seated in first row, 5th from right, in Frary Dining Hall, from the Pomona College yearbook, 1933. Black-and-white photograph, 10 × 8 in. (25.5 × 20.1 cm). Special Collections and Libraries, Claremont Colleges Library, Claremont, California

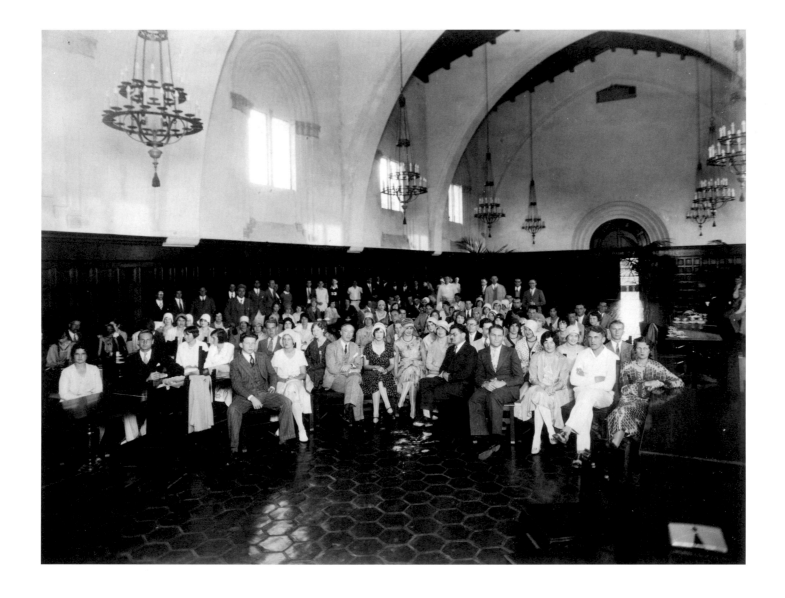

Introduction

"Prometheus 2017: Four Artists from Mexico Revisit Orozco" showcases José Clemente Orozco's mural *Prometheus* (1930) on the Pomona College campus in Los Angeles County and examines the multiple ways Orozco's vision resonates with four artists working in Mexico. Isa Carrillo, Adela Goldbard, Rita Ponce de León, and Naomi Rincón-Gallardo share Orozco's interest in history, justice, power, social protest, and storytelling, yet approach these topics from their own twenty-first-century sensibilities. The exhibition and attendant publication approach the themes of the mural from new perspectives that speak to our audience today. This proved prescient, as our research evolved almost simultaneously with rising activism and social protests at the Claremont Colleges and across the United States and Mexico.

The genesis of Orozco's *Prometheus* begins with Sumner Spaulding, the architect of Frary Dining Hall, and his observation that a mural was appropriate for the building. Many accounts suggest that Spaulding and Professor of Hispanic Civilization and Art History José Pijoán conceived of inviting the Mexican artist Orozco. Pijoán then inspired students to take up a collection for the commission. They arranged for Orozco to come to Claremont, California, where he lived for two months in a campus dormitory while working on the fresco. The *Prometheus* fresco still resides in Frary Hall, and students and visitors experience it daily in its original setting, which is a five-minute walk from the museum. As his theme, Orozco chose to portray the mythical Titan Prometheus in the act of bringing fire—enlightenment and knowledge—to humanity. Orozco felt the subject befitted an educational institution, and the mural celebrates the aspiration of art to illuminate while also highlighting the inherent tensions between creative and destructive forces.

Prometheus was the first mural painted in the United States by one of the eminent Mexican muralists Los Tres Grandes and thus signifies the beginning of a complex period of Mexican engagement with the US public. Orozco's vision of Prometheus as an allegory for art that attempts to reach a wider audience—bringing knowledge to the masses—highlights the ethos of Mexican muralism as a means to transform society.

Following the Mexican Revolution, art practice became firmly associated with the continuing struggle to build a nation, as epitomized by the public works of the Mexican muralists, who conceived of their art as a weapon for social justice and civic engagement. The goal of direct engagement with a broadly conceived citizenry—from rural farmers and city dwellers to military leaders—not only provided a model for a socially and politically engaged life but also provided public forums for civic debate. This ambitious and utopian vision of art as a revolutionary instigator of social change was complicated at the end of the 1920s, as different factions moved the revolution in a more conservative direction. The experimental phase of mural art came to a close at that point, and most muralists found themselves without public commissions. The changing political climate and subsequent lack of artistic opportunity led many artists to leave Mexico for the United States in search of patronage and new opportunities, including Orozco, who came to the United States in 1927.

The origin story of the "Prometheus 2017" exhibition lies in discussions between Pomona College Museum of Art Senior Curator Rebecca McGrew and Dartmouth College Professor of Art History and "Prometheus 2017" team member Mary K. Coffey. The two began talking in 2001, while Coffey was a visiting professor at Pomona College, about contemporary art, global conflict, and alternate ways of considering Orozco's *Prometheus*. Coffey contributed an essay to the college's 2001 publication, *José Clemente Orozco: Prometheus* (which was timed to celebrate the acquisition of seventeen *Prometheus* preparatory drawings in 2000, after nearly five decades of negotiations). In 2013, McGrew and Pomona College Museum of Art Curator of Academic Programs Terri Geis, an art historian who has published widely on Mexican modernism, were prompted to revisit the idea by a call for proposals issued by the Getty Foundation's Pacific Standard Time: LA/LA initiative, which is focused on artistic connections between Latin America and Los Angeles. Daniel Garza Usabiaga, a Mexico City-based art historian, joined the team shortly thereafter.

With a Getty Foundation Research and Planning Grant (awarded in 2014), we sought to examine, through the lens of *Prometheus*, how the public ethos of mural art contrasts with the private concerns of the artist.

Orozco's fresco reflects the tensions in his practice between a commitment to a political message and private agency. His esoteric and iconographic engagement with the myth involves his own biography and ideas about the artist as a prophet or seer. In our research, we observed conflicts between Orozco as an agent for social change and societal enlightenment and Orozco as an introspective creative visionary and myth maker. In the mural *Prometheus*, these tensions are deliberately unresolved; in our project, they are examined thematically, formally, and conceptually through the practices of the four contemporary artists in the exhibition.

With the support of the Getty Foundation's Implementation and Publication Grant (awarded in 2015), we further considered the role of the artist in public and private myth-making, examined how artists' strategies of engagement have changed since the early twentieth century, and asked what contemporary artists from Mexico working in the legacy of the mural ethos contribute today. The muralists' desire to politicize artistic expression and to foster social change is alive in contemporary Mexican art. Likewise, Orozco's principled skepticism about art's ability to change the world and his clear-headed yet passionate advocacy for a spiritual humanism can also be observed in the ways in which some contemporary artists in Mexico have shifted away from the ambitions of global revolution toward engaging with specific communities or individuals on a more modest scale, often focusing on particular micro-histories.

The four women artists from Mexico featured in "Prometheus 2017" explore the dynamics of power, communication, and desire. They offer a counterpoint to the masculinist imaginary of Orozco's mural in ways that many artists of Orozco's generation did not. In the 1930s, the art world in both Mexico and the United States was heavily male centric. Pomona College likewise had a predominantly male faculty, and Frary Hall, the location of the mural, was a male-only dining hall. The four contemporary artists in "Prometheus 2017" address the intersection between public art and private myth in powerful and vital ways that are not necessarily derived from a gendered practice but that introduce the female body and voice alongside interpersonal praxis.

Carrillo, Goldbard, Ponce de León, and Rincón-Gallardo each address Orozco's mural, person, and/or

practice in distinct ways. Carrillo's psychological portrayal of Orozco uses the esoteric practices of astrology and graphology to intimately explore his life and work. Referencing acts of political violence in recent Mexican history, Goldbard creates videos of sculptures that she fabricates with local artisans then activates or destroys using pyrotechnics. She embraces the metaphor of fire as a tool of both creation and destruction. Ponce de León revisits the history and legacy of mural art as a tool to reconceptualize community building and public art practice. Collaborating with Pomona College students, Ponce de León's project engages *Prometheus* through collective work sessions. Examining Greek mythology and historical dreams of utopia in Mexico, Rincón-Gallardo links a personal narrative with an exploration of the themes that are at the heart of *Prometheus* and Orozco's turn to myth. "Prometheus 2017" offers an historical parallel: students played a critical role in realizing Orozco's *Prometheus*, and current students worked collaboratively with the artists in the creation of the "Prometheus 2017" exhibition.

The exhibition dedicates a gallery to each of the contemporary artists, highlighting her unique connections to Orozco and the *Prometheus* mural. Inspired by the Getty Foundation's support for this project, the college commissioned an in-depth public practice artwork by Ponce de León that incorporated several visits to campus during its development and resulted in a new mural painting in the museum galleries. The foundation's support also allowed us to present three video works by Goldbard and to recreate one of her sculptures, which was later activated in a new pyrotechnic performance. Additionally, with the foundation's assistance, we were able to present new paintings and objects by Carrillo and to exhibit a nine-channel video installation by Rincón-Gallardo. None of these works has been exhibited previously in the United States.

A presentation of Orozco's preparatory drawings for the mural from the museum's permanent collection frames the key themes of "Prometheus 2017." Correlating closely with the version Orozco ultimately painted, the five compositional and twelve figure studies reveal the artist's explorations of composition and anatomy as they evolved from his formal academic training.

A timeline anchors elements of the exhibition with information on Orozco's life and artwork, the

Prometheus mural, Prometheus as a discursive figure, the history of Pomona College, and pertinent world events. Public programs — including scholarly lectures, artist conversations, performances, and academic courses — supplement the exhibition's goals and themes throughout the run of the project. These programs are supported by the research that was presented during the 2015–17 Orozco in Focus lecture series, which featured national and international scholars who examined the artistic, social, and political significance of Orozco.

This publication, *Prometheus 2017: Four Artists from Mexico Revisit Orozco,* presents a series of newly commissioned, substantive essays that contextualize Orozco and *Prometheus*; a section of critical essays focused on each of the contemporary artists; a detailed chronology of *Prometheus*; a bibliography tracing scholarly engagement with the exhibition themes; and reproductions of artworks and archival images that document the mural.

Each of the three scholarly essays addresses different aspects of Orozco, *Prometheus*, and the connections between Los Angeles and Mexico; collectively they present substantial new scholarship connecting Mexican muralism with contemporary art practices. The essay "Pandora Rising: José Clemente Orozco and Four Contemporary Women Artists from Mexico" provides an overview of the exhibition themes and situates the four contemporary artists and Orozco within a theoretical framework anchored by current studies of Orozco, contemporary art strategies, esoteric ideologies, social protest, and the work of philosopher Ivan Illich. Coffey's essay, "Putting Orozco's *Prometheus* in Motion: Reframing Mural Art's Meaning for Contemporary Art Practice," provides an interpretation of Orozco's mural from the standpoint of contemporary debates over relational aesthetics, site specificity, and embodiment. By returning to the historical moment of Orozco's production, Coffey teases out the skepticism, ambivalence, and melancholy that animated his practice. Garza Usabiaga's essay, "Muralism's Afterlife: Mural Practice and the Avant-Garde Legacy in Contemporary Art of Mexico," examines the mural as a form of public art, investing the form with a critical, social, and political posture that resonates with artists today.

"Prometheus 2017," made possible by the generous support of the Getty Foundation, brought together a committed team of artists, curators, and scholars to produce an exhibition and publication with thoughtful new interpretations and historical insight. The project broaders the existing literature on Mexican art and muralism and connects it specifically to contemporary art strategies, the historical and evolving understanding of audiences and the public, and the tension between public modes of address and the artist's private agency. This project examines this important legacy of artistic transmission between Mexico and Los Angeles, while foregrounding a deeper theoretical consideration of the issues within the historical and contemporary art works.

Rebecca McGrew ('85)
Senior Curator
Pomona College Museum of Art

Terri Geis
Curator of Academic Programs
Pomona College Museum of Art

November 22, 2016

Terri Geis and Rebecca McGrew

Pandora Rising

José Clemente Orozco
and
Four Contemporary
Women Artists from
Mexico

Pandora Rising: José Clemente Orozco and Four Contemporary Women Artists from Mexico

Terri Geis and Rebecca McGrew

> The original Pandora, the All-Giver, was an Earth goddess
> in prehistoric matriarchal Greece. She let all ills escape
> from her amphora (*pythos*). But she closed the lid before
> Hope could escape. The history of modern man begins
> with the degradation of Pandora's myth.... It is the history
> of the Promethean endeavor to forge institutions in order
> to corral each of the rampant ills. It is the history of fading
> hope and rising expectations. —Ivan Illich[1]

José Clemente Orozco's *Prometheus* mural confronts viewers with ambiguous depictions of the ancient Greek myth as a modern allegory. Drawing down fire from Mount Olympus and offering it to humankind, Orozco's Titan Prometheus is simultaneously praised and scorned by the recipients of his gift. The act is not portrayed as entirely heroic, and, as Karen Cordero Reiman notes, "Prometheus's posture makes it unclear whether he is recoiling from or submitting to the fire."[2] The mural imagery complicates any assertion that fire, a symbol of advancement through technology, is really what humans need. Will such a gift come at the cost of true humanity by precipitating insatiable greed? Or will fire be safe in human hands and a hopeful beacon of the future, as Prometheus's name ("forethought") implies?

When Pomona College commissioned the *Prometheus* mural in 1930, the project received the financial and moral support of the student body, and its creation can be viewed as celebrating intellectual, social, and democratic enlightenment within the environment of higher learning. In this sense, it adheres to the ideals of broad social progress and advancement proposed by the artists of the Mexican Mural movement. However, the imagery of the mural highlights Orozco's pessimism about humankind's ability to progress along a path to social justice. Alejandro Anreus characterizes Orozco's outlook as "*via negativa*, a perpetually critical stance that embraces no simplistic possibilities."[3]

These essential questions of pessimism and hope at the heart of the Prometheus myth are also central to the story of Pandora. As described by the Greek poet Hesiod in *Theogony* (c. 700 BC), Zeus was deeply angered by Prometheus's subversive theft of fire; in retribution, he created his own gift to mankind. He ordered the god Hephaestus to form the "lovely evil" Pandora out

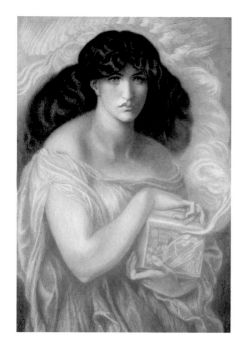

Dante Gabriel Rossetti, *Pandora*, 1879.
Colored chalks on cream wove paper,
40⅝ × 24¾ in. (103.2 × 62.7 cm).
Harvard Art Museums/Fogg Museum,
Cambridge, Massachusetts

of clay, and she was subsequently brought to life by the four winds.[4] Pandora, whose name means "all-giving," received an amphora filled by the gods with all of the ills and sorrows of the world. Despite the warnings of his brother Prometheus, the Titan Epimetheus ("afterthought") took the newly formed woman as his companion. She soon opened the lid of her vessel, unleashing upon humanity its myriad sufferings. One by one these negative forces flew out into the world, with only one item remaining in the amphora: hope.

While centuries of Western thinkers and poets have interpreted the act of Prometheus as the ultimate sacrifice on behalf of humankind's progress, Pandora stands ubiquitously as a symbol of careless, indulgent actions with devastating consequences. The gift of Promethean fire is viewed as the start of civilization, and Prometheus is characterized as a rebel against the gods, a force of revolution in aid of, but standing apart from, the human masses. One prominent example, Percy Bysshe Shelley's 1820 lyrical drama *Prometheus Unbound*, casts Prometheus as a champion of democracy and free will, as one who challenged corruption and repression. Pandora, on the other hand, is typically portrayed as a figure who endows humanity with relentless torments and suffering, including hatred, violence, famine, illness, and war. John Milton's *Paradise Lost* (1667 and 1674), for example, compares the actions of Pandora with those of Biblical Eve.

In Mexican texts and artworks from the post-Revolutionary period through the 1970s, the myth of Prometheus—and more broadly classical Greek culture—was used to examine notions of enlightenment within society. Prominent intellectuals in the 1920s, including the writer, politician, and early patron of the Mexican Mural movement, José Vasconcelos, used the myth to forward narratives of Mexico's progress through the humanities into a utopian age. In contrast, Orozco challenged the concept of the Titan as hero, as later would Austrian Catholic priest and radical thinker Ivan Illich. Illich wrote his seminal *Deschooling Society* while residing in Ocotepec, Mexico, in 1971. In the text, he questions modern narratives of human progress and employs the Prometheus myth to elaborate his views on alternative paths. If Orozco is ambivalent about the power of Prometheus's act to advance humanity, Illich rejects this concept altogether. For him, Prometheus is a symbol of technology out of control and of humankind's endless demands and expectations, which are perpetuated by institutions. Illich instead chooses Epimetheus and Pandora as models for the future. In *Deschooling Society*, he describes Pandora as the ancient bearer of hope and offers her as a symbolic alternative for contemporary society.

Questions regarding history, progress, and social justice also inform the four artists in the exhibition "Prometheus 2017: Four Artists from Mexico Revisit Orozco." Isa Carrillo, Adela Goldbard, Rita Ponce de León, and Naomi Rincón-Gallardo's practices emerged in the 1990s and early 2000s, in the context of a renewed focus, in Mexico and internationally, on activist art, socially engaged art, and public practice. Scholars and art critics have examined the aesthetic framework surrounding transdisciplinary art practices that focus on social interaction as a means of community involvement and public engagement.[5] In the context of this essay, public practice comprises art forms that utilize social relations as both content and form and refers to artist-prompted or artist-guided social activism or

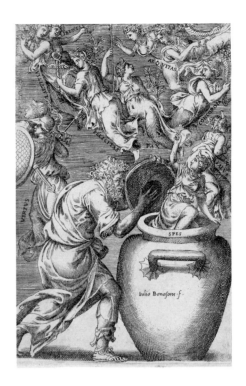

Giulio Bonasone, *Epimetheus opening Pandora's box*, 1531–76. Engraving, 6¾ × 4⁹⁄₁₆ in. (17.2 × 11.6 cm). Metropolitan Museum of Art, New York

interactions with a specific public that function as the art itself. In both cases, the artist attempts to create conditions for real social change.

Carrillo, Goldbard, Ponce de León, and Rincón-Gallardo use strategies of historical and archival research, public intervention, and intimately scaled social practice to connect with their publics and advance social issues. While Orozco was participating, however ambivalently, in the ambitious attempt at social re-ordering proposed by the epic, consolidating narrative of the mural program of his era, these four artists today come from a more subtle, mediated position in connection with specific communities. All four artists explore, to use Illich's phrase, the "history of fading hope and rising expectations" that confronts the twenty-first century, and each artist offers a vision of defiant hope, the only thing left in Pandora's box.[6]

This essay examines how notions of hope, pessimism, and action resonate with Orozco and each of the exhibiting contemporary artists. In order to do so, the text moves back and forth between the early twentieth century and the present era. In our context, *Prometheus* provides the core around which each artist's work revolves—as they activate, reference, or respond to the mural at Pomona College and Orozco the artist. We use four interconnected themes to explore confluences between Orozco and the contemporary artists. The first theme is *Inheritances*, the collecting and recounting of personal or collective memories through storytelling and bearing witness to current and historical events. The second theme, *The Hidden Message*, explores how secret or doubled messages within occult practices exist alongside political dialogues. The essay then examines *Reenactment and Repetition*, the process of reflecting on the multiplicity of perspectives found in the recreation of past events. The essay concludes with *Technology, Conviviality, and Hope*, which parallel Illich's notion of conviviality as refracted through collaboration and community. The four contemporary artists and their projects in "Prometheus 2017" constellate around these four themes, creating multiple points of alliance and commonality while ultimately highlighting a vision fueled by hope.

Inheritances—
The Individual Share to the Common Good

In 1929, Orozco wrote one of his few published statements: "New World, New Races and New Art." Here, he repeatedly questions the inheritance from the past as a means of inspiration for modern civilization, asserting, "The Art of the New World cannot take root in the old traditions of the Old World."[7] Artists of the "New World" instead have the "unavoidable duty" of producing "a New Art in a new spiritual and physical medium."[8] Yet, soon after this essay was written, Orozco selected a classical theme for his mural at Pomona. Orozco's depiction of uncertainty in Prometheus's act, along with the titles of the side panels of the mural, *Destruction of Mythology* and *Strangulation of Mythology*, indicates his desire to reference and repeat the inherited stories and symbols of the ancient world, but also to call these legacies into question and challenge their legitimacy for the future.

Orozco's vision and choice of subject matter participate in a wider Hellenist-inspired discourse in Mexico's revolutionary and post-revolutionary cultural production and educational discourse. In 1909, a group of writers and philosophers in Mexico formed the Ateneo de la Juventud (Athaeneum of Youth). This elite group, with members including Vasconcelos and Diego Rivera, stressed the importance of the humanities, proposing classical philosophy, drama, and poetry as a basis to form modern Mexican society. As Ernesto Mejía Sánchez notes, members spent their collective time "reading and rereading chorally the best of Hellenistic letters and studies."[9]

Some members of the Ateneo subsequently attempted to create modern epics, such as Vasconcelos's play *Prometeo vencedor* (*A Winning Prometheus*), which he wrote during a period of exile in San Diego, California, and published in 1920. The play forecasts the rise of a new aesthetic era, placing Prometheus in a philosophical dialogue with Satan as the two sit between the Mexican volcanoes Popocatépetl and Iztaccíhualtl. As a new breed of men and women—the *raza joven* (young race)—emerges, Prometheus declares, "The law of nature is repetition without end and the law of the spirit is to evolve while improving until the Absolute is mastered!"[10]

Vasconcelos firmly sought to draw parallels between the culture of Ancient Greece and the promise of evolution within twentieth-century Mexico, and he viewed educational reform as a crucial component. In late 1921, he was appointed minister of education; he sponsored the ambitious mural program, as well as a program of publishing and widely distributing classical texts through the National Autonomous University of Mexico. The mass-produced publications included *The Iliad*, *The Odyssey*, and the works of Plato and Euripides, as well as *Prometheus Bound*, for which Orozco is thought to have created an image.[11] In the view of Vasconcelos and other members of the Ateneo, reading and transmitting knowledge via recitation and repetition in public and private dialogues would lead to enlightenment.

Throughout the 1920s, Vasconcelos regularly returned to the figure of Prometheus. In the 1927 essay "Los caracteres del progreso" ("The Characteristics of Progress"), Vasconcelos analyzes modern concepts of development, noting the prevalent "scientific" idea of progress in relation to humankind's mastery of the forces of nature.[12] Vasconcelos instead proposes the "doctrine of Prometheus," asserting that technology is useless if not accompanied by a new level of awareness entailing an "inexhaustible capacity for protest, a lack of conformity and rebelliousness."[13] The heroism of Prometheus is not his gift of fire, but resides instead in his denunciation of "the tyrants who sacrifice lives in order to impose their command."[14] In the Prometheus story, Vasconcelos sees the model for Mexico, in which humankind values "the rights of the conscience over intolerance and the power of freedom over the forces of violence."[15]

On one level, Orozco's mural proposes a similar doctrine of freedom and rebellion. In an interview with the Pomona College *Student Life* newspaper, Orozco describes the side panels of the mural as representing, "the ancient times that Prometheus is upsetting by giving knowledge to man."[16] In the west panel, *Destruction of Mythology,* an imperious Zeus and Hera fall to the wayside

José Clemente Orozco, *Zeus, Hera, and Io* or *The Destruction of Mythology, Prometheus* (west panel), 1930. Fresco, 240 × 186 in. (609.6 × 472.4 cm). Pomona College

like rubble, their faces looking on in horror at Prometheus's act. However, while Vasconcelos envisioned the rise of a new *raza joven* through the ideals of education and enlightenment, Orozco was more pessimistic about humankind. Renato González Mello states of *Prometheus*, "The fire divides the masses; it promotes passion and hope, but also rage and desire. It does not bring man closer to rational divinity; rather, it provokes a confrontation."[17] Orozco questioned the inheritance of the classical world and the proposals of elite Mexican intellectuals to harness these narratives and ideals for the twentieth century, implying that a total break from the past might be required.

Orozco previously explored this theme in a scene from his mural cycle at the National Preparatory School in Mexico City, *La destrucción del viejo orden* (*Destruction of the Old Order*, 1926). Here, two revolutionaries turn to glance back at the total destruction of civilization behind them, represented by the rubble of white marble buildings with classical columns and arches. One of the men gestures forward with his hand and foot, as if to move into the future with a Promethean "forward-thinking" ethos. Yet he and his colleague seem frozen, staring at the remnants of the past, incapable of moving ahead.

If on one level Orozco advocates abandonment of the past, what is it that he intended for his audience, including the many students who have dined under the mural on a regular basis, to inherit from *Prometheus*? Perhaps he intended to facilitate an ongoing dialogue between multiple generations, in order to produce new narratives of "forward-thinking." As Orozco reflects in his 1929 essay, "Each new cycle must work for itself, must create, must yield its own production—its individual share to the common good."[18]

Rita Ponce de León's project for "Prometheus 2017" pivots on the concept of inheritances through intimate discussion and storytelling in a relayed chain of messages. From November 2015 through June 2017, Ponce de León facilitated a series of meetings and conversations between successive pairs of students. Each twosome first determined the conditions under which they would meet. For each meeting, Ponce de León asked the students to reflect on questions, including "What does *Prometheus* mean to you today?" and "What does art mean to you?" After each meeting, the pair created a package—photographs, drawings, written notes, diagrams, and transcribed conversations—of the most important ideas to bequeath to the next pair. Ponce de León, as she termed it, "inherited" the entire dialogic chain, and this became the conceptual material that fueled her project in "Prometheus 2017." She hopes that this process then "vanishes, so that only what matters survives," in the form of the final artwork.[19] What remain are Ponce de León's drawings of dreamlike symbolic imagery painted directly onto the walls of the gallery. By designing the artwork based on, but not directly representing, others' personal conversations, she offers participants the freedom to speak of their stories or dreams and contribute, to borrow from Orozco, their "individual share to the common good."

Ponce de León invited students to freely discuss topics "not to try to capture or accumulate ideas, but to deepen the political, situational, and intellectual in a human way."[20] The project thus reflects pressing concerns at Pomona College in 2016, including the divisive presidential election, the Black Lives

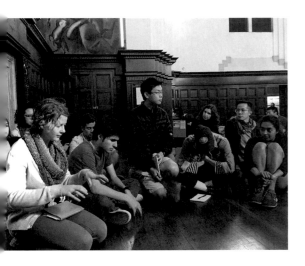

Student workshops with Rita Ponce de León at Pomona College, November 2015. Pomona College

Matter movement, and the global immigration and Syrian refugee crises—all of which inspired political organization by students at the Claremont Colleges. Ponce de León's work affirms the students' concerns for social justice, and this shared engagement with activism echoes, as James Oles explores, the "utopian drive" that sought to "solve social problems through art so evident in the great murals of the 1920s and 1930s."[21]

Within *Prometheus,* this utopian drive is complicated by Orozco's *via negativa,* and he alludes to the inability of society to live up to its own ideals of education, democracy, and enlightenment, as proposed, for example, by the Ateneo de Juventud described previously. The failures of the Mexican State's post-Revolutionary legacy were strongly underscored in September of 2014, when student teachers traveling by bus from the Rural Normal School of Ayotzinapa in Guerrero, Mexico, to attend a political protest were violently attacked by police. Six students were killed, 25 wounded, and another 43 disappeared. With the support of the international community, families continue to search for the missing students and for the truth about their disappearance. Ponce de León became involved with the ensuing global protests and has visited Oaxaca to work for justice for the missing students. The artist and students at Pomona bear witness to these contemporary tragedies and, by sharing stories, hope to pass on these inheritances to their peers.

Similarly, Adela Goldbard's investigations into society's ills form the basis of her videos and pyrotechnic sculptures. Her work starts with archival research into "official" (i.e., state-sanctioned) narratives of violent events in Mexico. Based on that research, she builds replicas of vehicles that were central to acts of political violence in recent Mexican history, then uses pyrotechnics to activate and destroy them. For example, in the video *Microbus* (2014), Goldbard portrays a public transportation vehicle set on fire as a drug cartel blockade. "Prometheus 2017" presents *Microbus* and two other videos by Goldbard—*Lobo* (2013) and *Plutarco* (2015)—along with a replica of the sculpture *Microbus* (2014/2017).

In words that recall the symbolism in Orozco's *La destrucción del viejo orden* mural, Goldbard compares conservation and destruction. She sees conservation "as an exercise of power: the past is something that is used as an instrument of legitimation by a culture or political party (Mexican state)." In contrast, "the act of destroying something, a monument or construction, is a means of constructing a collective memory in a different way."[22] Goldbard's performances and videos contest the means through which the government and the press manipulate facts to construct an "official" story. By confronting us with these grim recent events, Goldbard compels us as viewers to bear witness to—and remember—violence and injustices.

One of Goldbard's reference points for this body of work is the traditional festival of the Burning of Judas, in which "allegorical and ephemeral figures . . . are burned as a way to get rid of evil, in a purge, or an exorcism."[23] Goldbard works with communities in Mexico that for centuries have valued this ritual of exorcism (and whose pyrotechnic labors are, ironically, overseen by the Mexican government). The theme of ceremonial burning can also be interpreted in Orozco's work. Guadalajaran art critic Juan José Arreola describes one

Adela Goldbard, *Microbus,* 2014. Photographic still from 4k video projected in HD with stereo sound, 4 min. 38 sec.

unspecified work by Orozco as a kind of Judas burning: "We see, for example, this figure swollen with lies and wealth to the point of exploding because Orozco painted it like a Judas of reed and cardboard, using his tubes of paint like cartridges of gunpowder."[24]

To construct and then destroy her artworks, Goldbard collaborates with craftsmen and pyrotechnicians whose skills have been passed down for many generations in specific regions in Mexico. Critic Iván Ruiz cites Goldbard's exploration of vernacular culture as a "conceptual activation of folk art."[25] Goldbard notes that her replicas evoke a traditional "piñata" aesthetic; in her hands, the ephemeral materials serve as an allegory for the fragility of truth.[26]

The Hidden Message—
Eclipses and Veils

The public political discourse and widespread educational strategies in early twentieth-century Mexico existed in parallel with secret societies and esoteric thought. Vasconcelos, for example, describes in his autobiography how his early exile in New York was spent reading the "Theosophical chaos" of Madame Blavatsky and Annie Besant, which influenced his theoretical proposals for a utopian evolution.[27] González Mello has thoroughly examined the impact of private societies—Masonic, Theosophical, and Rosicrucian—on broader opinion in Mexico and on the development and elaboration of imagery within the Mexican mural program.[28] Furthermore, González Mello, Fausto Ramírez, and Sofía Anaya Wittman have explored the role of esotericism, including Freemason and Rosicrucian symbols, within Orozco's work. They note how the artist's use of hidden messages, alongside his engagement with Greek mythology, is at times filtered through the work of European philosophers, including Friedrich Nietzsche. Utilizing the mystical terms adopted by theosophy and alchemy, Wittman describes this as "a triple veil" over Orozco's work, "a mythological veil, an esoteric veil, and a Nietzschean philosophical veil."[29]

These veils provide an interpretive overlay for Orozco's early work, and they are especially evident in the artist's 1925 mural *Omnisciencia* (*Omniscience*), on the staircase of the Casa de los Azulejos in Mexico City. With its imagery of a kneeling figure receiving or transmitting illumination through fire, the mural has often been interpreted as an antecedent to *Prometheus*. Orozco intended for the mural to embody "the fertility of the spirit" and the "fruitful power of Mysticism in its highest forms...intuition and genius."[30] González Mello speculates that the text "Aesclepio," from the Egyptian-Greek secret society wisdom scriptures *Corpus Hermeticum*, influenced Orozco's imagery, specifically a passage on the fabrication of gods. The mural underscores an evolution of man through stages of initiation toward a higher, god-like consciousness, while also affirming that "Man creates and destroys Gods at his will and whim."[31]

The imagery of the cosmos and its potential meanings for humankind are also apparent in Orozco's early work. As Ramírez has noted, in one subsequently destroyed section of the murals at the National Preparatory School, *La lucha del*

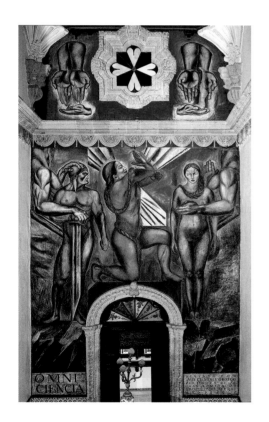

José Clemente Orozco, *Omnisciencia* (*Omniscience*), 1925. Fresco. Casa de los Azulejos (Sanborn's Restaurant), Mexico City, Mexico

hombre con la naturaleza (*The Battle Between Man and Nature*, 1922), Orozco painted an image that resembles the constellation of Ursa Major.[32] Ramírez ties this symbolism to Theosophical imagery, in which Ursa Major refers to the "seven planetary cycles that are necessary for the evolution of humankind."[33] González Mello also notes the planetarium-like appearance of the panel and concludes: "With so many vectors, celestial spheres, stars and solar movements, Orozco pointed to one of the fundamental ideas of modern hermeticism: the entire cosmos is a regular machine. Its stars, indeed, have an 'influence' over man; but their movements are regular and predictable."[34]

Orozco's interest in humankind's celestial connections was furthered by his acquaintance with the writer Emily S. Hamblen and her work on the visionary English artist and poet William Blake. In the late 1920s, Hamblen frequented the salon of the Delphic Circle, a New York private society. (Orozco's connection with the group will be examined the next section.) Hamblen's study, *On the Minor Prophesies of William Blake*, was published in 1930, the same year that Orozco painted *Prometheus*. S. Foster Damon's introduction to the book notes Hamblen's concept of the "zodiacal man, through whose enormous limbs circulate the starry hosts."[35] Examining Blake's work, Hamblen describes his vision of the human body as constructed through the signs of the zodiac. For example, Aries is the head of man; Gemini, the arms and shoulders; Scorpio, the genitals; and Pisces, the feet. She writes, "The body is to be our guide, not as a geographical map upon which we must locate things and persons and the course of events, but as the transcript of a psychological set of relationships to which all known and knowable objects, movements, impulses, qualities, and thoughts will conform. Each part has a definite meaning in the universe as conceived by the ancients and in the history of man."[36]

In Blake, Hamblen finds a model of defiance. A scholar on the work of Nietzsche, Hamblen repeatedly positions Blake as a predecessor of the philosopher, noting their shared intention of refuting moral codes and the "modern, so-called liberal tendency, to interpret the prophets and Christ as ethical teachers; founders of higher morality; a better social system."[37] Hamblen praises Blake's esoteric vision of an unfixed world, noting, "There is nothing in the universe which is not fluid except man's rational interpretation of himself and the world. The passion of the artist, the creator, the lover of his fellow-man is in his revolt against the tyranny of the moralistic system."[38] Hamblen's notions of creativity and defiance closely resonate with Orozco's imagery and the ambiguities of good and evil within his depiction of the Prometheus myth. In Orozco's artworks, esotericism often reinforces his worldview of skepticism, rebellion, and *via negativa*, while also demonstrating the power of the human body and humanity to transcend history and to evolve.

Isa Carrillo's exhibition "Mano izquierda" ("Left Hand," 2015) utilizes archival sources and divinatory practices—ranging from personal narratives to astrological investigations—to examine this legacy of esotericism in Orozco's life and work. Presented in its entirety in "Prometheus 2017," the project consists of a series of paintings, drawings, and mixed media works. The title of the project refers to Orozco's tragic loss of his left hand, at the age of 21, while

Isa Carrillo, "Mano izquierda" ("Left Hand"), 2015. Installation view, Museo Taller José Clemente Orozco, PAOS Residencias, Guadalajara, Jalisco, Mexico

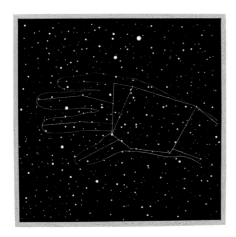

Isa Carrillo, *Constelación naciente III (Rising Constellation III)*, 2015. Wood, paint, and color pencil, 23⅝ × 23⅝ in. (60 × 60 cm)

making fireworks to celebrate Mexico's Independence Day. During a residency at the Museo Taller José Clemente Orozco in 2015, she explored the symbolism of Orozco's missing left hand and constructed a personality profile of him. With the help of graphologist Sandra Martínez Escobosa, Carrillo analyzed one of Orozco's letters to his wife, Margarita Valladares, from the publication *Cartas a Margarita (Letters to Margarita)*, for insights into his personality. Carrillo interpreted Orozco's astrological birth chart in consultation with Iván Sierra, a student with nine years of experience in palmistry. Sierra also assisted Carrillo in an analysis of photographs of Orozco's hands to uncover points of intersection between the muralist's handwriting and astrological profile. In addition, Carrillo researched astrological records of the night sky in the early twentieth century, seeking to determine the astral alignments on the day Orozco lost his hand.

Using this body of research, Carrillo constructed sculptures incorporating slide viewers of astrological images and test tubes of graphite and gunpowder. She also created paintings of constellations formed by traced outlines of Orozco's hands. As with figures from Greek mythology or Hamblen's vision of the zodiacal man, Carrillo's Orozco mysteriously transforms into a constellation. In her text "Stars in the Cosmos" (2015), a part of the same project, she created an enigmatic fable about this transformation: "Around 1930, astronauts from NASA and the Soviet Union observed something peculiar in the sky. A cluster of stars appeared to be a drawing, moving in the observable space. Records indicated that these stars formed a kind of strange constellation. It was as if a hand made the silhouette of a rabbit's profile, days later the profile of a dog, and finally a swan. It seemed as if the cosmos was making a joke.... It, the ghost of the hand, occupied a place in space. It took the shape of an outstretched, relaxed hand, with five fingers at rest. The trail of this constellation was marked until the end of time and for the rest of eternity."[39]

After Carrillo completed her investigations for the "Mano izquierda" exhibition, she began to think of them as an "'invisible sculpture' about the symbolic meaning of Orozco's 'left hand'...[T]he sculpture is invisible because I assembled a profile of his personality and sensibility using data rather than matter. Furthermore, his left hand was a ghost from the moment he lost it and for most of his life. So I thought about 're-shaping' this immateriality with matter. One element I tried to make present in the pieces is gunpowder, since Orozco was working with it when he had the accident that lost him his hand and caused him to dedicate himself to painting (rather than architecture)."[40]

In *Eclipse* (2015), a mixed-media work from "Mano izquierda," Carrillo combines a drawing with a slide viewer that contains a black-and-white image of *Paisaje metafísico (Metaphysical Landscape*, 1948), one of Orozco's last paintings. Carrillo interprets the painting as a solar eclipse. Her drawing is juxtaposed with a fragment of one of Orozco's letters to Valladares, in which he talks about the solar eclipse of the prior week, on April 28, 1930. Carrillo points out that Orozco wrote this letter while at Pomona College, working on *Prometheus*. She suggests that a solar eclipse and other stellar events may exist in the dark window of his *Paisaje metafísico*.

Like Orozco, Carrillo has also responded to the work of William Blake. Her 2014 exhibition "La eternidad en una hora" ("Eternity in an Hour"), at the Centro Cultural Jesús González Gallo in Chapala, Jalisco, Mexico, was inspired by the first four lines of Blake's poem "Auguries of Innocence." Carrillo's multi-part work reflects her explorations of mysticism, the human condition, and space-time conundrums. She combined her "Armonía macrocósmica" ("Macrocosmic Harmony") paintings, which are based on the work of the seventeenth-century cartographer Andreas Cellarius, with images of philosophers and artists, found photographs of individuals, Japanese koan phrases, and a compilation of phrases based on testimonies from various individuals.

In 2013, at the Zapopan Museum of Art in Guadalajara, Jalisco, Mexico, Carrillo conducted I Ching, palm, and tarot card readings for museum visitors. She offered these reading sessions in exchange for stories, childhood memories, familial legacies, and personal tragedies. She collected the oral narratives and memories that were shared with her and transformed them into new texts that she combined with found photographs and other images from her archives. In these early relational artworks, the repetition of similar thematic stories through different voices links mysticism and esotericism.

Reenactment and Repetition—
Reconstructing to Remember,
Destroying to Not Forget

During his time in New York from 1927 to 1929, Orozco was influenced by private societies, initiation rites, and ritually inspired reenactments. Through his relation-ship with the US writer Alma Reed, he became closely affiliated with the Delphic Circle. Founded by the Greek poet Angelos Sikelianos, the group envisioned the formation of an elite that would adopt the classical past as the means of generating a new future on a global scale. Orozco's connection with the Delphic Circle has been discussed in many studies on his work, and the artist wrote extensively about the group in his 1945 autobiography, describing it as a "Greek nationalist movement having for its purpose nothing less than the renaissance of ancient Greek culture."[41]

Sikelianos's wife, Eva Palmer-Sikelianos, envisioned the spectacle of theat-rical productions and musical performances as essential to inspiring humankind's evolution toward justice and harmony. She theorized that dramatic reenactment could generate "Upward Panic," which she described as a "sweeping emotion that does overcome enmities and misunderstandings, which makes hatred and fear fall inert in the great rotating wind of beauty."[42] The group ambitiously sought to revive the ancient Pythian Games at Delphi, Greece, holding a Delphic Festival at the site in 1927. As Orozco recounted: "*Prometheus Bound* and *The Suppliants* would be presented in the ancient Delphic theater itself. There was also a promise of Olympic Games in the stadium, exhibitions of popular art, and songs and dances of shepherds from Parnassus."[43] The Delphic Festivals were contempo-rary, partially conjectural reenactments of ancient events that referenced history,

myth, and oral storytelling traditions. The 1927 festival concluded with a lit torch relay, inspired by the Hellenic practice's symbolic repetition of the Promethean myth as an embodied chain leading to enlightenment.

Orozco did not attend these events or those of the Second Delphic Festival in 1930, but he was initiated into the Delphic Circle during a secret ceremony in New York, during which he received a Greek name, and a laurel wreath was placed on his head.[44] He also attended readings of *Prometheus Unbound* by Palmer-Sikelianos at the group's salon. In a letter to Jean Charlot, Orozco enthusiastically recounted one such event that combined Hellenic, Theosophical, and other dialogues of esotericism: "Mme Sikelianos, in Greek costume and Greek sandals, danced a part of *Prometheus*, singing the words in Greek. Wonderful!"[45]

Consistent with the Delphic Circle's practices of re-enactment and collectivity, Orozco's colleague Hamblen circulated Nietzschean concepts of eternal recurrence within the group, quoting the philosopher in her text on Blake: "If Genius, according to Schopenhauer's observation, lies in the coherent and vivid recollection of our own experience, a striving toward genius in humanity collectively might be deduced from striving toward knowledge of the whole historic past, which is beginning to mark off the modern age more and more as compared to earlier ages and has for the first time broken down the barriers between nature and spirit, men and animals, morality and physics. A perfectly conceived history would be cosmic self-consciousness."[46] Orozco's choice of the myth of Prometheus as theme for his mural at Pomona must be partially understood within this context of the Delphic Circle and its esoteric advocacy of ritualized reenactment and repetition as a means of enacting social change.

However, in keeping with Orozco's general stance of ambivalence and his failure to fully embrace the inheritance of the past, the artist did not wholeheartedly enter into the Delphic Circle ideals, and he occasionally wrote critically of the group in his letters to Charlot and his wife. Part of Orozco's critique may have stemmed from his general suspicion toward group activity, whether in Mexico or abroad. As José Pijoán, the Pomona professor who facilitated Orozco's mural commission, recounts, "With his fierce individualism [Orozco] was always at odds with mass movements, the mob mind and the assumption of authority."[47] Orozco's reluctance to embrace fully the activities of the Delphic Circle may be evidence of an understanding that the sweeping emotions of the masses were often manipulated for violent ends. He was surely aware that the revival of Hellenic culture was central to the rising German National Socialist Party, as was specifically outlined in 1925 by Adolf Hitler in *Mein Kampf*. In the same year, Vasconcelos published *La raza cósmica* (*The Cosmic Race*), in which he advocated an "aesthetic eugenics" that would lead to "voluntary extinction" through which "monstrosities would disappear."[48] Vasconcelos's unsuccessful 1929 presidential campaign marked his move toward the international fascist ideologies that were not without support in Mexico.

While Sikelianos, Palmer-Sikelianos, and other members of the Delphic Circle conceived of historical reenactment as a means of generating contemporary narratives of enlightenment, Orozco instead regularly invoked the past as a means of examining and bearing witness to contemporary horrors. For

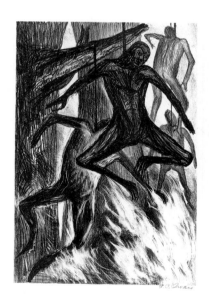

José Clemente Orozco, *The Lynching*, plate 6, from *The American Scene*, no. 1, 1934. Lithograph, 12¾ × 9 in. (32.4 × 22.9 cm). Philadelphia Museum of Art, Philadelphia, Pennsylvania. 1975-36-10

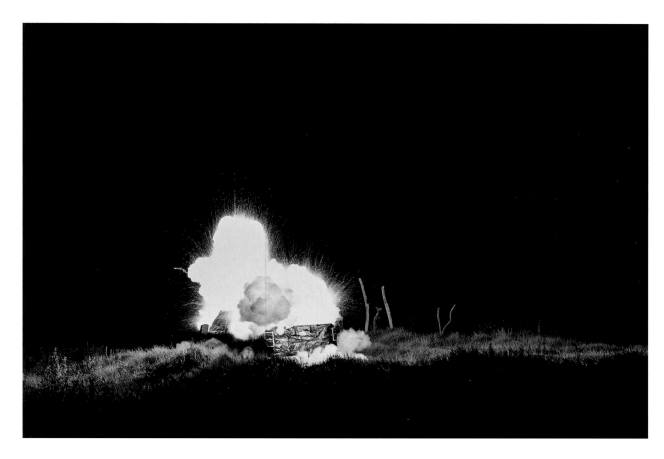

Adela Goldbard, *Lobo*, 2013. Photographic still from 4k video projected in HD with stereo sound, 6 min. 7 sec.

example, in the years following the painting of *Prometheus*, Orozco created similar imagery to examine racially motivated atrocities, as can be seen in the 1934 lithograph *The Lynching.* In this work, four castrated figures hang from tree branches as flames consume their bodies. While in the *Prometheus* mural fire is given to humans for the purpose of enlightenment, in *The Lynching*, humans use the gift of fire to enact extreme racial violence based on ignorance and prejudice. Orozco's willingness to recount atrocities led his contemporary Xavier Villaurrutía to describe the artist's process as a "seduction of horror."[49] More recently, Wittman has tied Orozco's vision of the world to Nietzsche's, describing Orozco as a "Dionysian artist" who continually depicts the "cruelties and horrors of the world."[50] Wittman quotes Nietzsche's 1872 *The Birth of Tragedy* to elaborate on Orozco's grim but powerful stance: "The tragic artist is not a pessimist, but only Dionysian, because he or she says yes to everything that is problematic and terrible."[51]

Reenactments and the mining of recent history play a central role in Goldbard's practice. She uses historical sources and citizen narratives— particularly of incidents of violence, dissidence, or repression—to reconstruct memories in spectacular pyrotechnical displays that merge the real and unreal. In *Lobo* (2013), for example, Goldbard staged the bombing of a Ford Lobo, a vehicle commonly used by Mexican drug cartels. The artist built the pickup using materials and methods drawn from Judas-effigy burning practices and the parade of the *toritos* (bull-shaped frames embedded with fireworks) during

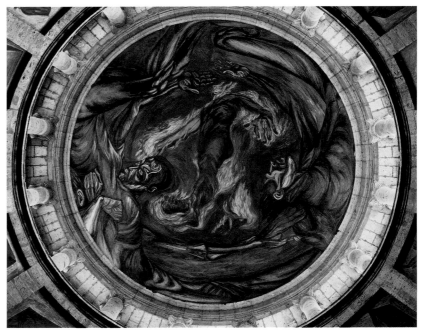

the annual National Pyrotechnic Festival in Tultepec, Mexico. Echoing the construction of the *toritos*, Goldbard used steel, wood, reeds, and papier-mâché to reproduce the vehicle and fireworks to activate and destroy it.

The ephemerality of Goldbard's replicas hints at the fragility of a system in which both the United States and Mexico fuel drug trafficking and organized crime while expending huge sums to combat them. In contrast to the unifying ethos of emotional catharsis through spectacle, such as Sikelianos-Palmer's "Upward Panic" incited by the re-enactment of ancient festivals, Goldbard's projects underscore the contemporary use of spectacle as a means of control and intimidation utilized by the cartels and the state, and subsequently re-enacted through media reporting. Like Orozco, her approach to history involves the engagement, witnessing, and recreation of atrocities.

The celebratory and dangerous nature of fireworks held special significance for Orozco, who, as noted previously, lost his hand while making fireworks for a national celebration. Fire is a constant within Orozco's work, from *Omnisciencia* through *Prometheus*, and it culminates in his fresco in the dome of the cupola at the Hospicio Cabañas in Guadalajara. Painted from 1937 to 1939, the *El hombre de fuego* (*Man of Fire*) panel portrays an anonymous tormented male figure subsumed by flames as three other men hover around his ascension. In Salvador Echavarría's analysis of the symbolism of this work, the central figure is "the spirit that enlightens the world.... As he burns he consumes himself to give light.... He is the substance of this miraculous flame which is the ultimate end of life: Conscience and Thought."[52] Ramón Mata Torres also discusses the significance of fire symbolism in the Hospicio Cabañas murals, including *La ciudad en llamas* (*City in Flames*). He suggests that the three fires in the painting thematically symbolize spirit, freedom, and civilization, and also represent moments when Mexico was "on fire" through revolutionary change: the abolishment of slavery, reform, and the 1910 Revolution. Mata Torres comments, "Fire fascinated Orozco

(left) José Clemente Orozco, *La ciudad en llamas* (*City in Flames*), 1937–39. Fresco. Hospicio Cabañas, Guadalajara, Jalisco, Mexico

(right) José Clemente Orozco, *El hombre de fuego* (*Man of Fire*), 1937–39. Fresco. Hospicio Cabañas, Guadalajara, Jalisco, Mexico

because it illuminates as it burns, tortures as it reveals, destroys as it sublimates, is life and death, is birth and the end of everything."[53]

Goldbard also deals with the potential for rebirth through the creative and destructive forces of fire. Her destructive celebrations explore "how the community expresses their political beliefs and their anger through festivity."[54] Using effigy destruction and pyrotechnic spectacle, the artist says she is "reconstructing to remember; destroying to not forget."[55]

Technology, Conviviality, and Hope—
The Courage to Think Out Loud

Juan Villoro describes Orozco as "a modern artist struggling with modernity. Unlike the futurists, he sang no hymns to the machines, nor celebrated the airplane. He saw technology as a new way to dehumanize."[56] In 1932, Orozco created the small mural *Man Released from the Mechanistic to the Creative Life*, at Dartmouth College, as a demonstration of fresco techniques. The work, which Orozco described as a "post-war theme," depicts the Greek mythological character Daedalus, the master artist and craftsman whose inventions, including the labyrinth of Crete and the wings of Icarus, often led to more harm than good. Orozco used the figure to question the dehumanizing impact of twentieth-century industry, and he reflected that his mural "represents man emerging from a heap of destructive machinery symbolizing slavery, automatism, and the converting of a human being into a robot, without brain, heart, or free will, under the control of another machine. Man is now shown in command of his own hands and he is at last free to shape his own destiny."[57]

Orozco's treatment of this theme continues, at times more cynically, in panels at the Hospicio Cabañas. In *Lo científico* (*The Scientific*, 1937–39), Orozco envisions the world in terms of cycles of creation and destruction, with man ultimately incapable of advancing. While a wheel of progress moves across the surface of the earth amidst a fire-red sunrise, remnants of the past— including Pre-Columbian sculptures and ancient European architectural fragments—are buried below. Mariano Rojas notes of this painting: "In Orozco's fresco, I glimpse a vision of progress that was exalted in the twentieth century, which contrasts sharply with the more humanistic vision of progress beginning to emerge in the twenty-first century. The mural presents an industrial wheel, mechanical, strong. The wheel moves forward—of course—but its destination is unclear. It seems that the movement has become a destination in and of itself. The splendor of this progress dazzles."[58] Rojas also notes that the wheel appears to have displaced the sun, a powerful symbol of human alienation from nature.

Despite his *via negativa*, Orozco attempted to embrace forms of progress that encourage creativity and connection. Orozco modeled his beliefs in both self-agency and collectivity for the Pomona students; while working on the mural, he lived in Clark Dormitory and dined with students in Frary Hall. At the opening ceremony for the mural, Orozco allegedly requested a reading of a poem by Delphic Circle member Leonard Charles Van Noppen:

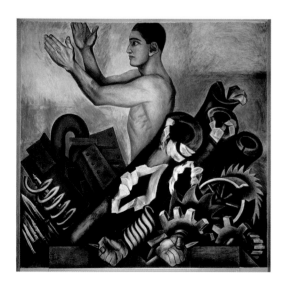

José Clemente Orozco, *Man Released from the Mechanistic to the Creative Life*, 1932. Fresco, 89 × 89½ in. (226.1 × 227.3 cm). Hood Museum of Art, Dartmouth College, Hanover, New Hampshire

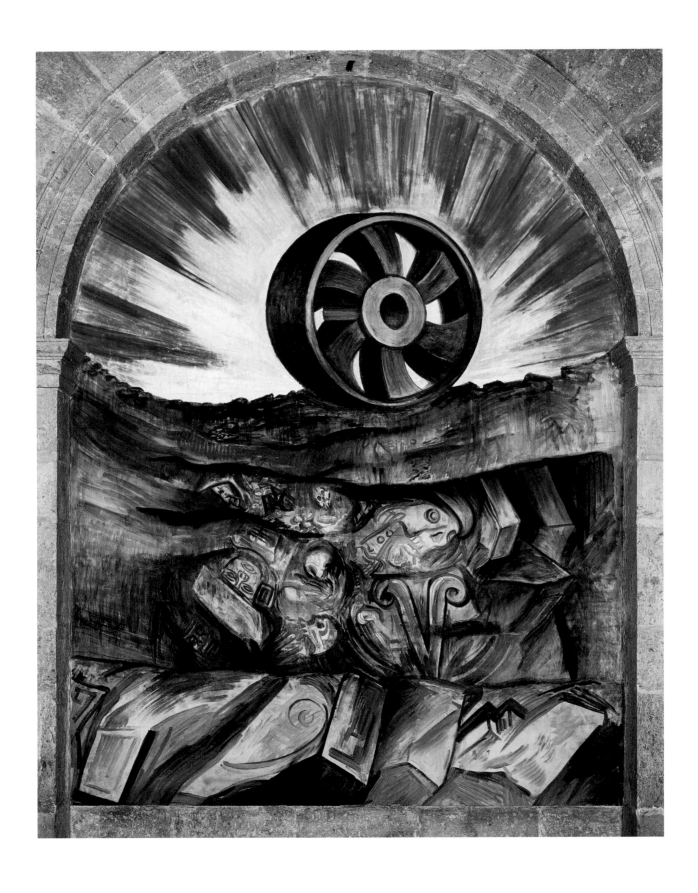

Come Ye Living, fight against the dead!
Rise up, make war, for they have sold the future
To their dark prison
Slay, Slay the despot Yesterday! Arise, the day
Is here![59]

The words demonstrate Orozco's desire for collective action against dehuman-
ization and oppression. In a letter to Justino Fernández, Orozco reflected on the
need to act creatively and with conviction, despite uncertainties: "The mistakes
or the hype don't matter. What matters is the courage to think out loud, to say
what one feels at the time one says it. To be reckless enough to proclaim what
one believes to be the truth regardless of the consequences and no matter who
fails. If one expects to have absolute truth in hand, they are a fool or will be
forever silent. The world would stop its motion."[60] Thus Orozco strove to harness
creativity, specifically mural making, for democracy. In his "New World, New
Races and New Art" essay of 1929, he concludes with words that intriguingly
echo the Promethean gift of fire to humankind. He states that a mural is powerful
because it "cannot be hidden away for the benefit of a certain privileged few. It
is for the people. It is for ALL."[61]

In 1973, nearly 45 years after Orozco created *Prometheus*, Ivan Illich
began to make regular visits to the Claremont Colleges in order to give lectures
at Pomona's consortial neighbor, Pitzer College. While there is no recorded
documentation of Illich visiting Frary Hall to see Orozco's mural, it is intriguing
to contemplate the philosopher's possible reactions to the work. Two years prior
to his first visit to Pitzer, Illich had published *Deschooling Society*, which provides
the epigraph at the beginning of this essay. Here he declares, "The Promethean
ethos has now eclipsed hope."[62] Illich writes, "Primitive man had relied upon
mythical participation in sacred rites to initiate individuals into the lore of society,"
but in Greece's Hellenist period, society "recognized as true men only those
citizens who let themselves be fitted by the *paidela* (education) into the institu-
tions their elders had planned."[63] How would Illich have viewed Orozco's vision,
in light of the fact that he, like Orozco, deeply questioned the structures of
education as a means of initiation into society?

In his 1932–34 mural *The Epic of American Civilization*, at Dartmouth
College, Orozco explicitly questions institutional authority and its negative effect
on education. In *Anglo-America*, a dour schoolteacher surrounded by robotic
children represents homogenization, while in *Gods of the Modern World*, Orozco
depicts a graduation ceremony as a macabre stillbirth observed by expression-
less professors and scholars. It has been suggested frequently that the robed,
skeletal professors represent the Pomona College faculty responsible for Orozco
not being fully paid for *Prometheus* and for the possible censorship of the
figure's genitals. Mary K. Coffey reflects that this unsubstantiated yet plausible
rumor underscores Orozco's overall belief in the negative effects of institu-
tionalized education.[64]

Deeply critical of tools of advancement—including education—as a means
of regulating society, Illich utilizes Prometheus as a symbol of technology out of

control: "Man has developed the frustrating power to demand anything because he cannot visualize anything which an institution cannot do for him. Surrounded by all-powerful tools, man is reduced to a tool of his tools."[65] Illich instead urges "a new sense of finiteness of the Earth" that could "open man's eyes to the choice of his brother Epimetheus to wed the Earth with Pandora."[66] He offers a vision of community and conviviality through the symbol of Epimetheus and Pandora: "We now need a name for those who value hope above expectations. We need a name for those who love people more than products, those who believe that no people are uninteresting. Their fate is like the chronicle of planets.... I suggest that these hopeful brothers and sisters be called Epimethean men."[67]

Like Orozco and Illich, Naomi Rincón-Gallardo takes on the myth of Prometheus and critically engages it rather than assuming that Prometheus's "gift" was a benevolent endowment for humankind. On view during the "Prometheus 2017" exhibition, her transdisciplinary artwork *Odisea Ocotepec* (*Ocotepec Odyssey*, 2014) consists of an installation of nine single-channel videos—each a unique visual and aural collage of psychedelic animations, musical compositions, and handmade costumes. The work explores the creation of counter-worlds through myth, science fiction cinema, and protest songs, with specific reference to liberation theology as it manifested in Mexico in the 1960s and 1970s. The project references the small town of Ocotepec, Morelos, where Illich lived, worked, and founded the progressive Center for Intercultural Documentation (Centro Intercultural de Documentación, CIDOC). Where Prometheus defied fate to deliver universal education and ended up punished by the gods, Rincón-Gallardo understands Epimetheus as embodying a faith in nature and ways of being that exist outside of institutional structures.[68] Throughout her practice, she urges a dependence on community rather than a blind trust in institutions.

Rincón-Gallardo cites Illich's views on conviviality and community as a major influence, noting his "aim to achieve a multi-dimensional balance of people's lives in relation to their use of technology/tools ...a balance that fosters people's autonomous skills to communicate and learn. Such a search for a multi-dimensional balance is an ongoing process of undoing that is hard to achieve, as it involves several renunciations to the ways urban societies function at their very core."[69]

Illich appears as a character within *Odisea Ocotepec*, often singing his theories. His *Deschooling Society* directly inspired one song in the project, "Epimeteo" ("Epimetheus"). Rincón-Gallardo reflects, "Illich calls for the re-birth of the Epimethean men as opposed to the highly ambitious, competitive, and modern Prometheus. Epimetheus embraces the respects of limits, balance, and nature."[70] The song's lyrics celebrate these possibilities: "It's not too late, she tells me, Pandora will return, My brother the Promethean, turns facts into problems, capricious patriarch, ambitious entrepreneur, he only knows how to innovate."[71] These themes recur throughout *Odisea Ocotepec*. In the song "Más allá de ciertos límites" ("Beyond Certain Limits"), the character of Illich recites lines in German from Johann Wolfgang Goethe's play *Pandora* (1810). In Goethe's reworking of the myth, Pandora delivers to humankind poetry and art, as opposed to misery and evil.

Naomi Rincón-Gallardo, *Salido del útero monacal* (*Exit from the Monastic Uterus*), from *Odisea Ocotepec* (*Ocotepec Odyssey*), 2014. Color video with sound, 5 min. 23 sec.

Rincón-Gallardo's adoption of these visions for Pandora's return is part of her work to both uncover and engage with alternative modernities and radical social experiences. Her lyrics in *Odisea Ocotepec* refer to post-colonial creativities formed in opposition to the narrow mandates of traditional hierarchies and ensuing injustices of exclusion. In one visually striking video in the *Odisea Ocotepec* project, *Salida del útero monacal* (*Exit from the Monastic Uterus*), Rincón-Gallardo creates a fictionalized, fanciful version of events in a Benedictine monastery in 1960s Mexico. Father Gregorio Lemercier initiated a program of psychoanalysis for priests at the Santa María Resurrección monastery in Cuernavaca, Morelos, Mexico. In consultation with the German psychologist Erich Fromm (a frequent visitor to Illich's nearby CIDOC), the priests began to explore psychoanalytic practices to combat personal issues, including alcoholism, depression, and perhaps most significantly, the repression of homosexuality within the church. (The Catholic Church heavily censured and eventually closed Lemercier's program.) In Rincón-Gallardo's piece, the priests hold their own umbilical chords and float within a womb-like space, singing of desire for liberation through rebirth: "In the bag of waters of the maternal cloister, we hesitate and seek love among brothers."[72]

Reflecting on these historic moments of subversion, Rincón-Gallardo seeks to apply the spirit of these strategies to her relational activities. She operates, as she puts it, from the perspective of a feminist woman of color, and her goal is to create opportunities for collective experimentation. For example, at a 2016 multi-day Feminist Training Camp organized by the collective No-Play in Berlin, Rincón-Gallardo collaborated with experimental sound artists to lead a participatory workshop entitled Collective FUTURISTIC SPELL! The group utilized games for non-actors, sound improvisation, collective reading/listening/looking/writing, witchcraft spells from different contexts, and D.I.Y. props-building to conjure "a sci-fictional multi-lingual feminist spell," thus embodying what Illich characterizes as Pandora's hopeful defiance.[73]

Illich's *Deschooling Society* also served as the original inspiration for Ponce de León's project at Pomona. In her initial proposal, she wrote:

> Since the mural is in an educational space, it seems appropriate to propose a specific starting point for discussing the image itself: the figure of the Epimethean man that Ivan Illich considered in *Deschooling Society* as being antagonistic to the Promethean figure. In the words of Illich, Prometheus "became the god of technologists and wound up in iron chains." Fire, stolen by Prometheus in defiance of the gods, is identified as knowledge, but also as the perpetually unsatisfied need to consume. Several decades ago, Illich stated that the reason for our crisis as a society is that our existence is entirely dependent on every kind of institution. We do not own our bodies, or our minds. I think it's opportune to discuss this theory with other people today, and I think it opens up a reflection on the role of art and school in relation to creation and learning.[74]

Illich's frustration with institutional authority echoes Orozco's criticism of institutional education. Ponce de León's project links their concerns about institutions of higher learning, but she views them from a more hopeful perspective. The artist developed her project through workshops with students, staff, faculty, and other members of the Pomona College community. Her artwork reflects a composition of multiple voices in dreamlike fragments of bodies, memories, and symbols painted in black ink on the gallery walls. The piece, arguably a mural, reconceptualizes what a collaborative public art practice can look like. Mirroring Orozco's words on the power of murals as artworks that are "for ALL," Ponce de León reflects that, in the shared chain of her process, "no one is owner of the content"; the "content is owned by all." The ideas generated in the chain are "seeds that are dedicated back to the people who participated."[75]

Nearly 90 years after Orozco painted *Prometheus* in Frary Hall, his call to embrace the power of humanity to transcend history and to evolve urgently bears repeating. The mural was created in the context of the early twentieth-century rise of nationalism and fascism, and subsequent cycles of freedom and repression demonstrate that hopeful strategies of activist engagement remain critical in the face of injustice and oppression. Orozco's outlook of embracing "no simplistic possibilities" confronts the cyclical repetition of history's "wheel of progress," which has often given rise to international powers that fuel violence, racism, and insatiable greed. Orozco dreamed instead of a humanity in control of its "own hands," with the freedom to forge and shape its "own destiny."

Through a process of dialogic practices and collective action, the "Prometheus 2017" project has sought to create a conceptual bridge from Orozco's vision to twenty-first-century practices of creativity and activism. Our goal has been to highlight Orozco's admonition that what matters is "the courage to think out loud, to say what one feels at the time one says it." This essential statement about action and hope is at the heart of the Prometheus myth and the story of Pandora. The symbolic force of Pandora, ancient bearer and preserver of hope, offers a courageous vision for collective society. Inspired by their forebear—José Clemente Orozco—Isa Carrillo, Adela Goldbard, Rita Ponce de León, and Naomi Rincón-Gallardo utilize a full spectrum of modes, styles, and themes to present vigorous, defiant visions for the future.

1. Ivan Illich, *Deschooling Society* (London and New York: Marion Boyars, 2002, originally published 1971), 105.

2. Karen Cordero Reiman, "Prometheus Unraveled: Readings of and from the Body: Orozco's Pomona College Mural (1930)," in *José Clemente Orozco in the United States, 1927–1934,* Renato González Mello and Diane Miliotes, eds. (Hanover, NH, New York, and London: Hood Museum of Art, Dartmouth College, and W.W. Norton & Company, 2002), 112.

3. Alejandro Anreus, "Los Tres Grandes: Ideologies and Styles," in *Mexican Muralism: A Critical History,* Alejandro Anreus, Robin Adèle Greeley, and Leonard Folgarait, eds. (Berkeley, CA: University of California Press, 2012), 42.

4. Hesiod, *Works and Days and Theogony,* trans. Stanley Lombardo (Indianapolis, IN: Hackett Publishing Company, 1993), 588.

5. Some notable examples include Claire Bishop, *Artificial Hells: Participatory Art and the Politics of Spectatorship* (London and New York: Verso, 2012); Nicholas Bourriaud, *Relational Aesthetics* (Dijon, France: Les presses du réel, 2002); Will Bradley and Charles Esche, eds., *Art and Social Change: A Critical Reader* (London: Tate Publishing, 2007); Pablo Helguera, *Education for Socially Engaged Art: A Materials and Techniques Handbook* (New York: Jorge Pinto Books, 2011); and Grant H. Kester, *Conversation Pieces: Community + Communication in Modern Art* (Berkeley, CA: University of California Press, 2004).

6. Illich, *Deschooling Society*, 105.

7. José Clemente Orozco, "New World, New Races and New Art," *Creative Art* 4 (New York) 1929, xlv.

8. Ibid.

9. Ernesto Mejía Sánchez in Alfonso Reyes, *Obras completas*, vol. 20 (Mexico: Economic Culture Fund, 1958–85), 12.

10. José Vasconcelos, *Prometeo vencedor* (Madrid: Editorial-America, 1920), 85.

11. Cordero Reiman, "Prometheus Unraveled," 105.

12. José Vasconcelos, "Los caracteres del progreso," *El Universal: El gran diario de México* (Mexico City), May 16, 1927.

13. Ibid.

14. Ibid.

15. Ibid.

16. Interview with José Clemente Orozco, *The Student Life* (Pomona College, Claremont, CA), May 17, 1930.

17. Renato González Mello, "Mysticism, Revolution, Millennium, Painting," in *José Clemente Orozco: Prometheus*, ed. Marjorie L. Harth (Claremont, CA: Pomona College Museum of Art, 2001), 52.

18. Orozco, "New World, New Races and New Art," xlv.

19. Rita Ponce de León, Proposal for Pomona College, December 2015, unpaginated.

20. Ibid.

21. James Oles, *Art and Architecture in Mexico* (New York: Thames and Hudson, 2013), 405.

22. Adela Goldbard, "Conservation as an Exercise of Power," *La Quemada Pública*, Zacatecas, Mexico, 2012, artist statement, unpaginated.

23. Luis Guillermo Sánchez, "Daño 'Colateral' Deja Marcas Más Profundas En La Sociedad: Adela Goldbard (Entrevista)," http://alternopolis.com/dano-colateral-deja-marcas-mas-profundas-en-la-sociedad-adela-goldbard-entrevista/. English translation by Audrey Young.

24. Juan José Bremer, *Exposición nacional de homenaje a José Clemente Orozco con motivo del XXX aniversario de su fallecimiento* (Mexico City: National Institute of Fine Arts/SEP, 1979), 14.

25. Iván Ruiz, "Cuando los márgenes arden: Adela Goldbard en Casa del Lago," *Horizontales* (Mexico City, Mexico), November 25, 2015, http://horizontal.mx/cuando-los-margenes-arden-adela-goldbard-en-casa-del-lago/. English translation by Audrey Young.

26. Adela Goldbard, interview with Rebecca McGrew, July 11, 2016.

27. José Vasconcelos, *A Mexican Ulysses: An Autobiography*, trans. W. Rex Crawford (Bloomington, IN: Indiana University Press, 1963), 57.

28. See Renato González Mello, *La máquina de pintar* (Mexico City: Institute of Aesthetic Research, National Autonomous University of Mexico, 2008).

29. Sofía Anaya Wittman, *José Clemente Orozco, el Orfeo mexicano* (Guadalajara, Mexico: University of Guadalajara, 2004), 165. English translation by Audrey Young.

30. José Clemente Orozco, "Casa de los Azulejos," unfinished, undated manuscript. Cited by González Mello, *La máquina de pintar*, 115. English translation by Jenny Muñiz.

31. Ibid.

32. Fausto Ramírez, "Artistas e Iniciados en la Obra Mural de Orozco," *Orozco: Una Relectura* (Mexico City: National Autonomous University of Mexico, 1983), 93.

33. Ibid., 93–94, footnote 67.

34. González Mello, *La máquina de pintar*, 103. English translation by Jenny Muñiz.

35. S. Foster Damon, "Introduction," in Emily S. Hamblen, *On the Minor Prophesies of William Blake* (New York: E.P. Dutton, 1930), ix.

36. Hamblen, *On the Minor Prophesies of William Blake*, 66–67.

37. Ibid., 389.

38. Ibid.

39. Isa Carrillo, *Mano izquierda* (Guadalajara, Mexico: PAOS, 2015), 5, exhibition catalog. English translation by Audrey Young.

40. Isa Carrillo, email to Rebecca McGrew, July 12, 2015.

41. José Clemente Orozco, *José Clemente Orozco: An Autobiography*, trans. Robert C. Stephenson (Mineola, NY: Dover Publications, 1962), 127. For discussions of Orozco's connection to the Delphic Circle, see Cordero Reiman, "Prometheus Unraveled" and González Mello, "Mysticism, Revolution, Millennium, Painting."

42. Eva Palmer-Sikel anos, *Upward Panic: The Autobiography of Eva Palmer-Sikelianos*, ed. John P. Anton (New York: Harwood Academic Publishers 1993), 225.

43. Orozco, *José Clemente Orozco: An Autobiography*, 127.

44. In his autobiography, Orozco recounted this initiation without giving an exact date, noting that he was "rebaptized with the name of Panseleros, that is, a famous Greek painter of Byzantine times." *José Clemente Orozco: An Autobiography*, 134.

45. José Clemente Orozco, "Letter to Jean Charlot, September 15, 1928," *The Artist in New York: Letters to Jean Charlot and Unpublished Writings, 1925–1929* (Austin, TX: University of Texas Press, 1974), 68.

46. Hamblen, *On the Minor Prophesies of William Blake*, 84.

47. José Pijoán, "Orozco," *Gentry 8* (Fall 1953), 3.

48. José Vasconcelos, *La raza cósmica/The Cosmic Race*, trans. Didier T. Jaén (Baltimore, MD, and London: Johns Hopkins University Press, 1997), 32.

49. Xavier Villaurrutía, "José Clemente Orozco y el horror," *El Nacional: Revista mexicana de la cultura* (Mexico City), Sunday supplement, September 25, 1949.

50. Wittman, *José Clemente Orozco, el Orfeo mexicano*, 124. English translation by Audrey Young.

51. Ibid.

52. Salvador Echavarría, *Orozco: Hospicio Cabañas* (Guadalajara and Mexico City, Mexico: Jalisco En El Arte, 1959), 56–57.

53. Ramón Mata Torres, *The Murals of Orozco in the Cabañas Cultural Institute* (Guadalajara, Mexico: Instituto Cultural Cabañas, 1991), 28.

54. Saúl Hernández-Vargas, "Prototipos para un desastre inminente: Entrevista con Adela Goldbard," March 26, 2015, http://www.tierraadentro.cultura.gob.mx/prototipos-para-un-desastre-inminente-entrevista-a-adela-goldbard/. English translation by Audrey Young.

55. Ibid.

56. Juan Villoro, "Viaje a Orozco: Vocación de incendio," *Revista de la Universidad de México* 63 (2009), 14. English translation by Audrey Young.

57. José Clemente Orozco, press release issued by the artist, May 25, 1932.

58. Mariano Rojas, "La Rueda del Progreso" (September 16, 2011), http://wikiprogressal.blogspot.com/2011/09/la-rueda-del-progreso-mariano-rojas.html. English translation by Audrey Young.

59. Cited in González Mello, "Mysticism, Revolution, Millennium, Painting," 50.

60. José Clemente Orozco, fragment of a letter to Justino Fernández, August 31, 1940, *Textos de Orozco* (Mexico City: Institute of Aesthetic Research, National Autonomous University of Mexico, 1955), 54.

61. Orozco, "New World, New Races and New Art," xlvi.

62. Illich, *Deschooling Society*, 105.

63. Ibid., 106.

64. Mary K. Coffey, email correspondence with Rebecca McGrew, October 6, 2016.

65. Illich, *Deschooling Society*, 109.

66. Ibid., 115.

67. Ibid., 115–16.

68. Naomi Rincón-Gallardo, email correspondence with Terri Geis, May 25, 2016.

69. Ibid.

70. Ibid.

71. Naomi Rincón-Gallardo, *Epimeteo* from *Odisea Ocotepec*, 2014.

72. Naomi Rincón-Gallardo, *Salida del útero monacal*, from *Odisea Ocotepec*, 2014.

73. Facebook event page: https://www.facebook.com/events/275115646162308/.

74. Rita Ponce de León, project proposal to Pomona College Museum of Art, April 2015.

75. Rita Ponce de León, Pomona College Studio Art class visit, September 28, 2016. During Ponce de León's workshops, several students shared stories of how the project has shifted their perspectives on education, served as a touchstone for their intellectual growth as students, and transformed their visions of their roles in society. Nicolas Orozco-Valdivia, a studio art major at Pomona, discussed the lasting impact the *Prometheus* mural and Ponce de León's project have had on him since his first participation in her workshop in November 2015. The exercises led by the artist in front of the mural shifted Orozco-Valdivia's thinking about his family legacy as educators and migrant farm workers. Noting the paradox in the mural between education as liberation from work and education as an enforced expectation for success, he shared how this realization impacted his vision of his future. Studio art major Davis Menard was one of the founding pairs in Ponce de León's project at Pomona. He cited the impact of the deep and personal conversations and noted that, for many of the participants, their interactions led to intense and lasting connections.

Mary K. Coffey

Putting Orozco's *Prometheus* in Motion

Reframing
Mural Art's Meaning
for Contemporary
Art Practice

Putting Orozco's *Prometheus* in Motion: Reframing Mural Art's Meaning for Contemporary Art Practice

Mary K. Coffey

What do a burning microbus, a set of conversations with college students, a psychedelic musical performance, and an exercise in astrology have to do with José Clemente Orozco's *Prometheus*, a mural painted in Pomona College's Frary Dining Hall in 1930? How can we understand Orozco's striving Titan as related, in any way, to the kitschy mythological characters who cavort through Naomi Rincón-Gallardo's *Odisea Ocotepec* (*Ocotepec Odyssey,* 2014)? For that matter, how does Orozco's imposition or Frary's architecture and its dining inhabitants inform Rita Ponce de León's more fragmentary and ephemeral engagements with the college's diverse community today? Can we understand Adela Goldbard's pyrotechnics as having any kinship with Prometheus's theft of fire? And how might Isa Carrillo's mystical meditation on Orozco's left hand refract the latter's struggles to reconcile his esoteric concerns with the public mandate of monumental mural art?

In this essay, I do not propose to answer these questions, for that is the task of each viewer as she navigates "Prometheus 2017: Four Artists from Mexico Revisit Orozco." However, I do offer an approach to these questions through a reassessment of Orozco's *Prometheus*. That is, in addition to attending to the form, iconography, and site dynamics of the mural proper, I engage in a more speculative exploration of how these features of the work might be reconsidered from the standpoint of contemporary debates over relational aesthetics, site specificity, and embodiment. In so doing, I provide a way of understanding Orozco's mural practice both in his time and in ours that seeks to bridge the gap between the concerns of publicly engaged artists then and now.

To begin, I quote scholar Karen Cordero Reiman, who writes that Orozco's "focus on art as a multivalent conceptual language, not as a narration, invites …a more active and engaged participation of the public in the construction and appropriation of its meanings." This active engagement of the public, she concludes, "must be understood as part of a social process rather than dogma."[1] Her argument about Orozco's mural art resonates with contemporary claims about a category of art practice that goes by various names, such as, "participatory," "relational," "dialogic," "collaborative," and "littoral," to list only a few. Nonetheless, despite this resonance, one must confront the irony of putting Mexican muralism into a dialog with "relational aesthetics," given that proponents of such art often distinguish its mode of public engagement from politically engaged art in general and the figurative tradition of 1930s realism in particular.

Nicolas Bourriaud, writing in *Relational Aesthetics*, the set of essays in which he codified the term, evokes the specter of utopian movements like muralism when he writes, "The age of the New Man, future-oriented manifestos, and calls for a better world all ready to be walked into and lived in is well and truly over."[2] "These days," he concludes, "utopia is being lived on a subjective, everyday basis, in the real time of concrete and intentionally fragmentary experiments."[3] In response, Grant Kester defends socially engaged art against what he calls the "visceral distaste" of critics such as Bourriaud for any art that proclaims an overtly political orientation. However, when attacking their tendency to "caricature" political art, Kester likewise conjures the specter of the figurative art of the 1930s, arguing that Bourriaud "collapses all activist art into the condition of 1930s socialist realism" and, in so doing, "fails to convey the complexity and diversity of socially engaged art practice over the last several decades."[4] It should be noted that when hailing the bad object of political art, Kester refers to "socialist realism," not Mexican muralism. Nonetheless, as those of us who work on figurative art from the early twentieth century know all too well, in the post World War II discourse on art, a signifying chain links Soviet-style agitprop with 1930s social realism with the pre-digested kitsch of commercial culture. This spectrum of realist art so concerned Clement Greenberg that it formed the foundation for his reactionary theory of modernism.[5] The Cold War discourse on painting conflates all forms of figuration with the ideological threat of mass culture. And I would argue that, to the extent that relational aesthetics has been theorized over and against the "society of the spectacle," this conflation is still operative.[6]

So how then, and why, for that matter, can we re-frame Mexican muralism within contemporary debates over the aesthetics and ethics of participatory art? One way to do this is via a reconsideration of site and the anti-narrative ethos of the fragment that constitutes Orozco's mural aesthetic. Orozco's *Prometheus* does, in part, partake of the "New Man" utopian discourses on the 1930s that Bourriaud satirizes. However, to the extent that it does, Orozco also expresses grave doubts about both "Man" and the artist's role in utopian politics. Similarly, Orozco's mural both invites and resists subjective experience. Through an aesthetic of the fragment, *Prometheus* allegorizes the challenges that come with collapsing the distance between artist and viewer. Finally, Orozco's mural anticipates the attention to embodiment and the challenges posed by difference in contemporary site-based work.

Orozco's *Prometheus*:
Form and Signification

To begin, we return to Cordero Reiman's essay in order to better understand what she means when she characterizes Orozco's rendering of the Prometheus myth as a "conceptually multivalent language" rather than narration. Like David Scott and Renato González Mello before her, Cordero Reiman argues that Orozco's *Prometheus* is an important transitional work between his early murals in Mexico from the 1920s and the murals he executed in the United States and

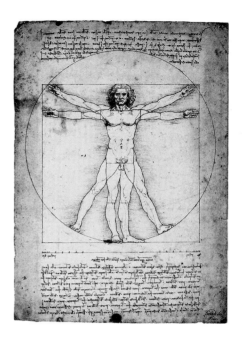

Leonardo Da Vinci, *The Vitruvian Man, Proportions of the Human Body according to Vitruvius*, c. 1492. Pen and brown ink with brush and brown wash over metalpoint on paper, 13⅜ × 9⅝ in. (34.3 × 25.5 cm). Galleria dell'Accademia, Venice, Italy

upon his return to Mexico in the 1930s.[7] These scholars view Prometheus as a powerful metaphor for the modern artist, one that had personal resonance for Orozco, a self-styled visionary who had been wounded by fire as a young man in an accident with explosives. They note that in Orozco's *Prometheus* we see the full emergence of his expressionistic style as well as an allegorical approach to both form and content that converts the classical male nude into a site of critique rather than cultural reification.

This critique hinges on the artist's distortion of Prometheus's nude body. While the disposition of the body within the arch suggests the humanist tradition of "man as the measure of all things," the Titan's form seems squeezed and torqued. He simultaneously pushes up, using his right foot as a powerful lever, while also appearing to be borne down upon by some unseen force. This effect is enhanced by the way that the arch's overhang cuts off the composition at the Titan's upturned hands, making it difficult, on first approach, for the viewer to perceive the exact object of his striving or the source of his oppression. In fact, to see the entire mural the viewer must come very near to the wall. Standing within the shallow niche, one can see the three scenes that frame the mural on a narrow adjoining wall. To the left, Zeus stands encircled by Hera and Io; to the right, a centaur battles serpents; and at the top, an abstract rectangular form is centered within a luminous field of blue pigment. However, from this proximity, the central figure loses much of its compositional coherence and seems to melt into dynamic lines of vibrant paint, a series of climbing and dripping forms.

Prometheus, while powerfully modeled, is disproportionate. Were he to stand, his bent left leg would be twice as long as his outstretched right. Moreover, the cramped c-curve of his twisting torso, along with his straining neck and upturned head, heighten a sense of physical discomfort. The compositional lines that determine the figure's relationship with those massed around him have been arbitrarily determined by the centered body of Prometheus, as preparatory sketches reveal. However, the trapezoidal form of each group, while generated by the orthogonal lines that converge upon the Titan, seems to work at cross-purpose to the vertical thrust of the composition, creating a kind of trough or inverted diamond shape at the base of the image that directs the eye toward the demigod's bent knee rather than his striving arms.

This disunity is echoed in the way that Orozco fragments the bodies of the men and women in the masses. As Renato González Mello has noted, Orozco used the academic tactic of life drawing; nonetheless, he argues, their bodies "appear fragmented. Hand gestures practically turn into calligraphy."[8] In undermining the purpose of life drawing, González Mello concludes, Orozco's *Prometheus* enacts a rupture with the academic tradition of composition and anatomy. And given the centrality of the nude to academic history painting, he suggests that Orozco's fragmentary treatment of the body also signals a critical reflection on the genre itself. This critique manifests more forcefully in his work of the 1930s. I will return to the issue of formal fragmentation and its relation to history later.

For Cordero Reiman, this demolition at the level of form enacts a re-signification of the Prometheus myth. Orozco's familiarity with the myth was informed

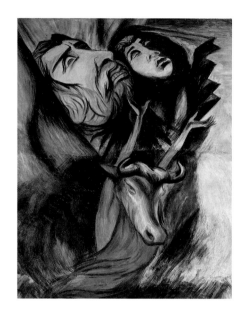

(top) José Clemente Orozco, *Zeus, Hera, and Io* or *The Destruction of Mythology*, *Prometheus* (west panel), 1930. Fresco, 240 × 186 in. (609.6 × 472.4 cm). Pomona College

(bottom) José Clemente Orozco, *Centaurs in Agony* or *The Strangulation of Mythology*, *Prometheus* (east panel), 1930. Fresco, 240 × 186 in. (609.6 × 472.4 cm). Pomona College

(pages 50–51) José Clemente Orozco, *Abstract Composition* or *Godhead*, *Prometheus* (ceiling panel), 1930. Fresco, 84 × 342 in. (213.4 × 868.7 cm). Pomona College

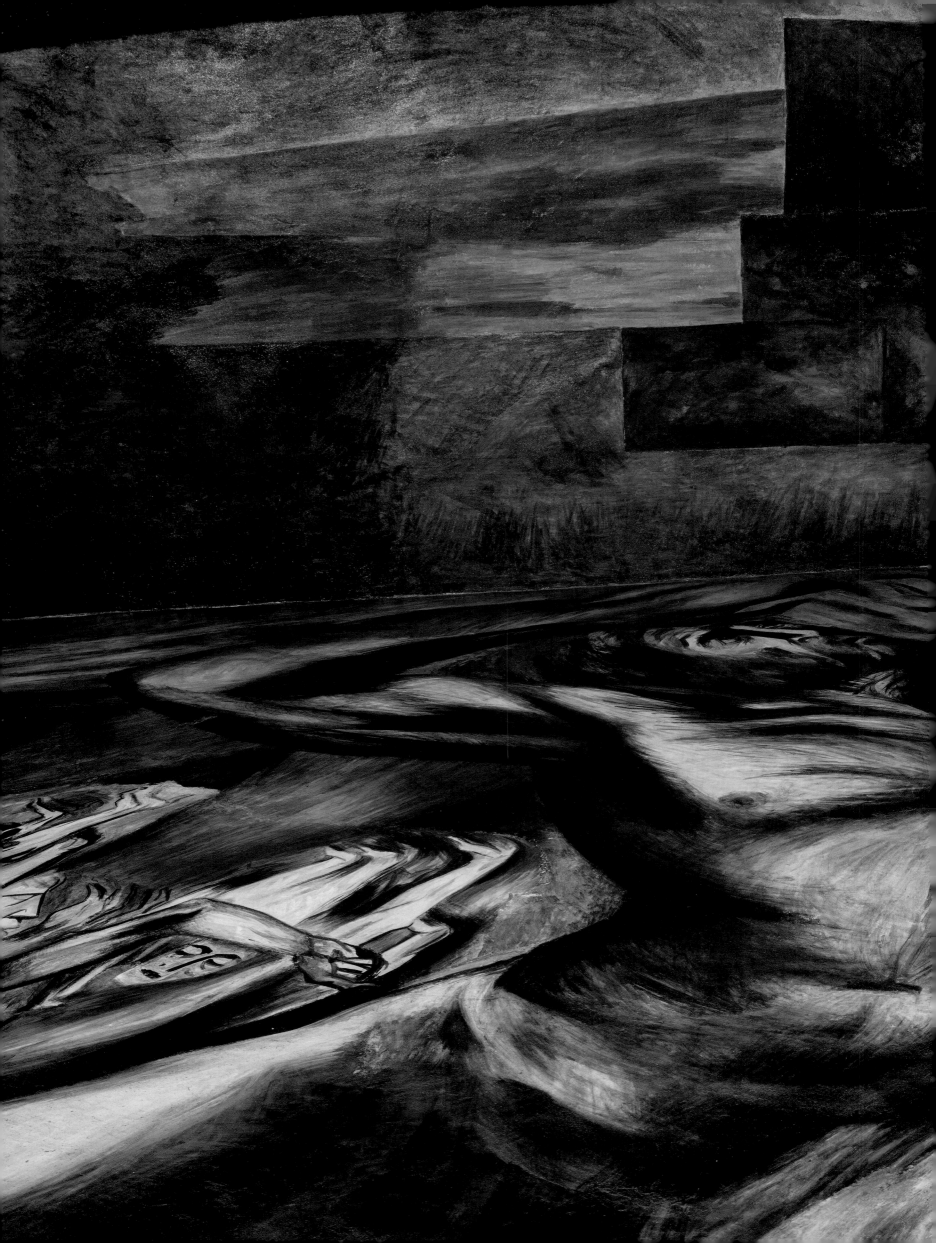

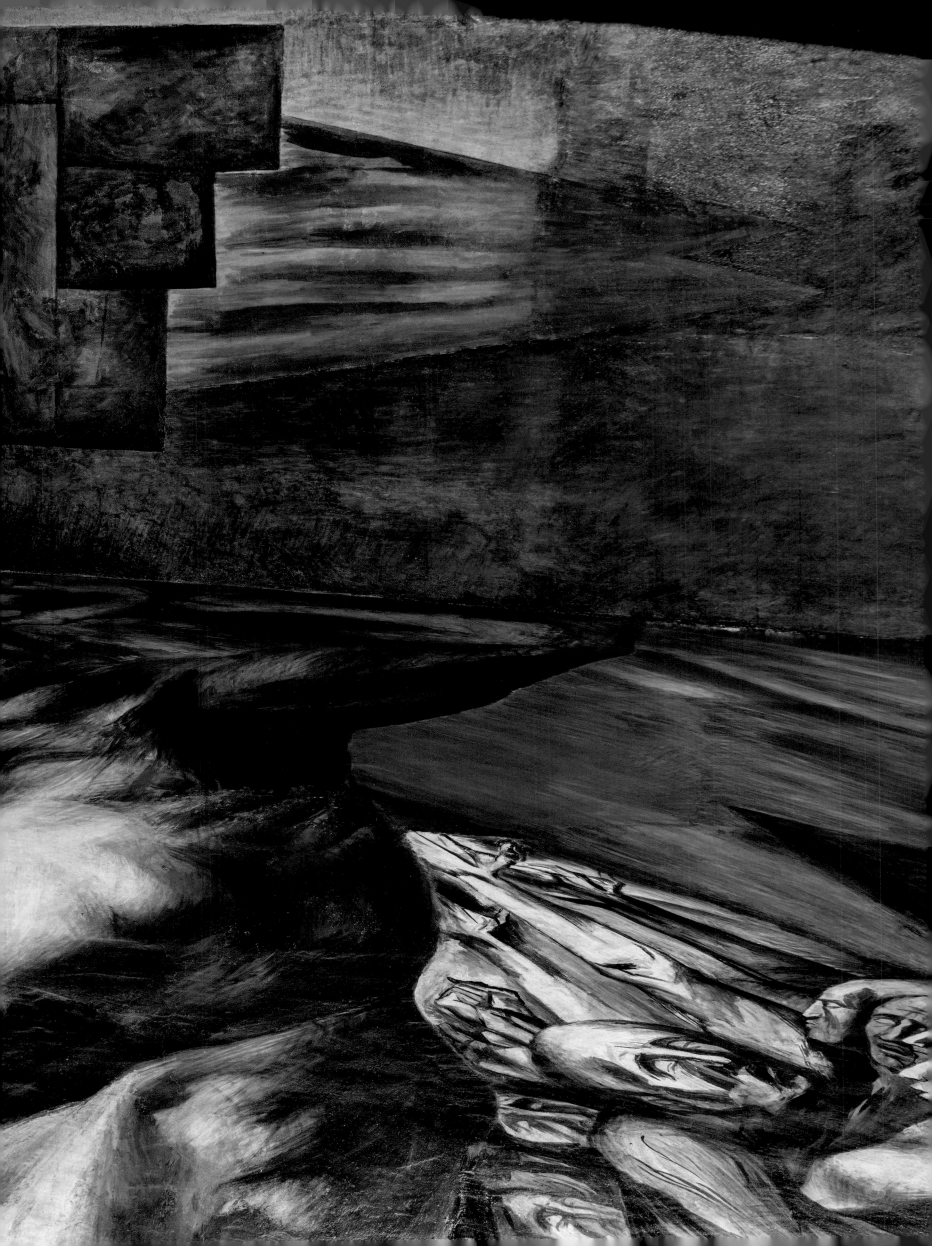

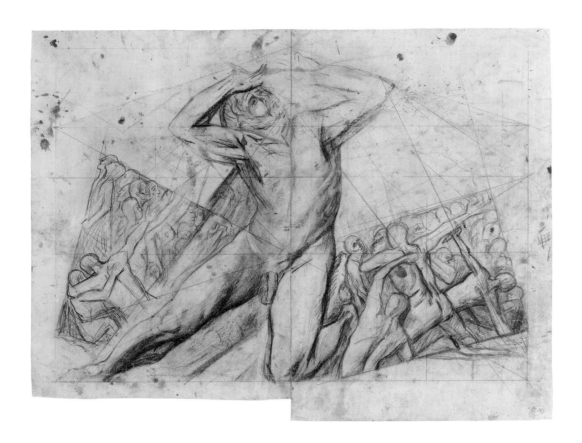

José Clemente Orozco, Study for central panel, *Prometheus* mural, 1930. Graphite on paper, 17⅝ × 23¾ in. (44.8 × 59.4 cm). Pomona College

by classical accounts in Aeschylus and Ovid, as well as modern sources such as Shelley's *Prometheus Unbound* and Nietzsche's *The Birth of Tragedy.* Likewise, Orozco would have been familiar with academic and Modernista treatments of the theme by prominent Mexican artists.[9] In his autobiography, Orozco highlights Alberto Fuster's *The Triptych of the Rebels.*[10] And as Cordero Reiman shows, his choice to situate Prometheus vertically, rather than reclining on a rocky shore, suggests that he was synthesizing the three "rebels" in Fuster's painting into one monumental heroic figure.[11]

This tendency to conflate heroic figures is typical among artists working within Masonic philosophical traditions, which Fausto Ramirez and González Mello have shown Orozco was.[12] Cordero Reiman elaborates on this influence, noting that the references to Zeus, Hera, and Io, as well as the animalistic conflict in the flanking panels, reflect Masonic "precepts of hierarchy and . . . an evolutionary transformation in the concept of divinity and man's relationship to it."[13] The Olympian gods, she notes are decentered and associated with natural forces and animalistic instincts. The godhead, from which Prometheus seems to steal fire, is an abstract form rather than an anthropomorphized figure, indicating that, for Orozco, the Titan's struggle represents man's existential desire for "immaterial godliness and spiritual illumination."[14] Prometheus's disobedience represents his rejection of the authority of the gods; his punishment reveals the vulnerabilities that accompany that act of liberation. The narrative ambiguity within the image—is Prometheus stealing the fire or being punished for his audacity?—associates the myth with Christian stories of the fall. Thus, Cordero Reiman writes, "Man, in pushing beyond his limits, abdicates the security of the gods' protection and of salvation and may become a demigod, but he also assumes the consequences of ambition, consciousness, and reason."[15]

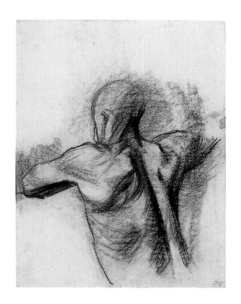

(above) José Clemente Orozco, Study of back torso with left arm raised over head, *Prometheus* mural, 1930. Graphite on paper, 14½ × 11⅜ in. (37.8 × 28.9 cm). Pomona College

(top right) José Clemente Orozco, Study of head and torso from back, *Prometheus* mural (central panel), 1930. Charcoal on paper, 14⅝ × 11⅜ in. (37.2 × 28.9 cm). Pomona College

(bottom right) José Clemente Orozco, Study of right forearm and detail, *Prometheus* mural (central panel), 1930. Charcoal on paper, 11⅜ × 14⅝ in. (28.9 × 37.2 cm). Pomona College

José Clemente Orozco, Details of masses in *Prometheus* (central panel), 1930. Fresco, 240 × 342 in. (609.6 × 868.7 cm). Pomona College

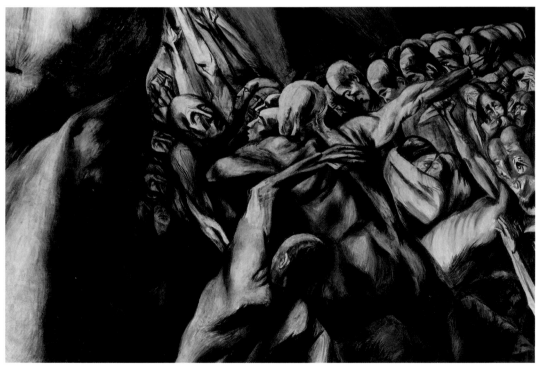

This duality is reflected in Orozco's treatment of the mass of figures as well. The predominantly female, in places indigenized, figures on the left seem to beg and entreat the demigod, while the Caucasian male figures on the right adopt defensive postures and cower in awareness of the punishment occasioned by Prometheus's transgression. This gendering and racialization of human attitudes toward Man's capacity to act like a god derives from Nietzsche's schema, wherein Aryan striving and Semitic sin are characterized as masculine and feminine principals, respectively. For Nietzsche, the Promethean myth encompasses both the Apollonian and Dionysian principals. Orozco's Titan literally embodies this contradiction, as he becomes a proxy for all of mankind, subsuming the affects of the masses around him into a singular, heroic but damned body. Thus we have, in both form and iconography, a mural that evokes the Prometheus myth yet deviates from both its narrative sources and its visual conventions. Rather than definitively locating the figure within a recognizable episode from the myth, Orozco's mural conflates the figure and story with other damned and martyred heroes. This is the multivalency to which Cordero Reiman refers, and we see it both in these iconographic ambiguities and in Orozco's fragmented and decisively non-classical treatment of the Titan's body.

Rita Eder argues that, in the 1930s, Orozco abandons the classicism of his academic training in favor of a style informed by the Baroque. This stylistic shift, she suggests, signals the emergence of Orozco's melancholic view of history as ruin. She writes: "If the ruin is, as [Walter] Benjamin points out with regard to Baroque allegory, the form in which history enters the stage, it is a history that breaks with the idea of classical order as eternal life, and instead assumes its decay."[16] Eder is referring to the piles of cultural fragments that comprise the many junk heaps in Orozco's murals of the 1930s. Her insight, however, bears upon *Prometheus* as well. For in this mural, the fragment-as-ruin has not yet become an iconographic motif, but it is imminent in the fragmented and distorted forms that constitute the bodies of the Titan and the masses he seeks to enlighten. In this nascent form of the mass, Orozco's concerns about the emancipatory capacities of art and the artist's omniscience first express themselves, despite the seemingly utopian theme of man becoming god that his invocation of the myth entails.

The Mass, the Public, and the Viewer's Share

Orozco's *Prometheus* does not seem to engage history or the present overtly. Rather, it does so via allegory wherein the tragic figure of Prometheus represents the modern artist not as liberator but as melancholic subject. His relationship with the masses, his subsumption of their affective responses to the loss of transcendent order and the achievement of divinity within a fallen world, allegorizes the contemporary plight of both art and politics in the 1930s. Scholars have noted that the mass-as-subject first emerges in Orozco's work in this mural.[17] This is not surprising given the rise of fascism and the growing

strength of the communist Left during the interwar period. This theme would recur from this point forward, taking on increasing importance in his oeuvre throughout the 1930s.

In his subsequent frescos, the masses, rather than being a poignant source of vexed identification, become a threat to the autonomy of the individual and a source of barbarism. This is most conspicuous in his historical mural cycle at the Hospicio Cabañas in Guadalajara, painted in 1939, after the rise of fascism and the calls for a Popular Front in the years preceding the outbreak of WWII. If, by the end of the decade, Orozco was confirmed in his suspicion of mass politics, in the early 1930s, when he painted *Prometheus*, he seems to have been more anxious about the threat that the mass presented for the autonomy of the artist. We should understand this concern within the context of the first decade of muralism, when the signatories—Orozco included—of the "Manifesto of the Technical Workers, Painters, and Sculptors Syndicate of Mexico" pledged "to socialize … individualized artistic expression" by repudiating easel painting in favor of a "monumental art" derived from "collective values" and placed in the service of popular "education and struggle."[18]

José Clemente Orozco, *The Mechanized Masses* (from the History of the Conquest cycle), 1938–39. Fresco. Hospicio Cabañas, Gaudalajara, Jalisco, Mexico

Throughout the decade, Orozco's peers in the movement took up competing claims about art, form, and politics. Diego Rivera and David Alfaro Siqueiros upheld acutely opposed positions. Their developing polemic would erupt in 1934, in an attack drafted by the latter in the pages of the *New Masses*. In "Rivera's Counter-Revolutionary Road," Siqueiros accused Rivera of being, among many things, a political demagogue and criticized his mural style for being overly didactic, deploying illusionistic banners and texts, and relying on esoteric iconography that effectively immobilized the viewer, inducing her to passively contemplate or read the mural.[19] In opposition to this, Siqueiros would develop his "cinematographic" style, wherein he borrowed from Sergei Eisenstein's film theory to develop an affective approach to form that mobilized the viewer physically in the hopes of bypassing intellection in favor of an emotional response that could form the foundation for political action.[20] These two paradigms for political art assumed different relationships between dialectical form and the viewer, but both artists firmly believed that he could affect political change in the viewer.

Whereas Rivera's "demagoguery" resided in telling his viewers what to think, Siqueiros's lay in an attempt to manipulate them emotionally, toward political ends of his choosing. Both artists believed that they were leading the masses toward a Marxist, and therefore an emancipatory, understanding of history. Both artists viewed history as an objective reality unfolding according to a dialectical logic that was rooted in class conflict. And while each believed that the artist could affect change in the viewer and thereby hasten the unfolding of history's dialectic, neither had much confidence or even interest in the viewers' own critical, creative, or conscious capacities.

For Rivera, the viewing subject, whether bourgeois, peasant, or proletariat, was an individual who needed to be instructed about the true nature of history. As he famously proclaimed in his 1960 autobiography, his murals "reflected the social life of Mexico as I saw it, and through my vision of the truth show the masses the outline of the future."[21] His positivist elitism was rooted in an

essentially pastoral attitude toward the public. Siqueiros, on the other hand, largely conceived of his audience as a proletariat in formation. For him, the job of mural art was to mobilize the public, to direct them toward action that could only be emancipatory because it would be guided by strict Marxist principles. Orozco, as we shall see, understood the idiosyncrasies of reception and therefore expressed grave doubts about orchestrating the political effects of art.

We see Orozco's suspicion first articulated in the statement he drafted for Dartmouth College's *Alumni Magazine* upon the completion of his fresco cycle *The Epic of American Civilization* (1932–34). "In every painting, as in any other work of art," he writes, "there is always an IDEA, never a STORY." He continues: "The stories and other literary associations exist only in the mind of the spectator, the painting acting as the stimulus. There are as many literary associations as spectators. One of them, when looking at a picture representing a scene of war, for example, may start thinking of murder, another of pacifism, another of anatomy, another of history, and so on. Consequently, to write a story and say that it is actually TOLD by a painting is wrong and untrue."[22]

In this passage, Orozco explicitly acknowledges that viewers make what they will of what they see. He links the "viewer's share" with "STORY," arguing that the work of art merely stimulates something in the mind of the viewer, and it is she who then weaves this into a narrative. Unlike Marcel Duchamp, who famously attributed the completion of the creative act to the viewer, Orozco does not wholeheartedly embrace her "share." Orozco's observation is melancholic insofar as he seems to acknowledge and lament the essential fluidity of signification and the inability of the artist to secure meaning through an appeal to a transcendent ideal.

Unlike Rivera and Siqueiros, Orozco was resigned to the fact that artists could not keep viewers from creating stories of their own from the ideas in the artist's work, and therefore, he expressed great skepticism about the ability of visual art to effect political change. Writing retrospectively in his autobiography about the Syndicate Manifesto and the heady early days of the mural movement, Orozco satirized the Manifesto's endorsement of what he called "combat painting," or art designed to "incite the oppressed to a struggle for liberation."[23] "When," he asks rhetorically, "is a painting or a piece of sculpture really calculated to arouse mental processes that will turn into revolutionary action in the viewer?"[24] Answering his own question, he notes that Catholic art has certainly helped to "quicken faith and devotion" among believers.[25] But he follows by observing that one sees equal devotion among the faithful in "Mosques" and "Protestant Churches."[26] In other words, the emotional experience of "faith and devotion" does not depend upon figurative art. Orozco concludes, "Instances of the arts exerting a decisive revolutionary influence upon the spectator must be conditioned by some factors as yet unknown and others of a purely fortuitous nature."[27]

He suggests that affective contexts, such as "standing in the plaza, while the flags are rippling in the sunshine and the bells are sounding and sirens are deafening us," make hearing the national anthem more effective than listening to it "alone, at home, on the phonograph."[28] For Orozco, the affective power of any art form depends upon its context of reception, the public nature of the experience as well as incidental and unpredictable factors (like a sunny day). For him,

Pablo Picasso, *Guernica*, 1937. Oil on canvas, 137½ × 305¾ in. (349.3 × 776.6 cm). Museo Nacional Centro de Arte Reina Sofia, Madrid, Spain

reception that moves the viewer is a whole-body experience articulated to and through other affective phenomenon, such as patriotism or religious faith. It is clear that Orozco did not attempt to orchestrate sensory surrounds for his mural projects (as Siqueiros would in the 1960s), so we must understand his observations here as a renunciation of affective political art of the kind that Marxists like Siqueiros were espousing in the 1930s. This begs the question, then, as to what mural art, as a public art, *was* for Orozco. He notoriously abjured explaining his art, and yet he endeavored again and again, in both paint and text, to insist upon its anti-narrative qualities. This feature of the work seems to hold the key to Orozco's convictions about a host of related issues: form, history, and the work's relationship to audience, architecture, and politics.

In "Orozco 'Explains,'" a short text Orozco drafted for the Museum of Modern Art (MoMA), upon the completion of his portable fresco *Dive Bomber and Tank* (1940), he re-phrased his Dartmouth statement, arguing that, "a painting is a Poem and nothing else. A poem made of relationships between forms as other kinds of poems are made of relationships between words, sounds or ideas."[29] He went on to characterize painting of this nature as a "machine-motor" that "sets in motion our senses, first; our emotional capacity, second; and our intellect, last."[30] Like Siqueiros, Orozco seems to suggest that visual art is first and foremost an emotional experience. But unlike Siqueiros, Orozco does not insist that his art moves the viewer in particular ways, let alone in particularly political ways. Nor does he believe that the sensory, emotional, or intellectual reaction of the viewer follows from a rigorously Marxist formal method. Rather, he places emphasis on the formal *poetry* of the work, insisting that each part of the "machine" can "function independently of the whole."[31] "The order of the inter-relations between its parts may be altered," he notes, "but those relationships may stay the same in any other order, and unexpected or expected possibilities may appear."[32]

Despite his emphasis on form as poetry, Orozco's explanation was not a defense of formalism. His remarks pertained specifically to *Dive Bomber and Tank*, a portable mural that was comprised of six freestanding panels that could

José Clemente Orozco, "Orozco 'Explains.'" *The Bulletin of the Museum of Modern Art 7*, no. 4, August 1940. The Museum of Modern Art, New York (details on pages 60–61)

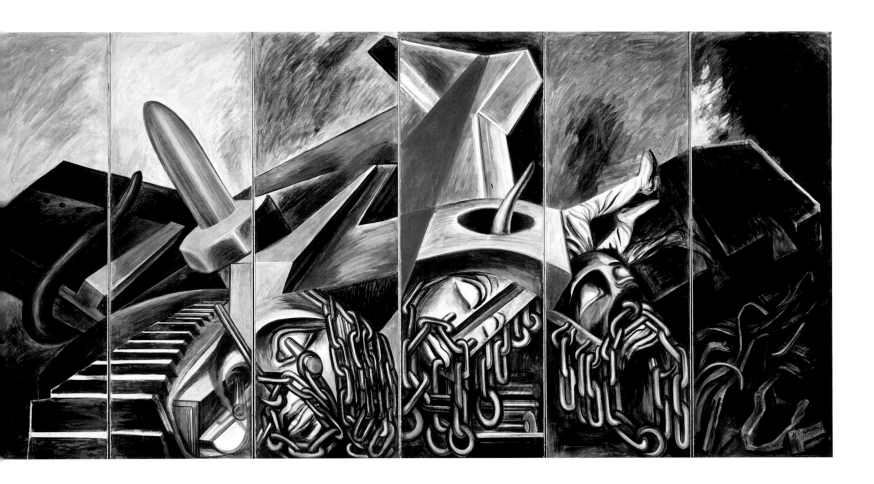

José Clemente Orozco, *Dive Bomber and Tank*, 1940. Fresco, six panels, each: 108 × 36 in. (275 × 91.4 cm), overall: 108 × 228 in. (275 × 550 cm). The Museum of Modern Art, New York. Commissioned through the Abby Aldrich Rockefeller Fund

be shuffled and re-shuffled literally (the panels could even be inverted!) into a number of configurations. In each instance, the "IDEA" of the work remains even as the order of its parts has been altered. As James Oles argues, the idea animating *Dive Bomber and Tank* was "the devastating capabilities of technology and modern warfare."[33] The mural "works," regardless of its physical iteration, he observes, because "there is a level of signification in the mural that is attached not to objects (the war machines [of the title]) but to fragments."[34] Oles asserts that *Dive Bomber and Tank* should be understood, therefore, as a reaction to the formalist utopianism embodied in the European avant-gardes, such as Cubism. For at the levels of composition and signification, Orozco's portable mural deliberately misuses Cubist fragmentation to signal destruction and chaos in general. In this sense, Oles likens Orozco's mural to Picasso's highly influential *Guernica* (1937), claiming that it takes the principle of collage in synthetic cubism and its formal and iconographic connections to wartime destruction to a literal extreme.[35]

In *Dive Bomber and Tank*, we see how Orozco's deployment of the fragment is both a formal procedure and a symptom of the modernity that the mural decries. The mural's status as a system of fragments and relations without an ideal arrangement makes the allegoresis of modern art palpable. And yet its critical potential persists. Orozco also addresses this confounding nexus of form, contingent meaning, and political redemption in his MoMA statement, "Orozco 'Explains.'" The statement itself can be understood as a melancholic allegory of the very problem of meaning his mural diagnoses and makes recognizable. A note at the start of the text, added by the museum, proclaims: "This

The following arrangements of the six panels are those preferred by Mr. Orozco.

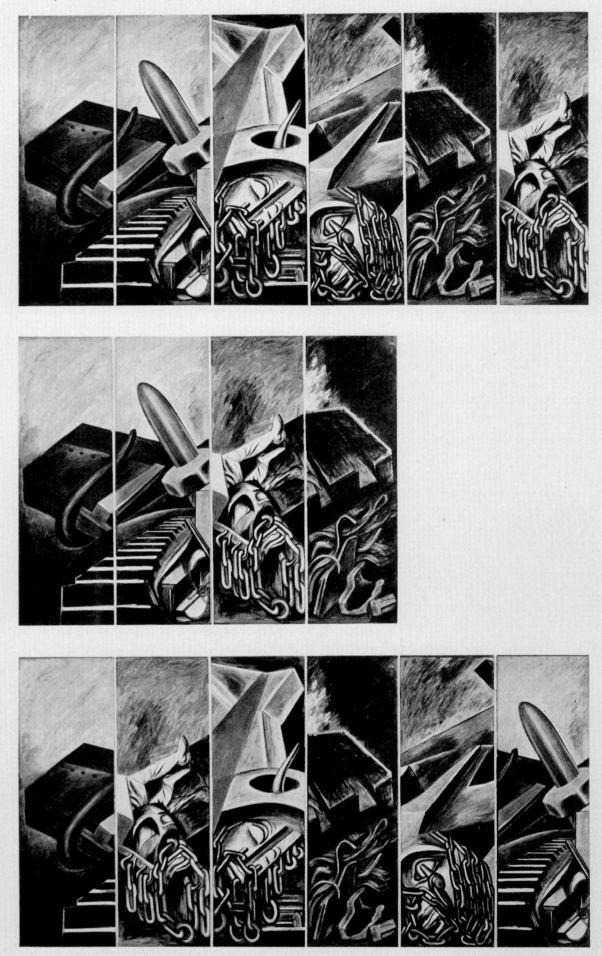

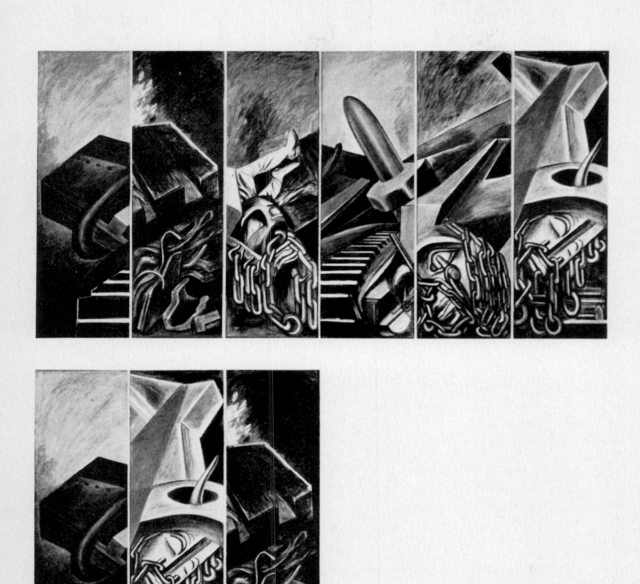

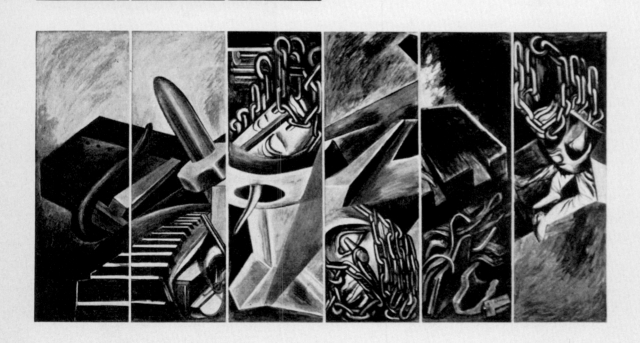

'explanation' was written by Mr. Orozco. The quotation marks in his title indicate his feeling that explanations are unnecessary."[36] Here, the scare quotes in the title around "Explains" indicate the conventional nature of language; his "explanation" is not what it seems to be—a clarification of his intentions or the mural's symbolism—but rather a melancholic lament about the public's demand for a "STORY." "The public wants explanations about a painting," he writes at the start of his text. Orozco does not, however, capitulate to this demand. Instead he satirizes the call for explanation, complaining, "The public refuses TO SEE painting. They want TO HEAR painting. They don't care for the show itself, they prefer TO LISTEN to the barker outside. Free lectures every hour for the blind, around the Museum."[37]

We might understand Orozco's frustration with the passivity of the public as not only a function of the polysemy of art, but also the position taken up by artists like Rivera, whose mural form seems to solicit and reward this kind of passivity. If so, then what kind of ideal public or viewer does Orozco imagine? He does not say explicitly, but one can discern a position from what he does say about painting as a "machine-motor" with "inter-relations between its parts." In the final section of his MoMA text, Orozco addresses the question of form most explicitly.

Orozco insists that his mural is a "machine," and not only can each panel be conceived of as an independently functioning machine, but also the "order of the inter-relations between its parts may be altered."[38] Nonetheless, he insists that the relationship between its parts "may stay the same in any other order and unexpected or expected possibilities may appear."[39] This seemingly contradictory "explanation" of his mural form at once insists upon the fragmented nature of the whole while also asserting that that fragmentation intimates a relationship (an "IDEA"?) that stays the same no matter what the arrangement of its parts. Further, it is the relationship between the interchangeable parts that generates "unexpected or expected possibilities." Orozco follows with a suggestive thought experiment: "Suppose we change the actual order of the plastic elements of the vaults in the Sixtine [sic] Chapel," at which point he trails off with ellipses.[40] Here he engages the reader in an act of imagination—the speculative "suppose we"—rather than making polemical assertions. He does not complete the thought, however. He does not tell us what might follow from such an exercise. He leaves this for us to ponder. Through this imagined act of montage, Orozco illustrates how "possibilities" can inhere in visual poetry and the constructive principle of form even when visual language is unmoored from any absolute meaning or truth correspondence.

Orozco concludes his "explanation" with what seems to be a non sequitur about linotypes (a print medium) in which he locates visual politics in what he calls "motion." He writes, "A linotype is a work of art, but a linotype in motion is an extraordinary adventure affecting the lives of many human beings or the course of history. A few lines from a linotype in action may start a World War or may mean the birth of a new era."[41] Here, Orozco obliquely connects political effects with the dissolution of the work of art as art (a mere linotype) and its conversion into something else, something in "motion." What does he mean? And why has he switched from a discussion of painting to the print-medium of the linotype? Like Siqueiros, he may be analogizing mural painting with mass media.

The print medium, like film, is a reproducible one, a non-auratic art form with the capacity to reach thousands of viewers because of its decontextualizing mobility. Like film, it is an art-in-motion.[42] When stripped of its auratic status as art, the linotype in motion—i.e. a print re-purposed for a propaganda poster and circulated in the streets—shifts the viewing experience from one of ritual (an experience with a unique object) to one that is explicitly political. If we are hearing echoes of Walter Benjamin's famous essay on "The Work of Art in the Age of Mechanical Reproduction," it is a deliberate correspondence on my part.[43]

By invoking reproducible art, Orozco engages with the utopian aspirations of his peers and their arguments about the mass politics of muralism as a *public* art. Recall that Siqueiros, in particular, sought to make mural art "cinematographic" by mobilizing the viewer and, thereby, the imagery. Rivera too equated mural art with mass media—such as film newsreels, radio broadcasts, and the nascent technology of television—in his published statements about his work, as well as through his iconographic programs.[44] However, unlike Siqueiros and Rivera, Orozco believed that the political effects of his art were not guaranteed. A mobilized work of art can "start a World War" *or* give "birth to a new era." Likewise, he does not argue that the political direction the work takes is determined by its adherence to an external truth, as Siqueiros did, or to a subjective one, as Rivera claimed.

If it is the case that a work in motion can either start a war or bring about a new order, what determines its political effects in either direction? Orozco is extremely coy on this point. Throughout the text he seems to eschew any conventional notion of agency. He refuses to make "I" statements. He never says what it is he intended, but rather speaks of what the public expects or of what painting is or can be: "parts can be ordered," "unexpected … possibilities may appear."[45] Read from the standpoint of the subject, there is a curious slippage between the artist and viewer in Orozco's text. We can see this most clearly in his supposition that "we" rearrange the plastic elements of the Sistine Chapel. Here he seems to invite us to become *monteurs*, destroying Michelangelo's masterpiece, cutting it up into parts and re-arranging them into new constructions that at once maintain some essential relationship while simultaneously producing unexpected possibilities. His "explanation," in the end, is a call to just such a viewer, one who sees rather than wants to listen, one who is active, rather than passive, one who can access the "IDEA" that springs forth from the image in fragments rather than one who crafts a triumphal story out of said fragments by lining them up into a linear tale. But this viewer, while active, finds possibilities in the work not through the subjective creation of a "STORY" but, instead, through accessing some kind of redemptive truth that lies beyond his or her contingent perspective.

If this is so, then who is the subject of the redemptive possibility (the "IDEA") that inheres in a work of art? Is it the artist or the viewer who performs the critical work of montage? The slippage in Orozco's text, the conspicuous absence of an "I" who speaks or writes or paints, begs the question anew as to the relationship between an absolute and the contingency of the art form, or in this case, the truth in painting and the perceiving subject. His language seems to suggest that these possibilities are both made (through the act of interchanging fragments) and found

("possibilities occur"). Similarly, he seems to insist upon a mediating concept that functions to inter-relate the parts, no matter their configuration, and thereby to appeal to a truth beyond the appearance of polysemic fragmentation. At the same time, he implies that redemption (the "birth of a new era") arises from the act of putting the work of art in "motion" toward political rather than mythifying ends.

Orozco's inability to answer this question definitively accounts for his melancholic attitude toward both the public and the politics of the art form. His uncertainty, his desire for the redemptive possibilities of an art in motion crossed with his skepticism about the viewer's share, may seem to lead us to an impasse, wherein art cannot have political effects because its politics can be neither securely ascertained within the communicative strategy of the work itself nor located within the intentional labor of the artist. However, Orozco's unwillingness to answer these questions may not leave us at an impasse. Rather, by expressing these doubts and raising these concerns, he anticipates many of the questions that continue to bedevil artists who seek diverse publics and whose work is guided by a critical ethos of engagement to this day. Like artists today who understand that they are negotiating the gaps between their intentions, the expectations of their patrons (typically art event organizers), and the experiences of the publics they engage, Orozco continued his work despite his skepticism. He maintained his commitment to public art, making monumental murals in institutional spaces that host a variety of viewers. And as Karen Cordero Reiman has indicated, he left the "construction and appropriation" of his murals' meaning to the public, through what she calls a "social process" rather than "dogma."[46] To better appreciate the social dimensions of the reception of Orozco's *Prometheus*, we shift our attention from form, iconography, and intentionality to site and to what Benjamin called the "afterlife" of the image.[47]

Site-Specificity, Embodiment, and the Performance of Difference

Orozco's murals persist through time, and in that sense, they exceed the time of their making even if they remain within concrete spatial settings that seem, conversely, not to change. This is particularly the case in his commissions in the United States, where he painted in institutional spaces that have, for the most part, continued to function in the same capacity despite what is now closing in on a century of existence. And yet, even if these sites have not changed their functions over time, I would argue they are not the same kinds of sites today that they were in the 1930s, predominantly because our understanding of site as a phenomenological or discursive space where artists operationalize their work has changed dramatically in the ensuing years.

The discourse of site-specificity that emerged in the 1960s and 1970s, with minimalism and the rise of institutional critique, has irrevocably changed how we view the institutional setting in which works of art are sited. And while artists explicitly articulated the discourses and practices of site-specificity in this period, the Mexican muralists anticipated their aims and many of their claims. Moreover,

if we refract Orozco's engagement with site, his status as a nomadic artist working in "one site after another," through contemporary critiques of the various modalities of site-specificity, our understanding of the *Prometheus* mural, as it exists today, changes.[48]

James Meyer distinguishes between two contemporary notions of site.[49] On the one hand, we have works that take site literally or, to recall Miwon Kwon's discussion, works that treat site as a phenomenological entity. For these artists, the site is a singular location whose physical features and ideological uses determine the formal outcome of the work. Within this conception of site, the work too is conceived of as a unique and singular phenomenon, commissioned especially for the site. On the other hand, we have functional sites, or what Kwon characterizes as a discursive entity, a process-oriented construction that is produced in and through the relays between institutions, texts, and bodies, a space that is often conjured by the work itself as a social phenomenon rather than an actual place. Whereas works sited in literal spaces seek permanence, those that are sited discursively are usually temporary.

For our purposes here, the literal site best characterizes the muralists' conception of site and Orozco's relationship to Frary Dining Hall, the unique location of *Prometheus*. Like the artists who pioneered the practice of site-specific work in the 1960s, the muralists were endeavoring to elude the bourgeois commodification of art associated with easel painting. As early as 1924, when they published their manifesto, these artists decried easel painting as "bourgeois" because it served an "aristocratic" and "ultra-intellectual clique" rather than profiting the people. In his 1929 manifesto, "New World, New Races and New Art," Orozco reiterated this claim, asserting that mural art is the "highest . . . form of painting" because "it cannot be made a matter of private gain; it cannot be hidden away for the benefit of a certain privileged few."[50] Thus, while not pointing to a capitalist system, these artists nonetheless associated the discreet nature of easel painting with the private market and privilege of the wealthy and proposed monumental works of art, sited in public spaces, as an alternative.

Similarly, many of the muralists were concerned with what Meyer dubs the "phenomenology of presence," paying attention to the ways that spectatorship unfolds in real time and space.[51] For Siqueiros, as indicated above, this took the form of mobilizing the viewer through cinematographic techniques. For Orozco, we can see this in the way he calibrates the viewer's experience of his mural to her movement from a distanced toward a more proximate view. This attention to the viewer's embodied relationship to the work is ramified by the formal and iconographic features of the work, which emphasize, as argued already, the physical discomfort of the Titan. His torqued movement suggests an experience that is similar to the physical disorientation that results from trying to view the mural at close-range, something the viewer must do if she wants to see the mural in its entirety. Just as Prometheus seems to strive toward an unseen abstraction, the viewer too must crane her neck and twist her torso to look up and try to apprehend the rectangular "god head" that is the source of the protagonists' aspiration and torture. At close range, however, the clarity of the figure threatens to dissolve into a cacophony of forms, a phenomenon that compels the viewer to

A cartoon in *The Student Life* accompanying "Prometheus Unbound, Myth Revealed," November 7, 1972. Special Collections and Libraries, Claremont Colleges Library, Claremont, California

move back in space, to once again allow the image to resolve into something legible. In this sense, Meyer's observation that site-specific work seeks to "counter [the] symbology of transcendent order with a real-time bodily experience of the literal site" seems to hold.[52]

The spatial and embodied dimension of the work does not entail the ideological critique of art institutions that often drove the site-specific work of the 1960s. But, as I have argued elsewhere, mural artists' concern with architecture—their stated desire to either destroy or incorporate it through their imagery—was converted by the 1960s into a nascent form of institutional critique, particularly as mural art became integrated into an official network of state institutions.[53] However, even in the 1920s and 1930s, artists were concerned with how to address the ideological conditions of the sites in which they painted. This became increasingly pressing as they moved to the United States, where they found themselves commissioned by private, often corporate, patrons and executing work in spaces that only nominally could be deemed public. This formed part of Siqueiros's critique of Rivera in his 1934 *New Masses* attack. There, he was particularly outraged by Rivera's willingness to work for capitalist patrons, such as the Rockefellers and the Fords, in spaces largely aimed at a bourgeois public, and through images that he deemed "touristic."[54] At the time, Siqueiros was training artists in a *taller*, organized as a working-class shop, and executing floats for May Day Parades. Orozco stayed out of their standoff; however, in calibrating the *Prometheus* mural so carefully to the physical experience of the space, he

too demonstrated an interest in using art to call the viewer's attention to the ideological dimensions of Frary Dining Hall and the specific viewing conditions afforded by its refectory space.

The mural's masculine rhetoric complements the gendered space of a male dining hall modeled after the ascetic purity of Franciscan mission architecture and the sober Gothic interiors of British universities. His heroic nudity and striving form seem to physically support the architectural frame. As has often been recalled, the architect, Sumner Spaulding, even joked that the building would collapse if the fresco were removed.[55] In this sense, Orozco's choice of subject and engagement of the architecture presumes an implicit homology between the male body, the viewing subject, and the gendered space of the dining hall. And yet, the Titan's anguished disposition and his conspicuous lack of genitalia have led to many attempts to supplement the male body over the years, to, as one student put it, "restore his manhood."[56] As I have argued before, these calls for restoration emerged only after the dining hall was sexually integrated, suggesting that the original homology between the Titan's body, the masculinized semi-public sphere, and the viewer's body had been ruptured by the presence of female college students.[57] Over time, rather than reifying the heroic masculinity of the modern artist and the gendering of public space as male, the mural has become a vexed signifier of gender trouble. The male body made visible and vulnerable in a mixed gender space augers anxieties over male prowess and a social and spatial order that is structured by an invisible logic of discreet gender difference.

Today commentary on the figure's genitals is inescapable. The tendency within student reception to literalize the murals' metaphorical body, as Cordero Reiman has argued, proceeds from Orozco's deviation from classical anatomy as well as the mural's relationship to its site.[58] And while student response registers the very difficulty of transcending the material condition of humanity that Orozco was promoting through his choice and treatment of the subject, it also grounds us in the very embodiment of the viewer that the mural activates. For Orozco, that embodiment was abstracted, imagined as a universal subject rather than a gender-specific one. But today, the embodied subjects that engage the mural inhabit multiple subject positions and bodies. It is no longer possible to see the mural as an expression of a generalized subject's will to power. Now, we are more likely to view Prometheus as a vulnerable and victimized male body. Thus, the mural, if once an ambivalent assertion of a spiritual rather than a physical conception of the artist, is now an ironized emblem of the modern subject in a post-modern condition of particularization and partiality: a fragment rather than a whole.

The shifting reception of *Prometheus* over time, as a consequence of its siting, and the inescapable gender dynamics of its fragmented male body for any embodied viewer are in part what inspired our team to propose a project to re-engage the mural from the standpoint of contemporary art practice by women. The decision to focus on female artists foregrounds our tendency today to mark and exploit difference rather than assert universal similitude. Rather than presume a universal artistic subject, we consciously chose to emphasize

Actual size card reading "Remasculate Prometheus," with an edited image of *Prometheus*. Circulated around the Pomona College campus anonymously in 2015. Pomona College Museum of Art Archives

female artists to highlight the importance of difference—gender or otherwise—to conceptions of artistic practice and reception today, without any preconceptions about how one's sex-assignment or gender-identity might determine one's experience with Orozco's mural. Instead, we sought to call attention to the rupturing of the homology between artist, body, and site, to insist upon the partiality of embodiment that is imminent in Orozco's aesthetic of the fragment, and to commemorate the gender-integration of Frary Dining Hall, a site condition that has radically re-inflected Orozco's mural.

Likewise, rather than simply re-inscribing the mural in its time and place, we sought to bring the concerns it raises about the artist and his or her public into a dialog with contemporary artists working with an ethos of collaboration and whose relationship to site is more "functional" than "literal." By bringing artists from Mexico to Claremont, this exhibition becomes a discursive site, an occasion to contemplate the relationship—both historical and contemporary—between the greater Los Angeles area and Mexico. In this process, Orozco's grappling with the public art ethos and mass culture of the 1930s becomes constellated to transnational conversations about the violence of capitalism, reason, and technology; the ongoing purchase of myth and mysticism; and the politics of community and collaboration taking place today.

And so we return to the set of questions posed at the outset. What do a burning microbus, a set of conversations with college students, a psychedelic musical performance, and an exercise in astrology have to do with José Clemente Orozco's *Prometheus*? How can we understand Orozco's striving Titan as related, in any way, to the kitschy mythological characters who cavort through Naomi Rincón-Gallardo's *Odisea Ocotepec*? For that matter, how does Orozco's imposition on Frary's architecture and its dining inhabitants inform Rita Ponce de León's more fragmentary and ephemeral engagements with the college's diverse community today? Can we understand Adela Goldbard's pyrotechnics as having any kinship with Prometheus's theft of fire? And how might Isa Carrillo's mystical meditation on Orozco's left hand refract the latter's struggles to reconcile his esoteric concerns with the public mandate of monumental mural art? Orozco would probably say, somewhat melancholically, that it is the viewer—not the artist or the curatorial team—who must imaginatively cut up and montage the parts of "Prometheus 2017," not only weaving atomized and idiosyncratic stories from the IDEAs presented in the works on display, but also finding redemptive possibilities in the process of putting *Prometheus* in motion.

1. Karen Cordero Reiman, "Prometheus Unraveled: Readings of and from the Body: Orozco's Pomona College Mural (1930)," in *José Clemente Orozco in the United States, 1927–1934*, ed. Renato González Mello and Diane Milliotes (Hanover, NH, New York, and London: Hood Museum of Art, Dartmouth College, and W. W. Norton, 2002), 117.

2. Nicolas Bourriaud, *Relational Aesthetics*, trans. Simon Pleasance and Fronza

Woods, with Mathieu Copeland (Dijon, France: Les presses du reel, 2002), 45.

3. Ibid.

4. Grant H. Kester, *The One and the Many: Contemporary Collaborative Art in a Global Context* (Durham, NC: Duke University Press, 2011), 31.

5. Clement Greenberg, "The Avant Garde and Kitsch," *Art and Culture: Critical Essays* (Boston: Beacon Press, 1962), 3–21.

6. It is a given in the scholarship on relational practices that these collaborative and dialogical approaches in art making have been necessitated by the extent to which mass-mediated spectacle has subsumed all forms of representation. All of these authors cite Guy Debord's *The Society of Spectacle* (1967) as the key text on and theorization of the problem that contemporary artists are attempting to evade, expose, or overcome through sociality.

(pages 70–71) Interior of Frary
Dining Hall and José Clemente
Orozco's *Prometheus* mural (1930),
2016. Pomona College

7. See David W. Scott, "Orozco's *Prometheus*: Summation, Transition, Innovation" and "*Prometheus* Revisited," in *José Clemente Orozco: Prometheus*, ed. Marjorie L. Harth (Claremont, CA: Pomona College Museum of Art, 2002), 13–46; and Renato González Mello, "Mysticism, Revolution, Millennium, Painting," in *José Clemente Orozco: Prometheus*, 47–62.

8. González Mello, "Mysticism, Revolution, Millennium, Painting," 57.

9. Modernismo was an artistic movement at the turn of the century that rejected the positivist orientation of the state and the classicism of the Academy in favor of more decadent and anti-rational subjects and styles.

10. José Clemente Orozco, *An Autobiography*, trans. Robert C. Stephenson (Mineola, NY: Dover, 1962), 25.

11. Cordero Reiman, "Prometheus Unraveled," 106–16.

12. Renato González Mello, *La máquina de pintar* (Mexico City: Institute of Aesthetic Research, National Autonomous University of Mexico, 2008); and Fausto Ramírez, "Artistas e iniciados en la obra mural de Orozco," in Luis Cardoza y Aragón, *Orozco: una relectura* (Mexico City: Institute of Aesthetic Research, National Autonomous University of Mexico, 1983), 61–102.

13. Cordero Reiman, "Prometheus Unraveled," 109.

14. Ibid., 111.

15. Ibid.

16. Rita Eder, "Against the Laocoon: Orozco and History Painting," in *José Clemente Orozco in the United States*, 237.

17. González Mello, "Mysticism, Revolution, Millennium, Painting," 57–59.

18. David Alfaro Siqueiros, Diego Rivera, Xavier Guerrero, Fermín Revueltas, José Clemente Orozco, Ramón Alva Guadarrama, Germán Cueto, and Carlos Mérida, "Manifesto of the Syndicate of Mexican Workers, Technicians, Painters and Sculptors," *El Machete* (1923), reprinted in Dawn Ades, *Art in Latin America: The Modern Era, 1820–1980* (New Haven, CT, and London: Yale University Press, 1989), 323–24.

19. David Alfaro Siqueiros, "Rivera's Counter-Revolutionary Road," *New Masses* (May 29, 1934), 16–19; and "Los Vehículos de la Pintura Dialéctico-Subversiva," in *Palabras de Siqueiros*, ed. Raquel Tibol (Mexico City: Economic Cultural Fund, 1996), 62–78.

20. Mari Carmen Ramírez, "The Masses are the Matrix: Theory and Practice of the Cinematographic Mural in Siqueiros," in *Portrait of a Decade: David Alfaro Siqueiros, 1930–1940*, ed. Olivier Debroise (Mexico City: National Institute of Fine Arts, 1997), 68–95.

21. Diego Rivera and Gladys March, *My Life, My Life: An Autobiography* (New York: Dover, 1960), 79.

22. José Clemente Orozco, "The Orozco Frescoes at Dartmouth" (1933), reprinted in *The Orozco Frescos at Dartmouth* folio, 1948, n.p.

23. Orozco, *José Clemente Orozco: An Autobiography*, 96.

24. Ibid.

25. Ibid.

26. Ibid.

27. Ibid.

28. Ibid., 96–98.

29. José Clemente Orozco, "Orozco 'Explains,'" *The Bulletin of the Museum of Modern Art* 7, no. 4 (August 1940), 2–11. Reprinted in *José Clemente Orozco in the United States*, 308. "Poem" is in boldface in the original.

30. Ibid.

31. Ibid., 309.

32. Ibid.

33. James Oles, "Orozco at War: Context and Fragment in *Dive Bomber and Tank* (1940)," in *José Clemente Orozco in the United States*, 203.

34. Ibid., 201.

35. Ibid., 202–3.

36. Orozco, "Orozco 'Explains,'" in *José Clemente Orozco in the United States*, 303.

37. Ibid., 306.

38. Ibid., 308.

39. Ibid., 309.

40. Ibid.

41. Ibid.

42. The term *auratic* refers to Walter Benjamin's argument that prior to mechanical reproduction works of art had "auras" as a consequence of their being unique objects experienced within a particular setting or space. These objects usually had some kind of ritual function. Once the object can be reproduced via mechanical means, Benjamin suggests, its aura is eroded. Multiple images of the *Mona Lisa*, for example, are not unique in the sense that Leonardo's painting is; moreover, the original meaning or force of Leonardo's work is eroded via its circulation and re-articulation as image. For Benjamin this is an epistemic shift, but not necessarily a negative one, for he saw great political potential in non-auratic art forms, such as prints, photographs, and film. Moreover, he insisted that the radical potential of any work of art could only be re-engaged if its status as art was first destroyed. See Walter Benjamin, "The Work of Art in the Age of Mechanical Reproduction," *Illuminations*, ed. Hannah Arendt, trans. Harry Zohn (New York: Schocken Books, 1968).

43. Benjamin, "The Work of Art in the Age of Mechanical Reproduction," 17–52.

44. Rivera's contemporary mural, *Man at the Crossroads Looking With Hope and High Vision Toward the Choosing of a Better Future* (completed in 1933, destroyed in 1934, re-painted in Mexico City at the Palace of Fine Arts in 1934) was commissioned for the RCA tower in Rockefeller Plaza, and it was explicitly about mass communications through film, television, and radio. In his statements to the press about this mural, Rivera routinely argued that murals, as works of public art, were forms of mass communication. For reproductions of Rivera's press statements, see Irene Herner de Larrea, *Diego Rivera: Paraíso Perdido en Rockefeller Center* (Mexico City: EDICUPES, 1986). For a critical analysis of Rivera's mural and its critical take on mass communications and the nascent technology of television, see Robert Linsley, "Utopia Will Not Be Televised: Rivera at Rockefeller Center," *Oxford Art Journal* 17, no. 2 (1994): 48–62.

45. Orozco, "Orozco 'Explains,'" in *José Clemente Orozco in the United States*, 303.

46. Cordero Reiman, "Prometheus Unraveled," 117.

47. The concept of a work of art's "afterlife" is addressed in Walter Benjamin, "Edward Fuchs, Collector and Historian," trans. Knut Tarnowski, *New German Critique* 5 (Spring 1975), 27–58. It is elaborated with regard to art history in Howard Caygill, "Walter Benjamin's Concept of Cultural History," in *The Cambridge Companion to Walter Benjamin*, ed. David S. Ferris (Cambridge, England: Cambridge University Press, 2004), 73–96.

48. See Miwon Kwon, *One Place After Another: Site-Specific Art and Locational Identity* (Cambridge, MA: MIT Press, 2004).

49. James Meyer, "The Functional Site; or, The Transformation of Site-Specificity," *Space, Site, Intervention: Situating Installation Art* (Fall 2000): 23–37.

50. José Clemente Orozco, "New World, New Races and New Art," *Creative Art* 4, no. 1 (January, 1929). Republished in *¡Orozco! 1883–1949* (Oxford, England: Museum of Modern Art, 1980), 46.

51. Meyer, "The Functional Site," 26.

52. Ibid., 25.

53. See Mary K. Coffey, *How a Revolutionary Art Became Official Culture: Murals, Museums, and the Mexican State* (Durham, NC: Duke University Press, 2012).

54. Siqueiros, "Rivera's Counter-Revolutionary Road," 62–78.

55. Sumner Spaulding, *Time* (October 13, 1930), 30, quoted in Scott, "Orozco's *Prometheus*," 15.

56. Mike Boyle, "And on the Sixth Day God Created Man: The Time Has Come for Prometheus to be Delivered from Genderless Shame," *The Student Life*, April 21, 1995, 10.

57. Mary K. Coffey, "Promethean Labor: Orozco and the Gendering of American Art," in *José Clemente Orozco: Prometheus*, 63–77.

58. Cordero Reiman, "Prometheus Unraveled," 117.

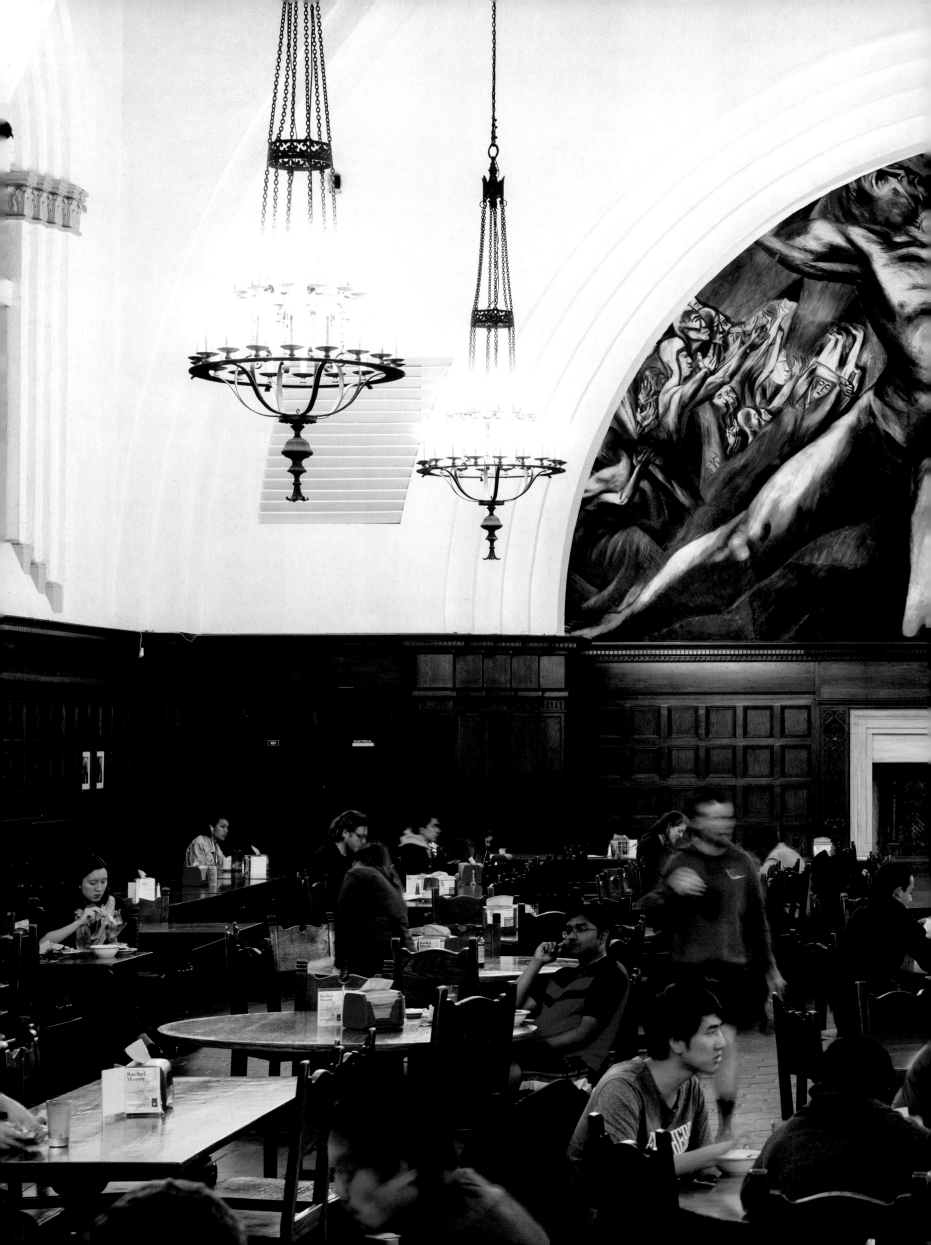

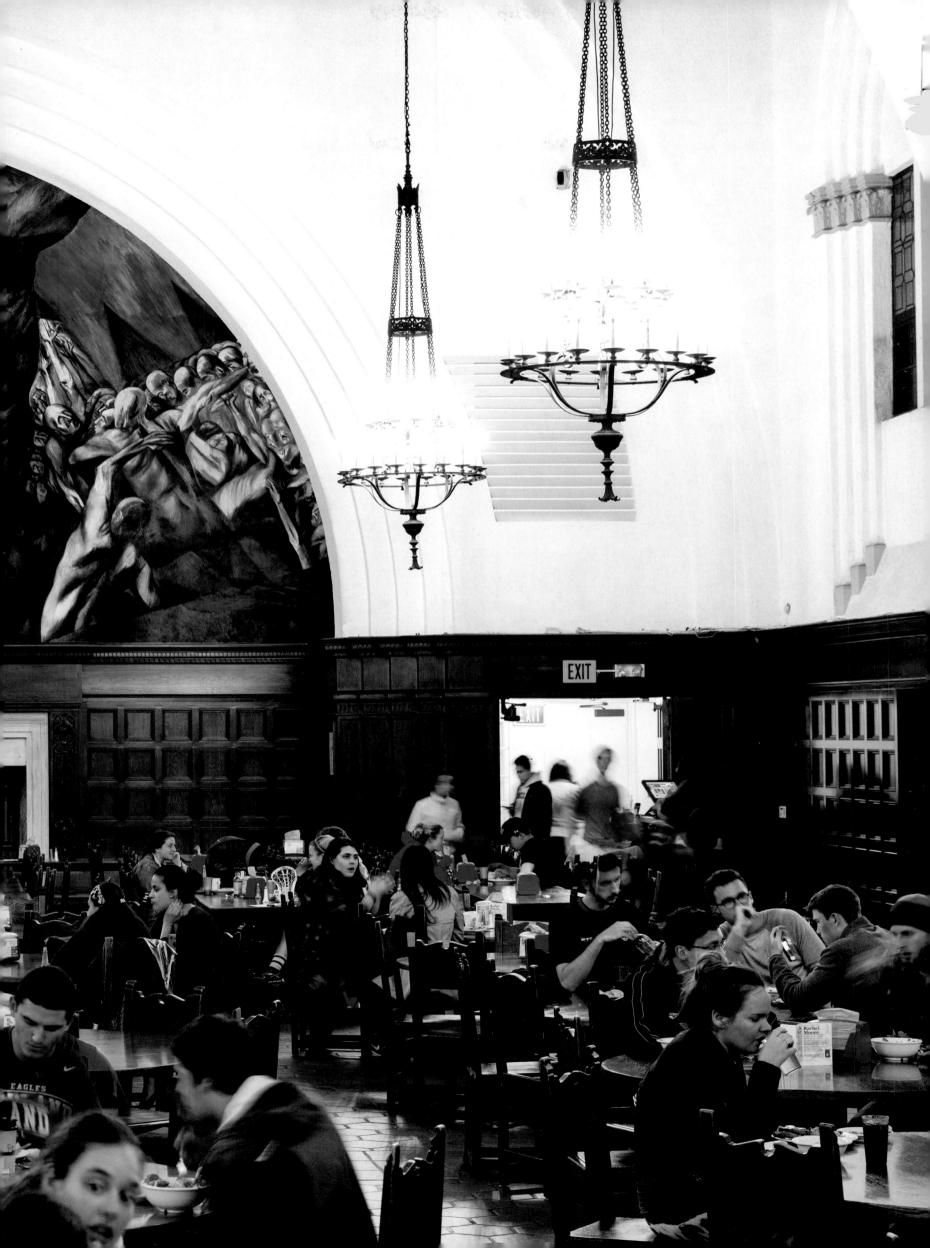

Daniel Garza Usabiaga

Muralism's Afterlife

Mural Practice
and the
Avant-Garde Legacy
in
Contemporary
Art of Mexico

Muralism's Afterlife:
Mural Practice and the Avant-Garde
Legacy in Contemporary Art
of Mexico

Daniel Garza Usabiaga

While many accounts of the history of muralism conclude around 1953, a significant connection to the movement persists within contemporary art practices in Mexico.[1] Indeed, it is possible to argue that the lessons of muralism have continued to change and actualize for more than sixty years, with political critique as its most enduring legacy. Muralism was commonly practiced by individuals who espoused left-wing or communist ideologies and championed anti-fascism, anti-imperialism, and anti-militarism. Many of its adherents saw muralism as a practice that could also address other social urgencies, including critiques of the lifestyles of the local bourgeoisie, poverty, social inequality, and the abuses of power inflicted by the forces of the government. Frequently confused with Socialist Realism, the work of the muralists often questioned and criticized the government and Mexican society. On more than one occasion, this practice led to censorship and even the destruction of the artworks. These concerns dovetail with other important features of muralism, including its inherent vocation as a public art form that was often carried out in large-scale format and some of the muralists' emphasis on a collective nature of production. (However, many muralists did not acknowledge or give credit to their numerous collaborators and assistants.) With these considerations in mind, this essay highlights key examples of contemporary art practices in order to examine how the mural, as a medium,[2] has an afterlife in Mexico and how contemporary artists react to, reflect on, or relate to the legacy of muralism.

In recent history, several groups of artists within Mexico have actively engaged in the production of collective murals. The artists in the Workshop of Plastic Research (Taller de Investigación Plástica, TIP) have most thoroughly and consciously followed the program of muralism. Founded in 1976 and still active today, the TIP's work is described as a "collective Muralism born in community participation."[3] The members of this group engage with peasant and indigenous communities in the provinces in order to determine the content and style of each mural. In a work titled *La corrupción educativa en las comunidades* (*Corruption in the Education of the Communities*, 1980), which was executed in the town of Aranza, in Michoacán, the TIP collaborated with the local community to select several art historical images and reinterpreted them in order to address current social problems. For example, in response to the abuses of rural educational authorities, the TIP painted a mural in which they appropriated a donkey

Workshop of Plastic Research (Taller de Investigación Plástica), *La corrupción educativa en las comunidades* (*Corruption in the Education of the Communities*), 1980. Acrylic paint on wall, dimensions unknown. Aranza, Michoacán, Mexico

Gabriel Orozco, *Mural Sol*, 2000. Acrylic paint on wall, dimensions variable. Museo Tamayo, Mexico City

from Francisco Goya's satirical *Los Caprichos* (1799), in order to portray the ignorance of the state-funded rural teachers.[4] In this work and others, the TIP adheres to a version of realism that intersects with muralism yet also is invested with traits of Pop, Surrealism, and even post-painterly abstraction.

Although not directly related to the activities of the TIP, similar initiatives of collective muralism occurred in the state of Chiapas after 1994, with the emergence of the Zapatista National Liberation Army (Ejercito Zapatista de Liberación Nacional, EZLN). The mural of Taniperla is the most widely known example of a work produced by the Zapatistas' sympathizers. Originally titled *Vida y sueños de la cañada Perla* (*Life and Dreams in the Perla Glen*, 1998) the mural depicted an idealized vision of the collective life of the local Tzeltal community. Scholar Sergio Valdez oversaw the mural's production and the local community executed the work. One day after its official inauguration on April 10, 1998, the Mexican Army destroyed the mural. Since then, the mural has been reproduced several times by different communities in several states of Mexico, as well as in Argentina and the United States. Artist and writer Eduardo Abaroa suggests that we see these murals as possible precursors to the participatory strain within contemporary art that gained momentum around the globe at the end of the twentieth century.[5]

While local residents in rural settings have undertaken collective mural projects such as *Vida y sueños*, other projects that reference the legacy of muralism have taken place within the centralized, high-profile artistic venues of Mexico City. For example, in Gabriel Orozco's first retrospective in Mexico, at the Museo Tamayo in 2000, the artist included a mural, produced by commercial sign painters (*rotulistas*), on one of the walls inside the museum.

Mural Sol (2000) appropriated the publicity of the popular Mexican beer brand Sol. It was certainly not a coincidence that Orozco decided to produce a mural to be showcased at a museum that was founded by Rufino Tamayo, who is often regarded as the fourth great muralist. During the second half of the twentieth century, in an epoch in which many—including international agencies, such as the Pan-American Union, Mexico's National Institute of Fine Arts, and art critics such as Octavio Paz—began to view realism with extreme suspicion, the Mexican state chose Tamayo's oeuvre for international export, due to the works' arguably apolitical stance. As Willy Kautz asserts, in conceiving *Mural Sol* for this museum, Orozco equated "the stereotyped and marketed vision of Mexico in the advertisement with the tradition of institutional Muralism, through the contraposition between a suggestive imaginary of an export product and the symbolic machinery of the Post-Revolutionary State."[6] *Mural Sol* alludes to the visual regimes of two epochs and the current dominance of the imaginary of consumption, advertisement, and the culture of the spectacle in general.

In the same year as Orozco's mural project, another contemporary artist reconfigured an advertisement as a form of public art and placed it in line with the legacy of muralism. In *Melate* (2000), Minerva Cuevas appropriated the publicity for a National Lottery game in Mexico. In place of the millions of pesos being offered as the prize, she substituted images representing the millions of people living in poverty at that time in the country. In an exercise of *détournement*, this mural was placed in the public realm, operating as traditional publicity, hidden in plain sight. *Melate* gave visibility to the wealth disparity that characterizes Mexican society and pointed to the National Lottery—which is widely considered more a vehicle for the enrichment of the ruling political elites than social assistance for the poor—as a participant in this situation. Cuevas has repeatedly enlisted the mural's potential for political critique. In several projects, she has used images from Del Monte Foods in murals placed within larger installations. In *Del Montte* (2003), for example, she produced a mural-sized work that appropriated the logo of the company in order to explicitly condemn the involvement of transnational corporations in several orchestrated coups d'état that took place in Central America during the second half of the twentieth century. In front of the mural, Cuevas stacked cans bearing labels of the same design.

The Sala de Arte Público Siqueiros (SAPS)—a Mexico City institution that has devoted a great part of its program to revising the history and legacy of David Alfaro Siqueiros and muralism—has hosted many contemporary projects that reference muralism. Teresa Margolles's *Muro baleado* (*Shot Wall*), presented at SAPS in 2009, is a work with undeniable sculptural attributes that can also be discussed in relation to the mural. For this work, the artist dismantled a wall (the prototypical surface and support of the mural) of a house in Culiacán in the northern Mexican state of Sinaloa. The wall had been riddled with bullet holes during crossfire between bands of organized crime. The work is exhibited as a transportable mural that is reassembled brick by brick at each venue. *Muro baleado* carries the traces of the rampant violence unleashed in the country since former president Felipe Calderón began his so-called War on Drugs in

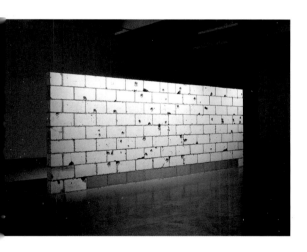

(top) Minerva Cuevas, *Del Montte*, 2003. Acrylic paint on wall, black-and-white research scheme on paper, and 100 relabeled tomato cans, scheme: 35½ × 23⅝ in. (90 × 60 cm); mural: 196⅞ × 236¼ in. (500 × 600 cm). Mexico City Museum, Mexico City

(bottom) Teresa Margolles, *Muro baleado* (*Shot Wall*), 2009. 130 blocks with bullet holes, 83¾ × 156 × 4 in. (213 × 396 × 10 cm). Sala de Arte Público Siqueiros, Mexico City

Rita Ponce de León, *David*, 2013. Ink on wall, video, and paper blocks with printed images, dimensions variable. Sala de Arte Público Siqueiros, Mexico City

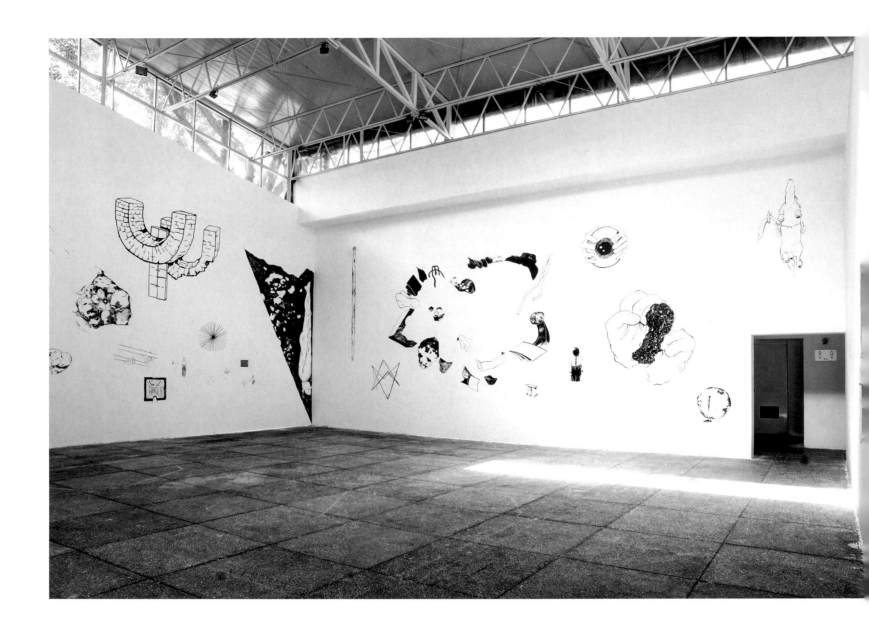

2006. Without resorting to traditional exercises of representation, Margolles's critical piece speaks of how commonplace extreme violence has become. In 2011, Margolles produced *El grito* (*The Cry*), at the Museum of Modern Art in Mexico City. For one part of this project, the artist covered a segment of the museum's expansive glass windows with human fat and sweat taken from dozens of t-shirts worn by a group of teenagers for several months without being washed. Margolles's participants were within the age range that is considered most vulnerable to enlistment by organized crime. The application of grease, like painting, emphasized the materiality of the glass, while also nullifying its transparency and obscuring the view of the garden beyond. Margolles's glass mural points to the pessimistic view of the future that is widely shared amongst Mexican youths today, in comparison to other countries of Latin America. This is not surprising considering that, in Mexico, young individuals' rights to health, education, employment, and social participation are permanently violated, according to non-government organizations.[7]

Rita Ponce de León also engaged in forms of collective participation for the execution of a project of mural proportions at SAPS. For *David* (2012), she conducted research in the institution's extensive archives on Siqueiros and selected several images that encompassed the muralist's artistic production and ideas. Ponce de León structured the project around a group of concepts, including concentration, restriction, and fluidity. She interviewed several people to explore how these terms are understood today in relation to current social conditions, and then made new large-scale drawings, based on the work of Siqueiros, in order to give visibility to their perspectives. These drawings occupied the four walls of the SAPS gallery, constructing a mural out of fragments. While Ponce de León's approach was very much in line with Siqueiros's concepts of a total environment artwork, in which the whole space became the surface of the mural, she offered fragmented images instead of comprehensive and totalizing narratives. Some of her drawings, which depict, among other things, a volcano and a prostrate man, recall works by Siqueiros, such as the muralist's *Fuego* (*Fire*, 1939) and *Tormento a Cuauhtémoc* (*Cuauhtémoc's Torment*, 1950). Other drawings by Ponce de León allude to specific works by Siqueiros in order to highlight social concerns. For example, a fist tied with a rope and an image of a group of children surrounding a tiny female figure—evocative of Siqueiros's *Madre campesina* (*Peasant Mother*, 1931)—can be interpreted in relation to Ponce de León's concepts of restriction and concentration, which are evident in the constraint placed on the hand and the disparity in scale between the miniscule female figure of indigenous appearance and the children around her.

The collective Tercerunquinto, comprised of Julio Castro, Gabriel Cázares, and Rolando Flores, engaged provocatively with the legacy of muralism in a project presented at SAPS in 2011. *Restauración de una pintura mural* (*Restoration of a Mural Painting*) involved the restoration of a hand-painted political advertisement in the rural community of San Andrés Cacaluapan, Puebla. Occupying the entire façade of a small house, the advertisement had mural proportions, and it was originally painted circa 1999 in advance of the federal election of 2000. Proceeding as if this political propaganda created by an unknown worker was

like a mural painted by one of Los Tres Grandes, Tercerunquinto worked with a team of conservators in order to completely restore its original appearance, over one decade after it was produced. The ad was for the presidential campaign of Francisco Labastida, who became the first candidate from the PRI party to lose a federal election in the history of the Mexican state since the late 1930s, when it was anointed as the official party. The restored image was in contrast with the conditions of 2011, one year before a federal election in which the candidate of the Institutional Revolutionary Party (Partido Revolucionario Institucional, PRI), Enrique Peña Nieto, was the expected winner. In an exercise of recovered memory, Tercerunquinto sought to insert a past moment of questioning and rejection of the PRI into the national and even international media's intense campaign of image reconstruction and the considerable enthusiasm for a "new" PRI.

Artist Diego Berruecos has devoted considerable attention to the history of the PRI. His series Genealogía de un partido (Genealogy of a Party, 2007– ongoing) investigates the party's institutional forms, the ways it has sought to monumentalize and memorialize its existence, and the quotidian life of the party through more than 70 years of rule. His mural-sized work e.l.m. (2010) is composed of 642 condolence notices printed in the newspapers one day after the death of the first wife of Peña Nieto—Mónica Pretelini. At the time Governor of the State of Mexico, Peña Nieto was widely known to be the PRI candidate for the next elections and, likely, the new head of state. These notes—lamenting the death of Pretelini and offering sympathy to Peña Nieto—were sponsored by municipal, state, and national authorities; workers' unions; private corporations; media conglomerates; and innumerable other institutions. The incredible number of notices was unprecedented in the printed press, and the size of each projected the economic power of those who sponsored it. For example, a large media conglomerate placed a notice of two full pages, while one of the smallest was paid for by a union of rural workers and other impoverished organizations. By collecting these condolence notes and pasting them to the wall in a sort of mural, Berruecos's work gave scale and visibility to the powerful and pervasive cronyism that distinguishes Mexican political culture and that runs through all sectors of society.

In 2010, the Bank of Mexico issued a new 500 peso note that prominently features an image of Diego Rivera, taken from his painting Autorretrato dedicado a Irene Rich (Self-Portrait Dedicated to Irene Rich, 1941). This note is at the center of Daniel Aguilar Ruvalcaba's project Nuevo muralismo mexicano (New Mexican Muralism, 2014). For this ephemeral work, the artist hired a commercial sign painter to make an exact copy of the note, in its actual size and color, on a white wall of mural proportions. The artist paid 500 pesos for this task, that is, the exact value of the note. Because currency devaluation is experienced each time this work is commissioned, the project presents a critique of economy. Aguilar Ruvalcaba moves muralism from concerns once aligned with Socialist Realism into the terrain of what could be referred to as Capitalist Realism. He also highlights the degree of institutionalization of the historical avant-garde of muralism in Mexico, by pointing out an insurmountable contradiction: When muralists or their works are featured on money—something that, undoubtedly, would have

Tercerunquinto (Julio Castro, Gabriel Cázares, and Rolando Flores), *Restauración de una pintura mural* (*Restoration of a Mural Painting*), 2010. Photograph of one of the artists working on the mural. Sala de Arte Público Siqueiros, Mexico City

(right) Tercerunquinto (Julio Castro, Gabriel Cázares, and Rolando Flores), *Restauración de una pintura mural* (*Restoration of a Mural Painting*), 2010. Acrylic paint on wall, dimensions variable. San Andrés Cacaluapan, Puebla, Mexico

Daniel Aguilar Ruvalcaba, *Nuevo Muralismo Mexicano* (*New Mexican Muralism*), 2014. Acrylic paint on wall, 2½ × 6⅛ in. (6.6 × 15.5 cm). SOMA, Mexico City

been inconceivable for most of them—it devalues the image of muralism, which becomes an institution, spectacle, merchandise, or official art.

Even if images of murals are found on bank notes or sold as souvenirs today, the legacy of muralism as an avant-garde practice nevertheless resists the sort of reification that has oversimplified its history and its contributions since the beginning of the 1950s, not only in Mexico but also internationally. The examples discussed in this essay share with their predecessors the use of the wall as surface and support of the works. In this way, they revisit the medium of the mural. At the same time, they also can be addressed in regards to the avant-garde legacy of muralism. The contemporary works can be reflexive, commenting upon and revising the institutional history of muralism, or they may analyze the works and ideas of its practitioners. Also, they can engage critically with problematic political and economic situations or scenarios that are not, necessarily, limited to local circumstances. In this way, contemporary artists can comment on the severe corruption that defines the Mexican state as well as on several effects of global neoliberal economic policies. More than adhering straightforwardly to the legacy and history of muralism, these contemporary practitioners actualize the critical vocation that characterized this historical avant-garde.[8]

1. The literature on muralism is vast. Some succinct and insightful accounts of its history can be found in the following: Mary K. Coffey, *How a Revolutionary Art Became Official Culture: Murals, Museums, and the Mexican State* (Durham, NC: Duke University Press, 2012), 1–24; James Oles, *Art and Architecture in Mexico* (London: Thames & Hudson, 2013), 234–325; and Shifra Goldman, *Contemporary Mexican Painting in a Time of Change* (Albuquerque, NM: University of New Mexico Press, 1981), 1–26. Most accounts of the history of muralism conclude with the construction of the new campus of the National Autonomous University of Mexico (UNAM) in 1953. These analyses examine the changes to the mural movement's political intentions during the 1930s and 1940s, determined in great part by local and international circumstances. The university campus represents an apex in the history of muralism, particularly under the model of what is termed the Mexican School of Painting. In a great number of historical accounts, this narrative of emergence, "heroic" period, and peak revolves around the figures of Los Tres Grandes—Diego Rivera, José Clemente Orozco, and David Alfaro Siqueiros. Worth noting are postwar murals by Roberto Matta, Joseph Renau, and Taro Okamoto, which were developed outside of Mexico, in places such as the United States, the Federal Republic of Germany, and Japan.

2. With this I am implying that such works, like the projects of muralism, rely on the wall as support and surface.

3. Raquel Tibol, "Un taller para la investigación plástica," *Proceso* (August 1977). See http://www.espejel.com.

4. Ida Rodríguez Prampolini, "¿Arte o justica? El Taller de Investigación Plástica de Morelia," *PLURAL, Revista Cultural de Excélsior*, second edition, vol. IX–V, no. 1017 (February 1980).

5. Eduardo Abaroa, "Los dos Méxicos," *Circuitos de flujo (Arte y política)* (Quito, Ecuador: Constructo, 2012), 136. With its emphasis on participation and community formation, the program of relational aesthetics recalls the strategies found in the production of collective murals like those executed by the TIP and the Zapatistas' initiatives. Abaroa's observation is timely, particularly given the impact of the EZLN on the formation, during the second half of the nineties, of a critical consciousness against neoliberal capitalism. This intellectual movement, which reached global proportions but began to lose momentum after 2001, was characterized by new and highly original Marxist revisions and proposals. In the field of political theory, the popularity of Antonio Negri's work is expressive of the 1990s' spirit of revolt. Political protests, such as the one that took place against the World Trade Organization's convening in Seattle, in 1999, and the global popularity of Naomi Klein's *No Logo* (2000) evidence how much public sentiment has changed since the beginning of the 1990s. In the field of art, the emergence and early enthusiasm for the participatory platform of relational aesthetics exemplifies this.

6. Willy Kautz, *Hay más rutas que las nuestras. Las colecciones de Tamayo después de la modernidad*, exhibition brochure (Mexico City: Museo Tamayo, 2013), xi.

7. See, for instance, Ana Langer, "En México, jóvenes ven futuro sin optimismo," *El Economista*, May 25, 2016, http://eleconomista.com.mx/sociedad/2013/08/22/mexico-jovenes-ven-futuro-sin-optimismo, and Paulina Monroy, "Jóvenes sin presente ni futuro en México," *La verdad del Sureste. Periodico de la sociedad civil*, May 25, 2016, http://www.la-verdad.com.mx/jovenes-sin-presente-ni-futuro-mexico-21750.html.

8. Mari Carmen Ramírez argues that muralism is a case of *ex-centric* historical avant-garde practice. See Mari Carmen Ramírez, "El clasicismo dinámico de Siqueiros. Paradojas de un modelo ex-céntrico de vanguardia," in Olivier Debroise, ed., *Otras rutas hacia Siqueiros* (Mexico City: Curare/National Institute of Fine Arts, 1996), 125–46.

José Clemente Orozco

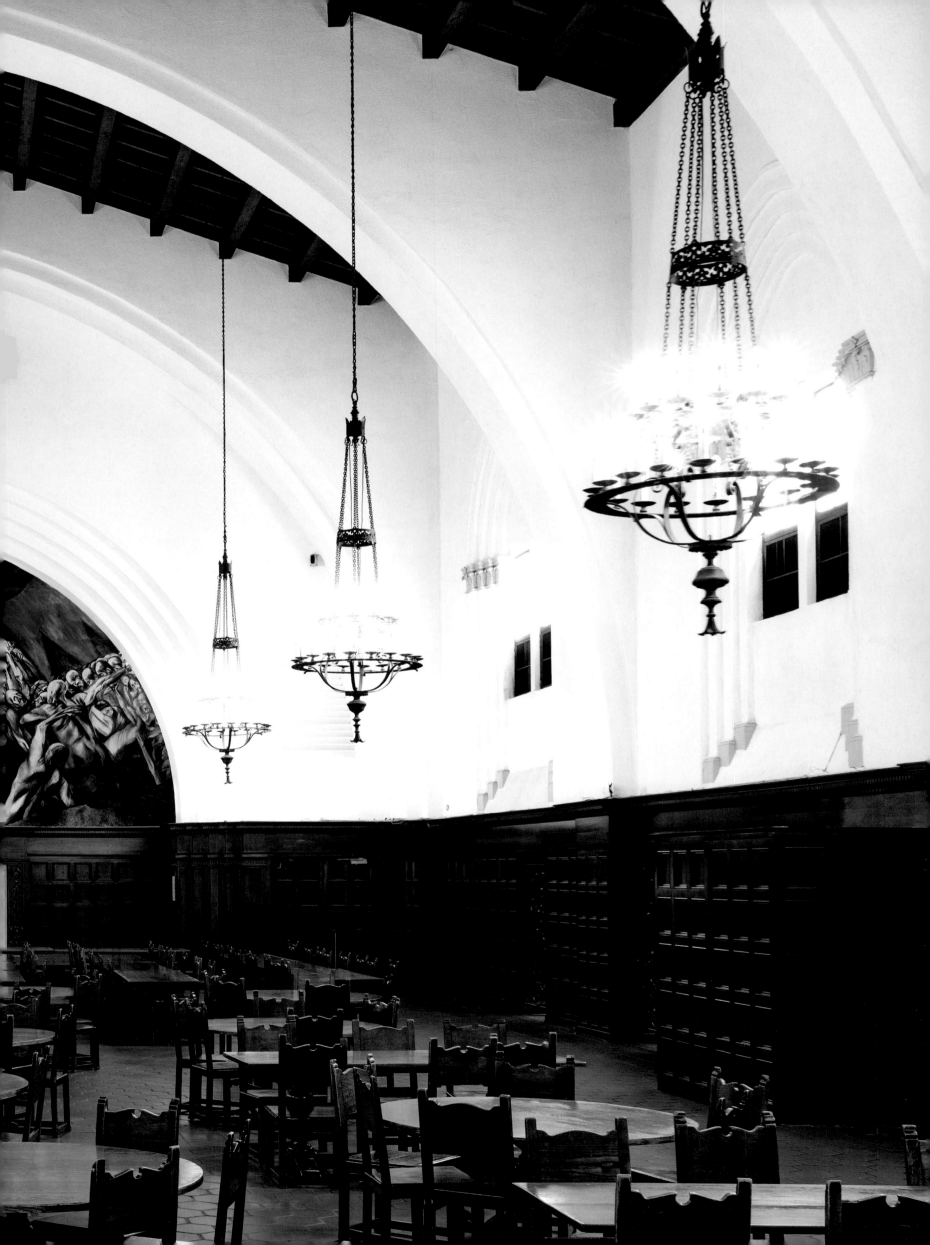

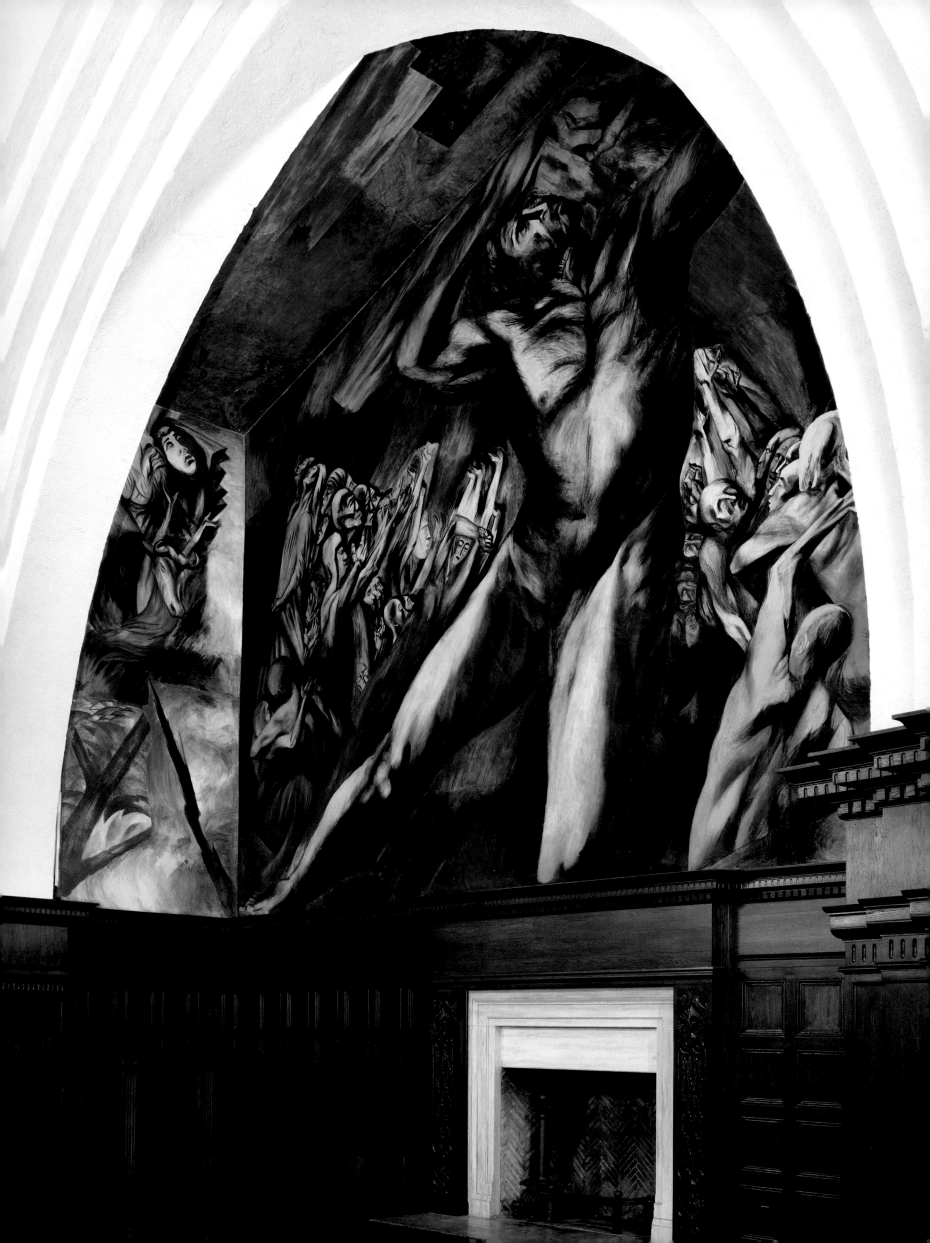

(pages 86–87) Interior of Frary Dining Hall and José Clemente Orozco's *Prometheus* mural (1930), 2016. Pomona College

(pages 88–107) José Clemente Orozco, *Prometheus*, 1930. Fresco, 240 in. × 342 in. (609.6 cm × 868.68 cm). Pomona College

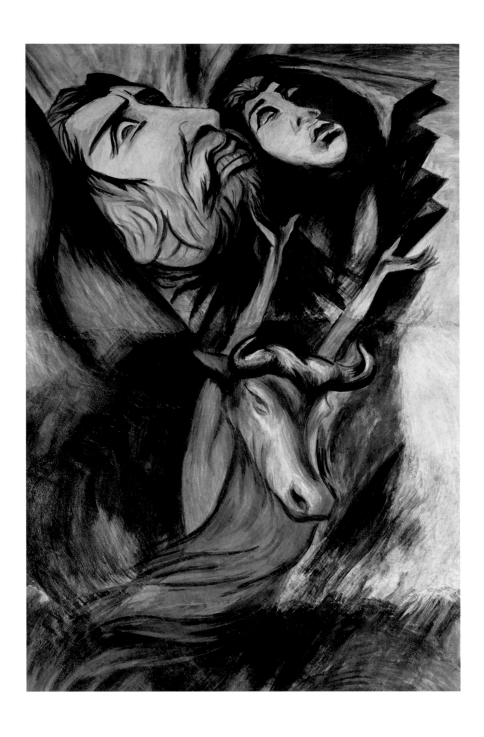

José Clemente Orozco

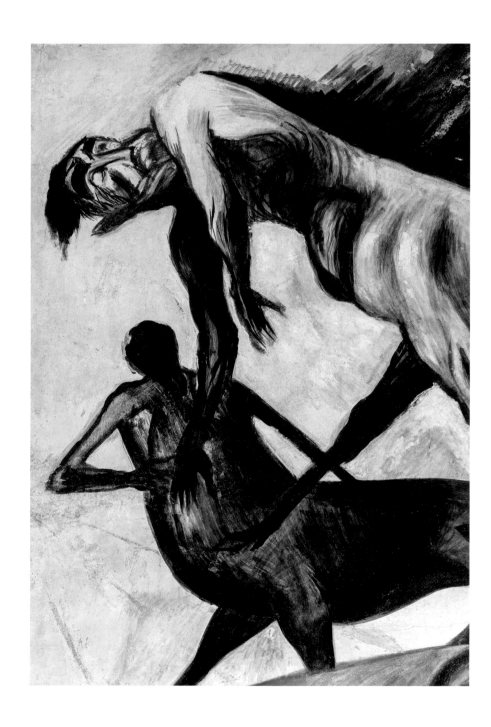

José Clemente Orozco

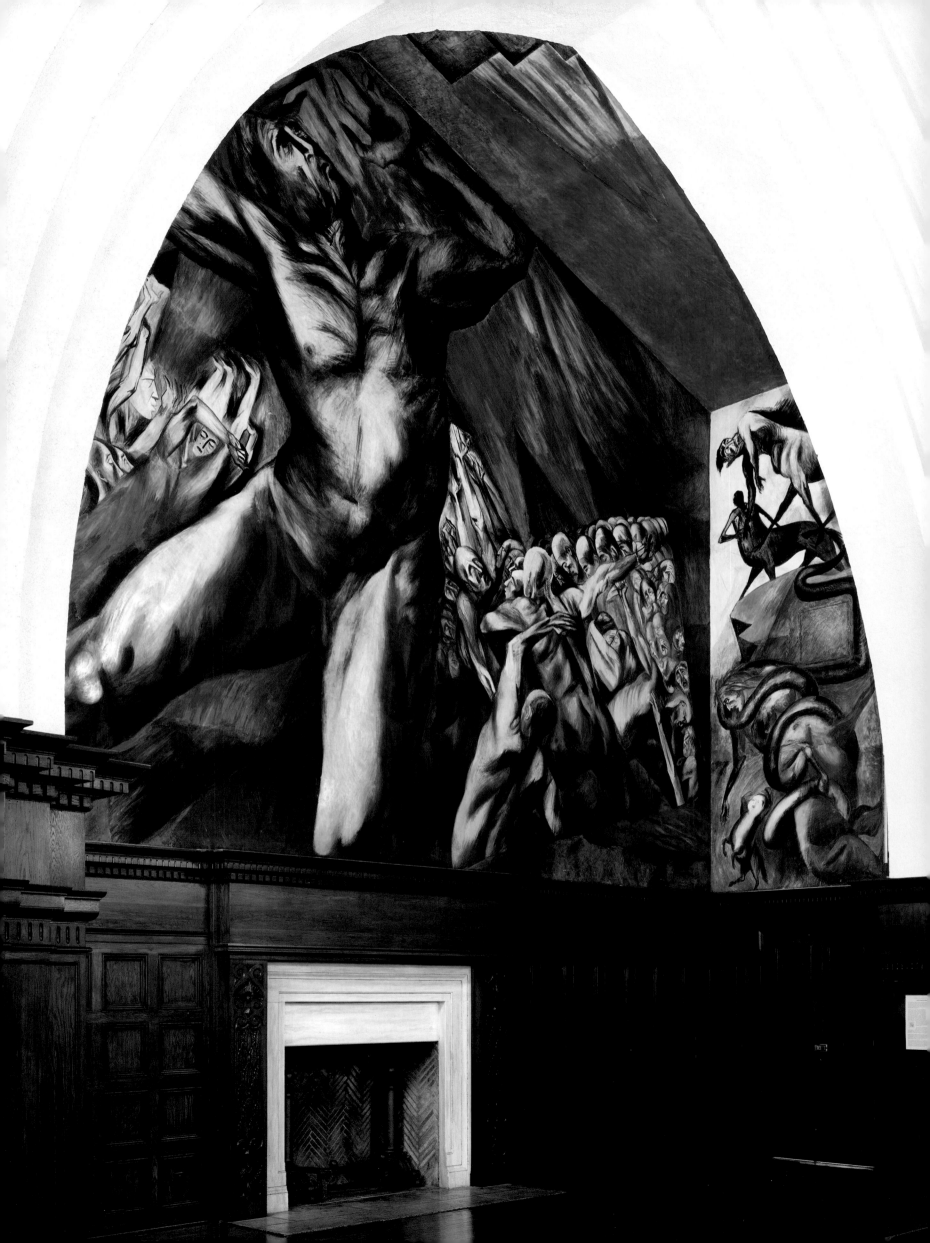

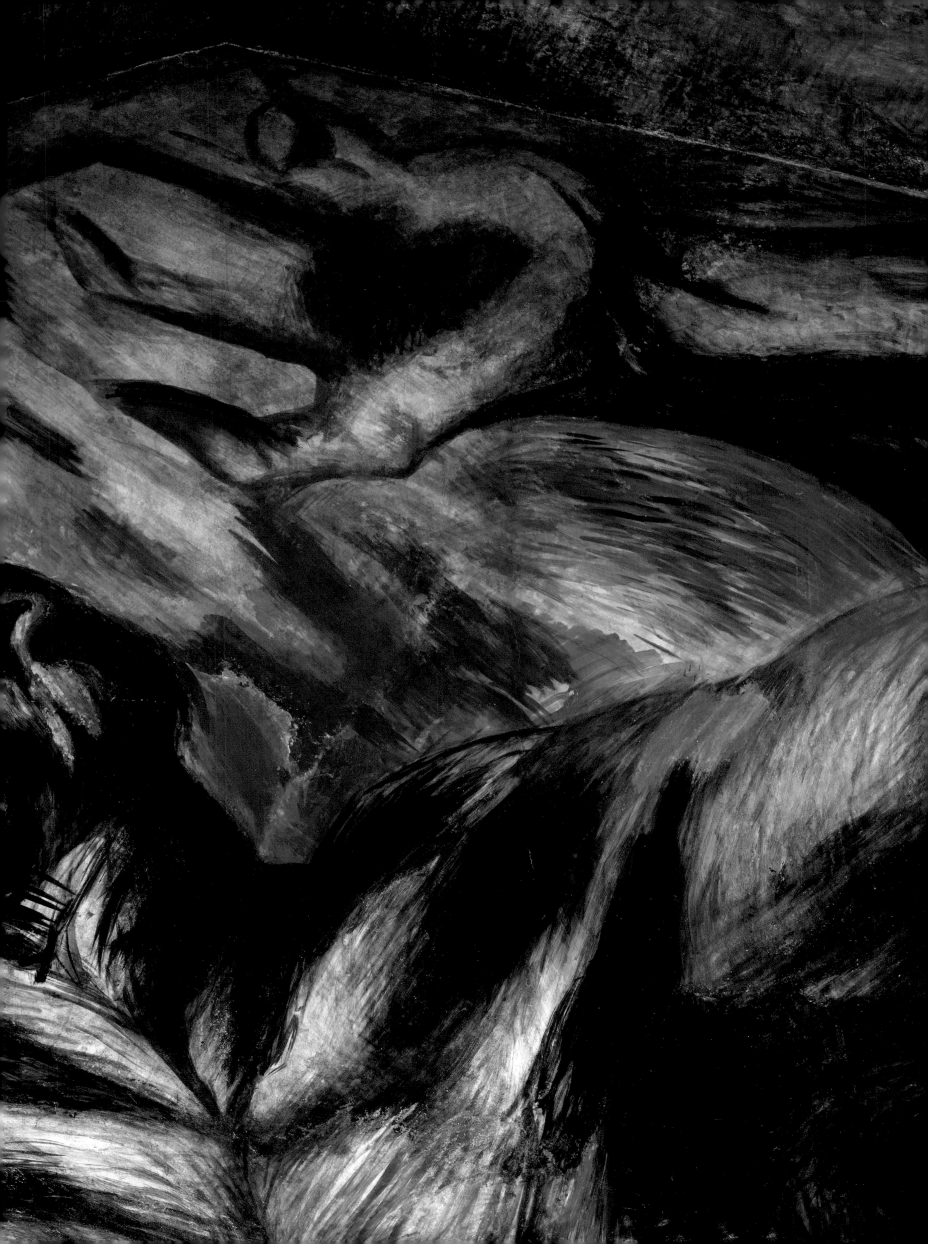

José Clemente Orozco

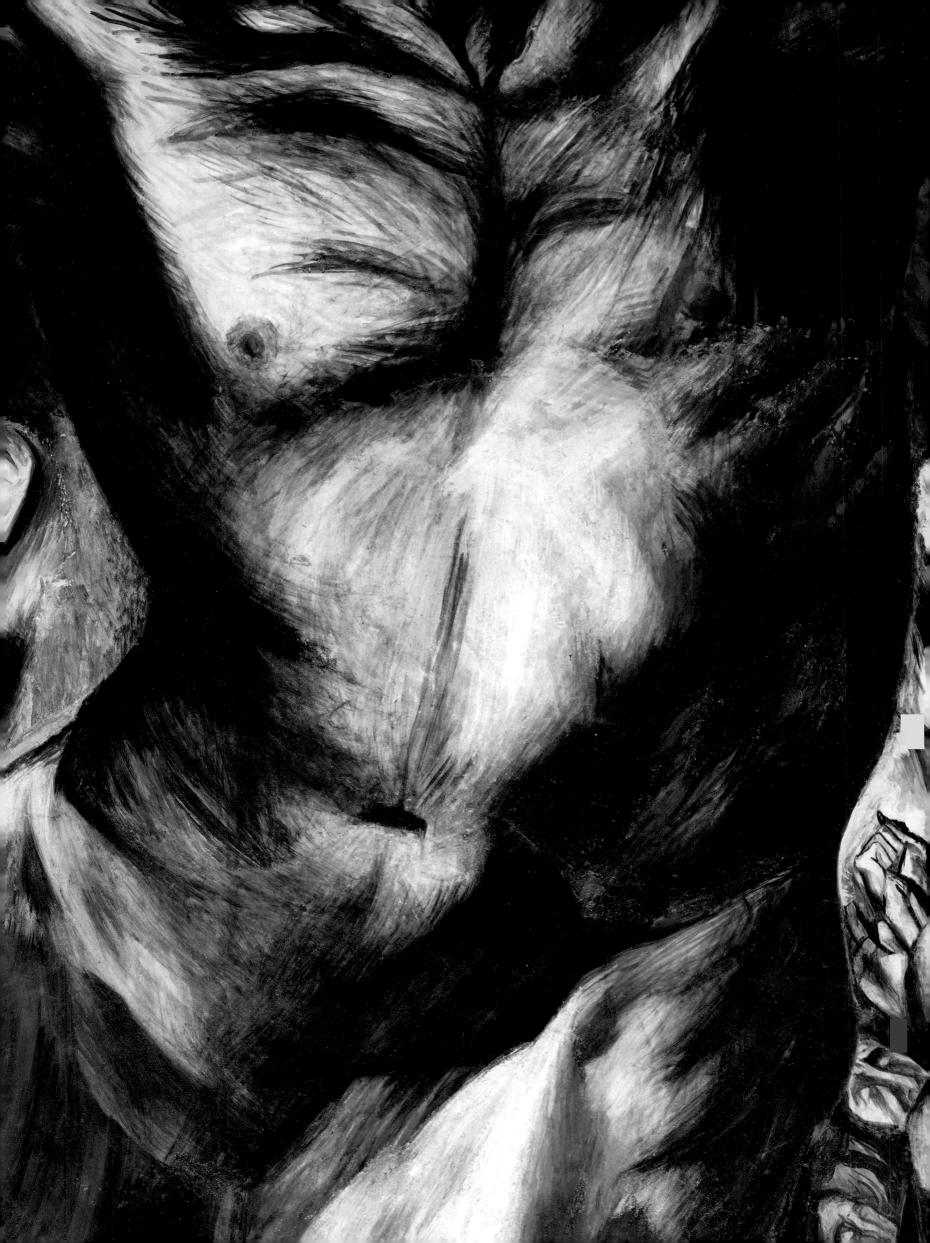

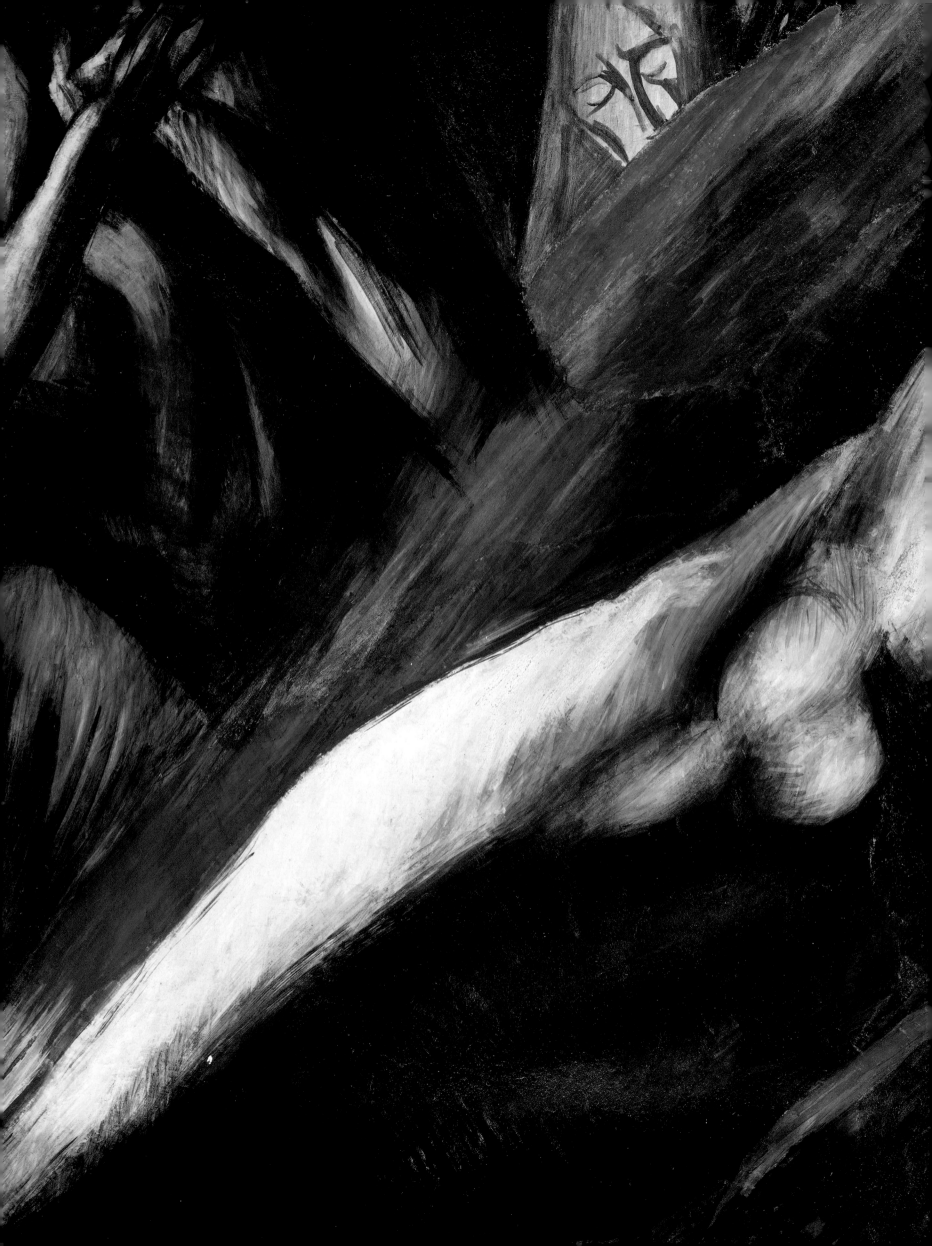

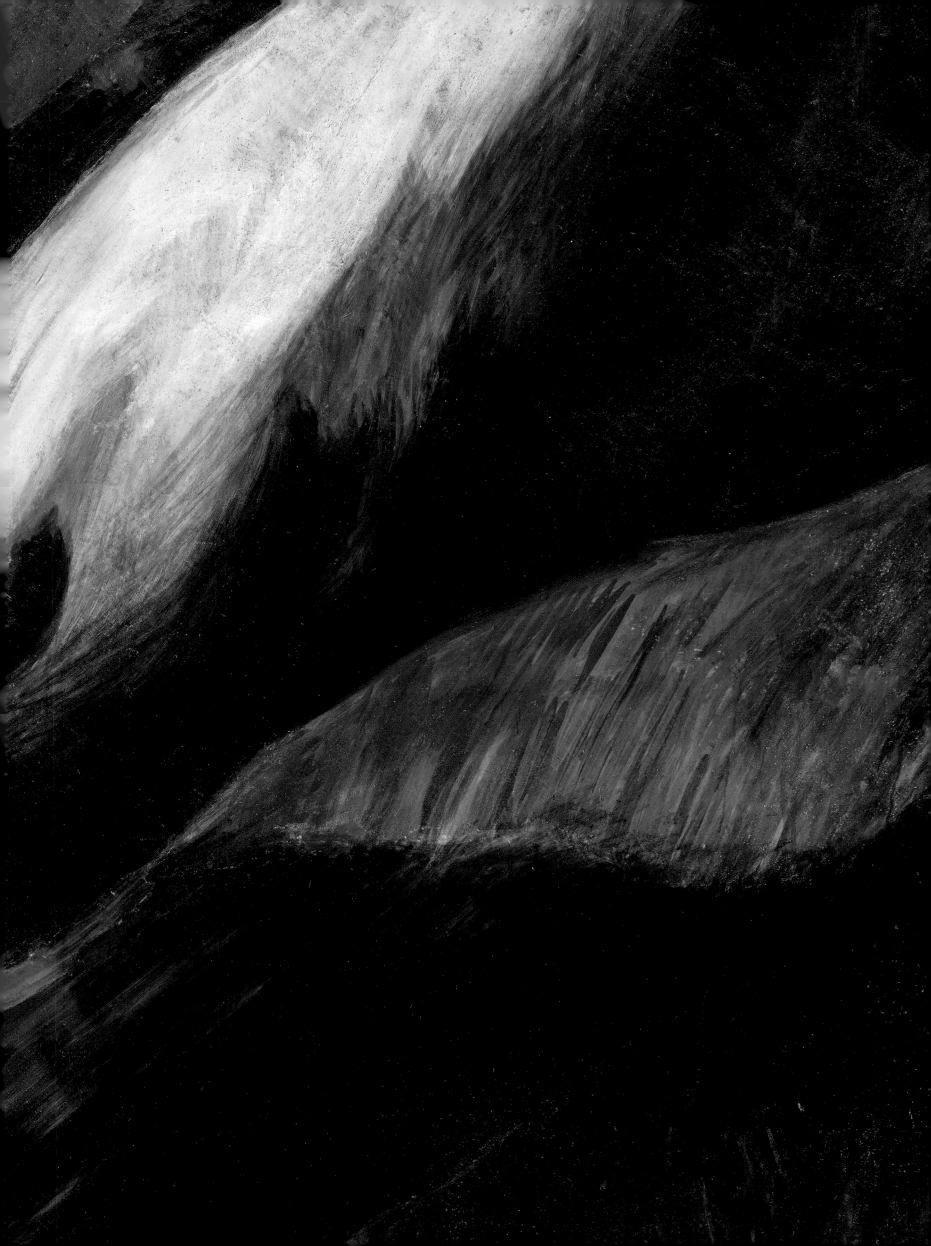

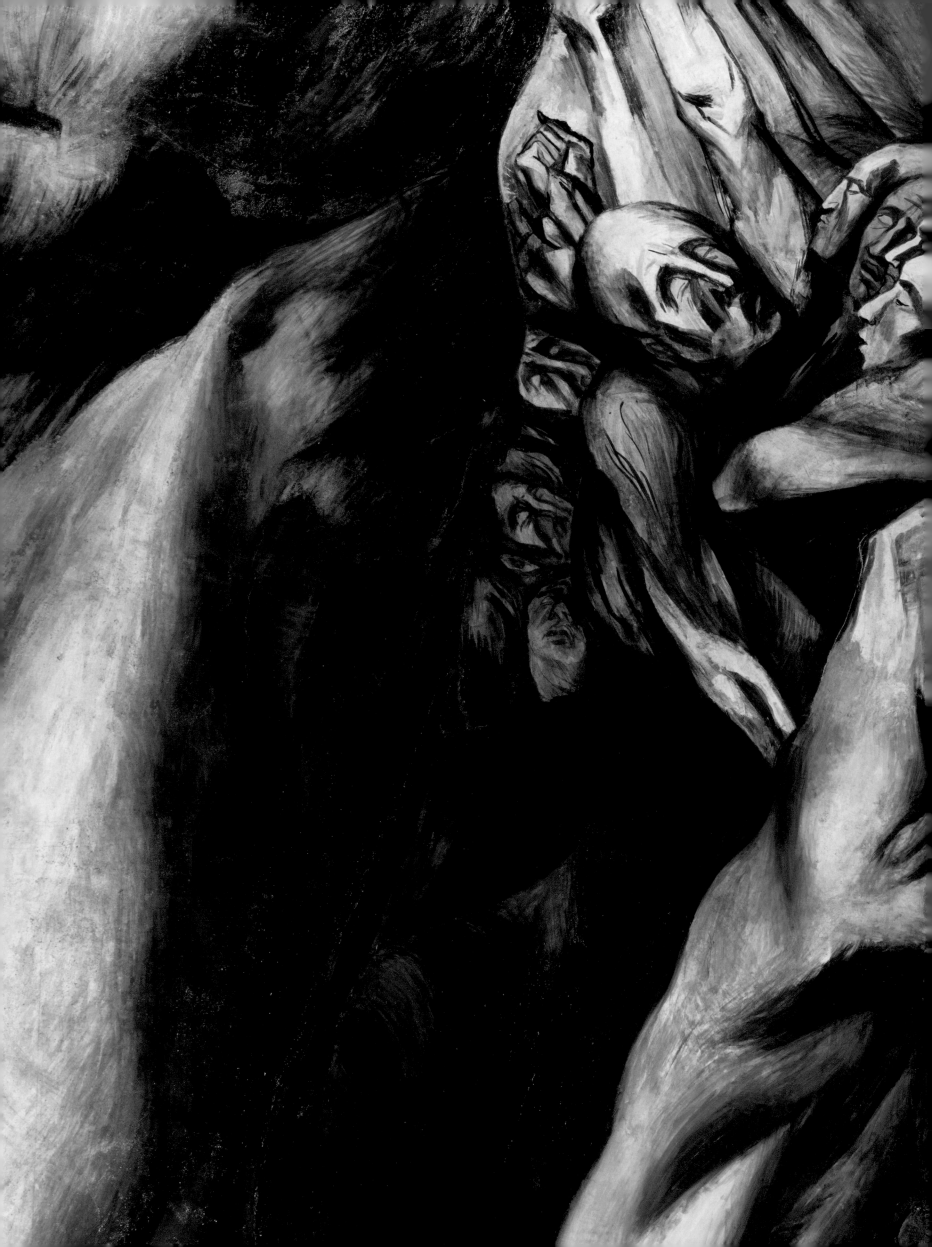

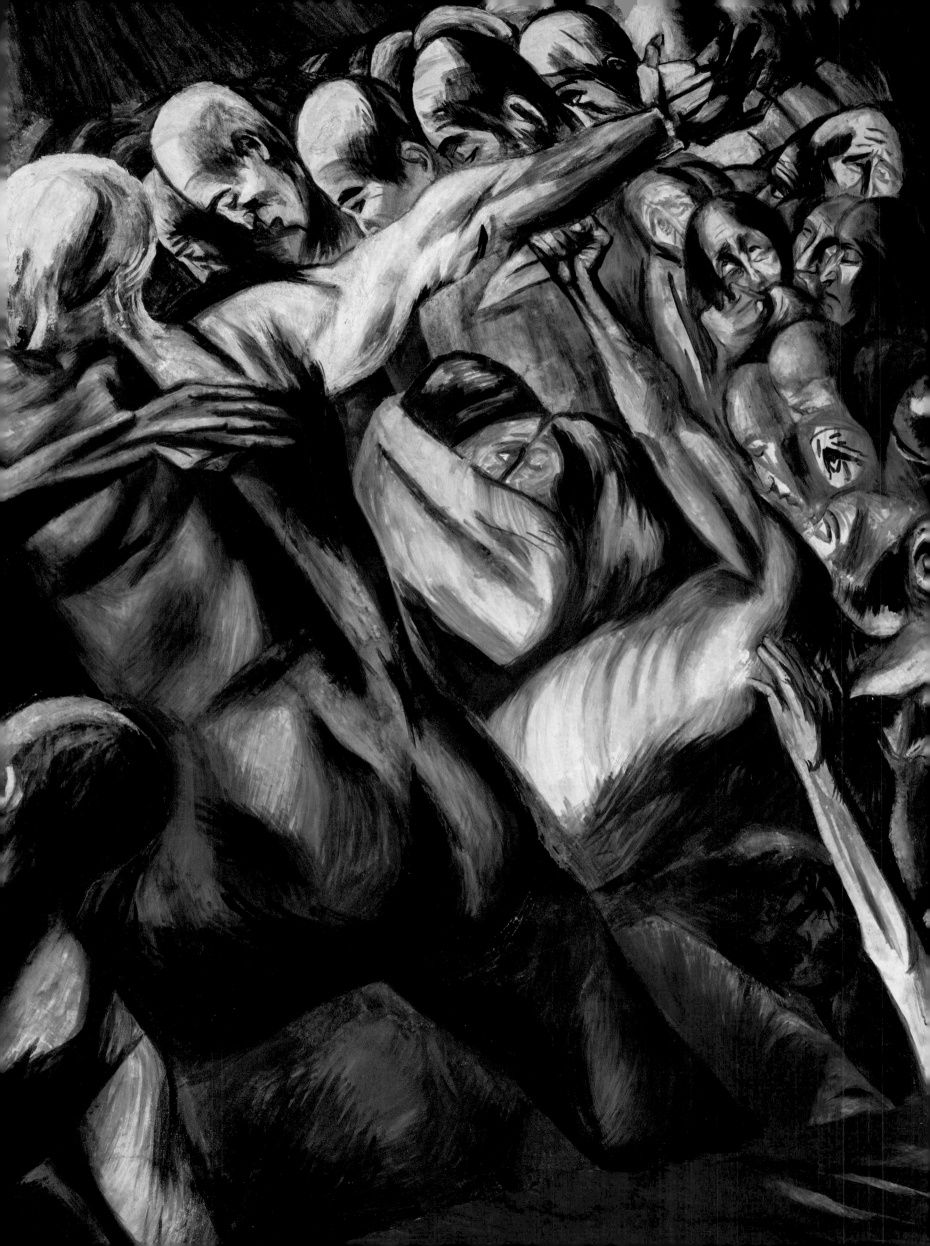

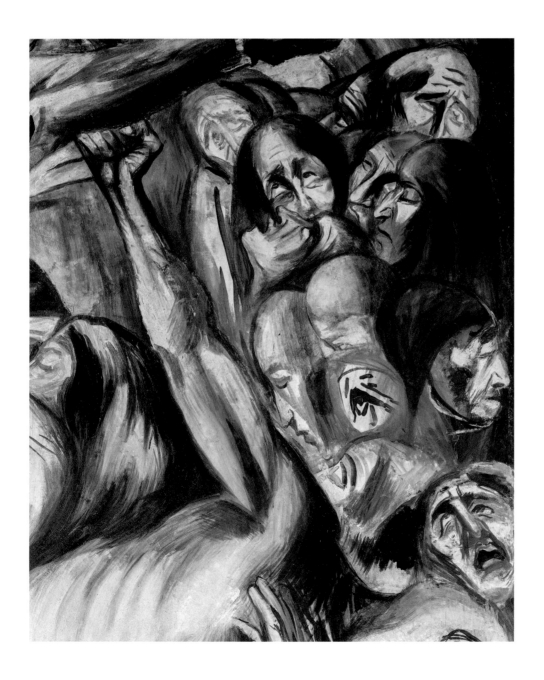

José Clemente Orozco

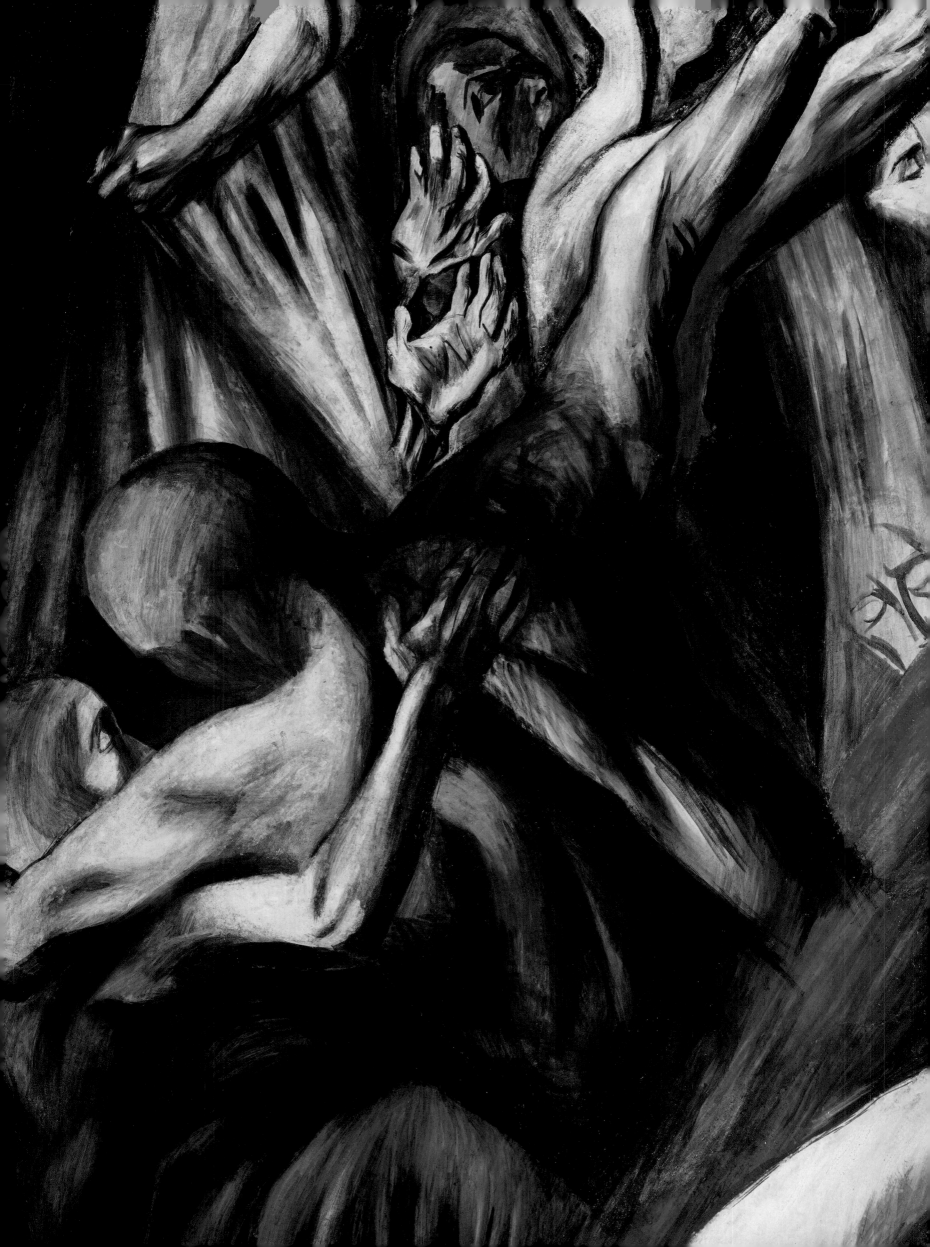

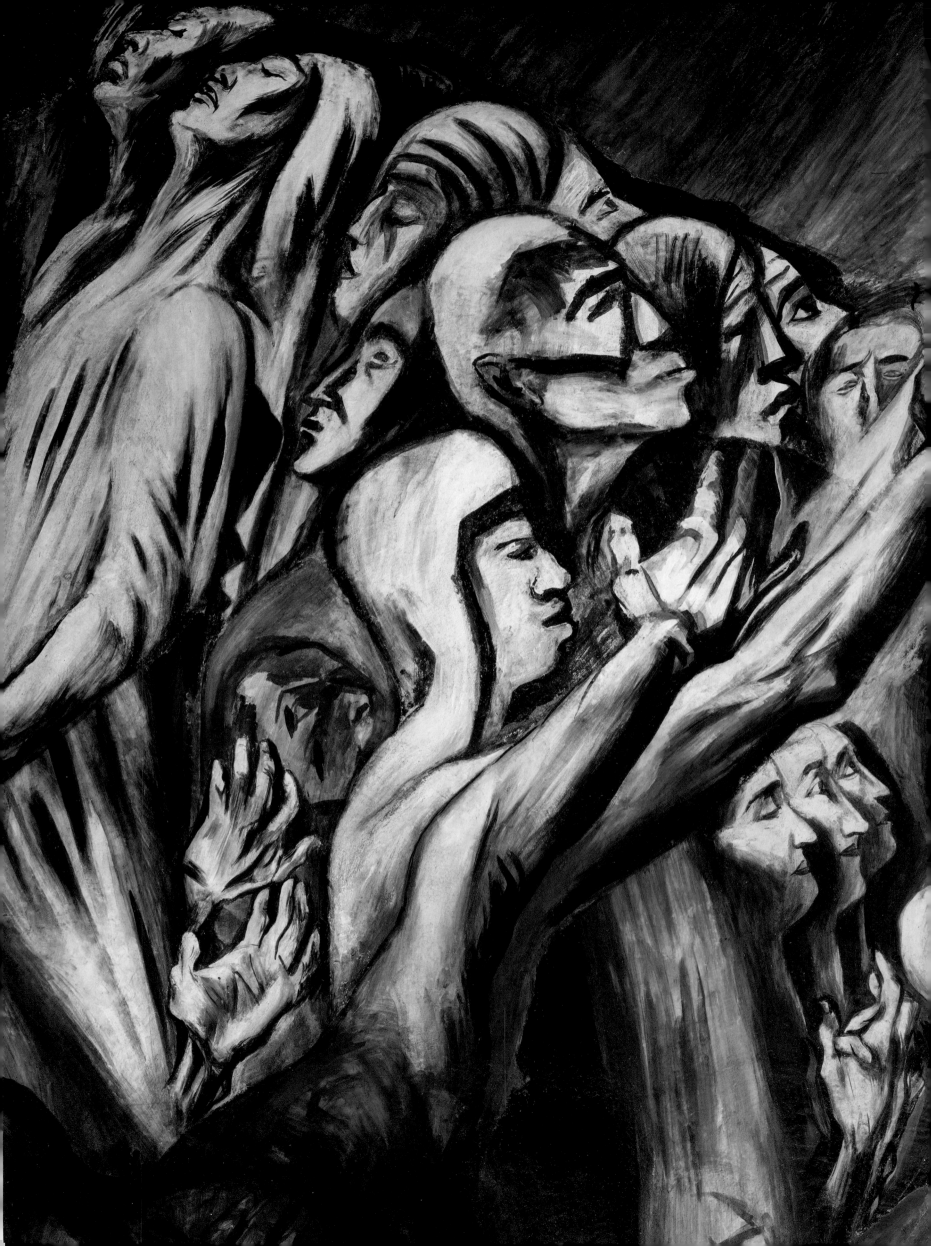

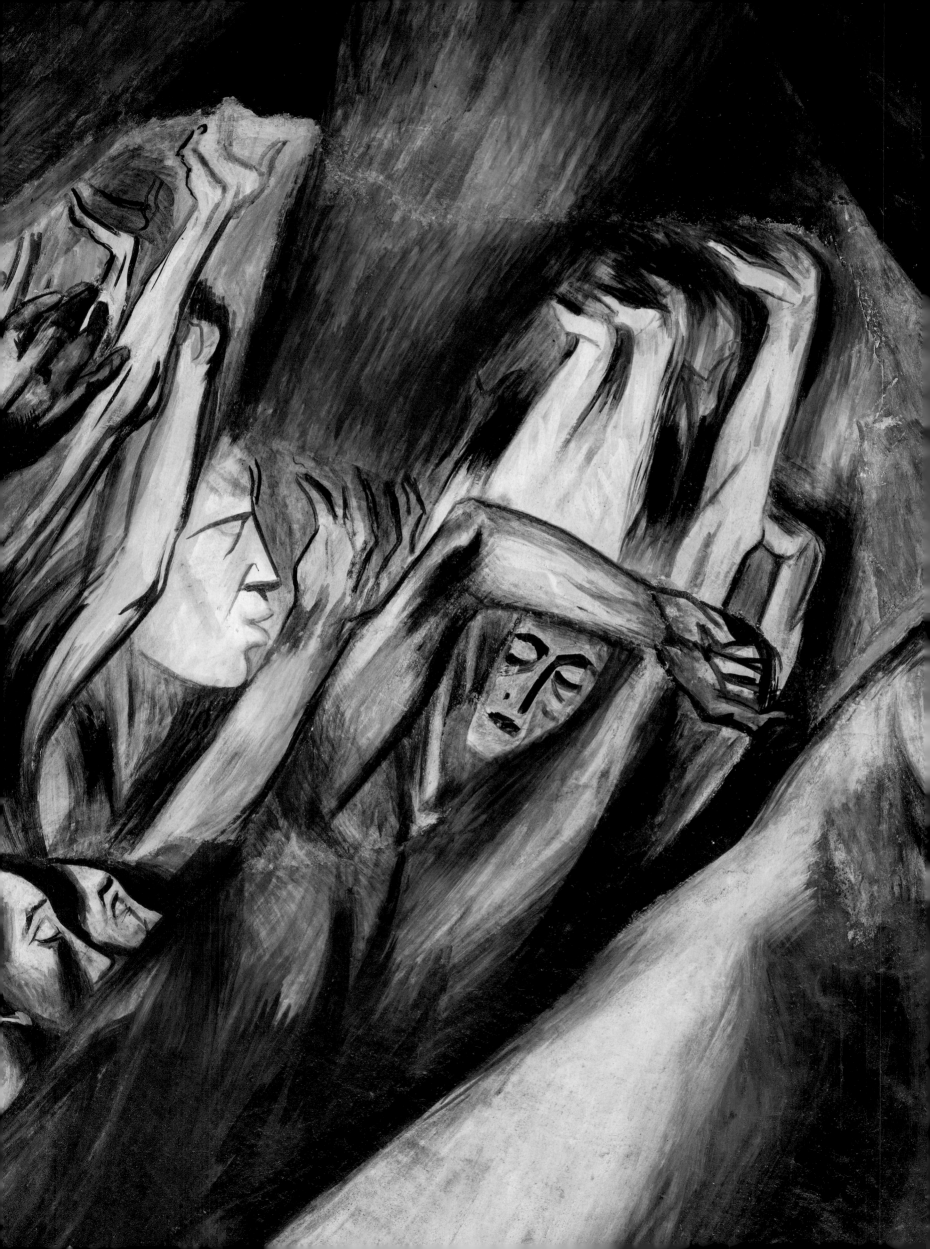

José Clemente Orozco

José Clemente Orozco

Isa
Carrillo

To Grasp, But Not Possess: Isa Carrillo's "Left Hand"

Mary K. Coffey

> Ideas are to objects as
> constellations are to stars.
> —Walter Benjamin[1]

> We are stardust
> Billion year old carbon
> We are golden
> Caught in the devil's bargain
> And we've got to get ourselves
> Back to the garden.
> —Joni Mitchell[2]

In Isa Carrillo's *Constelación naciente* (*Rising Constellation*, 2015), we face three identical images of the night sky. In one, we see a field of stars. In the next, some of these stars are conjoined in a constellation in the form of an outlined hand. In the final image, the constellation has been enhanced with contour lines that give it an illusory sense of dimension. Despite the effects of drawn illusion, its ephemeral presence threatens at any moment to dissolve back into a field of disparate points of light. In this series of drawings, Carrillo presents us with the "ghost" of José Clemente Orozco's left hand, an appendage that was blown up in an accident with explosives when the artist was a young man.

Orozco's accident left him physically deformed. It definitively put an end to his family's aspirations for him to become an agricultural engineer, thus allowing him to pursue painting professionally. This accident was, therefore, both fortuitous and traumatic, encouraging some to see Orozco's career-long interest in the generative and destructive power of fire as biographical in origin.[3] In his *Prometheus* mural, for example, we see the Titan striving toward what is presumably the flame he stole from the gods. This theft comprises his gift to mankind, a liberating act for which he was brutally

punished. Formally, Prometheus's hands seem to disintegrate in the blaze, suggesting that there is a great price to be paid for the audacity of god-like ambition. If, in fact, Prometheus is an allegory of the modern artist, then Orozco presents us with a series of tensions: between creativity and destruction, between liberation and bondage, and between earth-bound matter and the immateriality of the divine.

Carrillo too presents us with a series of unresolved tensions. Her idiom is more conceptual and relational than Orozco's expressionist bombast. She graduated from the University of Guadalajara with a degree in visual arts in 2005. Like Orozco, her practice is deeply engaged with mysticism. But in her case, she has dedicated six years to the study of chirology, the ancient practice of reading hands, popularly understood as "palm reading," a form of fortune telling. This selection of objects derives from her installation "Mano izquierda" ("Left Hand," 2015), which was first exhibited at the Museo Taller José Clemente Orozco, in 2015. Part of Carrillo's process for producing the works for this installation included the use of chirology to analyze photographs of Orozco's existing hand in an attempt to glimpse the artist's personality.

Carrillo's recourse to esoteric divining practices—such as chirology, astrology, and graphology—calls into question the legacy of the Enlightenment. Like Orozco, she employs an aesthetic of the fragment to activate her project. Orozco deploys this aesthetic through his critical engagement with the idealizing form and cultural ascription of the academic nude. Carrillo, alternatively, exploits the fragment by exploring the disenchanted world of scientific reason and its techniques of reproduction. In Orozco's *Prometheus*, the locus of these tensions is the torqued body of the Titan. In Carrillo's installation, it is the constellation. *Constelación naciente* might be read, therefore, as an allegorical image that encourages contemplation of the fragment's relation to the whole, the individual's connection to the universe, the relationship between esoteric knowledge and science, and the materialization of the immaterial. In a fable-like account of the hand's life that Carrillo penned for her installation, she describes that, upon its liberation from the artist's body, Orozco's left hand rematerialized in outer space as a constellation.

(pages 112–15) *Constelación naciente* (*Rising Constellation*), 2015. Wood, paint, and colored pencil, installation: dimensions variable; three drawings: 23⅝ × 23⅝ in. (60 × 60 cm) each

German philosopher Walter Benjamin seized upon the constellation as a key metaphor in his attempts to theorize the role of allegory in a fallen world and the power of constructivist montage to create new material arrangements out of the fragments that result from the destruction of the bourgeois *scheinwelt* (world of illusions). Arguing, "Ideas are to objects as constellations are to stars," Benjamin suggested that the montaged fragments of the destroyed *scheinwelt* disclose an idea that is at once comprised of these disparate parts while also pointing to a "higher unity that is implicit within them but cannot be 'grasped' or possessed as an object itself."[4] In this sense the constellation conjures a figure without reconstituting the illusion of presence, completeness, or an illusory whole.

Max Pensky elaborates Benjamin's metaphor, noting that constellations are at once a vestige of myths and tools of navigational science. In their duality, he argues, constellations both retain and negate myth. In this sense, the constellation is an apt concept for Carrillo's installation. For she subjects the datum of Orozco's life and person—his birthdate, his private correspondence, the contours of his hand—to the analytic systems of ancient divining practices that are simultaneously employed and refuted by modern forensic science. Her objects have the appearance of lab specimens, astronomical photographs, and archival documentation. Yet the person they attempt to bring into focus is nowhere to be found. Instead, each object represents a symbolic rendering of information about Orozco that Carrillo gleaned through in-depth readings of his astrological charts, his handwritten letters to his wife Margarita Valladares, or his grandson's hands.[5]

Thus, the concentration of gunpowder contained in the test tubes in *Error de cálculo (polvos cósmicos)* (*Miscalculation [Cosmic Dust]*, 2015) approximates the proportion necessary to achieve the blast that destroyed the artist's hand. But it also relates to the relationship between fire and earth signs in astrology, and the fact that these predominated on both Orozco's birthday and the date of his accident. Likewise, the lunar eclipse in *Mensajes ocultos* (*Hidden Messages*, 2015) recalls the fact that Orozco's residency in Claremont coincided with one of these events. Carrillo also notes that Orozco's moon was in Virgo, which, according to astrologists, gave him a tendency to analyze and control rather than to follow his emotions.

Through this esoteric science, Carrillo creates what she calls an "invisible sculpture," not only of Orozco's missing left hand, but also of the artist's "sensibility and personality."[6] The disparate objects in her installation collectively comprise a montage of fragments drawn from the detritus of modern life that retain their status as discreet phenomena while also pointing toward an ungraspable entity: the artist. The mythic idea of the artist that this object-constellation discloses is no more or less manifest than the lunar eclipse rendered in a linocut or the stars envisioned through Stellarium (a free software program that generates images of the sky in the past from a specific location on earth) or the particle explosions captured in photographs from an old physics textbook. In each instance, material techniques of representation index an immaterial reality that can be grasped but not fully possessed by the object. Like the man of fire who disintegrates in the act of self-creation, Carrillo's Orozco is so much stardust "caught in the devil's bargain."

1. Walter Benjamin, *The Origins of German Tragic Drama*, trans. John Osborne (London: Verso, 1998), 34.

2. Jori Mitchell, "Woodstock," 1970, lyrics © Sony/ATV Music Publishing LLC.

3. David Scott, "Orozco's *Prometheus*: Summation, Transition, Innovation," in *José Clemente Orozco: Prometheus*, ed. Marjorie Harth (Claremont, CA: Pomona College Museum of Art, 2002), 15.

4. Max Pensky, *Melancholy Dialectics: Walter Benjamin and the Play of Mourning* (Amherst, MA: University of Massachusetts Press, 1993), 70.

5. Carrillo worked with graphologist Sandra Martínez Escobosa to analyze Orozco's handwriting and astrologer Iván Sierra to develop his astrology chart.

6. Isa Carrillo, personal correspondence with Rebecca McGrew, fall 2015.

Isa Carrillo

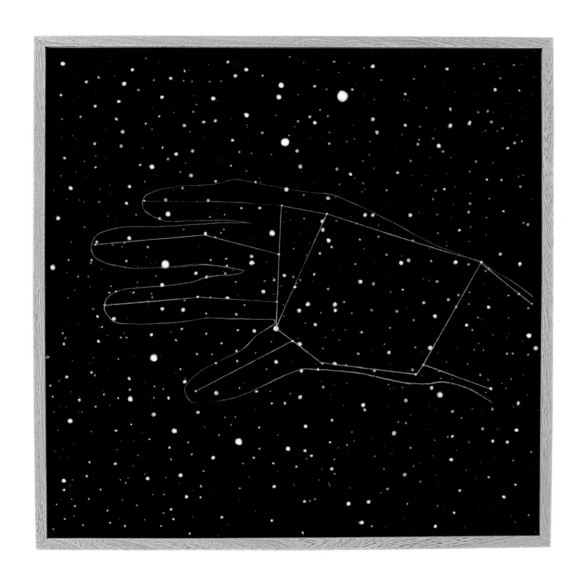

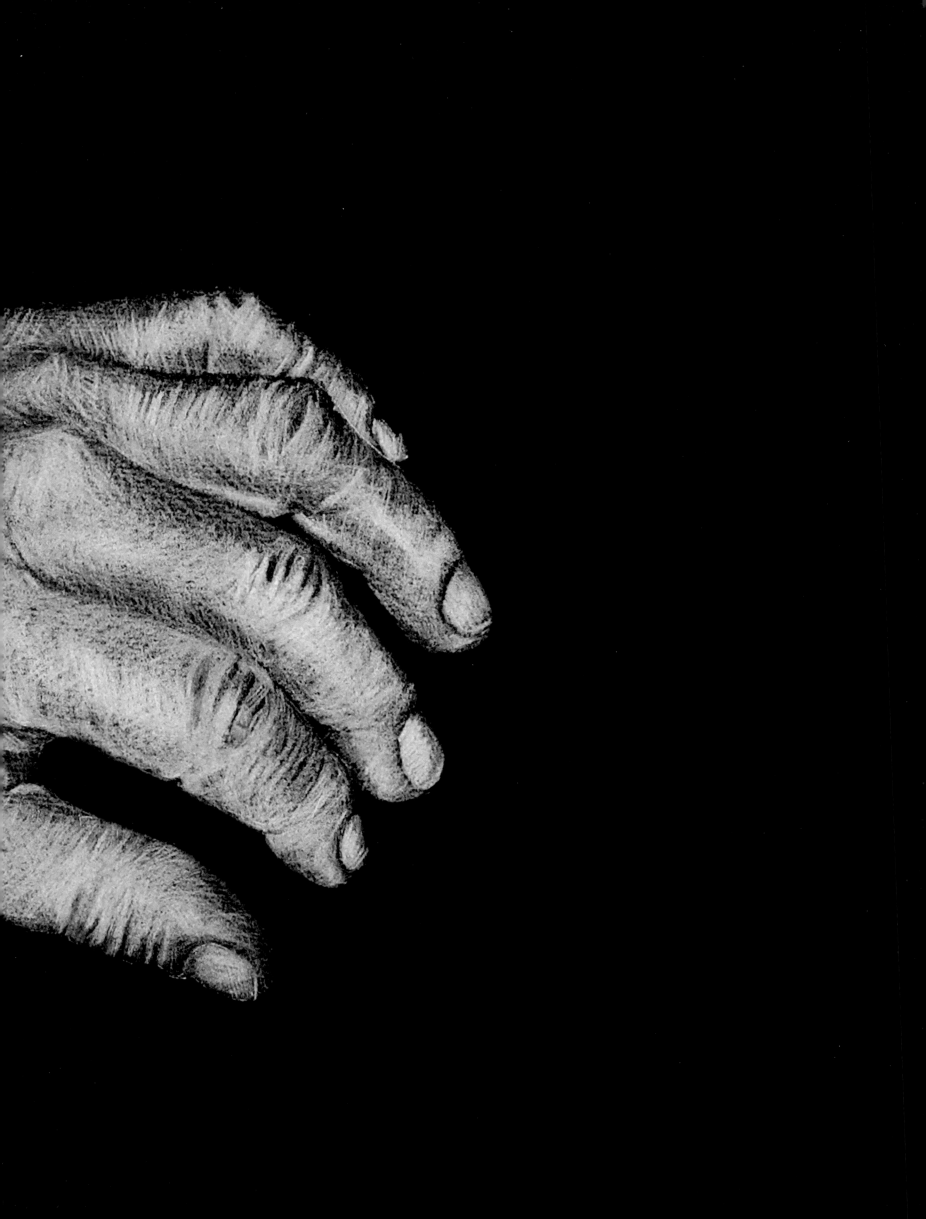

(pages 116–19) *Variaciones para una mano izquierda (Variations for a Left Hand)*, 2015. Five pencil drawings on paper, 19¹¹⁄₁₆ × 11¹³⁄₁₆ in. (50 × 30 cm) each

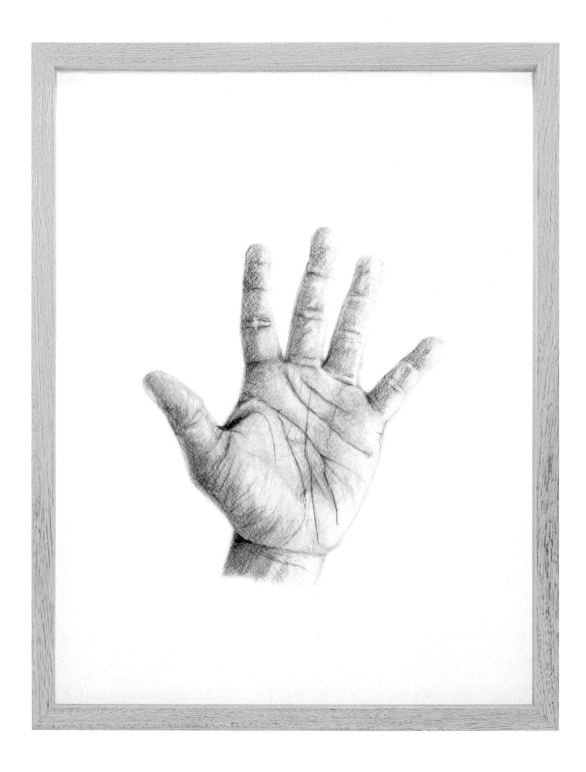

Isa Carrillo

Isa Carrillo

Isa Carrillo

(pages 122–25) *Eclipse*, 2015. Pencil, paper, page book, transparency, slide viewer, installation: dimensions variable; drawing: 11¹³⁄₁₆ × 9 in. (30 × 23 cm); slide viewer: 7¹⁄₁₆ × 3¹⁵⁄₁₆ × 7¹⁴⁄₁₆ in. (18 × 10 × 20 cm)

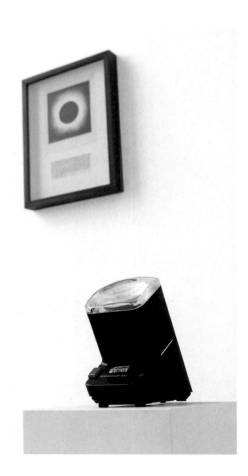

Isa Carrillo

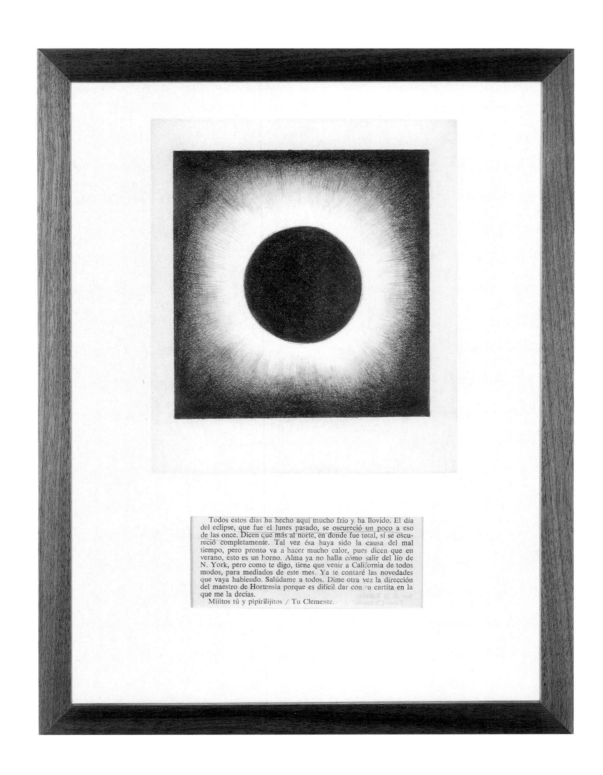

Todos estos días ha hecho aquí mucho frío y ha llovido. El día del eclipse, que fue el lunes pasado, se oscureció un poco a eso de las once. Dicen que más al norte, en donde fue total, sí se oscureció completamente. Tal vez ésa haya sido la causa del mal tiempo, pero pronto va a hacer mucho calor, pues dicen que en verano, esto es un horno. Alma ya no halla cómo salir del lío de N. York, pero como te digo, tiene que venir a California de todos modos, para mediados de este mes. Ya te contaré las novedades que vaya habiendo. Salúdame a todos. Dime otra vez la dirección del maestro de Hortensia porque es difícil dar con tu cartita en la que me la decías.
Miiitos tú y pipirilijitos / Tu Clemente.

Isa Carrillo

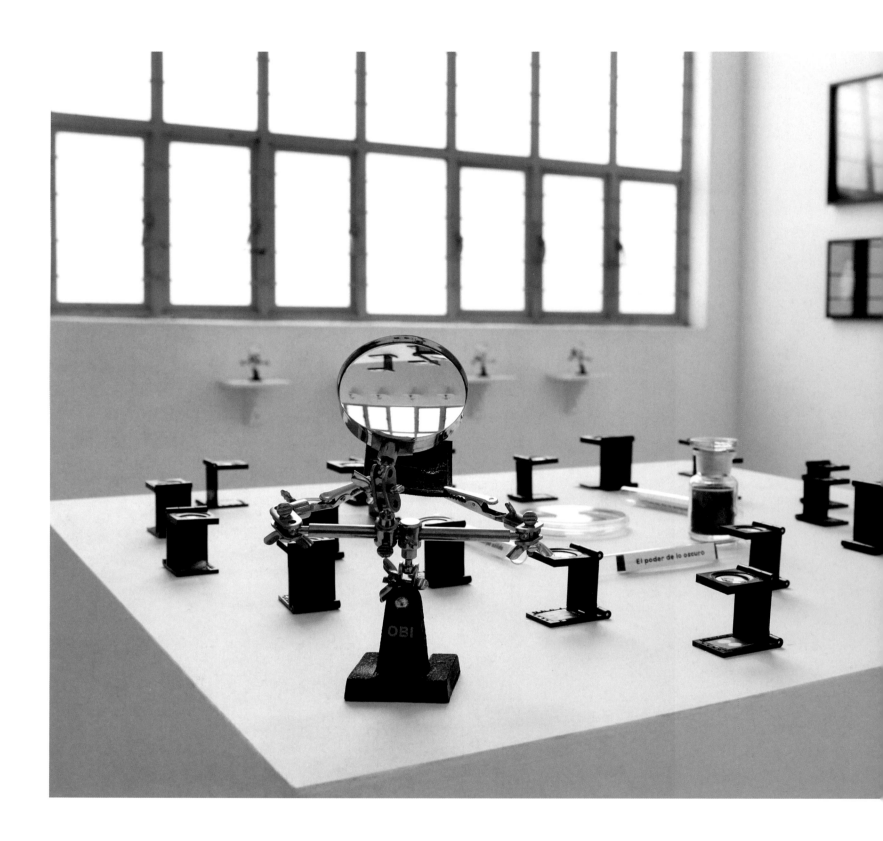

Isa Carri lo

Elegía microscópica (*Microscopic Elegy*), 2015. Magnifying glass, slides, test tubes, paper, and insects, dimensions variable

Isa Carrillo

Error de cálculo (polvos cósmicos)
(*Miscalculation [Cosmic Dust]*), 2015.
Test tubes, gunpowder, and wood,
4¾ × 5⅛ × 1³⁄₁₆ in. (12 × 13 × 3 cm)

Isa Carrillo

(pages 131–33) *Mensajes ocultos* (*Hidden Messages*), 2015. Four magnifying glasses and linoleum, 5⅞ × 3⅛ × 2 in. (15 × 8 × 5 cm) each

Isa Carrillo

Isa Carrillo

Isa Carrillo

Adela
Goldbard

Adela Goldbard:
Destroying to Remember

Rebecca McGrew

Starkly lit against an inky black sky, a rickety black four-door pickup truck slowly rolls into the center of the frame. A sudden explosion ignites the truck in a fiery blaze, rocketing shards of material through billowing clouds. As the smoke clears, flames illuminate the organic armature of the pickup, while lightning flashes in the distance. All of this happens in the span of a few minutes.

Adela Goldbard staged this bombing of a life-sized sculpture of a Ford Lobo pickup for her video *Lobo* (2013). The Ford Lobo (sold as the F-150 in the United States) is commonly used by Mexican drug cartels. In an essay on *Lobo*, critic Iván Ruiz observes that, over the last two decades, the best-selling Ford Lobo has become "stigmatized under the banner of drug trafficking." The truck came to "project an image of evil, where power, virility, eccentricity and cruelty intertwine."[1]

The artist built the truck using materials and methods drawn from traditional Mexican Judas-effigy burning practices and the *toritos* parades that take place during festivals in southern and central Mexico, including the annual National Pyrotechnic Festival in Tultepec.[2] Goldbard worked with Tultepec artisans to build her sculpture, using steel, wood, indigenous reeds, and papier-mâché, and engaged their expertise to destroy it with fireworks. She considers *Lobo* a "complex and multilayered symbol of social and political unrest and turbulence in Mexico" that critically examines how fiction and reality merge in art, language, and politics.[3]

Goldbard based *Lobo* on actual events portrayed in newspaper clippings, which she has been collecting for years. Her archive, which primarily consists of images of fires, explosions, accidents, attacks, and protests, presents a litany of state-sanctioned injustices. With this research, Goldbard investigates how the media twists language to hide the truth. She characterizes this manipulation as a form of violence. Although she starts with current events, she alters her subjects, using fiction as a critical tool to highlight the tragedy

and strangeness of charged political incidents. Goldbard's re-creations rupture reality, blurring and confounding the ordinary and the extraordinary, or the everyday and the horrific.

Goldbard trained as a photographer, and her contemporary artistic influences include German sculptor and photographer Thomas Demand and the Swiss conceptual artist duo Peter Fischli and David Weiss. She is inspired by their photographs and videos of hand-built sculptures and models. Goldbard was raised in Mexico with a deep investment in social justice, and the political and social engagement of muralists José Clemente Orozco, Diego Rivera, and David Alfaro Siqueiros, who critiqued current events and advocated for vernacular cultures through popular traditions, also resonate with her. In particular, Orozco's critical, violent, and often satirical imagery of the Mexican government's propaganda that glorifies the Revolution engages with themes that are central to Goldbard's work—injustice, violence, displacement, and destruction through fire.

Goldbard first linked social and cultural engagement and archival research in an earlier work, called *En el camino/On the Road* (2010), a photographic interpretation of Jack Kerouac's 1951 book *On the Road*. Kerouac's fictionalization of a trip he and his fellow Beats took to Mexico City over the Pan-American Highway served as a guide for Goldbard's own travels through contemporary Mexico. During her journey, she collected found objects and transformed them into impermanent sculptures, which she then photographed.

As Goldbard built her archive of contemporary newspaper accounts of current events in Mexico, one of the things she noticed was "the fragility manifested in the structures that appeared in the photographs: planes that seem to be made of paper, facades—and even entire streets—where the buildings seem to be cardboard rather than concrete."[4] For the temporary sculpture *La Quemada Pública* (*The Public Burning*, 2012), Goldbard made a cardboard replica of the Salón de las Columnas (Hall of Columns) at La Quemada, an archeological site in the state of Zacatecas, Mexico. The abandoned pre-Columbian city of Chicomóztoc has a complicated history. It was transformed by the Aztecs and then by the Spanish; currently the site is undergoing institutional preservation efforts. To replicate the Hall of Columns, Goldbard consulted with archeologists. One

(top) Vandalism of bust of Luis Donaldo Colosio, presidential candidate of the PRI assassinated in 1994. Morelia PRI headquarters, November 13, 2014. Photograph from Adela Goldbard archives

(middle) Vandalism of bust of Plutarco Elías Calles, founder of the PNR, at the PRI national headquarters, November 6, 2006. Photograph from Adela Goldbard archives

(below) Assistant setting up wires for pyrotechnic performance piece. Photograph from Adela Goldbard archives

Adela Goldbard

of the archeologists shared with Goldbard a theory that the sacred site was ritually burned in order to protect it from conquerors.[5] The artist was fascinated by this paradox of destruction in the interest of conservation. With the help of volunteers from the city, she built the ephemeral structure from cardboard boxes. Once completed and photographed, she destroyed the piece with fire.

For *La Isla de la Fantasía* (*Fantasy Island*, 2012), Goldbard collaborated with local artisans to design and build temporary sculptures of planes and helicopters belonging to the Mexican government and military that had been involved in accidents. Basing their models on press photographs, they used reeds, cardboard, newspaper, and paste to create life-sized replicas. Goldbard then documented the resulting papier-mâché aircrafts. Her photographs emphasize the aircrafts' strangeness and fragility and, by extension, the precariousness of the government and political system they represent.

To further explore the consequences of state-sanctioned violence, Goldbard turned to video. *Lobo* represents one of her first forays into using the visual language of film, such as slow-motion pans and special effects. The new series Paraallegories utilizes traditional ideas of allegory—a story, poem, or picture that symbolically carries a moral or political message. In the video *Microbus* (2014), she restaged a highway blockade with a sculpture of a burning microbus. Popular in central and southern Mexico, privately owned microbuses provide cheap transportation, which the Mexican government increasingly seeks to regulate and curb. The microbus has taken on symbolic importance in Mexico, as unions and other collectives have used burning microbuses (and other buses) to block highways and capture the attention of local and federal governments and the media during protests. Organized crime groups also have burned microbuses, mostly for the purpose of obstructing authorities.

Plutarco, putos (2015),[6] Goldbard's newest video in the Paraallegories series, presents a narrative based on the busts of Plutarco Elías Calles located outside many Institutional Revolutionary Party (Partido Revolucionario Institucional, PRI) headquarters in Mexico. President from 1924 to 1928, Calles founded the National Revolutionary Party (Partido Nacional Revolucionario, PNR), in 1929, as a centrally controlled

party machine linked to the federal government. (The PNR later became the PRI.) Goldbard notes that the statues, under constant attack and frequently the site of protests, "stand for the PRI, and by metonymic extension, for the decisions and actions the PRI politicians make."[7] In *Plutarco, putos*, a black pickup, with a massive golden bust sitting upright in its bed, drives across a lush green field. The truck reverses, the bust facing the camera. As it draws closer, fireworks explode in the distance. Men emerge from the truck and dump the bust into a nearby river. As the golden sculpture slowly floats down the river, the men drive away. For Goldbard, this action also references the gruesome, and all too common, disposing of murdered bodies by drug cartels. The fireworks allude to a celebration happening miles away, contrasting the festive with the tragic.

Plutarco, putos; *Microbus*; and *Lobo* synthesize Goldbard's aesthetic approach and intellectual interests. The works unite her background in art and art history; her archival research into political violence in Mexico; her examination of mass media's manipulative language; her collaborations with Mexican artisans, such as piñata makers and pyrotechnicians; and her embrace of the language of cinematic strategies. By creating ephemeral objects that survive only in the photographs and videos that document them, she is, essentially, "destroying to remember, and constructing to resist."[8]

1. Iván Ruiz, "Lobo," *80 años del Instituto de Investigaciones Estéticas,* Pablo Amador and Óscar Flores, eds. (Mexico City: Institute of Aesthetic Research, National Autonomous University of Mexico, 2016). English translation by Audrey Young.

2. Tultepec municipality is the capital of pyrotechnics in Mexico. In December 2016, a tragic explosion at a fireworks market killed dozens of people. See Sara Sidner and Catherine E. Shoichet, "Mexico Fireworks Market Explosion Leaves 35 Dead," *CNN*, December 22, 2016, http://www.cnn.com/2016/12/21/americas/mexico-fireworks-market-explosion/.

3. Adela Goldbard, in conversation with the author, July 10, 2016.

4. Saúl Hernández-Vargas, "Prototipos para un desastre inminente: Entrevista con Adela Goldbard," March 26, 2015, http://www.tierraadentro.cultura.gob.mx/prototipos-para-un-desastre-inminente-entrevista-a-adela-goldbard/. English translation by Audrey Young.

5. Archeologist Humberto Medina based this hypothesis on his and other archeologists' research in Zacatecas.

6. Goldbard found the title *Plutarco, putos* on a bust written in graffiti.

7. Adela Goldbard, correspondence with the author, May 8, 2016.

8. Hernández-Vargas, "Prototipos para un desastre inminente."

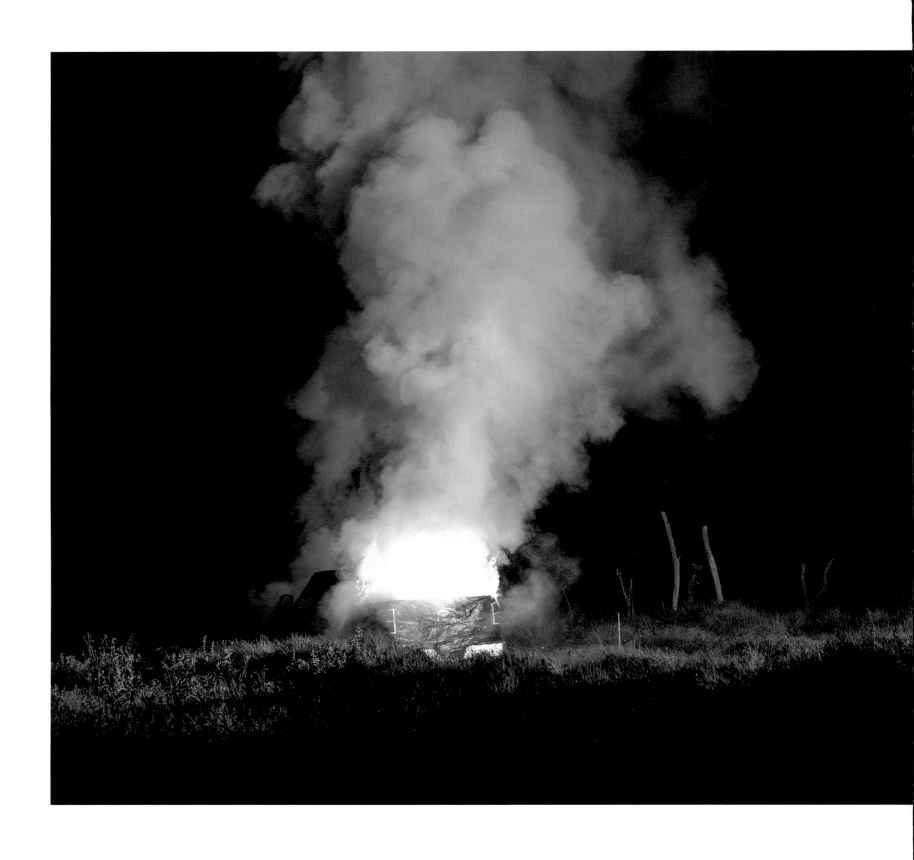

Adela Goldbard

(pages 140–43) *Lobo*, 2013. Photographic stills from 4k video projected in HD with stereo sound, 6 min. 7 sec.

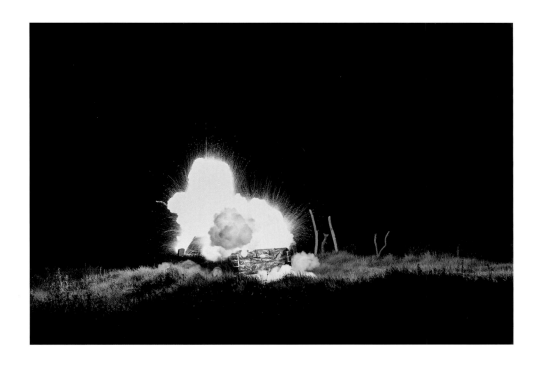

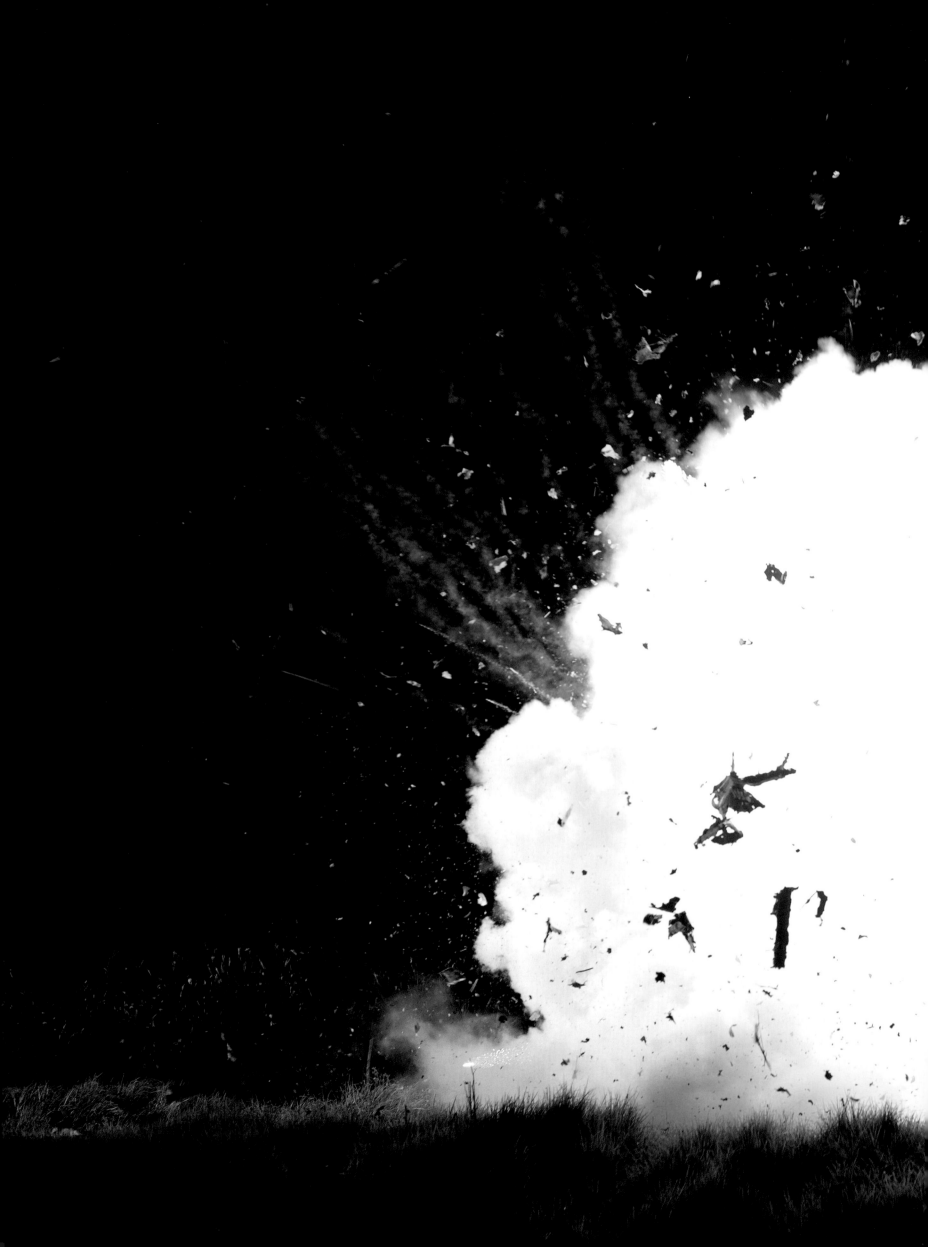

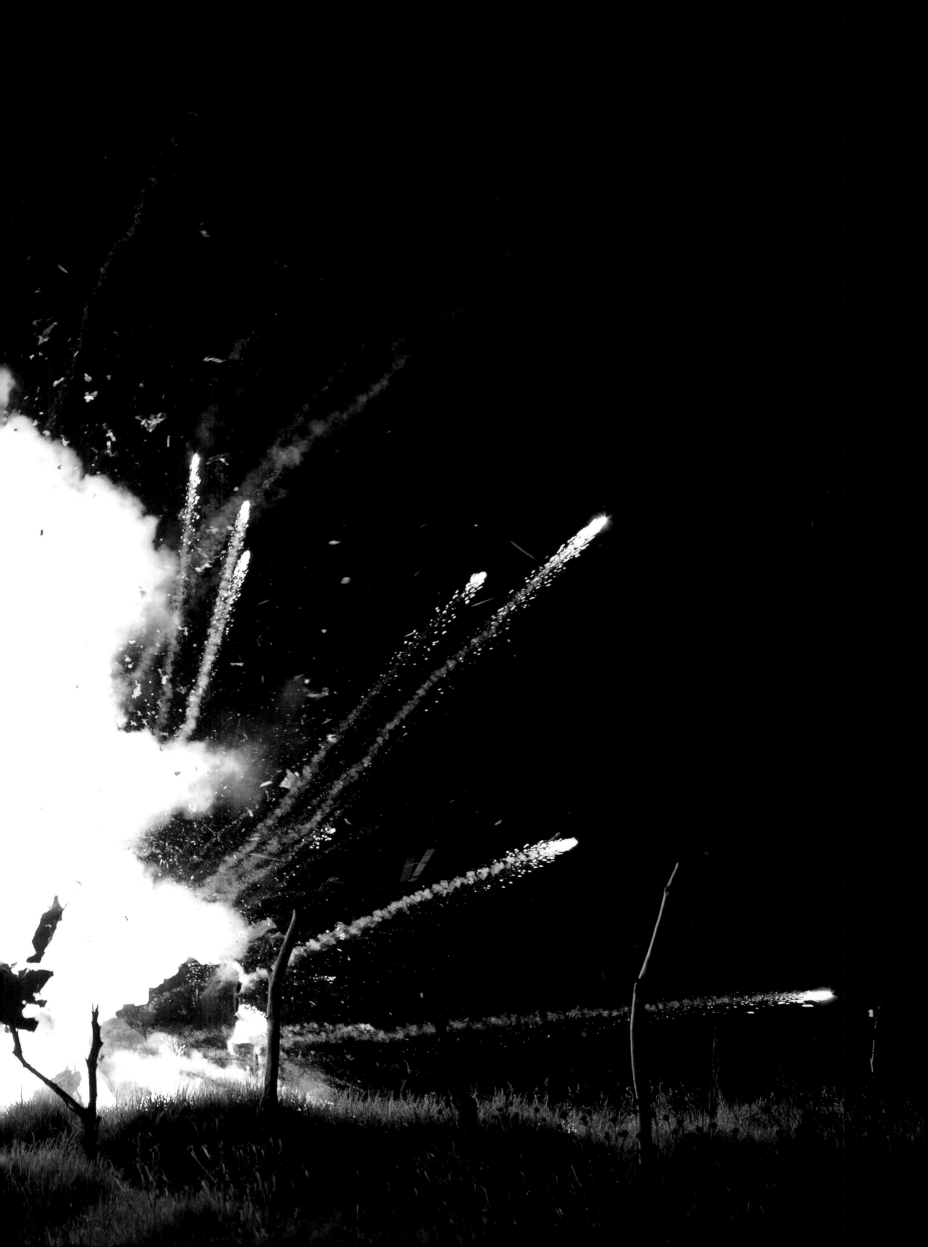

(pages 144–47) *Plutarco, putos*, 2015.
Production stills from 4k video projected
in HD with stereo sound, 9 min.

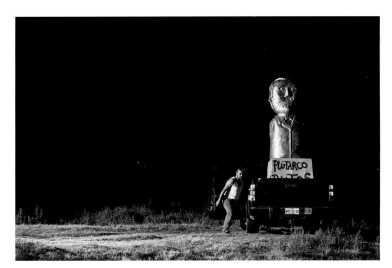

Adela Goldbard

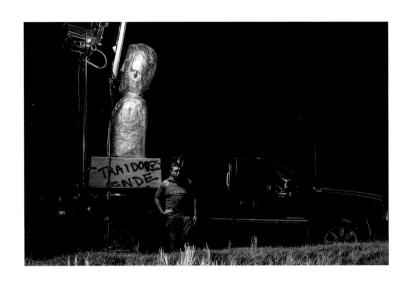

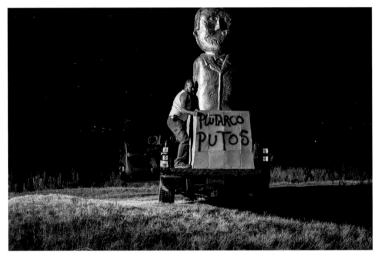

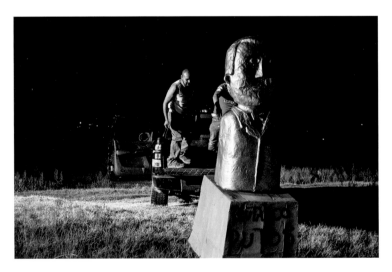

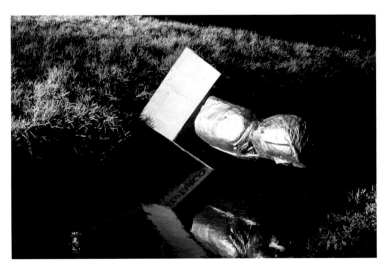

Adela Goldbard

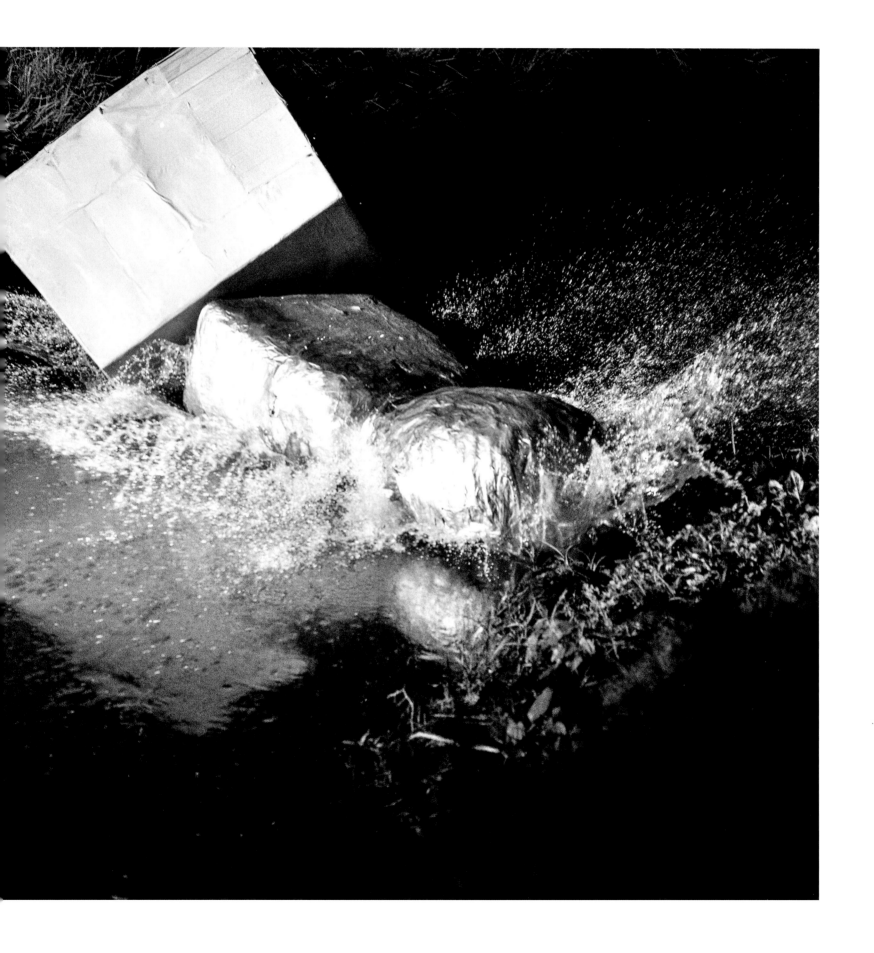

Adela Goldbard

(pages 149–51) *Microbus*, 2014.
Photographic stills from 4k video projected
in HD with stereo sound, 4 min. 38 sec.

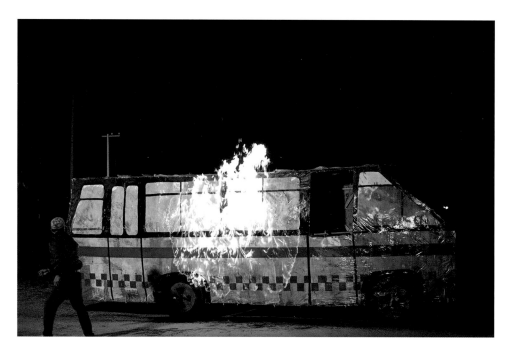

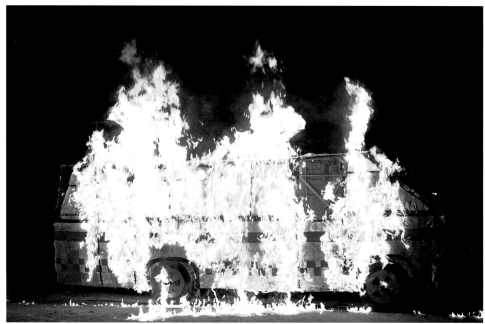

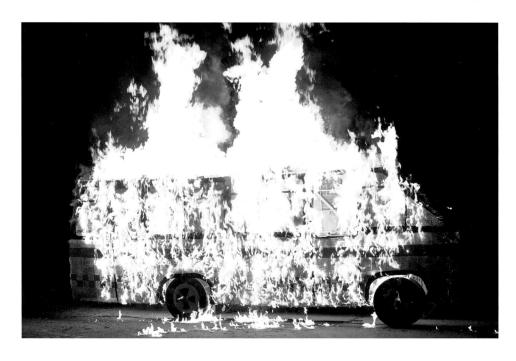

Adela Goldbard

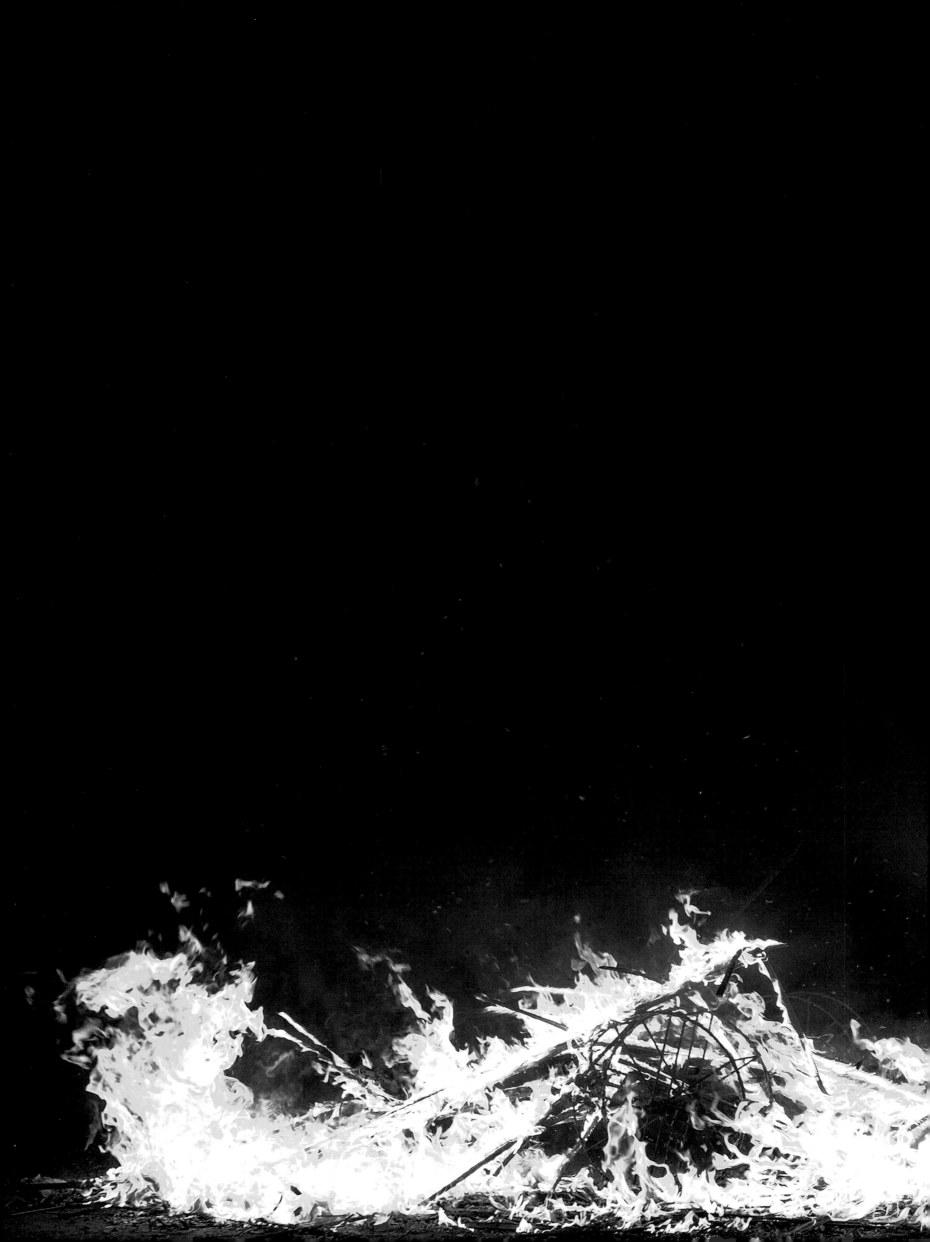

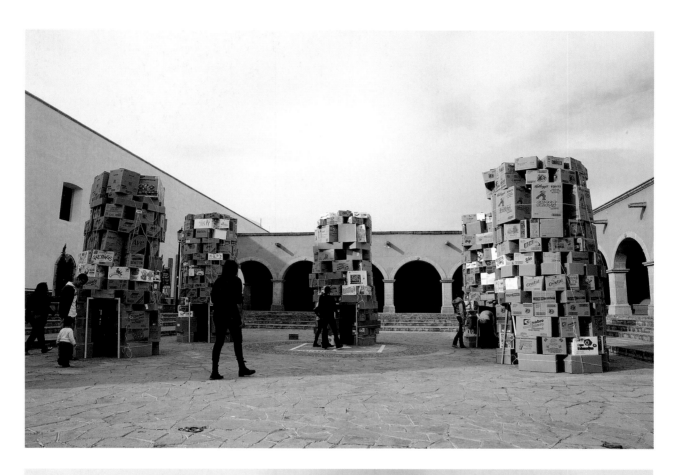

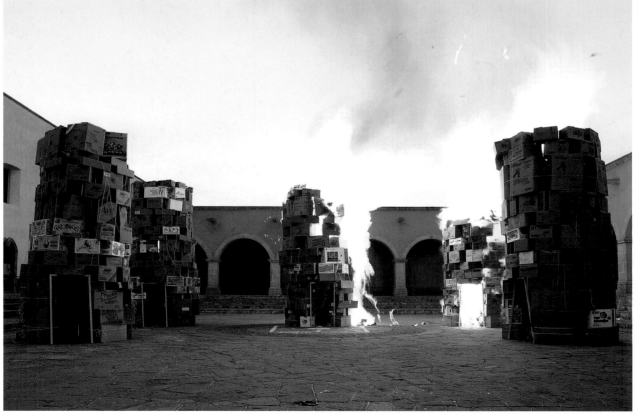

Adela Goldbard

Agusta 109-S XC-EDM, from *La Isla de la Fantasía* (*Fantasy Island*), 2012. Lightjet print, 55 x 70 in

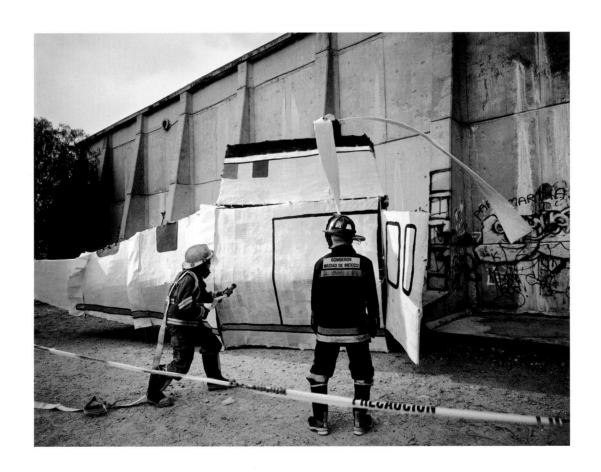

Adela Goldbard

Cessna 182 5498, from *La Isla de la Fantasía*, 2012. Lightjet print, 55 x 70 in.

(pages 156–57) *Tomamos la carretera a Monterrey. Las grandes montañas coronadas de nieve se alzaban delante de nosotros …* (*Now we resumed the road to Monterrey. The great mountains rose snow-capped before us . . .*), from *En el camino / On the Road*, 2010. Lightjet print, 55 x 70 in.

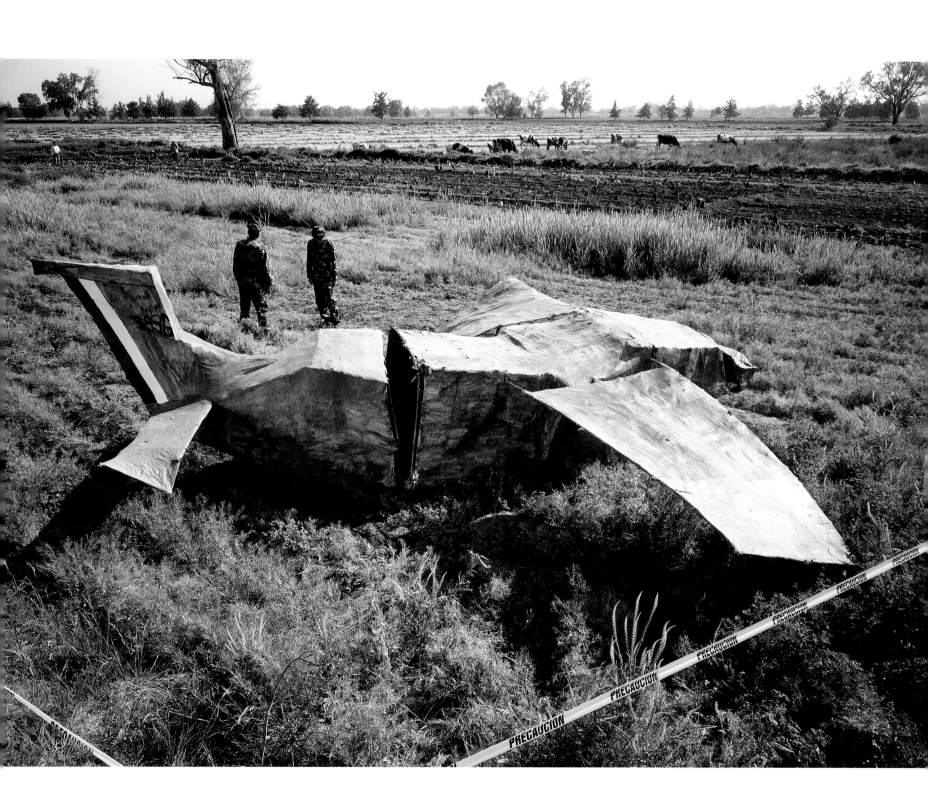

Adela Goldbard

Rita
Ponce de León

Rita Ponce de León:
Storytelling

Daniel Garza Usabiaga

Drawing is at the center of Rita Ponce de León's artistic practice. Her images often seem incomplete and highly ambiguous; they defy the limits between abstraction and figuration and confuse ordinary perception. She attended the National School of Painting, Sculpture and Engraving, "La Esmeralda," in Mexico City, and she is part of a generation of students who were encouraged to reexamine the practice of drawing and take it in new directions—from the production of installations to the publication of fanzines. The workshop of artist José Luis Sánchez Rull has been especially influential in this regard for more than a decade. Often, Ponce de León's works propel the spectator to examine her images closely, in search of relations and meanings between them. Many of her projects highlight the presence of the body, particularly her installations of large-scale drawings that are dispersed across the walls of an exhibition space like a constellation of fragments. Her drawings demand the engagement of spectators, who have to move through the gallery in order to see the totality of the work.

The methodology behind most of Ponce de León's projects consists of conversations. She uses questionnaires and interviews, in person and online, with friends, acquaintances, and specific communities of people to gather information on themes ranging from education and memory to dreams and historical consciousness. She illustrates her respondents' perspectives with evocative and highly suggestive drawings that, like all acts of recollection, remain ambiguous and open ended. In this sense, her work recalls storytelling; several of her drawings even allude to the old domain of illustration found in outmoded publications. Through her research, Ponce de León focuses on experiences and perspectives that are shared within specific groups of individuals. Empathy is key to this process; it allows the artist to perceive what is common, more than what is different, within a collective. At the same time, empathy builds a shared ground between the spectator and her work.

The centrality of the body is a recurrent feature in Ponce de León's projects. In addition to placing her drawings around different points on the walls, she sometimes introduces sculptural elements in order to articulate a more complex scene. The spectator has to negotiate with these elements, moving around the space or interacting in a direct fashion with her tridimensional interventions. Sometimes, the public even has to crawl in order to transit through the interventions and see the totality of the work. Whilst the body moves, it is confronted with an array of fragments. In this sense, Ponce de León proposes the viewer as an active body, one with a highly imaginative consciousness that can find meaning and connections between seemingly arbitrary fragments.[1] The artist's interest in a body that articulates new perceptions through movement resonates with her interest in butoh dance. Ponce de León describes this unique dance discipline—which Tatsumi Hijikata and Kazuo Ohno originated in Japan after the Second World War—as endowed with the potential to generate mental images that motivate movement.

Ponce de León began a line of projects in which her drawings utilize the walls unconventionally in 2011. Rather than being hung in a line at the same height, they appear scattered in different places across the walls. Although linked by a particular research interest, no strict narrative connects these highly ambiguous and evocative fragments. This strategy forces the spectator to become aware of the space and the situation in order to negotiate relations and meaning. As happens in the works of the twentieth-century surrealist Yves Tanguy, Ponce de León's drawings affirm their presence while at the same time blending with the space.[2] As a result, her images sometimes seem to appear suddenly and unexpectedly. The artist has used other strategies to integrate her drawings with the surface of the walls, such as when she removed parts of the frames of some small-scale works that were featured in *Endless Openness Produces Circles* (2014).

Ponce de León first incorporated tridimensional work into a drawing installation in *He decidido bifurcarme* (*I Have Decided to Bifurcate*, 2011). In this work, a wooden structure hanging from the ceiling appeared to float, creating a material horizon in the space. For *Cordillera* (*Mountain Range*, 2012), she designed a structure that the public had to travel beneath in order to see the totality of the drawings. In *Endless Openness Produces*

Sketches for *En forma de nosotros* (*In the Shape of Us*), 2016. Installation of audio recordings, ink on paper, and clay, dimensions variable. 32nd Biennial, São Paulo, Brazil

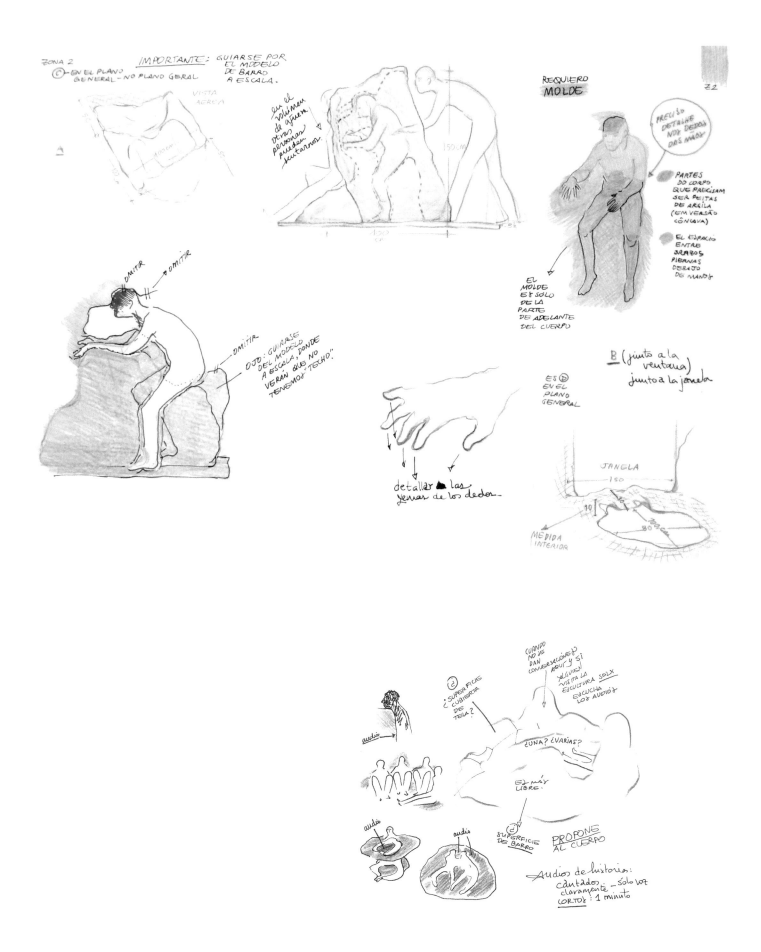

Rita Ponce de León

Circles, an aluminum structure interacted with a window within the exhibition space.[3] The sculpture, of minimalist semblance, operated as a drawing, tracing a sort of continuum between the interior and exterior space. The iron structure that she designed for *Días enteros con los ojos cerrados* (*Full Days with Closed Eyes*, 2013) not only displays several of her drawings but also operates like a drawing itself: it features details that have the appearance of a hand or the leg of a strange bird.

Ponce de León's process of gathering information from friends, acquaintances, and different communities makes the participation of others essential to her works. At least since the end of the 1990s, contemporary artists worldwide have employed similar strategies of participation and collective work. Ponce de León is aware of this context, and she is particularly sensitive to issues of representation that this strain of contemporary art often raises. She never seeks to function as the representative of a particular community or to encompass, with her work, an absolute representation. She doesn't display the primary sources of her research, and her drawings defy an exclusive reading or a singular point of view.

In several projects, Ponce de León has applied this kind of engagement to other facets of the work. For *Es todo gracias a ti* (*It Is All Thanks to You*, 2013), for example, she produced and gathered several sculptural elements, from stones to geometric forms made of wood. These objects sought to represent testimonies and opinions regarding concepts such as domination, threat, fear, alliance, and expansion. The spectator, then, was invited to manipulate these objects, and the artist conceived of each reconfiguration of the installation by viewers as a transformation and subversion of the assigned meanings of the concepts. *Con tus propias manos* (*With Your Own Hands*, 2014) also emphasized a participatory dimension. Here, she created an installation that constantly could be transformed and moved from one side of the gallery to the other. The artist divided the space with a piece of cloth; several orifices within this membrane allowed spectators to see and hand objects and drawings between the spaces. The objects, made out of wood or knitted yarn, and the apertures in the cloth recalled several of her drawings, in which limbs and objects seem to pop up from the wall. Some of the works were hung from the ceiling and others were lying on the floor. The installation was constantly reconfigured from one side of the gallery to the other. *Con tus propias manos* evidences some of Ponce de León's phenomenological concerns: a tactile perception of the space and the objects, the "apparition" of things and images, situations endowed with a certain estrangement that provokes new perceptions, and the presence of a consciousness that creates meanings and connections between fragments.

For her project in "Prometheus 2017," a work that was commissioned by the Pomona College Museum of Art in response to *Prometheus* (the mural painted by José Clemente Orozco in Pomona's Frary Dining Hall in 1930), Ponce de León utilized a characteristic methodology. She developed a system of conversation between students on pressing issues regarding life on campus. Her project was conceived as an alternative to the traditional forms of student unions and assemblies; she created intimate situations for dialogue that gave students an opportunity to share testimonies and reflections. These conversations began two years before the opening of the show. In the intervening time, the artist received the results of the multiple sessions via email. For the exhibition, she produced drawings that seek to transmit the students' responses and experiences through her own suggestive imaginary. Once again recalling storytelling, Ponce de León has produced a new reading from inherited knowledge, giving visibility to experiences and engaging new ones, all from the perspective of someone who is external to life on the campus. The first of the discussions between students took place under *Prometheus*. With this gesture, Ponce de León actualized the public character sought by the muralists in their practice: namely, the mural as the site for informed and productive discussions on pressing matters.

1. On the positive meaning of the fragment from a phenomenological perspective, see Dalibor Vesely, *Architecture in the Age of Divided Representation: The Question of Creativity in the Shadow of Production* (Cambridge, MA: MIT Press, 2006), 317–54.

2. Ponce de León's *La mesa de Breton* (*Breton's Table*, 2012), which she presented as part of *Cordillera*, explicitly references a legacy of the historical avant-garde whilst actualizing it through contemporary aesthetic concerns, such as participation and the creation of situations of dialogue. Ponce de León and artist Rodrigo Hernández, a close collaborator in some of her projects, were among the first artists of their generation, in Mexico, to revise and actualize some practices of the historical avant-garde. For example, see Ponce de León's series *Dibujos de cambio de idea (Comencé diciendo algo pero lo olvidé y dije otra cosa)* (*A Change of Mind Serves to Advance an Honest Mind Drawings [I Started Saying Something But I Forgot and Said Something Else]*), 2014.

3. For the production of this project, Ponce de León collaborated with architect Pablo Pérez Palacios.

Nuestra montaña voluntaria (Our Voluntary Mountain), 2012. Ink on wood, steel cables, 325½ × 285½ × 2⅛ in. (827 × 725 × 5.5 cm). 80M2 Livia Benavides Galería, Lima, Peru

Rita Ponce de León

Es todo gracias a ti (*It Is All Thanks to You*), 2013. Wood, stone, fabric, polyurethane foam, and PVC floor, dimensions variable. Zona Maco, Mexico City

(pages 168–71) Rita Ponce de León in collaboration with architect Pablo Pérez Palacios, *Endless Openness Produces Circles*, 2014. Ink on wall, ink drawings on paper, metal, and fabric, dimensions variable. Kunsthalle Basel, Basel, Switzerland

Rita Ponce de León

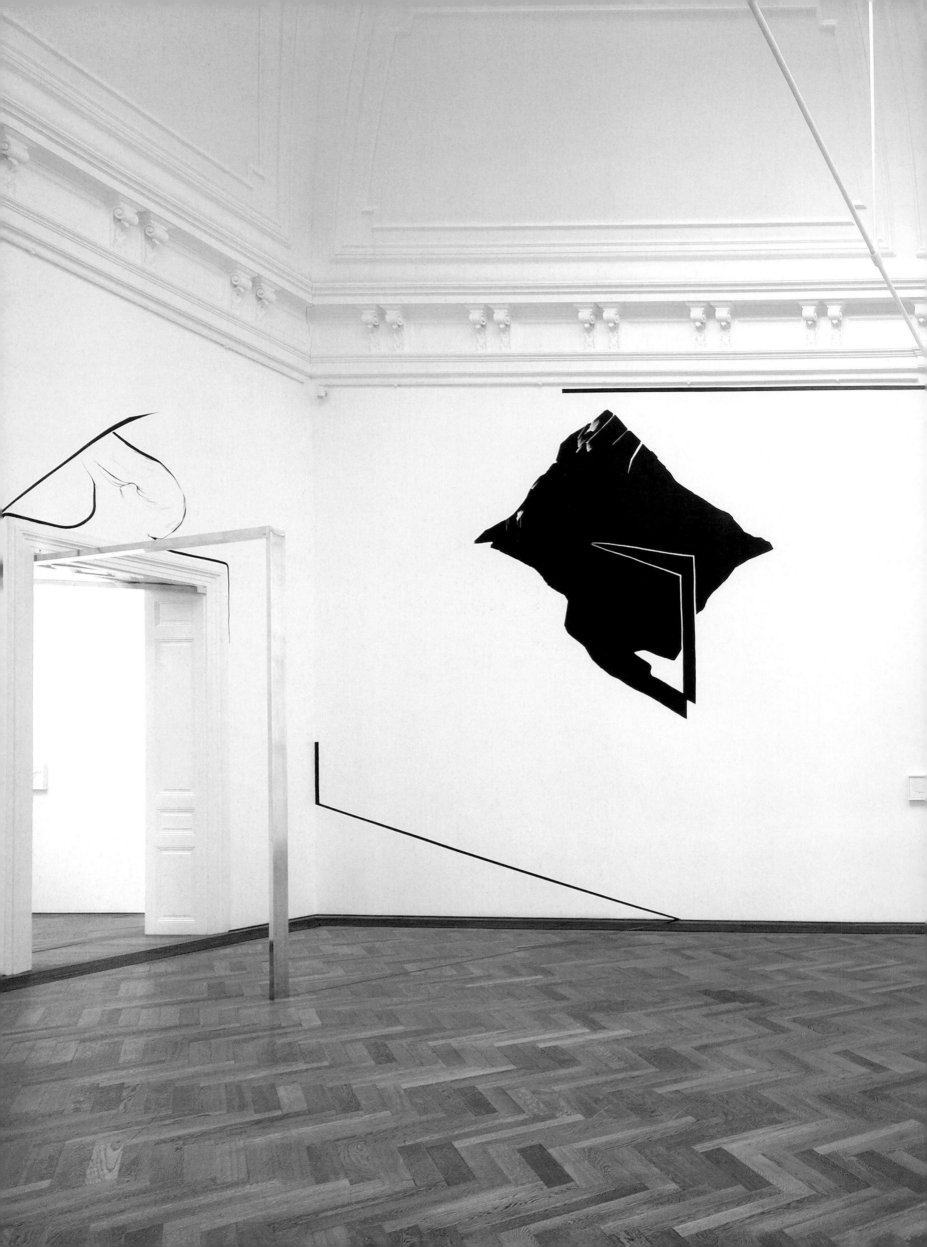

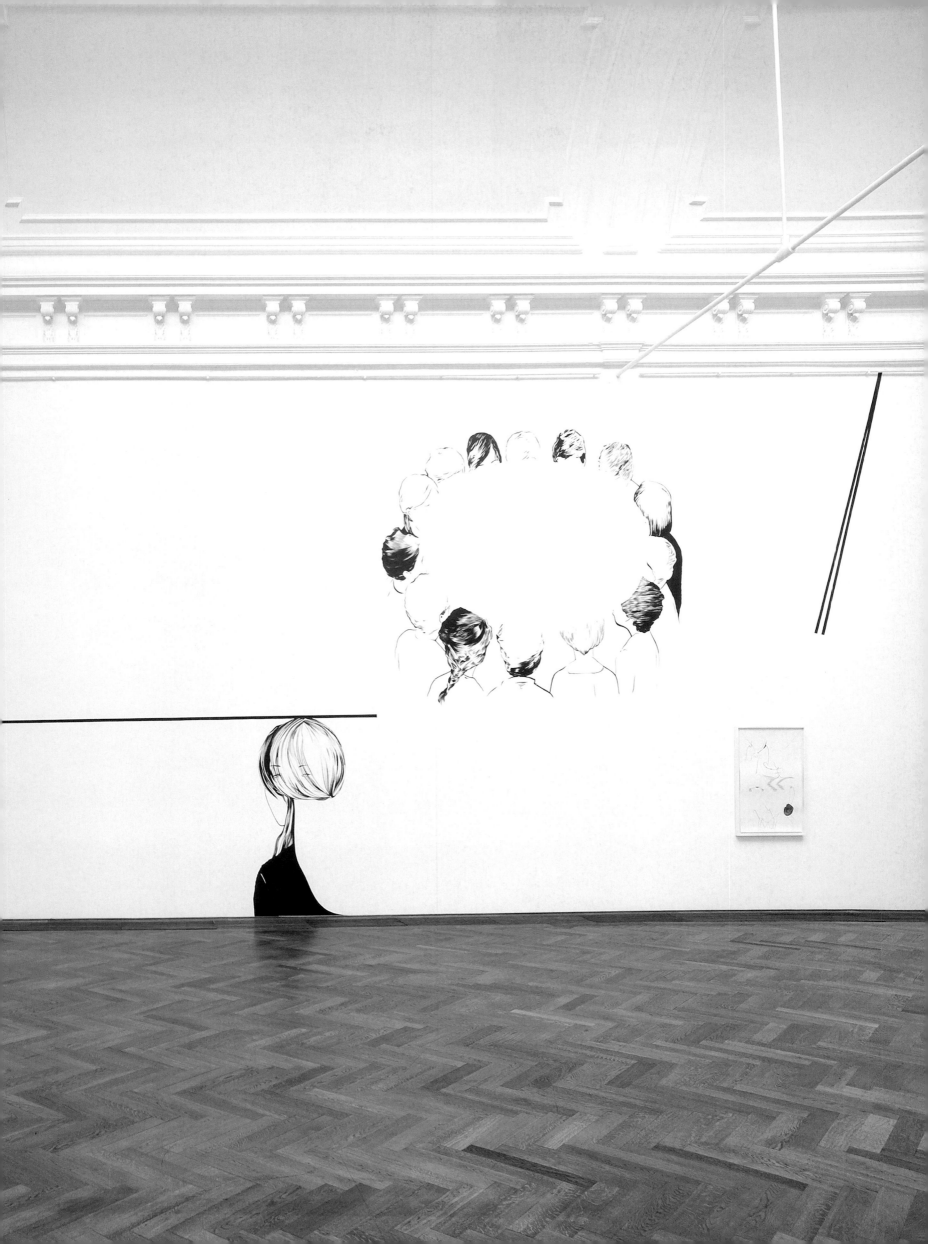

Rita Ponce de León

Un lugar para la brisa (objectos) (*A Place for the Breeze [Objects]*), 2014. Ink and color pencil on paper, 27½ × 27½ in. (70 × 70 cm). 80M2 Livia Benavides, Lima, Peru

Rita Ponce de León

Rita Ponce de León

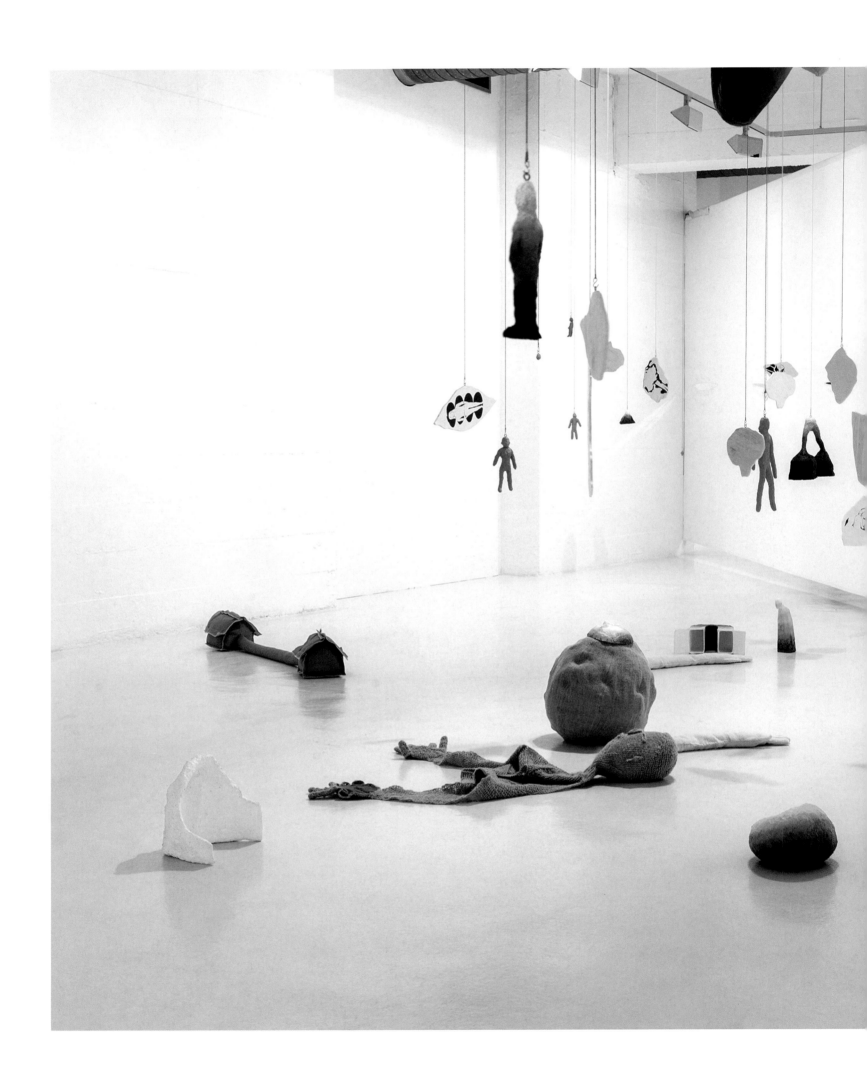

Rita Ponce de León

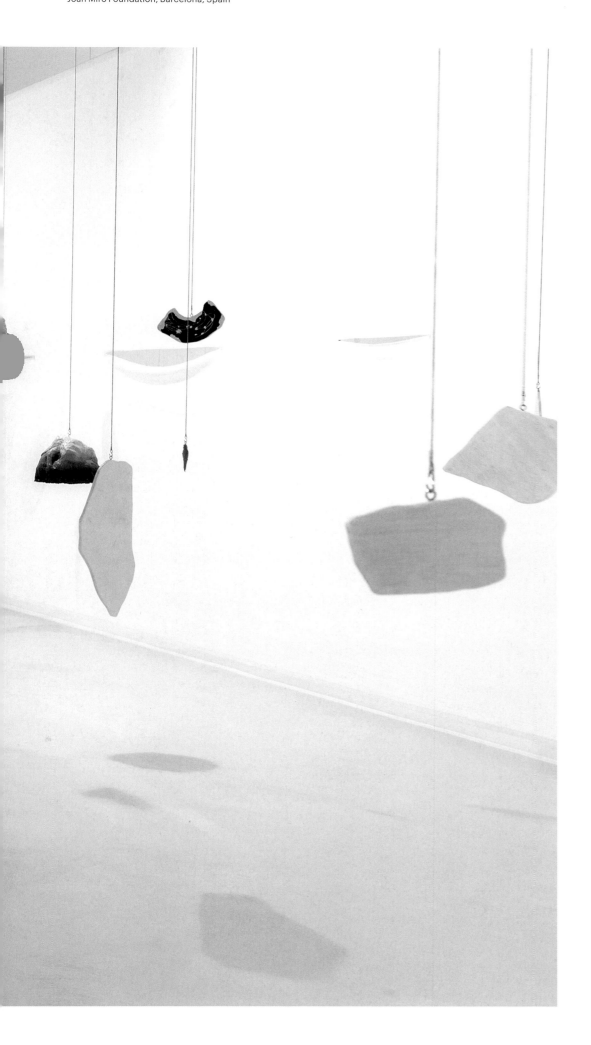

Con tus propias manos (*With Your Own Hands*), 2014–15. Ink drawings on wood, metal, fabric, and papier-mâché, dimensions variable. ESPAI13, part of Lesson O by AZOTEA (Juan Canela and Ane Agirre), Joan Miró Foundation, Barcelona, Spain

(below) *Líneas Aéreas Naturales* (*Natural Air Lines*), 2015. Ink on paper, dimensions variable. 80M2 Livia Benavides, Lima, Peru

(right) *Investigador 5* (*Investigator 5*), 2015. Ink and color pencils on paper, 27½ × 19¾ in. (70 × 50.2 cm). 80M2 Livia Benavides, Lima, Peru

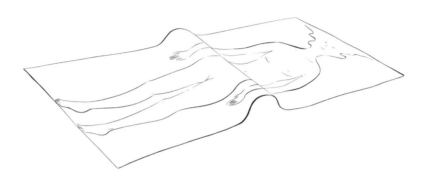

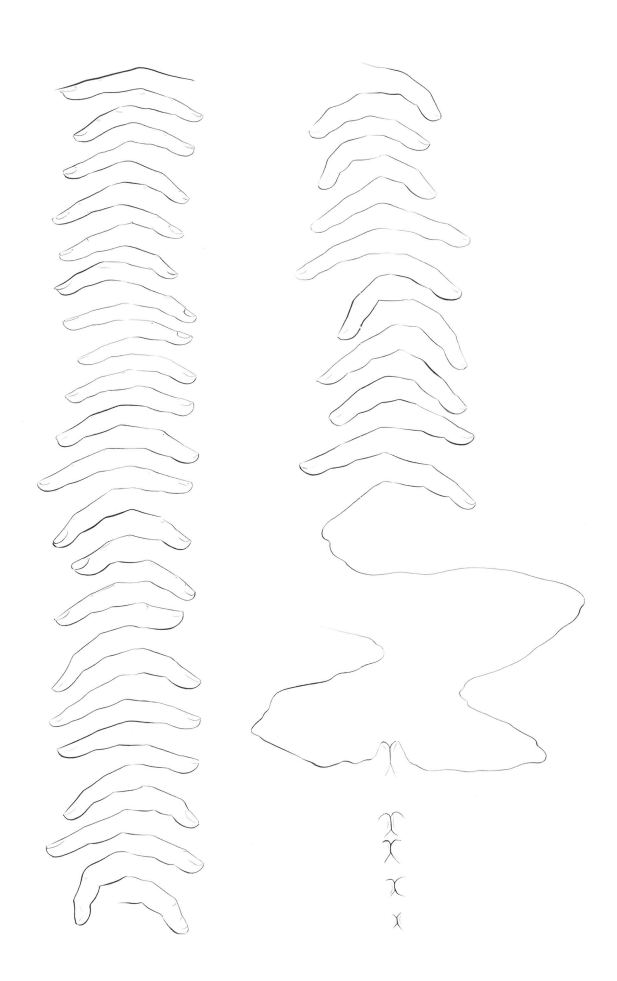

AFUERA (Outside), from *En forma de nosotros*, 2016. Ink on paper, 11⅝ × 13¾ in. (29.7 × 34.9 cm)

Rita Ponce de León

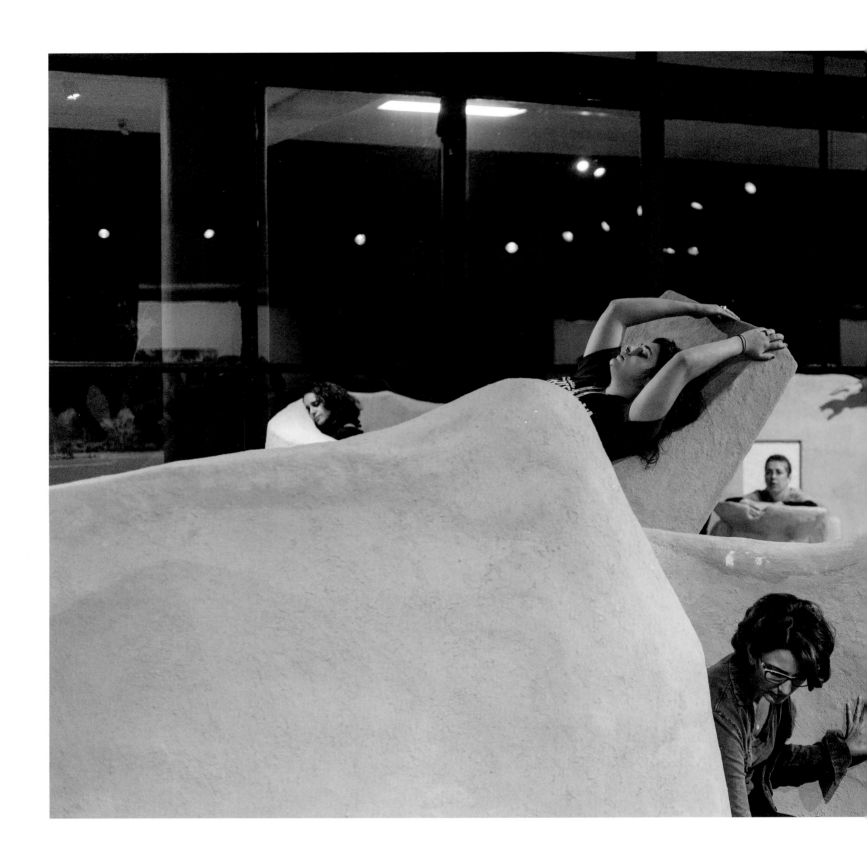

Rita Ponce de León

En forma de nosotros, 2016. Audio recordings,
ink on paper, and clay, dimensions variable.
32nd Biennial, São Paulo, Brazil

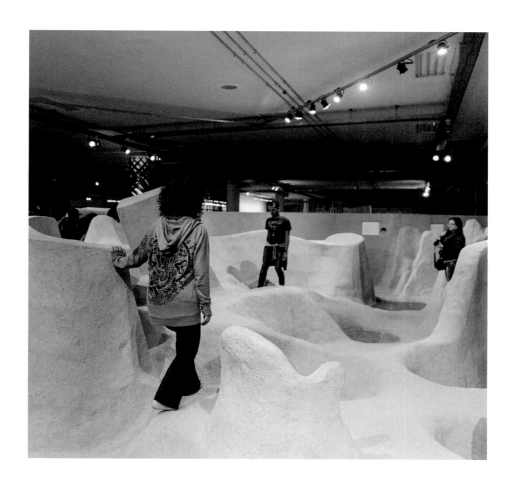

Rita Ponce de León

Rita Ponce de León and Tania Solomonoff in collaboration with Joelle Gruenberg. *Desconocer juntos, ir a otro* (*Ignore Together, Approach to Another*), 2016. Fabric, metal hooks, vinyl texts, and ink drawings on wall, dimensions variable. 80M2 Livia Benavides Gallery, Lima, Peru

Naomi
Rincón-Gallardo

Galactic Axolotl:
Naomi Rincón-Gallardo

Terri Geis

The axolotl, a Mexican salamander with bright reddish-pink, feathery gills framing its head, is indigenous to the waters of the ancient Lake Xochimilco in southern Mexico City. The creature has long occupied the imaginations of writers, poets, and artists, not only for its singular, otherworldly appearance, but also due to its devolution from terrestrial to aquatic life, and its sustained larval state throughout its lifespan. Julio Cortázar's fantastical short story "Axolotl" (1953), for example, presents the tale of a man who becomes obsessed with observing an axolotl in an aquarium. Though fearing its "little pink Aztec" face, he attempts to reconcile the contradiction of the animal's physical difference yet uncanny connection to human beings and finally moves through the thin glass barrier to become an axolotl himself.[1] The strange, regressive amphibian serves as an apt symbol for interrogating the modern mythologies of humankind's perpetual advancement.

Cortázar's character also wonders what the axolotl is thinking. In the piece *Insaciables* (*Insatiable*), from Naomi Rincón-Gallardo's nine-channel experimental musical video *Odisea Ocotepec* (*Ocotepec Odyssey*, 2014), we find one possible answer. Rincón-Gallardo dresses in a handmade, neon-lit costume as a "galactic queer axolotl," a powerful astronaut-sage who returns to earth to predict humankind's demise through over-consumption.[2] Hovering in a multi-colored sky, the axolotl chants apocalyptic predictions that are echoed by an equally adamant chorus: "Every trace will leave you with newfound frustrations.... Your mind will cloud with canned dreams...your strengths will atrophy with designed services."[3] The artist's human-salamander condemns humanity's current course, and presents the possibility of looking to—or even devolving to—the past in order to create a different future.

For Rincón-Gallardo, who positions herself as a queer feminist of color in a post-colonial context,

the axo otl's "larval world [of] pure possibility" represents a symbolic alternative that resists "coming to terms with norms."[4] This concept of metamorphosis is central to *Odisea Ocotepec*. Many of the piece's videos consist of musical stories of the Mexican countercultures of the 1960s and 1970s, a period in the country that entailed creative and at times halluci-nogen-driven utopian quests. Rincón-Gallardo layers her archival investigations of Mexico's micro-histories with fictionalized and fantastical re-enactments. In this world, Mexican monks influenced by Freudian psychoanalysis regress into fetuses, and hippies on pilgrimage to an indigenous Mazatec healer-shaman become giant dancing mushrooms.

The critiques of society sung by Rincón-Gallardo's galactic axolotl are formulated from the writings of Austrian Catholic priest and philosopher Ivan Illich. *Odisea Ocotepec* takes its name from the small Mexican village in the state of Morelos, where Illich settled and established the Center for Intercultural Documentation (Centro Intercultural de Documentación, CIDOC) in 1961. Offering a strong critique of the period's Third-World development schemes as outlined by the United States and the Catholic Church, and inspired by indige-nous communitarian systems, Illich and CIDOC offered seminars that advocated limits to development and suggested a more "convivial" use of technology's tools. A fictionalized, time-traveling Illich, performed by the artist Marie Strauss, appears within *Odisea Ocotepec*. This drag Illich wears a shiny, retro-futuristic costume inspired by 1960s Mexican science fiction films, which were cheaply constructed D.I.Y. worlds similar to carnivals and folk parades. In the piece *Epimeteo* (*Epimetheus*), the character Illich wanders through village streets and fields of cacti, singing in the style of Latin American protest folk songs, criticizing and ultimately abandoning neoliberal ideologies. "I let go with my friends," the character Illich concludes, "in the shadow of conviviality."[5]

The concept of "conviviality" is crucial to Rincón-Gallardo's work, and it grounds her projects within a social practice context. In the 1973 text *Tools for Conviviality*, Illich explains that he intends the term to be synonymous with the ancient Greek *eutrapelia*, meaning a graceful playfulness in personal relations.[6] *Odisea Ocotepec* is based upon such playfulness, through the artist's humorous and open method of collaboration, musical

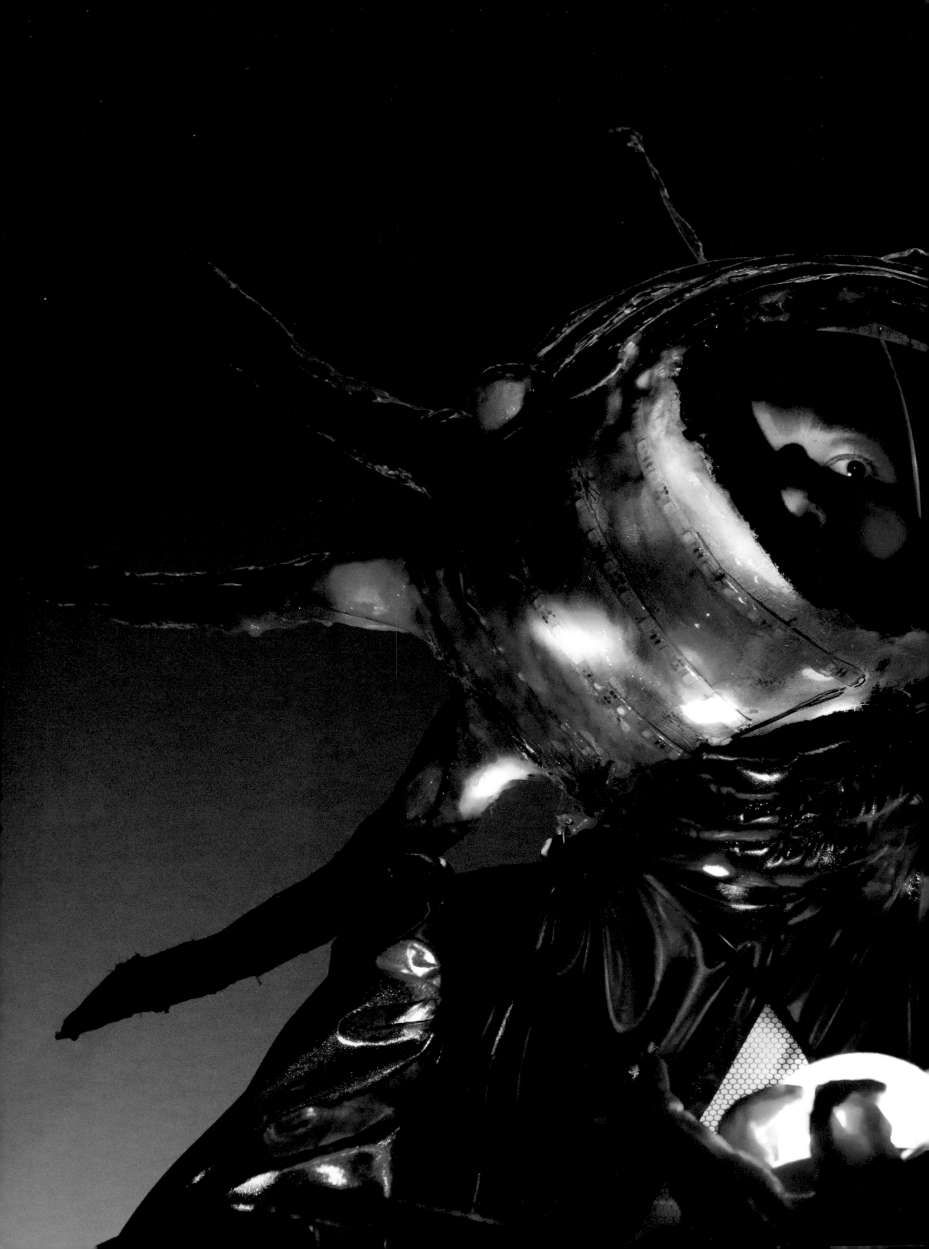

(pages 188–93) *Odisea Ocotepec* (*Ocotepec Odyssey*), 2014. Performance accompanying exhibition of nine-channel video installation. Academy of the Arts of the World, Cologne, Germany

production, and prop building. Rincón-Gallardo envisions the process of working with friends as a means of encouraging solidarity and understanding. For example, two of the songs in *Odisea Ocotepec* were written and performed by INVASORIX, a collective formed in 2013 by Rincón-Gallardo and seven other women artists seeking to enact a "queer-feminist protest."[7] The name of the collective humorously references the 1966 film *El Planeta de Las Mujeres Invasoras* (*Planet of the Women Invaders*), in which a spaceship of female aliens travels to earth in a plot to conquer the planet. Rincón-Gallardo reflects, "I don't believe in revolution with a capital 'R,' but I think it's urgent to work in crafty, restless, and hopeful ways to shape our lives in a method that involves humor, critique, and resistance coupled with thinking and acting."[8] This approach has also led to a live performance of *Odisea Ocotepec* in Cuernavaca, Mexico, which included a group of local school children, and also a performance in Cologne, Germany, with local musicians.

Rincón-Gallardo's video projects often address historic acts of resistance and collective efforts to reshape reality while also underscoring tensions between the group and the individual. The artist's 2012 *Utopías Pirata* (*Pirate [Bootleg] Utopias*) offers a fictionalized musical based upon interviews with members of the Mexican activist punk collective, Anti-Authoritarian Revolutionary Youth (Juventud Antiautoritaria Revolucionaria), known as JAR. Formed in Mexico City in the early 1990s, against the backdrop of the North American Free Trade Agreement (NAFTA), many members of JAR were inspired by the Zapatista National Liberation Army (Ejército Zapatista de Liberación Nacional, EZLN). JAR engaged in protests against neoliberal policies, conducted environmental workshops, and created zines, among other activities. While conveying a sense of JAR's activities, *Utopías Pirata* avoids a single, monumental narrative of the group's history and instead explores individual accounts of identity construction and ideological dissent within the group.

Rincón-Gallardo's videos acknowledge individual differences within a collaborative process and the right to exist on multiple and at times contradictory levels. The artist also initiates collaborative workshops from this perspective, including a 2016 event with the Berlin-based No-Play group and its Feminist Training Camp, entitled Collective FUTURISTIC SPELL! Working with games, improvisation, and D.I.Y. prop building, the workshop sought to "conjure transformative resistances" through a "multi-lingual feminist spell," with the ultimate purpose of tracing "new signs for future affinities articulating otherness, difference, and specificity."[9]

Rincón-Gallardo has described her convivial and simplified D.I.Y. process of cultural labor as a "look backwards" to "slowly quit."[10] Her words, suggesting a defiant abandonment of progress, recall the immobile, regressive axolotl, with its "faint movements," as Cortázar's character puts it.[11] Rincón-Gallardo notes that the axolotl is an endangered species, "just as so many cosmologies and resistances are."[12] The amphibian was thought extinct due to the massive urban growth and subsequent pollution of its natural habitat—the Xochimilco network of lakes and canals of Mexico City. However, in early 2014, scientists recorded axolotl sightings in the lake, suggesting that resistant creatures may yet continue to invent their micro-histories.[13]

1. Julio Cortázar, "Axolotl" (1953), reprinted in English translation in *Blow-Up and Other Stories*, trans. Paul Blackburn (New York: Pantheon Books, 1967), 4.

2. Naomi Rincón-Gallardo, introduction to *Odisea Ocotepec*, NaomiRincon.org, http://naomirincongallardo.org/odisea-ocotepec.html.

3. Naomi Rincón-Gallardo, *Insaciables*, from *Odisea Ocotepec*, 2014.

4. Naomi Rincón-Gallardo, *Ajolote, Reflexividad* (*Axolotl, Reflexivity*) from *Odisea Ocotepec*, 2014, and email correspondence with author, May 25, 2016.

5. Naomi Rincón-Gallardo, *Epimeteo* from *Odisea Ocotepec*, 2014.

6. Ivan Illich, *Tools for Conviviality* (London and New York: Marion Boyars, 2009), xii.

7. INVASORIX Tumblr site, http://invasorix.tumblr.com/about.

8. Naomi Rincón-Gallardo, quoted in Andrea Karnes, "Outsice In," *México Inside Out: Themes in Art Since 1990* (Fort Worth, TX: Modern Art Museum of Fort Worth, 2013), 41.

9. Rincón-Gallardo, email correspondence with author, May 25, 2016. This workshop was held at the neue Gesellschaft für bildende Kunst in collaboration with Freja Bäckman and Wassan Ali.

10. Rincón-Gallardo, introduction to *Odisea Ocotepec*.

11. Cortázar, "Axolotl," 3.

12. Rincón-Gallardo, email correspondence with author, May 25, 2016.

13. Kashmira Gander, "Axolotl found in Mexico City lake after scientists feared it only survived in captivity," February 24, 2014, *The Independent* (London), http://www.independent.co.uk/environment/axolotl-found-in-mexico-city-lake-after-scientists-feared-it-only-survived-in-captivity-9148775.html.

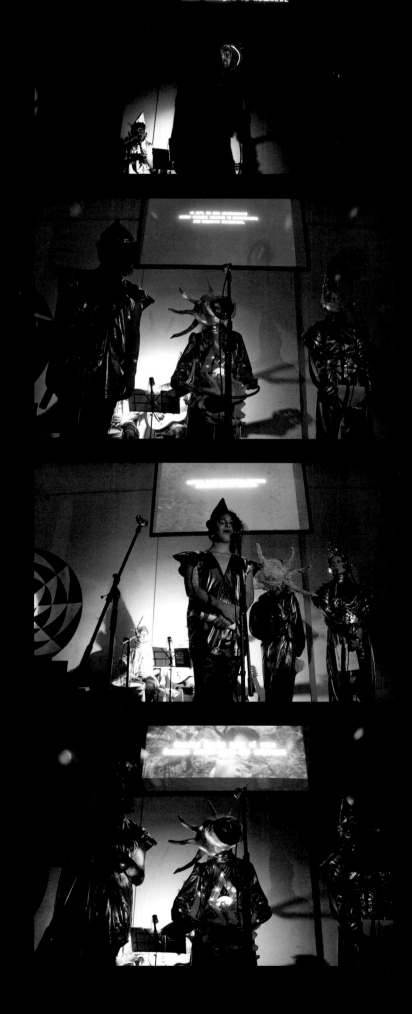

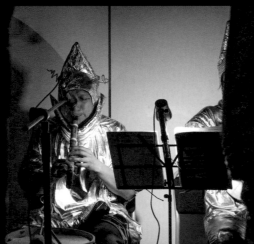

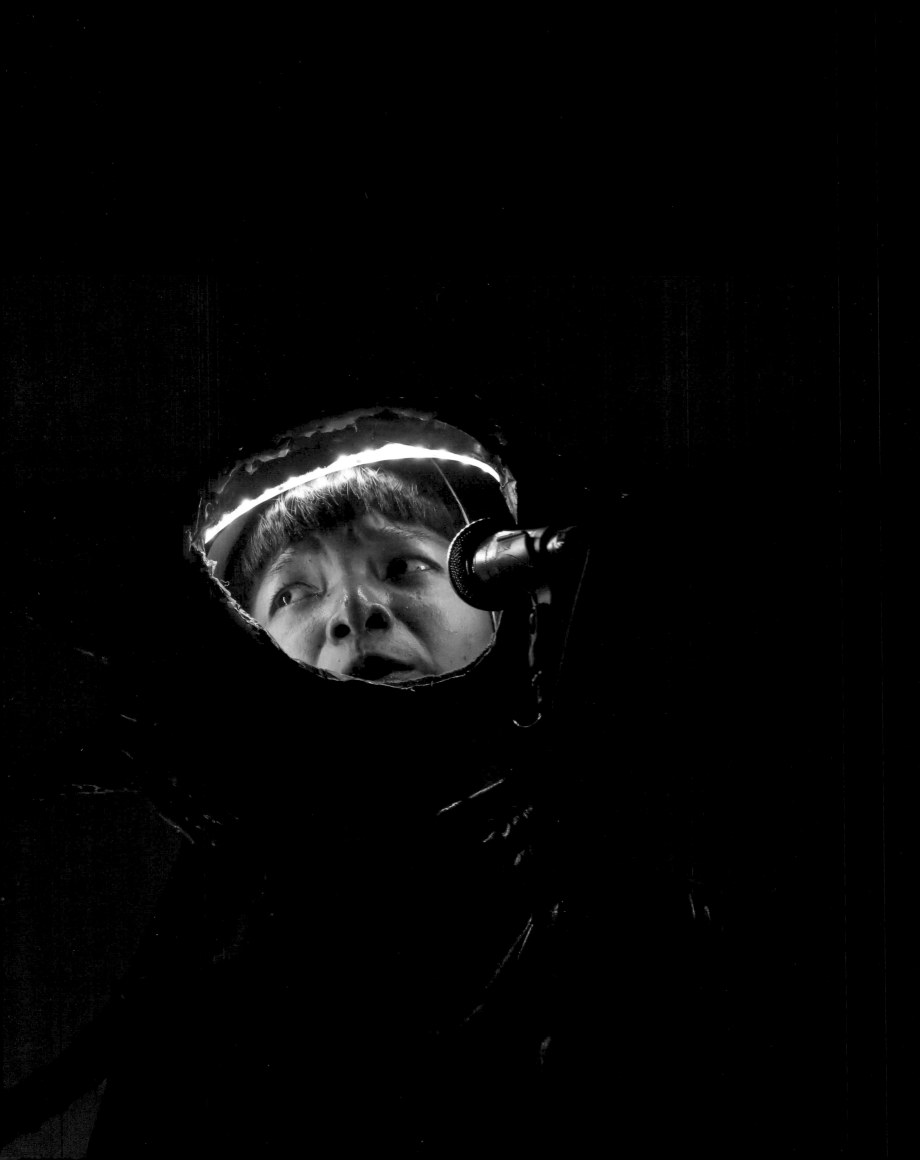

Naomi Rincón-Gallardo

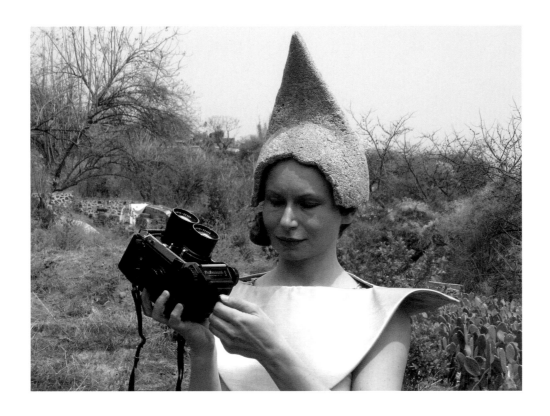

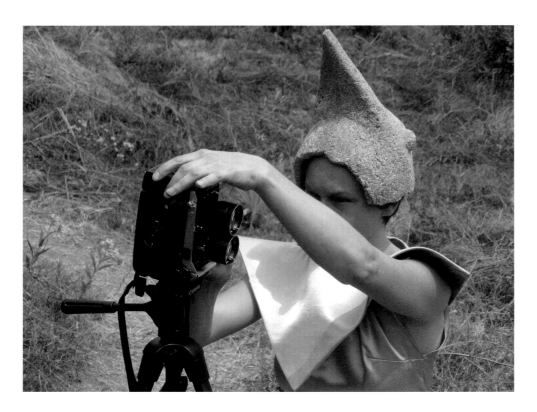

Naomi Rincón-Gallardo

Epimeteo, from *Odisea Ocotepec*, 2014.
Production stills from color video with sound,
3 min. 25 sec.

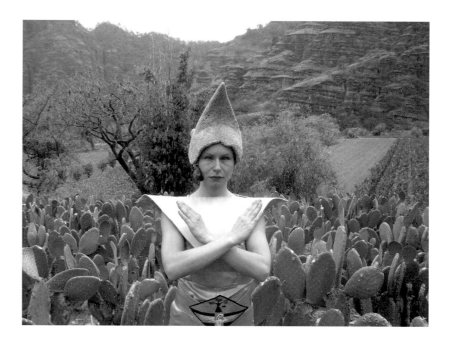

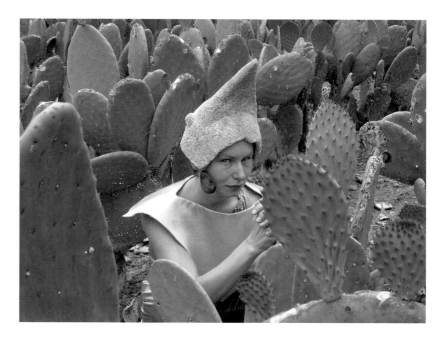

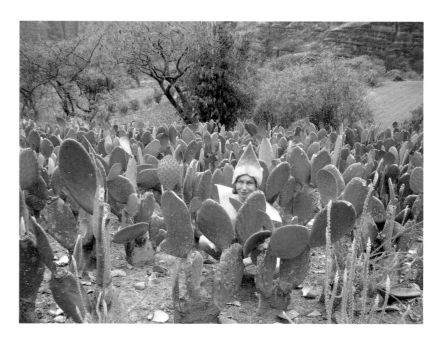

Naomi Rincón-Gallardo

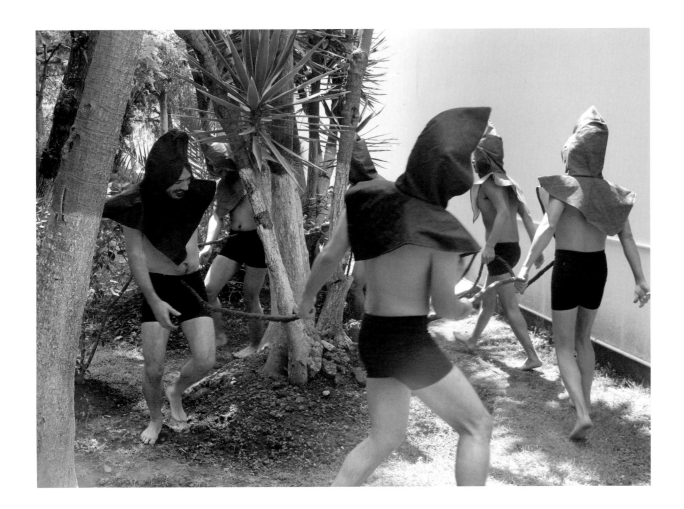

Naomi Rincón-Gallardo

(pages 198–201) *Salida del útero monacal* (*Exit from the Monastic Uterus*), from *Odisea Ocotepec*, 2014. Production stills from color video with sound, 5 min. 23 sec.

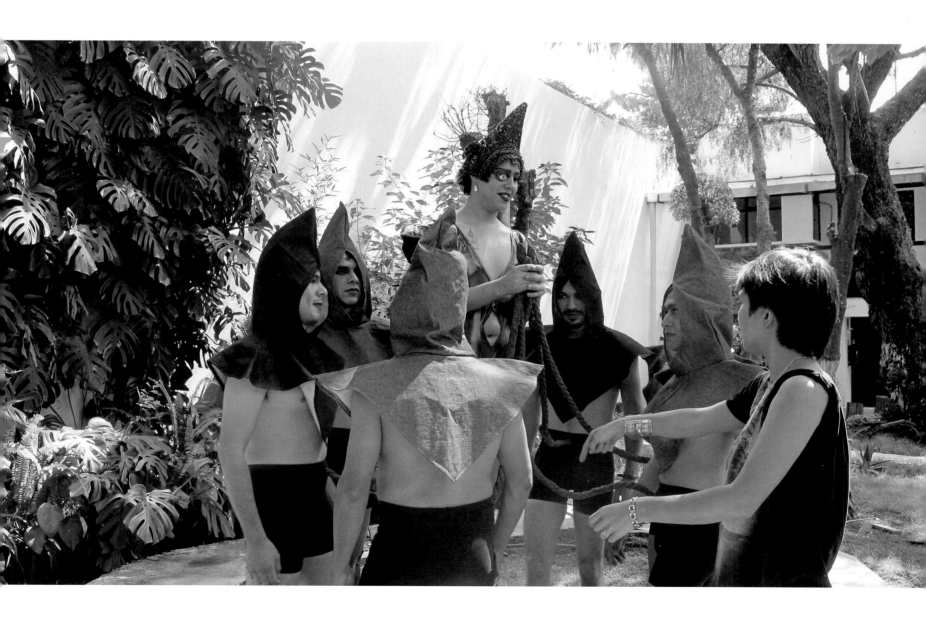

Naomi Rincón-Gallardo

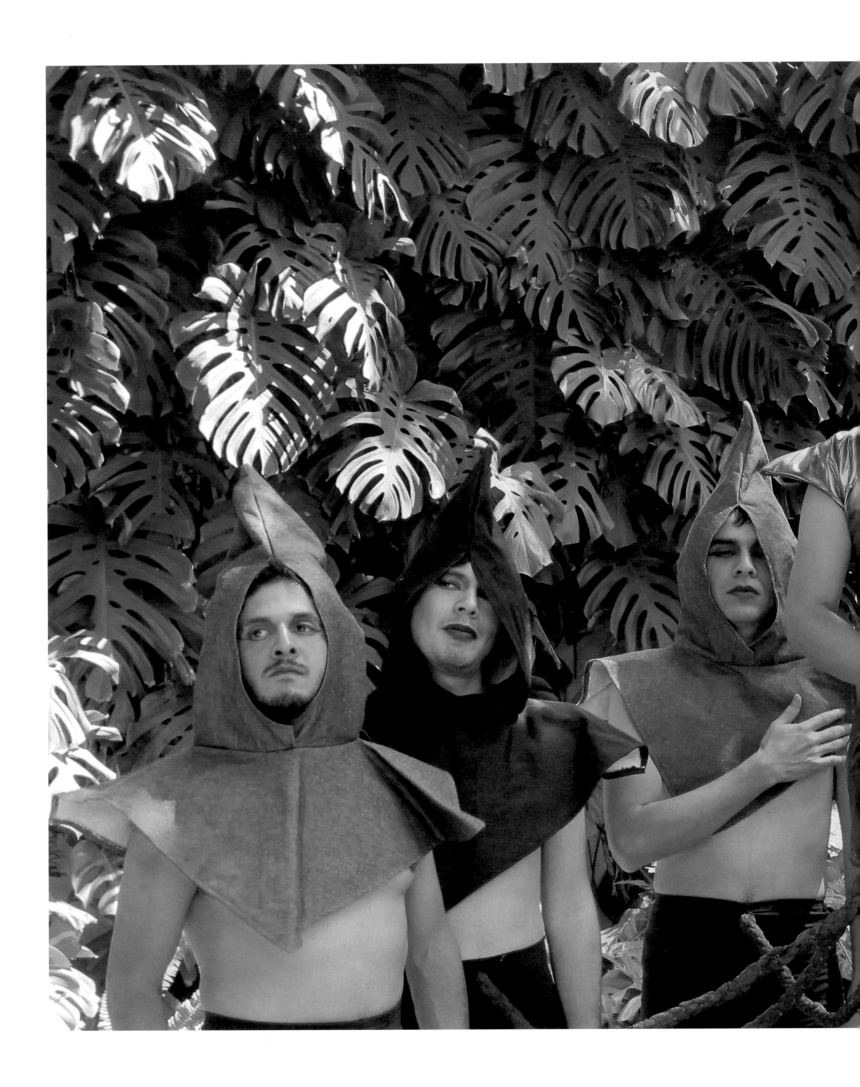

Naomi Rincón-Gallardo

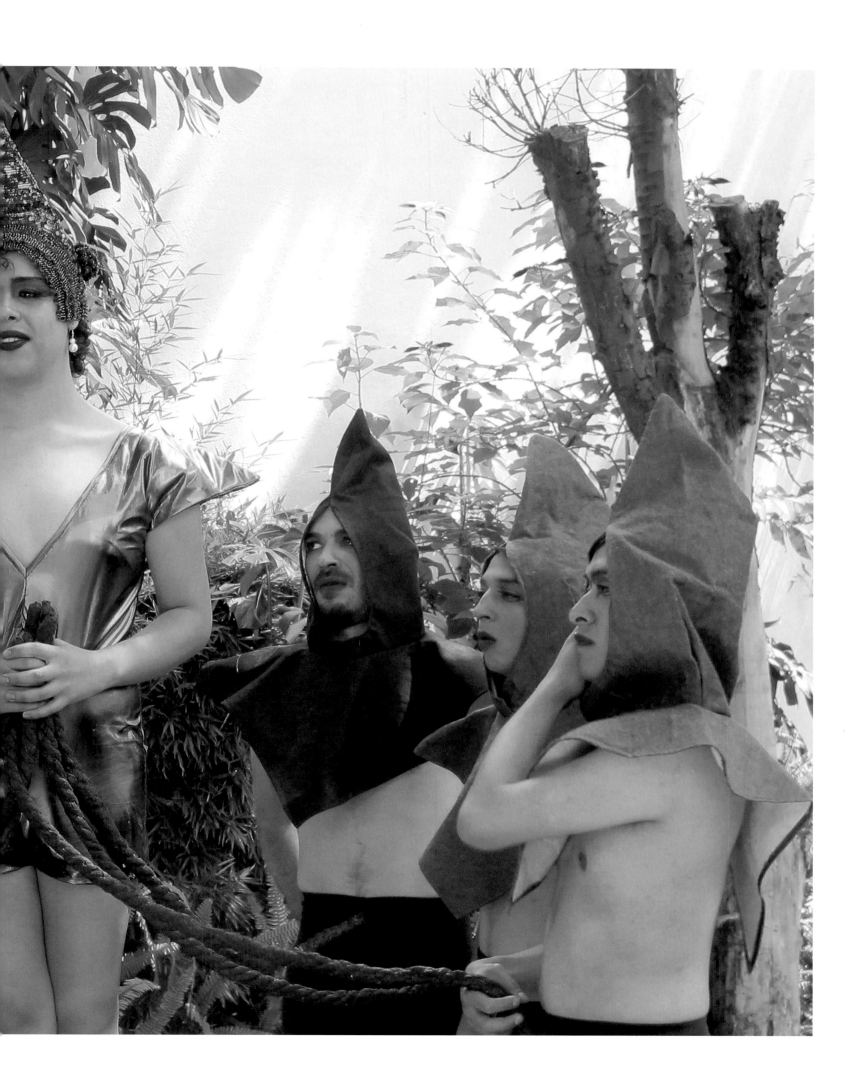

Naomi Rincón-Gallardo

(right) *Salida del útero monacal*, from *Odisea Ocotepec*, 2014. Color video with sound, 5 min. 23 sec.

(pages 204–5) *Psicosíntesis Technicolor* (*Technicolor Psychosynthesis*), from *Odisea Ocotepec*, 2014. Color video with sound, 9 min. 12 sec.

Naomi Rincón-Gallardo

(top) *Anunciación del más allá* (*Announcement from Beyond*), from *Odisea Ocotepec*, 2014. Color video with sound, 3 min. 22 sec.

(bottom) *Verbo alienante* (*Alienating Verb*), from *Odisea Ocotepec*, 2014. Color video with sound, 2 min. 15 sec.

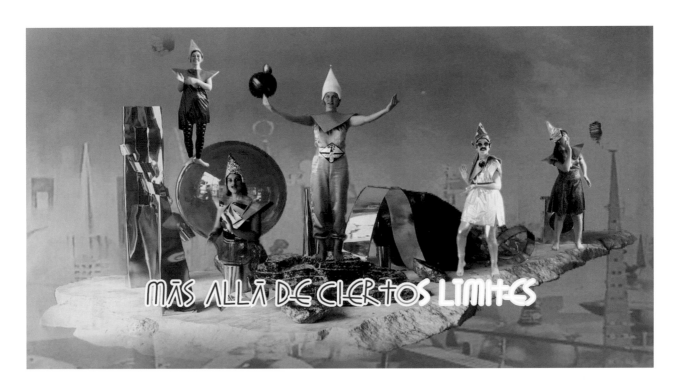

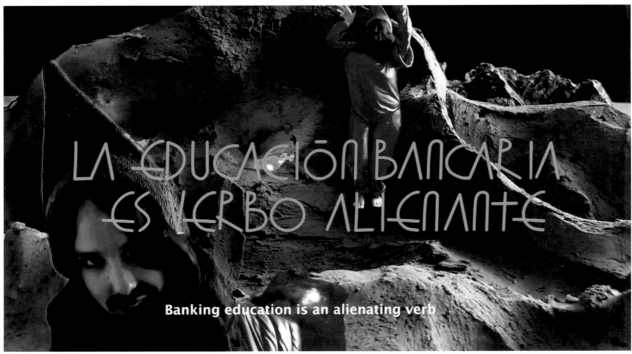

Naomi Rincón-Gallardo

(top) *Epimeteo*, from *Odisea Ocotepec*, 2014.
Color video with sound, 3 min. 25 sec.

(bottom) *Insaciables (Insatiable)*, from *Odisea Ocotepec*, 2014. Color video with sound,
2 min. 38 sec.

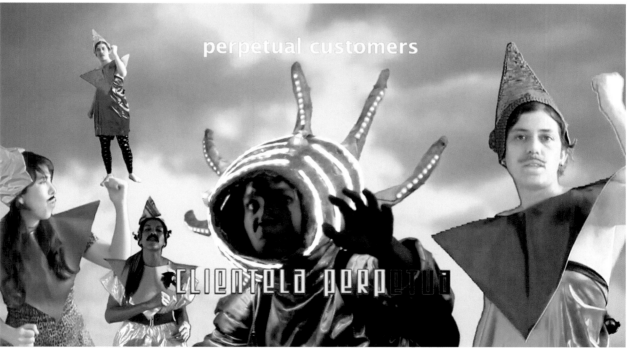

Naomi Rincón-Gallardo

Selected
Chronology

The following chronology contextualizes the work of José Clemente Orozco and the four living artists represented in "Prometheus 2017" (Isa Carrillo, Adela Goldbard, Rita Ponce de León, and Naomi Rincón-Gallardo). The chronology takes its thematic cues from the *Prometheus* mural itself and the contemporary artists' engagements with the mural and its maker, Orozco. The chronology is organized into five main threads: Orozco's biography; Pomona College history; textual and visual representations of the mythic Prometheus; intersections between Orozco, Pomona College, and *Prometheus*; and events from the intertwined histories of Mexico and the United States. The incidents recorded range in scale from the initiation of the North American Free Trade Agreement to Orozco writing a letter to his wife, Margarita. Throughout, themes of politics, education, social unrest, and the role of an artist in society recur. This chronology does not attempt to be exhaustive; instead, it proposes one way among many to contextualize the constellation of artworks in "Prometheus 2017."

Compiled by Benjamin Kersten

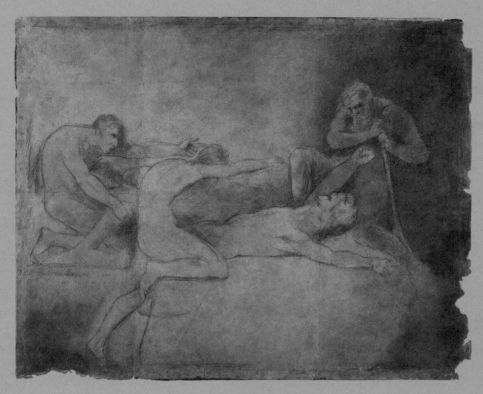

George Romney, *Prometheus Bound*, c. 1778–79. Black chalk on six sheets of laid paper, 40 × 50 in. (101.6 × 127 cm). National Museums Liverpool, The Walker Art Gallery, Liverpool, England

c. 700 BC

Greek poet Hesiod writes the poems *Theogony* and *Works and Days*, the first written accounts of the Prometheus narrative. Prometheus steals fire from the gods of Mount Olympus for the benefit of humankind in direct violation of Zeus. In response, Zeus condemns Prometheus to eternal suffering: Zeus's eagle eats Prometheus's liver every day, and Prometheus's liver heals every night, binding Prometheus to a cycle of torment. *Theogony* includes an account of Prometheus's birth, and *Works and Days* recounts Prometheus's theft from the gods.

c. 500–400 BC

Prometheus Bound, a Greek tragedy about Prometheus, is commonly attributed to the author Aeschylus, although authorship remains debated. Whereas Hesiod represented Prometheus as more of a trickster, this narrative turns Prometheus from a figure of blame into a benefactor. Surviving fragments of two other plays, *Prometheus Unbound* and *Prometheus the Fire-Bringer*, suggest that *Prometheus Bound* was the first of a trilogy.

c. 490–420 BC

Plato writes *Protagoras*, one of his early dialogues. In this version of the myth, fire symbolizes skill, science, and reason, or *techne*, which Plato identifies as superior to instinct. Sappho, Aesop, and Ovid are among many authors who wrote on the Prometheus myth over the next few hundred years.

1360

Giovanni Boccaccio's *Genealogy of the Pagan Gods*, in which Prometheus instills wisdom in every man, demonstrates the transition toward the humanist attitudes of the Renaissance.

1515

Piero di Cosimo's series of five paintings, *The Myth of Prometheus*, indicates a shift toward Prometheus as a theme for visual representation in painting and centers on Prometheus as the creator of humankind.

1519

Hernán Cortés arrives in Veracruz, initiating the Spanish conquest of Mexico.

1772–74

Johann Wolfgang von Goethe writes his poem "Prometheus," published in 1789. In the poem, a defiant Prometheus disparages the gods for their indifference to human suffering.

John Flaxman, *Prometheus Chained to the Rock*, 1792–94. Pencil with pen and ink on paper, 10⅞ × 14¼ in. (27.5 × 36.3 cm). Royal Academy of Arts, London

September 16, 1810

In a speech and battle cry in front of his church, Catholic priest Miguel Hidalgo y Costilla pronounces the Grito de Dolores (Cry of Dolores) in Guanajuato, Mexico, demanding independence from the Spanish. The Mexican War of Independence lasts until 1821.

1816

Lord George Gordon Byron's poem "Prometheus" celebrates the strength and struggles of humanity.

1818

Mary Shelly publishes *Frankenstein; or, The Modern Prometheus*, which reiterates Prometheus's bending of the laws of nature. Shelly explores the overlapping impulses that drive both creation and destruction.

Theodor von Host, Frontispiece to Mary Shelley's *Frankenstein* (London: Colburn and Bentley, 1831). Steel engraving, 3⅝ × 2¾ in. (9.3 × 7.1 cm)

1820

Percy Bysshe Shelly rewrites Aeschylus's lost *Prometheus Unbound*. In Shelly's version, Prometheus's triumph over Zeus personifies the capacity for intellect to overcome the tyranny of religious institutions.

October 4, 1824

The Federal Constitution of the United Mexican States of 1824 is ratified, recognizing a central capital and president while granting authority to the states.

1846–48

The United States instigates war with Mexico. The conflict ends with the signing of the Treaty of Guadalupe Hidalgo, in which Mexico cedes nearly half of its territory, including California, to the United States.

1858–72

Benito Juárez, of Zapotec descent, serves as Mexico's president and helps bring about a period of reform. In 1867, he leads the republic to victory against the five-year French intervention, reaffirming Mexico's sovereignty.

1872

Friedrich Wilhelm Nietzsche writes *The Birth of Tragedy* and uses Prometheus to theorize the relationship between ancient Greece and modern Germany.

November 23, 1883

José Clemente Orozco is born in Zapotlán el Grande (now Ciudad Guzmán), Jalisco, Mexico, to Irineo Orozco Vázquez and María Rosa Flores Navarro.

October 1887

Pomona College is founded.

Sumner Hall at its original location, 1887. Photograph, 9⅝ × 7½ in. (24.3 × 19.2 cm). Special Collections and Libraries, Claremont Colleges Library, Claremont, California

1890

Orozco's family moves to Mexico City after living briefly in Guadalajara, Mexico. Orozco enters the primary school attached to the Teachers College. Orozco takes night courses in drawing at the Academy of San Carlos.

1897–1900

Orozco attends the School of Agriculture in San Jacinto, on a scholarship from the Government of Jalisco, where he trains as an agronomist and cartographer.

1901–14

Orozco studies at the National Preparatory School in Mexico City, with the intention of entering a career in architecture.

1904

Orozco loses his left hand while using gunpowder to make fireworks to celebrate Mexico's Independence Day.

1907–14

Orozco returns to the Academy of San Carlos to study painting and meets mentors Gerardo Murillo (Dr. Atl), who values Michelangelo's expressive representations of anatomy, and Julio Ruelas, a Symbolist who often depicts mythological themes tinged with torment.

1910

The Mexican Revolution begins with calls to overthrow President Porfirio Díaz. Instability lasts for a decade, and power changes frequently in a highly factionalized civil war. After

Díaz flees the country, Francisco Madero is elected president but is later assassinated in a coup led by Victoriano Huerta. Following the coup, Venustiano Carranza organizes a Constitutionalist faction and clashes with the Northern Division, led by Pancho Villa, and the Zapatistas, followers of Emiliano Zapata who seek agrarian and land reforms.

1911

Orozco participates in student strikes at the Academy of San Carlos. During this time, he also works as a cartoonist for Leftist newspapers, often condemning the new government of Francisco Madero.

1912–13

Orozco sets up a studio in Mexico City.

1914

Orozco flees the capital with Dr. Atl and joins Carranza's Constitutionalist forces in Orizaba, Mexico. Orozco contributes satirical artworks to the revolutionary newspaper *La vanguardia* (*The Vanguard*), which Dr. Atl edits.

1916

Orozco's first solo exhibition at the Librería Biblos gallery in Mexico City includes his watercolor series La casa de las lágrimas (The House of Tears), which mainly represents sex workers.

1917

The Constitutional Congress approves the Constitution of Mexico. Military clashes dwindle, although skirmishes continue to occur until Álvaro Obregón, who hails from the northern Mexican state Sonora and supports land reform and secular, state-run education, is elected president in 1920, effectively

bringing the revolution to an end. Leaders from Sonora preside over the following fourteen years, guiding post-revolutionary reconstruction.

1917

Due to unfavorable conditions for the arts in Mexico, Orozco travels to San Francisco, California, and New York City. During his journey, customs agents in the border city of Laredo, Texas, destroy about sixty of La casa de las lágrimas paintings, citing them as immoral.

1920

Orozco returns to Mexico City and works in the suburb of Coyoacán.

1920s and early 1930s

Pomona College hosts multiple Friends of the Mexicans conferences, attended by Mexican and United States government officials, addressing topics such as immigration, economic status, and the educational needs of Mexicans and Mexican-Americans in Southern California.

October 14, 1921

Pomona College President James Blaisdell institutes an annual celebration of Founders' Day. As part of the celebration, students take part in the "Ceremony of the Flame," during which they pass a "torch of Christian education."

1921–24

President Obregón appoints lawyer and philosopher José Vasconcelos as Minister of Public Education. Vasconcelos invites artists to paint works on public walls as part of a wider effort to engage intellectuals in furthering Obregon's goals to consolidate a new sense of national community.

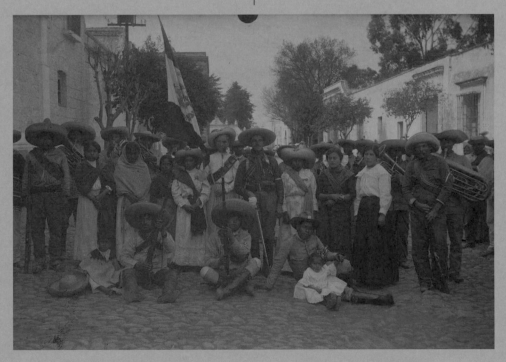

Sabino Osuna, *Un ejercito del pueblo* (*A People's Army*), c. 1910–14. Photograph. Special Collections & University Archives, UCR Library, University of California, Riverside

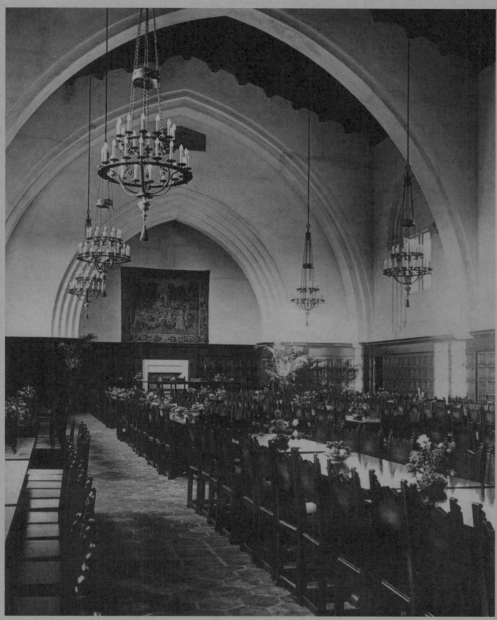

W. M. M. Clarke, *Frary Dining Hall before the painting of Prometheus*. 1929.
Photograph. Pomona College Museum of Art Archives

December 1925

Orozco exhibits work at the Galerie Bernheim-Jeune in Paris, France.

1926

Orozco paints the mural *Revolución social* (*Social Revolution*) at the Industrial School in Orizaba, Veracruz, Mexico, and begins a series of drawings titled Horrores de la Revolución (The Horrors of the Revolution).

1926

Orozco returns to the National Preparatory School and replaces much of his earlier work. He removes panels including *Cristo destruyendo su cruz* (*Christ Destroying His Cross*). He paints new images including *Cortés y la Malinche* and *La trinchera* (*The Trench*), dedicated to themes of the conquest, the revolution, and political corruption.

May 9, 1927

Angelos Sikelianos, Greek poet and founder of the Delphic movement, and his wife, Eva Palmer-Sikelianos, organize the First Delphic Festival in Greece, during which they stage a production of Aeschylus's *Prometheus Bound* at the ancient theater of Delphi.

1927

Orozco returns to the United States, arriving in New York City on December 16. He intends to stay for three months but remains for seven years.

1927–29

Orozco predominantly resides in New York City. Here he meets Alma Reed, a writer and translator of poems by Sikelianos. With

1921–24

Vasconcelos invites a team of artists, including Orozco, to paint the walls of the National Preparatory School in Mexico City, launching the Mexican Mural Movement. Orozco begins his first murals there in 1923, but student protests bring the project to a halt in 1924.

1922

The Society of Independent Artists in New York invites the Society of Mexican Artists to present an exhibition, which includes Orozco, David Alfaro Siqueiros, Diego Rivera, Jean Charlot, Dr. Atl, and others.

1923

Xavier Guerrero organizes the first exhibition of modern art from Mexico in the United States, in Los Angeles: "The Arts and Crafts of Mexico," with watercolors and drawings by Guerrero, Adolfo Best Maugard, and art students in Mexico.

November 23, 1923

Orozco marries Margarita Valladares. The couple has three children.

1923–24

The Syndicate of Technical Workers, Painters, and Sculptors (El Sindicato de Obreros Técnicos, Pintores, y Escultores), based in Mexico City, writes a manifesto and launches a paper called *El machete* (*The Machete*). In 1924, following an attempted coup led by Adolfo de la Huerta, they publish a seventh issue, featuring their manifesto, which condemns "bourgeois individualism" and advocates for art that fights for the people.

1925

Orozco paints the privately commissioned *Omnisciencia* (*Omniscience*) at the Casa de los Azulejos in Mexico City.

*Entrance To Refectory
Mens Dormitory Pomona College
Webber & Spaulding Architects*

Webber and Spaulding Architects, Drawing
of entrance to Frary Dining Hall, 1929. Photograph of
charcoal on paper, 7⅜ × 9⅝ in. (18.8 × 24.4 cm).
Special Collections and Libraries, Claremont Colleges
Library, Claremont, California

PROMETHEUS RECONCEIVED

Orozco's Nearly Completed Fresco of Fire-Bringing Titan Gives Claremont Masterpiece

BY ARTHUR MILLIER

When Prof. Jose Pijoan asked Jose Clemente Orozco to come from New York to Claremont to paint a mural, that was a typical act of audacious faith on the professor's part.

The Mexican artist arrived. Said the professor, "I have no money." The painter said nothing for a moment then with a quiet smile asked, "But have you the wall?"

The history of what followed is the history of most significant achievements. The historian claimed the wall by right of conquest and the fresco painter, during the last three months, has energized that wall with his sublime conception of Prometheus bearing fire to cold, longing humanity, until it lives as probably no wall in the United States lives today.

It is not quite finished. When the scaffolds come down at commencement time, artist and art his-torian will leave us. Orozco for New York, Pijoan for Paris and Spain and a new professorship at the University of Chicago. But Prometheus will remain and the visitor to California, seeking one of the stirring paintings of our time, will go to Pomona College to see the giant sacrificing himself as he carries out his mission. He will see more than a Greek myth for here is an eternal truth of more value than much those college boys learn from their books. The bringers of fire to mankind must—as Orozco shows—burn the hands and back that bear the flame.

It was Architect Sumner Spaulding's feeling that the great walls

(Continued on Page 16, Column 7)

PROMETHEUS RECONCEIVED

(Continued from Ninth Page)

of the dining hall needed color. With Prof. Pijoan he sought for decoration. They saw a tapestry and an old painting of men at table surrounded by food; but these things cost too much. They thought then ure drawing. Where joints turn, where sinews grow taut, every emotion is expressed. He has little interest in anatomy for its own sake and so despite the great scale there is no feeling of oppressive bulk, only of superb power. I would like to see him paint an "Agony in the Garden."

Many people have been out to Claremont to see the fresco grow. Some are thrilled, some are disturbed, but none see it and remain passive. It is an unpedagogic painting which some find disturbing to the gentle, cloistered ideal of a college. But adults often misjudge youth with its longing for action, sacrifice and suffering. Orozco, painting out of his background of revolution and war in Mexico—just such a background as the renaissance painters knew—presents his theme with the direct violence it deserves. A master of dynamic composition his picture is powerful beyond anything one can anticipate.

Actually it brings to us a bit of the most significant art outburst of our time. The esthetic experiments of modern Paris are trifling matters compared to the Mexican wall paintings of the last nine years.

* * *

THE first time Orozco came to the United States he tinted photographs for a living in California. Going back to Mexico City, he painted his murals in the Preparatory School which were, in the violent manner of the day, stoned and worshiped. During the revolution he had observed the tragedy and humor that stalks in the wake of armies and his drawings and paintings depicting these things have been likened to Goya's. He cartooned his countrymen unmercifully and his drawings, published in political magazines, are said to have made and unmade cabinets. At Pomona his associates describe him as quiet and melancholy. His photograph reveals a face sensitive and distinguished.

His lithographs and reproductions of his other works tell us of exceptional power to extract from an experience just those elements that characterize it. This faculty gives to his work a singular force that makes his compositions unforgettable. On first seeing the fresco one may involuntarily exclaim, "How crude!" It is not crude, but it is brutally direct in presenting those lines, surfaces and muscles that tell of the giant's suffering. And it is a special tribute to the artist's sense for wall painting that he has given his theme a design that would be less interesting on a smaller scale. He has done that rare thing, been big enough for his wall.

No man can say when an artistic renaissance will dawn. We plod along and work, but we are scarcely yet in the midst of so exciting an experience. But something did happen in Mexico and produced artists who had the power to attack and go clean through with their themes. Their aim was seldom a consciously esthetic one. Though all the leaders except Orozco had studied in Europe, their impulsion was to speak picture language to a wide public proclaiming indifferently the pain and pleasure, the corruption and no-

(Continued on Page 25, Column 5)

THRILL FROM AIR CO

The Claremont Fresco

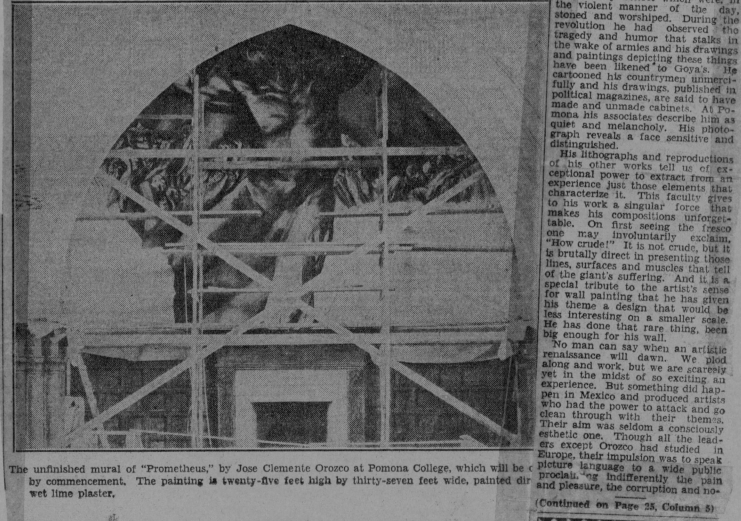

The unfinished mural of "Prometheus," by Jose Clemente Orozco at Pomona College, which will be completed by commencement. The painting is twenty-five feet high by thirty-seven feet wide, painted directly on wet lime plaster.

REQUIEM *Wash Drawing* by JOSÉ CLEMENTE OROZCO 1915

NEW WORLD, NEW RACES AND NEW ART

by José Clemente Orozco

THE ART OF THE NEW WORLD cannot take root in the old traditions of the Old World nor in the aboriginal traditions represented by the remains of our ancient Indian peoples. Although the art of all races and of all times has a common value—human, universal—each new cycle must work for itself, must create, must yield its own production—its individual share to the common good.

＊　　＊　　＊

To go solicitously to Europe, bent on poking about its ruins in order to import them and servilly to copy them, is no greater error than is the looting of the indigenous remains of the New World with the object of copying with equal servility its ruins or its present folk-lore.

However picturesque and interesting these may be, however productive and useful ethnology may find them, they cannot furnish a point of departure for the New Creation. To lean upon the art of the aborigines, whether it be of antiquity or of the present day, is a sure indiction of impotence and of cowardice, in fact, of fraud.

If *new* races have appeared upon the lands of the *New* World, such races have the unavoidable duty to produce a *New Art* in a new spiritual and physical medium. Any other road is plain cowardice.

＊　　＊　　＊

Already, the architecture of Manhattan is a new value, something that has nothing to do with Egyptian pyramids, with the Paris Opera,

xlv

José Clemente Orozco, "New World, New Races and New Art." *Creative Art*, vol. 4 (1929), p. 45. Pomona College Museum of Art Archives

Palmer-Sikelianos, Reed cofounds the cultural salon Ashram and Delphic Studios gallery and provides exhibition space and support for Orozco.

January– February 1928

The Art Center Gallery in New York City hosts a large group show of Mexican art under the auspices of the Rockefeller Foundation.

September– October 1928

Orozco exhibits a series of lithographs, Mexico in Revolution, based upon his earlier Horrores de la Revolución drawings, at the Ashram and at the gallery of Marie Sterner in New York City.

1929

The Eli P. Clark Dormitories and Frary Dining Hall complex, designed by architect Sumner Spaulding, opens. The project combines Beaux-Arts, medieval monastic, and Spanish Mission Revival Style architecture.

1929

The idea arises for a mural project in the interior of Frary Hall at Pomona College. Many accounts suggest that José Pijoán, who was teaching art history at the college, conceived of the idea in conversation with Spaulding. Pijoán discusses the matter with Jorge Juan Crespo de la Serna, a Mexican artist living in Hollywood. Crespo de la Serna contends that he suggested that the

college hire Orozco. Without approval from the administration, Pijoán and Crespo de la Serna contact Orozco and invite him to paint the mural.

January 1929

Orozco publishes "New World, New Races and New Art" in *Creative Art* journal, which proclaims the mural is the most altruistic form of art.

April 1929

Orozco exhibits paintings, lithographs, and drawings depicting New York and Mexico and studies for the Preparatory School murals at the Art Students' League in New York City. He also illustrates the first English edition of Mariano Azuela's novel *Los de abajo* (*The Underdogs*).

November 1929

In the year following his presidency in Mexico, Plutarco Elías Calles founds the National Revolutionary Party (Partido Nacional Revolucionario, PNR), a centrally controlled party machine indistinguishable from the state. The party formation capitalizes on the symbolism of the Mexican Revolution, using it as a legitimating source for power.

1930

Orozco exhibits work in several cities throughout the United States, including Detroit, Boston, San Francisco, Denver, Los Angeles, and New York.

"Prometeo: El fresco de Pomona." *Nuestra Ciudad*, vol. 1, no. 7 (October 1930), p. 49. Special Collections and Libraries, Claremont Colleges Library, Claremont, California

(pages 216–17)
Interior view of Frary Hall and *Prometheus*, 1933.
Pomona College Archives

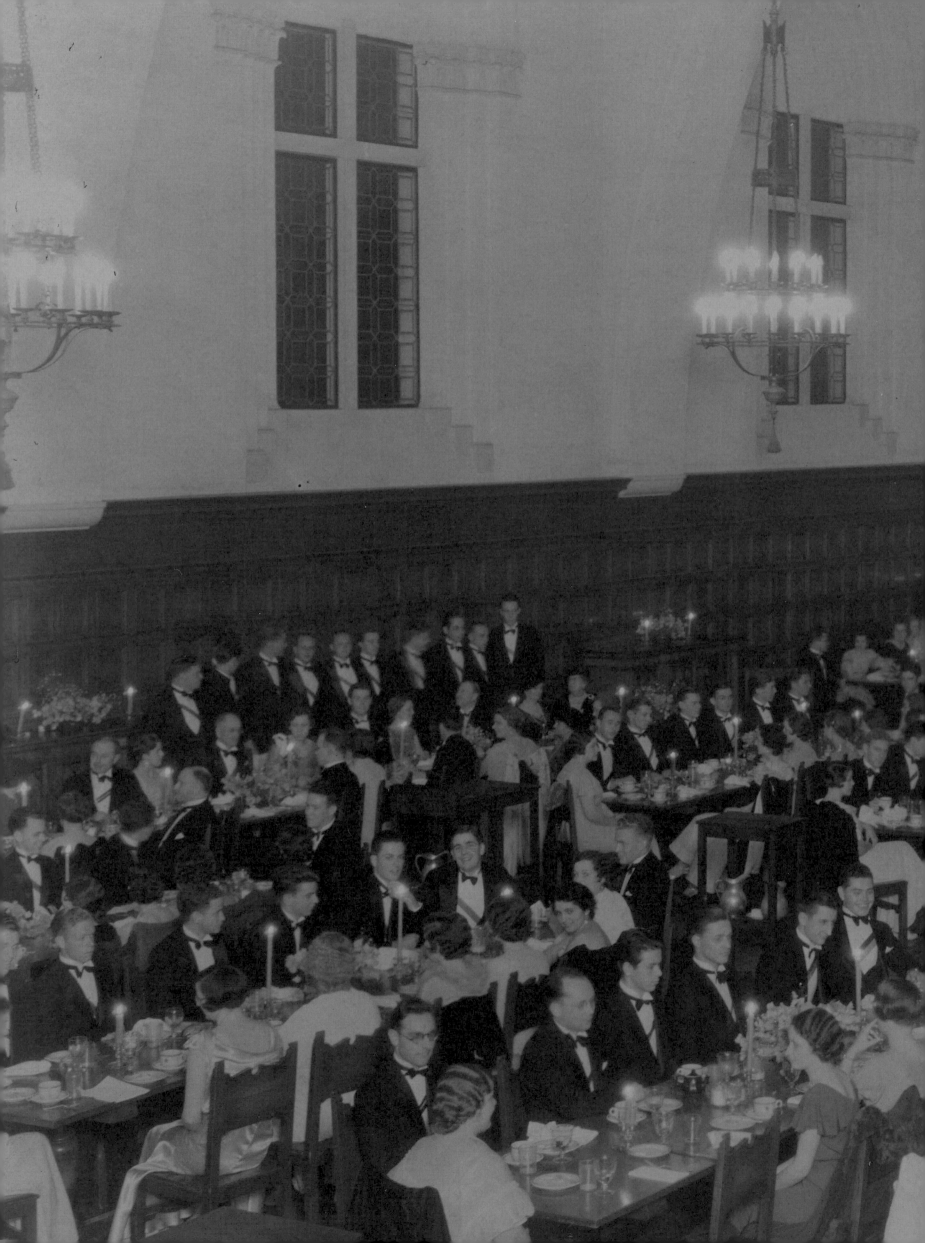

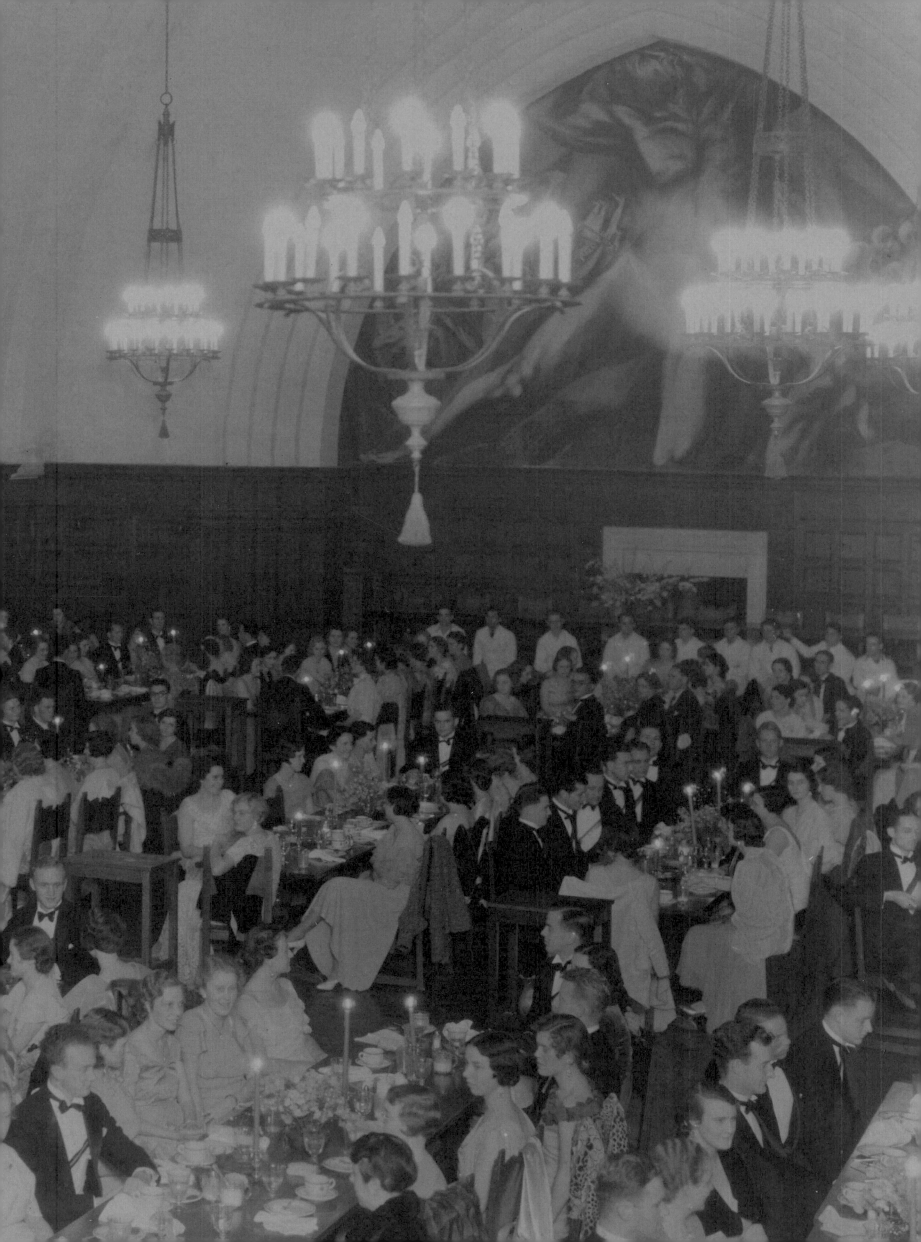

218

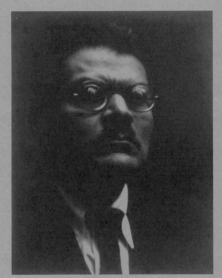

Edward Weston, *José Clemente Orozco*, 1930. Gelatin silver print, 9⅝ × 7⅜ in. (24.5 × 18.7 cm). Pomona College Museum of Art, Claremont, California

January 17, 1930
Orozco sends a telegram to Crespo de la Serna accepting the project at Pomona College and indicating that he could begin painting in March.

March 19, 1930
Pomona College newspaper *The Student Life* announces the plan for a mural and the choice of Orozco. It notes that students have raised the initial funds for the project.

March 21, 1930
Orozco and Crespo de la Serna arrive in Claremont. Pijoán arranges for Orozco and Crespo de la Serna to stay with students in the Clark Dormitories. After an initial visit to the site, they spend two weeks planning Orozco's mural.

April 5, 1930
The *Los Angeles Times* reports on preparations for the mural project, reproducing a sketch of the mural and noting that scaffolding has been erected.

April 19, 1930
The Student Life publishes a special "Fresco Edition." Articles discuss fresco techniques, the Prometheus narrative, the necessity of art at a college, early critical reception of the mural, social change, and the idea of having Orozco paint the remaining walls of Frary Dining Hall.

April 28, 1930
A solar eclipse takes place. Orozco describes the phenomenon in a letter to his wife Margarita.

May 17 and 26, 1930
The Student Life publishes interviews with Orozco. In the May 17 interview, Orozco indicates that main parts of the mural are completed.

June 6, 1930
The Student Life reports that Orozco has completed the *Prometheus* fresco after 57 days of work. In an interview for *Time* magazine, Spaulding says, "I feel as though the building would fall down if the fresco were removed." Despite his enthusiasm, the mural receives a mixed reception, with some disparaging the treatment of an Ancient Greek myth by a Mexican artist.

July 12, 1930
Orozco sends a letter to Crespo de la Serna expressing confusion over the promised fee for the mural, which he contends he never received.

October 1930–October 1931
Seven paintings and four drawings by Orozco are on view in the exhibition "Mexican Arts," which opens at the Metropolitan Museum of Art and travels to several other institutions in the United States, including the Los Angeles County Museum of Art.

1931
Orozco exhibits work in a solo show at the Downtown Gallery in New York City and participates in several group shows.

January 19, 1931
A series of murals painted by Orozco at the New School for Social Research in New York City is inaugurated. The murals are entitled *Science, Labor, and Art*; *Homecoming of the Worker of the New Day*; *Struggle in the Orient*; *Struggle in the Occident*; and *Table of Universal Brotherhood*.

February 26, 1931
Immigration agents surround La Placita, the heart of a Mexican community near Olvera Street, in downtown Los Angeles, and conduct one of the biggest raids in the midst of what officials call repatriation campaigns. During the 1930s, the United States government deports somewhere between 500,000 and two million Mexican Americans and Mexicans. Most of those deported are United States citizens.

August 1931
The Plaza Art Center on Olvera Street in Los Angeles hosts a city-sponsored exhibition, organized by the Delphic Studios and the Weyhe Galleries of New York and curated by F. K. Ferenc and Crespo de la Serna. The exhibition includes works by Orozco.

1932
Orozco spends three months traveling in Europe, visiting England, France, Italy, and Spain.

1932–34
Orozco paints *The Epic of American Civilization* cycle at the Baker-Berry Library at Dartmouth College in Hanover, New Hampshire. He completes the mural on February 13, 1934.

1934
Orozco exhibits in Chicago and La Porte, Indiana. The artist returns to Mexico, where he and Rivera are commissioned by the state to paint murals at the Palace of Fine Arts in Mexico City. Orozco paints *Catarsis*

Party at Alma Reed's Delphic Studios, with David Alfaro Siqueiros, Chago Rodriguez, Alma Reed, Enrique Riverón, José Clemente Orozco, and Julia Codesico, c. 1936. Photograph, 7½ × 9½ in. (19 × 24 cm). Enrique Riverón papers, 1918–90. Archives of American Art, Smithsonian Institution, Washington DC

SUPLEMENTO DOMINICAL DE

25 DE SEPTBRE. DE 1949
SEGUNDA EPOCA
Número
131
Director-Gerente:
Lic. Guillermo Ibarra

EL NACIONAL
AL SERVICIO DE MÉXICO
REVISTA MEXICANA DE CULTURA

HOMENAJE A JOSE CLEMENTE OROZCO

Orozco Autorretrato.

Front page of the Sunday supplement to *El Nacional*, September 25, 1949. Special Collections and Libraries, Claremont Colleges Library, Claremont, California

(*Catharsis*), depicting humanity in an uproar. The Palace is inaugurated on September 29, 1934.

August 29, 1935–June 30, 1943
The Federal Art Project funds artists to paint murals in public buildings in the United States as part of the New Deal, partially inspired by Obregón and Vasconcelos's earlier program of mural commissions in Mexico.

1936
Orozco completes murals at the Assembly Hall of the University of Guadalajara, including *Hombre creativo* (*Creative Man*) and *Los miserables* (*The Wretched*).

February 1936
Orozco returns briefly to New York to attend the American Artists' Congress as part of the delegation of Mexican revolutionary writers and artists.

1937
Orozco completes murals at the Government Palace in Guadalajara on the theme of independence, including *Hidalgo* and *El circo contemporáneo* (*The Contemporary Circus*).

1938
President Lázaro Cárdenas renames the PNR the Party of the Mexican Revolution (Partido de la Revolución Mexicana, PRM).

1939
Orozco completes murals for the Hospicio Cabañas in Guadalajara. The 55 panels draw from Mexican history to depict men, machines, and war, culminating in the cupola fresco *El hombre de fuego* (*Man of Fire*).

September 16, 1939
Manuel Gómez Morín founds the National Action Party (Partido Acción Nacional, PAN), which becomes the organized opposition to the ruling party.

1940
Orozco paints the portable mural *Dive Bomber and Tank* for the New York Museum of Modern Art's exhibition "Twenty Centuries of Mexican Art" in June. The exhibition runs from May 15 to September 30 and includes a brochure with text by Orozco.

1940
Orozco paints the mural *Alegoría de Mexico* (*Allegory of Mexico*) at the Gabino Ortíz Library in Jiquilpan, Michoacán.

1940–52
The Mexican state embraces muralism again under the presidencies of Manuel Ávila Camacho and Miguel Alemán.

1941
Orozco completes a mural representing two allegories of justice surrounded by disorder for the Supreme Court of Justice in Mexico City.

1942
Orozco begins decoration for the church of the Hospital de Jesús Nazareno, in Mexico City, on the subject of the apocalypse; he never completes the project.

1942
"The Indefinite Period," organized by McKinley Helm at the Institute of Modern Art, in Boston, travels to Los Angeles. The exhibition showcases Mexican art from the twenties and thirties.

1943
Orozco is a founding member of the National College in Mexico City, where he presents an exhibition of his work in October.

1945
Orozco completes murals for the Turf Club of Mexico City, including *Joie de vivre* and a privately commissioned mural *La primavera* (*Spring*) for Dr. José Moreno.

1946
Ávila Camacho renames the PRM the Institutional Revolutionary Party (Partido Revolucionario Institucional, PRI).

1947
The National Institute of Fine Arts in Mexico City exhibits a retrospective of Orozco's work.

Student Life, Oct. 27, 1953

'Prometheus' Fresco, Center of Much Controversy, Has Interesting History

Appropriate Murals Depicting Other Myths Planned, But Orozco Left, Leaving No Artist Available to Match Power of His Work

Did Pomona College pay Jose Orozco for painting his world famous mural, "Prometheus", on the north wall of Frary Dining Hall?

According to a letter written shortly before his death in 1949, he received no money for his work. The story collected from Pomona College professors, including Dr. James W. Crowell, and from Mrs. Earl (Fuzz) Merritt, is this:

The administration wanted a mural in Frary. In the art history department at the time (1930), there was a Professor Pijohn, who was instrumental in bringing the Mexican artist here, as his first American commission.

Here the story differs. Mr. Crowell contends the agreement was that the students raised $1,000 and Professor Pijohn collected contributions amounting to $1,000, and gave this amount to Orozco.

Mrs. Merritt says Orozco arrived at Pomona, and found he had no contract. But, he decided, "Here is a wall. I will paint it." His original plan was to paint other Greek myths around the hall.

After he finished Prometheus, there was no organized effort to retain him, so he returned to New York, with no money, Mrs.

—Frampton Photo

"'Prometheus' Fresco, Center of Much Controversy, Has Interesting History." *The Student Life*, October 27, 1953. Special Collections and Libraries, Claremont Colleges Library, Claremont, California

Merritt states, and perhaps a little bitter.

To Dartmouth

After doing a mural at the School of Social Research in New York, he went to Dartmouth, where he did a series of murals on three sides of a long room.

One side of this was divided into two parts. One shows the origin of Latin American culture, the other of North American culture. Included in this section are skeletons, in mortar boards, surrounded by test tubes, filled with our cultures. Although there is no definite proof, it is said that one of these fossils resembles President Jackwell, then president of Scripps, and the other is a caricature of President Edmunds, president of Pomona at the time.

Raise $2000

According to Mrs. Merritt, Orozco's agent arrived at Pomona from New York, insisting upon payment for his work. It was agreed that if the students, led by Associated Men Students, could raise $1,000, Professor Pijohn would find donations for the rest. Although there are records which say AMS did raise their $1,000, there is no proof that it ever reached Orozco or his agent, who says that amount was to have been $2,500.

Professor Dennison, of the philosophy department, was a great supporter of the mural, and explained its symbolism, beauty and appropriateness.

Stole Fire

Prometheus was the Greek god who outwitted Zeus and stole fire from the chariot of the sun. He gave this fire back to mankind, from whom Zeus had taken it. For this effrontery, Prometheus was chained to a peak where each day vultures fed on his liver, which, each night was restored. From this torture he was delivered by Hercules. Mankind is reputed to be indebted to him for many useful arts and for the use of fire, plants, and domestic animals.

Off-Center Anatomy

Originally Prometheus was not quite as "nude" as in his present form. At the insistence of critics, Orozco returned to the mural just before he left the campus, and finished the more detailed work. Therefore parts of Prometheus' anatomy are slightly off-center, and not complete.

One of the arguments for not finishing the room with murals was that it would destroy the acoustics of the hall. But overriding this was the "inappropriateness" of such a mural in the dining hall, as apparently some of the trustees considered this work.

Sketches Displayed

Original sketches on which the fresco is based will be displayed in the Honnold Library exhibit this month. The display will also contain scrapbooks of materials the muralist used, newspaper clippings, photographs and other items.

1947

Orozco completes a series of easel paintings entitled *Los teules* (*White Gods*), which depicts the suffering that accompanied the conquest of Mexico.

1948

Orozco completes an outdoor mural, *Alegoría nacional* (*National Allegory*), at the National Normal School, in Mexico City.

1948

Orozco accompanies Rivera, Frida Kahlo, Siqueiros, Dr. Atl, Juan O'Gorman, and other left-wing intellectuals in a raid on the Del Prado Hotel to restore to a Rivera mural the words "God does not exist," which right-wing Catholic students had removed.

1949

Orozco returns to the Government Palace in Guadalajara and completes his last mural. Titled *La gran legislación revolucionaria Mexicana* (*The Great Mexican Revolutionary Legislation*), the mural depicts Father Miguel Hidalgo, independence movement leader José María Morelos, Benito Juárez, and Venustiano Carranza.

September 7, 1949

Orozco dies in Mexico City of heart failure at the age of 65. He is buried in Mexico City's Rotunda of Illustrious Men.

November 30, 1949

Pomona College Associated Men Students (AMS) holds a memorial dinner in tribute to Orozco, with materials on display in the library and a lecture by Dr. Kenneth E. Foster, chairman of the art department.

Dr. Peter Selz, chairman of the Pomona College art department, showing a student a photo-mural of work by José Clemente Orozco, 1956. Photograph. Pomona College Museum of Art Archives

October 21–30, 1953

The library at the Claremont Colleges presents an exhibition of materials related to Orozco and Prometheus. On October 28, the International Relations Club hosts a banquet honoring Orozco and the new Mexican consul general in Los Angeles, Adolfo G. Dominguez.

September 22, 1955

Alma Reed hosts a conference titled Orozco y el Nuevo Humanismo (Orozco and the New Humanism) at Galería Excelsior, Mexico City.

May 1956

The *Los Angeles Times* and *Pomona Progress Bulletin* feature articles on Pomona College students, including Richard Chamberlain '56 and Mowry Baden '58, who clean the *Prometheus* mural under the direction of Professor of Art James Grant.

November 14, 1956

Tirsa Scott, wife of artist and art historian David W. Scott, writes to Margarita Orozco to enquire about purchasing the preparatory drawings for *Prometheus* on behalf of Pomona College. This inquiry launches almost a half century of negotiations around the acquisition of the preparatory works.

1957

David Scott publishes the first scholarly work about the *Prometheus* mural in the *College Art Journal* XVII, no. 1.

1961

Pomona College establishes coeducational dining in Frary Hall on Monday evenings. Male student protestors hold signs with messages such as "Eat alone and like it"; women occupy the dining hall, holding signs with messages such as "Prometheus for president."

November 22, 1962

Clemente Orozco, Orozco's oldest son, writes to Tirsa Scott about the preparatory drawings for *Prometheus*. He expresses the opinion that the drawings should reside at Pomona College with the mural.

1965

The *Prometheus* preparatory drawings are exhibited at Pomona College.

1967

Black and Mexican American students at Pomona College demand ethnic studies departments.

Mexico en el Arte, no. 10–11 (Mexico City: Institute of Fine Arts, 1950). Front cover, featuring one of José Clemente Orozco's murals at the Supreme Court of Justice, in Mexico City, completed in 1941. This panel of the mural illustrates the struggles of workers. Special Collections and Libraries, Claremont Colleges Library, Claremont, California

Initially, this was quite a year.

Cartoon in *The Student Life*, May 13, 1969. The acronyms refer to the political unrest and organizing that took place on campus. Special Collections and Libraries, Claremont Colleges Library, Claremont, California

(pages 222–23) "Vida Illustres: José Clemente Orozco" (August 12, 1968), pp. 26–27. Special Collections and Libraries, Claremont Colleges Library, Claremont, California

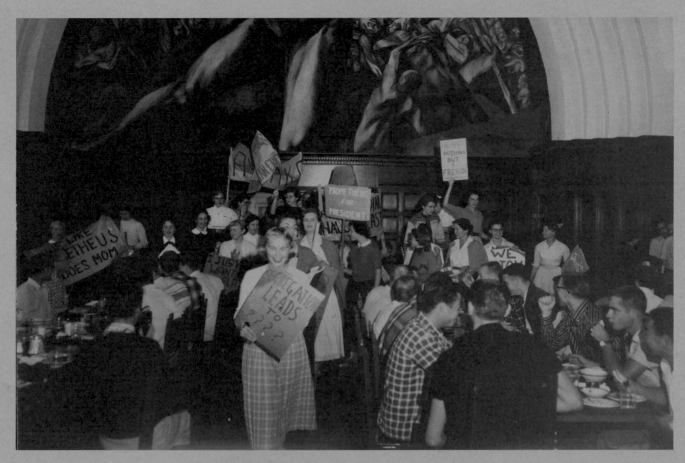

Female students occupying Frary Dining Hall in support of gender integration, 1969. Photograph.
Special Collections and Libraries, Claremont Colleges Library, Claremont, California

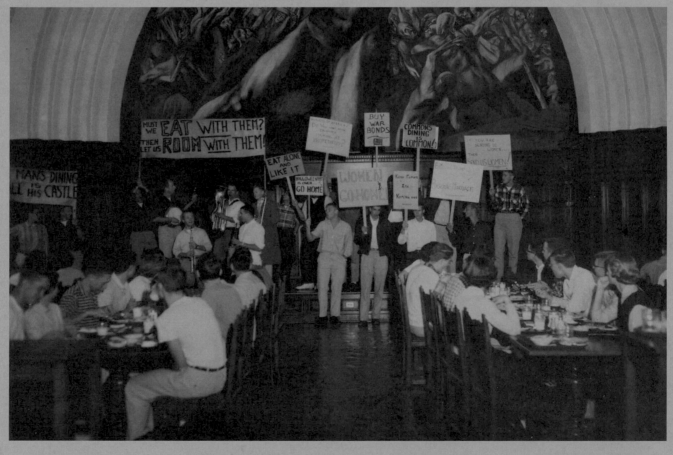

Male students protesting the gender integration of Frary Dining Hall, 1969. Photograph.
Special Collections and Libraries, Claremont Colleges Library, Claremont, California

July 1968

The Mexican military violently represses a street fight between students at the National Preparatory School in Mexico City. On July 30, soldiers blast the main door of the school with a bazooka, killing students inside the building. The event sparks organizing efforts among students already dissatisfied with the Mexican government.

September 1968

Mexican American students at the Claremont Colleges found the organization Students for the Advancement of Mexican-Americans (SAMA). Students continue to push for a Chicano Studies program and the recruitment of more Mexican American students. Black students establish the intercollegiate Black Student Union.

October 2, 1968

Police officers and military troops shoot into a crowd of unarmed protestors at the Plaza de las Tres Culturas in the Tlatelolco area of Mexico City, killing a large number of students and civilians. The government attempts to quell the anti-government demonstrations before the inauguration of Mexico City's Summer Olympics on October 12.

March 1969

The Black Student Union holds rallies across the Claremont Colleges. Faculty and Students Together (FAST) is founded to show support for proposals made by Black and Mexican American students. The Chicano Studies Department, the second oldest in the nation, is founded alongside the Intercollegiate Department of Black Studies (IDBS).

1969–70

The gender integration of Pomona College dormitories occurs, and Frary Dining Hall becomes fully coed. Students pay increasing attention to the minimized genitals of the nude male body of *Prometheus* and instances of vandalism to the mural occur.

1971

Ben Johnson, founder and director of the conservation laboratory at the Los Angeles County Museum of Art, is the first professional conservator to treat the mural after a roof leak causes damage. Johnson also treats areas of flaking paint and removes a penis that students had added to the mural in acrylic paint.

November 1972

An article in *The Student Life* on Prometheus's lack of genitals recounts an anonymous attempt to attach a codpiece to the fresco.

1976

Pomona College professor Gerald Ackerman touches up areas of damage to the mural using pastel chalks after students affix Christmas tree bulbs and a bread stick to the mural using tape.

March 1978

The Claremont Colleges host the National Association of Chicano Studies conference and advocate for interdisciplinary research and conjoining research and action.

July–December 1982

In a series of food fights and vandalism, students throw plates, apples, tomatoes, ice cream, and other articles in Frary Dining Hall, damaging the *Prometheus* mural.

April 1981–June 1983

Conservator Nathan Zakheim executes conservation work on *Prometheus*.

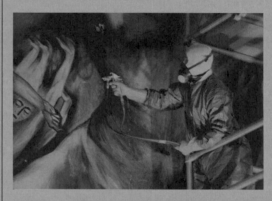

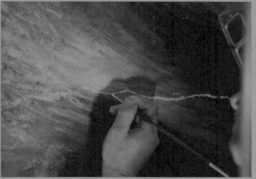

Nathan Zakheim and associates executing conservation work on *Prometheus*, 1981–83. Photographs. Pomona College Museum of Art Archives

September 11–14, 1984

Fiesta California: A Celebration of Mexican Culture, an annual event sponsored by the Chicano Studies Department, highlights Orozco's centennial. Bridges Auditorium at Pomona College presents an exhibition of paintings by Orozco in Clemente Orozco's private collection accompanied by a lecture by Clemente Orozco.

Cartoon in *The Student Life* with puns about Prometheus's genitals, November 7, 1972. Special Collections and Libraries, Claremont Colleges Library, Claremont, California

Prometheus Revealed, Fresco Comes C

Almost all the denizens of Pomona College know the sad history of the Prometheus fresco in Frary Hall—how the artist Orozco painted the Titan to conform in all respects to the cultural standards of normal male anatomy, and how squeamish trustees brought such pressure to bear upon the administration that Orozco was called back and forced to paint over Prometheus' genitals. Unfortunately, folks, this stirring saga of blood, vengeance, and the suppression of artistic vision is, as far as it's possible to ascertain the facts, mildly apocryphal. In light of the recent defacement of the fresco, it seems appropriate at this time to try to set straight the record of its past, and discuss its future. Most of the information below has been gleaned from past issues of the **Student Life** appearing in 1930-31. Other sources will be specifically noted.

For the fact that Pomona has "Prometheus" at all, we can thank the energy and impetuosity of Dr. Joseph Pijoan, a former Pomona art professor. Shortly after Frary was constructed in 1929, Pijoan, entirely on his own initiative, approached the men living on North Campus—which then consisted of Clark I and Smiley—and proposed that they get an artist to decorate their dining hall; at a faculty meeting with Spaulding, the architect of Frary, on March 6, 1930, Pijoan suggested that a fresco would be in keeping with the 13th century design of the hall; it was decided to engage either Diego de Riviera or Jose Clemente

Orozco. On March 19, Pijoan announced that he had arranged for Orozco to do the fresco for $2000, half of which sum the frequenters of Frary pledged themselves to raise; Orozco arrived in Claremont two days later.

Artist Arrives

Throughout the lightning-swift action of deciding upon and bringing in Orozco, Pijoan followed the unorthodox of consulting no one but the students. Neither the trustees nor the administration were ever approached for permission or the necessary funds, Pijoan promising to raise $1000 to match the men students' pledge.

No Trustees

The students were pleased to procure the work of an artist of Orozco's stature and took a great interest in the fresco's progress. Orozco himself lived in Clark while painting the mural and welcomed observations of and queries about his work. On May 17 and 24, the **Student Life** published articles in which Orozco explained his views on art and his conception of "Prometheus"; the rapport between artist and students is obvious.

Folk-Lore

At this point, the folk-lore drifts from the path of accuracy. The fresco was completed during the summer of 1930; preparatory sketches indicate that an anatomically complete figure was

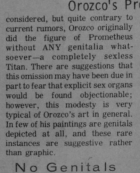

Orozco's Prometheus: The Real Thing, 1956.

considered, but quite contrary to current rumors, Orozco originally did the figure of Prometheus without ANY genitalia whatsoever—a completely sexless Titan. There are suggestions that this omission may have been due in part to fear that explicit sex organs would be found objectionable; however, this modesty is very typical of Orozco's art in general. In few of his paintings are genitals depicted at all, and these rare instances are suggestive rather than graphic.

No Genitals

According to Earl Merritt, who was the director of the dorms at the time the fresco was painted, Orozco returned to Frary about three months later, on his way from Los Angeles to New York, for a last look at his creation. Mr. Merritt happened to be in the hall, and Orozco commented to him, "You know, I regret that I have not finished Prometheus himself. He lacks the natural organs the figure should have." Having brought his colors with him, Orozco pulled a table over to the wall, quickly added a modest set of genitals to the giant figure, and departed.

An official photograph was taken of "Prometheus" in 1956, which **clearly shows the organs as Orozco**

painted them. Dr. E. Wilson Lyon, president emeritus of Pomona College, has stated that there has been no alteration of the fresco since the photo was taken—with the exception of a fig leaf fashioned of green blotting paper which temporarily adorned the mural.

More

Yet it is obvious to the student body that Prometheus has been sadly lacking in recent years. The most likely explanation lies in the piece-meal construction of the figure. The mural is a fresco—a form of art in which the color is applied to wet plaster and, as the plaster hardens, becomes an itegral part of the wall. The picture will then last as long as the wall it's painted on. The genitals, however, were painted on dry—al secco—and did not have the lasting properties of the fresco proper. It seems likely that 42 years after Orozco's hasty application, that portion had been significantly eroded, a process doubtlessly aided by the sporadic attention of pranksters. In any case, Prometheus has never been "censored", and the Robin-Hood-ethic of giving to the impoverished which seems to have inspired the most recent defacement is misguided, not to mention damaging to an irreplacable piece of art worth, it has been estimated, at least one million dollars. It seems ironic that the students who once raised $1000 to bring the fresco into existence and who defended it against the conventional art critics who failed to appreciate Orozco's genius should now in their turn be so blind to its artistic merits as to vandalize what E. Wilson Lyon has noted is "considered the greatest fresco north of the Rio Grande" and "one of the major murals in North America".

What will happen to the mural now? Any more attentions lavished upon it in the manner of the current disfigurement may well destroy its value as an original work of art. The area of Prometheus' groin is already in much worse condition than the rest of the figure. Mr. Johnson, the conservator from the L.A. County Museum who has watched over Prometheus for years, has arranged to come to Pomona in a few weeks to examine

the fresco. At tha pected that the damage will be as for restoration wi

How did this concerning bowdlerization or that Orozco left huff, and that the the Dartmo depicting a ske procession in a figure beari resemblance Edmunds, a form Pomona. Howeve details are somew dispute seems to payment for the m untoward curtail license. There is whether Orozco nothing at all for h case, he did not n he'd been promise that Pijoan himse from the Pomona of April, 1930, ma connection with t

Scan

Despite his po proclivities, Pijoa majestic vision. S left Pomona, he his plans for the re $25,000, Pijoan missioning Orozco pictoral history of window casement god overcoming arch over the sou to show the downf who attempted to The mind boggles concepualize the s of such an undert

Frary is an un setting for one masterpieces, a Ackerman, the c Pomona art de fresco is well-pla seen to advantage relatively dry, an not in immedia decrepitude, as a housing a numb murals in Mexico that in a situation are so few natu painting's pr Prometheus shou respected by the appreciate him m

...and the gods, enraged, withdrew the gift of fire. But Prometheus took pity on mankind. Daring the wrath of Zeus, he stole a flame from the cradle of fire...

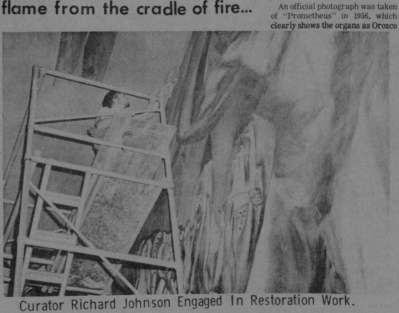

Curator Richard Johnson Engaged In Restoration Work.

"Paintings and Drawings by José Clemente Orozco," 1984. Front cover of exhibition brochure. Pomona College Museum of Art Archives

September 19 and 20, 1985

Two violent earthquakes, with magnitudes of 8.1 and 7.9, respectively, strike the area around Mexico City. The natural disaster initiates urban social movements challenging the government.

December 5, 1987

"Fireplay: The Legend of Prometheus" premieres at Garrison Theater, Scripps College. Leonard Pronko, chair of the Pomona College Theatre Department, directs the Kabuki-style presentation, written by Carol Fisher Sorgenfrei. The play features an arrogant, power-hungry Prometheus and a benevolent and foolish Epimetheus.

1988–94

Carlos Salinas de Gotari serves as president of Mexico and institutes a series of neoliberal reforms, including the deregulation and privatization of transportation companies, banks, and agriculture.

1990

Marjorie L. Harth, director of the Pomona College Museum of Art from 1981 to 2004, negotiates a one-year loan of the seventeen preparatory drawings for *Prometheus* with Orozco's children, Clemente, Lucrecia, and Alfredo.

September 1–October 14, 1991

An exhibition of the preparatory drawings at the Pomona College Museum of Art coincides with the Los Angeles County Museum of Art's hosting of the exhibition "Mexico: Splendors of Thirty Centuries." The Metropolitan Museum of Art organizes the latter exhibition, which also travels to San Antonio, Texas, to coincide with negotiations for the North American Free Trade Agreement.

January 1, 1994

The North American Free Trade Agreement, signed by the United States, Mexico, and Canada, goes into effect. On the same day, the Zapatista Army of National Liberation (Ejército Zapatista de Liberación Nacional, EZLN) stages a rebellion in the Mexican state of Chiapas.

1995

Conservator Aneta Zebala notes an area of paint loss that seems to indicate vandalism; conservation is completed in May. Zebala begins conducting annual inspections of the mural.

1995

An article in *The Student Life*, subtitled "The Time Has Come for Prometheus to Be Delivered from Genderless Shame," asserts that the current restoration process provides an opportunity to supplement the mural. The issue also includes a caricature of Prometheus clutching at his groin.

February 18, 1999

Lucrecia Orozco and Alfredo Orozco fax a letter to Harth expressing a desire to sell the preparatory drawings. Clemente Orozco had previously, and unofficially, accepted an offer Harth had made; however, holes in communication and Mexican laws regarding cultural patrimony delayed the acquisition process.

September 21–25, 2000

Harth and Elizabeth Villa travel to Mexico City to acquire the 17 preparatory drawings. Orozco's daughter and son-in-law bring the drawings to Mexico City.

December 1, 2000

PAN candidate Vicente Fox Quesada is elected the 55th President of Mexico, breaking 70 years of rule by the PRI. He holds the office through November 30, 2006.

2001

The Pomona College Museum of Art publishes *José Clemente Orozco: Prometheus*. Texts include reprints of essays by David Scott; new essays by Renato González Mello, Mary K. Coffey, and Harth; and a reprint of Lord Byron's poem "Prometheus."

"And on the Sixth Day God Created Man: The Time Has Come for Prometheus to Be Delivered from Genderless Shame." *The Student Life*, April 21, 1995. Special Collections and Libraries, Claremont Colleges Library, Claremont, California

(left) A feature on *Prometheus*, in *The Student Life*, January 16, 1973. Special Collections and Libraries, Claremont Colleges Library, Claremont, California

228

January 22–March 3, 2002
The Pomona College Museum of Art presents the exhibition *José Clemente Orozco: The Drawings for Prometheus*.

March 9, 2002–April 13, 2003
José Clemente Orozco in the United States, 1927–1934 originates at the Hood Museum of Art, at Dartmouth College, and travels to the San Diego Museum of Art and the Museo de Arte Carrillo Gil, in Mexico City. The exhibition features paintings, prints, drawings, watercolors, and preparatory studies for murals.

December 2006
Mexican President Felipe Calderón initiates a policy of national security known as the War on Drugs, unleashing unprecedented violence against the civilian population from both organized crime syndicates and federal security forces.

December 2, 2011
As workers at Pomona College campaign to unionize, the college dismisses seventeen workers, sixteen of whom worked in the dining hall, for failing to produce documentation verifying their working status in the United States. The firings follow a complaint made earlier in the year against Pomona College's hiring practices.

April 7–June 17, 2012
The Hood Museum of Art partners with the Pollock-Krasner House and Study Center to celebrate Jackson Pollock's centennial with the exhibition *Men of Fire: José Clemente Orozco and Jackson Pollock*, exploring the importance of Orozco's murals to the abstract expressionist.

May 2012
The PRI party returns to power with the election of Enrique Peña Nieto. Protests erupt throughout Mexico in response, calling for fairness in democratic elections, unbiased coverage of politics in the media, and an end to political corruption. The PRI advances neoliberal reforms, particularly in the energy sector, education, and telecommunication.

April 31, 2013
Dining hall workers at Pomona College vote 57–26 in favor of joining UNITE HERE, Local 11, and to ratify a three-year contract on December 17.

September 26, 2014
During the night, municipal police and other armed men attack buses carrying students from the Ayotzinapa Normal School near Tiztla, Guerrero. The students had plans to

Students protesting racial discrimination at Claremont McKenna College, November 11, 2015, as part of a larger wave of protests at college campuses across the country. Photo: Alex Smith for *The Student Life*

(left) Seventeen silhouettes painted on Walker Wall, Pomona College's free-speech wall, representing 17 employees who were fired following a controversial investigation of the college's work authorization practices, in December 2011. Pomona College Archives

(pages 230–31) Wall painted with portraits of the 43 missing students from Ayotzinapa, October 14, 2014. Photograph. Cuartoscuro, Mexico City. Photo: Diego Simón Sanchez/Cuartoscuro

use buses in a demonstration in Mexico City commemorating the students massacred in the 1968 demonstration at the Plaza de las Tres Culturas. Forty-three students go missing, and three students and three bystanders are killed during the attacks.

October 13, 2014
Amidst ongoing protests, an investigation by the Mexican government concludes that members of the Guerreros Unidos drug gang mistook the forty-three students for members of the rival Rojos gang and initiated the attack.

March 13–August 23, 2015
"José Clemente Orozco: Figure Studies" at the San Jose Museum of Art showcases Orozco's understanding of the expressiveness of the human body.

September 2015
The Inter-American Commission on Human Rights releases a report discrediting many findings of the Mexican government's investigation of the disappearance of the students from Ayotzinapa.

November 12, 2015
Over a thousand students from the Claremont Colleges, accompanied by members of the faculty and staff, gather at Honnold Mudd Library and march against institutional racism, standing in solidarity with students of color protesting at colleges across the United States, including the University of Missouri, Yale University, Occidental College, Smith College, Duke University, Bowdoin College, Ithaca College, Brown University, and Columbia University.

August 29–December 16, 2017
As part of the Getty-sponsored initiative Pacific Standard Time: LA/LA, the Pomona College Museum of Art presents an exhibition on the contemporary resonances of Orozco's artistic vision, showcasing artworks by Isa Carrillo, Adela Goldbard, Rita Ponce de León, and Naomi Rincón-Gallardo.

1. For a thorough chronology of José Clemente Orozco's life, see Renato González Mello and Diane Miliotes, eds., *José Clemente Orozco in the United States 1927–1934* (Hanover, NH, New York, and London: Hood Museum of Art, Dartmouth College, and W.W. Norton & Co., 2002).

Exhibition Checklist

José Clemente Orozco

Prometheus, 1930
Fresco mural
240 × 342 in. (609.6 × 868.7 cm)
Pomona College, Claremont, CA. P30.1.1

Study for central panel,
Prometheus mural, 1930
Graphite on paper
17⅝ × 23⅜ in. (44.8 × 59.4 cm)
Pomona College, Claremont, CA. Purchase
made possible through the Estate of Walter
and Elise Mosher. P2000.2.1

Study of arm reaching left and
detail of hand, *Prometheus* mural
(central panel), 1930
Charcoal on paper
12⅞ × 11⅜ in. (32.7 × 28.9 cm)
Pomona College, Claremont, CA. Purchase
made possible through the Estate of Walter
and Elise Mosher. P2000.2.10

Study of torso from back,
Prometheus mural (central panel), 1930
Charcoal on paper
16½ × 12 in. (41.9 × 30.5 cm)
Pomona College, Claremont, CA. Purchase
made possible through the Estate of Walter
and Elise Mosher. P2000.2.11

Study of head and torso from back,
Prometheus mural (central panel), 1930
Charcoal on paper
14⅝ × 11⅜ in. (37.2 × 28.9 cm)
Pomona College, Claremont, CA. Purchase
made possible through the Estate of Walter
and Elise Mosher. P2000.2.12

Study of raised left arm with outline
of head, *Prometheus* mural (central
panel), 1930
Charcoal on paper
11¾ × 7⅜ in. (29.9 × 18.7 cm)
Pomona College, Claremont, CA. Purchase
made possible through the Estate of Walter
and Elise Mosher. P2000.2.13

Study of back of torso with left arm
raised over head, *Prometheus* mural
(central panel), 1930
Charcoal on paper
14½ × 11⅜ in. (36.8 × 28.9 cm)
Pomona College, Claremont, CA. Purchase
made possible through the Estate of Walter
and Elise Mosher. P2000.2.14

Study of leaning figure, *Prometheus*
mural (central panel), 1930
Charcoal on paper
15⅝ × 12 in. (39.7 × 30.5 cm)
Pomona College, Claremont, CA. Purchase
made possible through the Estate of Walter
and Elise Mosher. P2000.2.15

Study for figure with raised left arm,
Prometheus mural (central panel), 1930
Charcoal on paper
12¹⁄₁₆ × 9½ in. (30.6 × 24.1 cm)
Pomona College, Claremont, CA. Purchase
made possible through the Estate of Walter
and Elise Mosher. P2000.2.16

Contour study of torso and left arm,
Prometheus mural (central panel), 1930
Charcoal on paper
12¾ × 11⅛ in. (32.4 × 28.3 cm)
Pomona College, Claremont, CA. Purchase
made possible through the Estate of Walter
and Elise Mosher. P2000.2.17

Study for ceiling panel (*Abstract
Composition* or *Godhead*), *Prometheus*
mural, 1930
Graphite on paper
6⅜ × 28 in. (16.2 × 71.1 cm)
Pomona College, Claremont, CA. Purchase
made possible through the Estate of Walter
and Elise Mosher. P2000.2.2

Study for west panel (*Zeus, Hera, and
Io* or *The Destruction of Mythology*),
Prometheus mural, 1930
Graphite on paper
13⅞ × 6½ in. (35.2 × 16.5 cm)
Pomona College, Claremont, CA. Purchase
made possible through the Estate of Walter
and Elise Mosher. P2000.2.3

Study for east panel (*Centaurs in
Agony* or *The Strangulation of Mythology*),
Prometheus mural, 1930
Graphite on paper
13⅝ × 7⅝ in. (34.6 × 19.4 cm)
Pomona College, Claremont, CA. Purchase
made possible through the Estate of Walter
and Elise Mosher. P2000.2.4

Study of centaur and baby for east
panel (*Centaurs in Agony* or
The Strangulation of Mythology),
Prometheus mural, 1930
Graphite on paper
8 × 8¾ in. (20.3 × 22.2 cm)
Pomona College, Claremont, CA. Purchase
made possible through the Estate of Walter
and Elise Mosher. P2000.2.5

Study of two raised arms, *Prometheus*
mural (central panel), 1930
Charcoal on paper
12¹⁄₁₆ × 9⁹⁄₁₆ in. (30.6 × 24.3 cm)
Pomona College, Claremont, CA. Purchase
made possible through the Estate of Walter
and Elise Mosher. P2000.2.6

Study of raised right forearm and fist,
Prometheus mural (central panel), 1930
Charcoal on paper
11⅜ × 6¼ in. (28.9 × 15.9 cm)
Pomona College, Claremont, CA. Purchase
made possible through the Estate of Walter
and Elise Mosher. P2000.2.7

Study of left forearm and fist, *Prometheus*
mural (central panel), 1930
Charcoal on paper
11⅜ × 13 in. (28.9 × 33 cm)
Pomona College, Claremont, CA. Purchase
made possible through the Estate of Walter
and Elise Mosher. P2000.2.8

Study of right forearm and detail,
Prometheus mural (central panel), 1930
Charcoal on paper
11⅜ × 14⅝ in. (28.9 × 37.2 cm)
Pomona College, Claremont, CA. Purchase
made possible through the Estate of Walter
and Elise Mosher. P2000.2.9

Isa Carrillo

Constelación naciente
(Rising Constellation), 2015

Wood, paint, and colored pencil
Installation: dimensions variable;
three drawings: 23⅝ × 23⅝ in.
(60 × 60 cm) each

Eclipse, 2015

Pencil, paper, page book,
transparency, slide viewer
Installation: dimensions variable;
drawing: 11¹³⁄₁₆ × 9 in. (30 × 23 cm);
slide viewer: 7⅛ × 3¹⁵⁄₁₆ × 7¹⁵⁄₁₆ in.
(18 × 10 × 20 cm)

Elegía microscópica
(Microscopic Elegy), 2015

Magnifying glass, slides, test
tubes, paper, and insects
Dimensions variable

Error de cálculo (polvos cósmicos)
(Miscalculation [Cosmic Dust]), 2015

Test tubes, gunpowder, and wood
4¾ × 5⅛ × 1³⁄₁₆ in. (12 × 13 × 3 cm)

Mensajes ocultos
(Hidden Messages), 2015

Four magnifying glasses and linoleum
5⅞ × 3⅛ × 2 in. (15 × 8 × 5 cm) each

Suite #1, 2015

Transparencies and slide projector
Dimensions variable

Variaciones para una mano izquierda
(Variations for a Left Hand), 2015

Five pencil drawings on paper
19 ¹¹⁄₁₆ × 11¹³⁄₁₆ in. (50 × 30 cm) each

Adela Goldbard

Plutarco, putos, 2015

4k video projected in HD with stereo
sound, 9 min.

Lobo, 2013

4k video projected in HD with stereo
sound, 6 min. 7 sec.

Microbus, 2014

4k video projected in HD with stereo
sound, 4 min. 38 sec.

Reconstruction of *Microbus*, 2014/2017

Reeds, wood, cardboard, paper, paint,
paste, and pyrotechnic equipment
90 × 79 × 250 in. (230 × 200 × 635 cm)

Rita Ponce de León

Noor and Davis, 2017

Installation of ink drawings
Dimensions variable

Naomi Rincón-Gallardo

Odisea Ocotepec
(Ocotepec Odyssey), 2014

Nine-channel video installation,
individual works listed below

Epimeteo (Epimetheus), 2014

Color video with sound, 3 min. 25 sec.

Anunciación del más allá
(Announcement from Beyond), 2014

Color video with sound, 3 min. 22 sec.

Insaciables (Insatiable), 2014

Color video with sound, 2 min. 38 sec.

Verbo alienante
(Alienating Verb), 2014

Color video with sound, 2 min. 15 sec.

Salida del útero monacal
(Exit from the Monastic Uterus), 2014

Color video with sound, 5 min. 23 sec.

Psicosíntesis Technicolor
(Technicolor Psychosynthesis), 2014

Color video with sound, 9 min. 12 sec.

Ajolote, Reflexividad
(Axolotl, Reflexivity), 2014

Color video with sound, 2 min. 39 sec.

Naomi Rincón-Gallardo
with INVASORIX:

Nadie aquí es ilegal
(Here No One Is Illegal), 2014

Color video with sound, 3 min. 10 sec.

El ano nos une
(The Anus Unites Us), 2014

Color video with sound, 5 min. 12 sec.

———

All works courtesy of the artist unless
otherwise noted.

Selected Bibliography

1.
The Making of a Myth

Aeschylus. *Prometheus Bound of Aeschylus*. Translated by Robert Whitelaw. Oxford: Clarendon Press, 1907.

Boccaccio, Giovanni. *Genealogy of the Pagan Gods*. Edited and translated by Jon Solomon. Cambridge, MA: Harvard University Press, 2011.

Byron, George Gordon. "Prometheus" (1816). *Poetry Foundation*. http://www.poetryfoundation.org/poem/173099#poem.

Goethe, Johann Wolfgang von. *The Poems of Goethe*. Translated by E. A. Bowring, W. E. Aytoun, Theodore Martin, G. H. Lewes, Edward Chawner, Leopold Noa, Thomas Carlyle, J. S. Dwight, A. J. W. Morrison, H. W. Longfellow, J. Sprague, and Henry Dale. New York: T. Y. Crowell & Co., 1882.

Hesiod. *Theogony. Works and Days. Testimonia*. Edited and translated by Glenn W. Most. Loeb Classical Library 57. Cambridge, MA: Harvard University Press, 2007.

Nietzsche, Friedrich. *The Birth of Tragedy* (1872). Translated by Douglas Smith. Oxford and New York: Oxford University Press, 2000.

Plato. *Laches. Protagoras. Meno. Euthydemus*. Translated by W. R. M. Lamb. Loeb Classical Library 165. Cambridge, MA: Harvard University Press, 1924.

Shelley, Mary Wollstonecraft. *Frankenstein, or, the Modern Prometheus*. Waiheke Island: The Floating Press, 2008, originally published in 1818. eBook Academic Collection, EBSCOhost.com.

Shelley, Percy Bysshe. *The Complete Poetical Works of Percy Bysshe Shelley*. Edited by George Edward Woodberry. Boston and New York: Houghton Mifflin, 1901, originally published in 1820. http://www.bartleby.com/139/.

2.
José Clemente Orozco and the Mexican Mural Movement

Anreus, Alejandro, Leonard Folgarait, and Robin Adèle Greeley, eds. *Mexican Muralism: A Critical History*. Berkeley, CA: University of California Press, 2012.

Brenner, Anita. *Idols Behind Altars: Modern Mexican Art and Its Cultural Roots* (1929). Mineola, NY: Dover Publications, Inc., 2002.

Cardoza y Aragón, Luis. *Orozco*. Mexico City: Universidad Nacional Autónoma de México, 1959.

———. *La nube y el reloj: pintura Mexicana contemporánea*. Mexico City: Universidad Nacional Autónoma de México, Instituto de Investigaciones Estéticas, 1940.

Cervantes, Miguel and Beatriz Eugenia Mackenzie. *José Clemente Orozco: Pintura y verdad*. Guadalajara, Jalisco: Instituto Cultural Cabañas, 2010.

Charlot, Jean. "Orozco's Stylistic Evolution." In *College Art Journal* 9, no. 2 (Winter 1949–1950): 148–57. http://www.jstor.org/stable/772989.

Coffey, Mary K. "Angels and Prostitutes: José Clemente Orozco's Catharsis and the Politics of Female Allegory in 1930s Mexico." In *CR: The New Centennial Review* 4, no. 2 (2004): 185–217.

———. *How a Revolutionary Art Became Official Culture: Murals, Museums, and the Mexican State*. Durham, NC: Duke University Press, 2012.

Elliott, David, ed. *¡Orozco! 1883–1949*. Oxford: The Museum of Modern Art, 1980.

Fernández, Justino. *Obras de Orozco en la colección Carrillo Gil*. Mexico City: A. Cabañas (distributor), privately printed, 1949.

———. *Orozco: forma e idea*. Mexico City: Libreria de Porrúa, 1942.

———. *Textos de Orozco. Estudios y Fuentes del arte en México IV*. Mexico City: Imprenta Universitaría, Instituto de Investigaciones Estéticas, 1955.

Goldman, Shifra M. *Dimensions of the Americas: Art and Social Change in Latin America and the United States*. Chicago and London: University of Chicago Press, 1994.

González Mello, Renato. *La máquina de pintar: Rivera, Orozco y la invención de un lenguaje emblemas, trofeos y cadáveres*. Mexico City: Universidad Nacional Autónoma de México, Instituto de Investigaciones Estéticas, 2008.

———. *Orozco ¿Pintor revolucionario?* Mexico City: Universidad Nacional Autónoma de México, Instituto de Investigaciones Estéticas, 1995.

———, and Diane Miliotes, eds. *José Clemente Orozco in the United States 1927–1934*. Hanover, NH, New York, and London: Hood Museum of Art, Dartmouth College, and W. W. Norton & Co., 2002.

Harth, Marjorie L., ed. *José Clemente Orozco: Prometheus*. Claremont, CA: Pomona College Museum of Art, 2001.

Hurlburt, Laurance P. *The Mexican Muralists in the United States*. Albuquerque: University of New Mexico Press, 1989.

Indych-López, Anna. *Muralism without Walls: Rivera, Orozco, and Siqueiros in the United States, 1927–1940*. Pittsburgh, PA: University of Pittsburgh Press, 2009.

Instituto Nacional de Bellas Artes. *José Clemente Orozco (Homenaje en ocasión del 1er aniversário de la fundación del Museo Taller dedicado a su memoria)*. Mexico City: Instituto Nacional de Bellas Artes, 1952.

———. *José Clemente Orozco, Serie "La Verdad."* Mexico City: Instituto Nacional de Bellas Artes, 2004.

————. *Sainete, drama y barbarie. J. C. Orozco, Centenario, 1883–1983*. Mexico City: Instituto Nacional de Bellas Artes, 1983.

Marrozzini, Luigi, ed. *Orozco: Obra gráfica completa*. San Juan, Puerto Rico: Instituto de Cultura Puertorriqueña, Universidad de Puerto Rico, 1970.

Orozco Valladares, Clemente. *Orozco, Verdad Cronológica*. Guadalajara, Jalisco: EDUG Universidad de Guadalajara, 1983.

Pacheco, Cristina. *Orozco, iconografía personal*. Mexico City: Fondo de Cultura Económica, 1983.

Paz, Octavio. *Essays on Mexican Art*. Translated by Helen Lane. New York: Harcourt Brace & Company, 1993.

————. "Social Realism in Mexico: The Murals of Rivera, Orozco, and Siqueiros." In *Artscanda* (December 1979–January 1980): 58–67.

Reed, Alma. *Orozco*. New York: Oxford University Press, 1956.

Schmeckebier, Laurence E. *Modern Mexican Art*. Minneapolis, MN: The University of Minnesota Press, 1939.

Talleres Gráficos de la Nación. *20 dibujos de José Clemente Orozco de la exposición de agosto de 1945 en el Colegio nacional, México, 1945*. Mexico City: Talleres Gráficos de la Nación, 1945.

Tibol, Raquel. *Cuadernos, José Clemente Orozco*. Mexico City: Secretaría de Educación Pública-Cultura and CONAFE, 1983.

————. *José Clemente Orozco: una vida para el arte: breve historia documental*. Mexico City: Fondo de Cultura Económica, 1984.

Zavala, Adriana. *Becoming Modern, Becoming Tradition: Women, Gender, and Representation in Mexican Art*. University Park, PA: Pennsylvania State University Press, 2010.

3.
Art and Writing

Azuela, Mariano. *The Underdogs*. Illustrated by José Clemente Orozco. New York: Brentano's, 1929.

Illich, Ivan. *Deschooling Society*. New York: Harper & Row, 1971.

La Vanguardia (Orizaba, Veracruz), 1915.

Orozco, José Clemente. *The Artist in New York: Letters to Jean Charlot and Unpublished Writings*. Foreword and notes by Jean Charlot, translated by Ruth L. C. Simms. Austin and London: University of Texas Press, 1974.

————. *An Autobiography*. Translated by Robert C. Stephenson. Austin, TX: University of Texas Press, 1962.

————. "Orozco 'Explains.'" *The Bulletin of the Museum of Modern Art* (New York) 7, no. 4 (August 1940): 2–11.

————, Margarita Valladares de Orozco, and Tatiana Herrero Orozco. *Cartas a Margarita: 1921–1949*. Mexico City: Ediciones Era, 1987.

Siqueiros, David Alfaro, Diego Rivera, Xavier Guerrero, Fermín Revueltas, José Clemente Orozco, Ramón Alva Guadarrama, Germán Cueto, and Carlos Mérida. "Manifesto del Sindicato de Obreros Técnicos, Pintores, y Escultores" (1923). *El Machete* (Mexico City), no. 7 (June 1924): 4.

Vasconcelos, José. *La raza cósmica*. Madrid: Agencia Mundial de Librería, 1925.

4.
Theories of Social Practice and Relationality in Contemporary Art

Bishop, Claire. *Artificial Hells: Participatory Art and the Politics of Spectatorship*. London and New York: Verso, 2012.

Bourriaud, Nicholas. *Relational Aesthetics*. Translated by Simon Pleasance and Fronza Woods, with Mathieu Copeland. Dijon: Les Presses Du Réel, 2002.

Bradley, Will and Charles Esche, eds. *Art and Social Change: A Critical Reader*. London: Tate Publishing, 2007.

Helguera, Pablo. *Education for Socially Engaged Art: A Materials and Techniques Handbook*. New York: Jorge Pinto Books, 2011.

Kester, Grant H. *Conversation Pieces: Community and Communication in Modern Art*. Berkeley, CA: University of California Press, 2004.

————. *The One and the Many: Contemporary Collaborative Art in a Global Context*. Durham, NC: Duke University Press, 2011.

Kwon, Miwon. *One Place after Another: Site-Specific Art and Locational Identity*. Cambridge, MA: MIT Press, 2002.

Meyer, James. "The Functional Site; or, The Transformation of Site Specificity." In *Space, Site, Intervention: Situating Installation Art*, edited by Erika Suderburg, 23–37. Minneapolis, MN: University of Minnesota Press, 2000.

Musée d'Art Moderne de la Ville de Paris and Museo Amparo. *Resisting the Present: Mexico, 2000–2012*. Barcelona: Editorial RM, 2011.

Widholm, Julie Rodrigues, ed. *Escultura Social: A New Generation of Art from Mexico City*. New Haven, CT: Yale University Press, 2007.

This selected bibliography lists sources that informed the production of this catalog and the exhibition it accompanies. It does not encompass every record consulted or provide a comprehensive accounting of every text concerning José Clemente Orozco, Mexican muralism, the myth of Prometheus, and social practice and relationality in contemporary art. It includes sources that served as touchstones during our research and can be a resource for future inquiry.

Artist Biographies

José Clemente Orozco was born in 1883, in Zapotlán el Grande (now Ciudad Guzmán), Jalisco, Mexico, and died in 1949 in Mexico City, Mexico. He lived and worked in Mexico City; New York City; and Guadalajara, Jalisco, Mexico. He studied painting at the Academy of San Carlos, Mexico City.

Orozco's numerous solo exhibitions include "Luz entre líneas" ("Light Between Lines"), Instituto Cultural Cabañas, Guadalajara (2016); "José Clemente Orozco in the United States, 1927–1934," Hood Museum of Art, Hanover, New Hampshire, which traveled to the San Diego Museum of Art, San Diego, California, and Museo de Arte Carrillo Gil, Mexico City (2002–3); "José Clemente Orozco: The Drawings for Prometheus," Pomona College Museum of Art, Claremont, California (2002); an exhibition of the preparatory drawings for Prometheus, Pomona College Museum of Art, Claremont (1991); "¡Orozco! 1883–1949," Museum of Modern Art, Oxford, England (1980); a retrospective exhibition of Orozco's works, Palace of Fine Arts, Mexico City (1947); "J.C. Orozco: Paintings and Drawings," Hudson D. Walker Gallery, New York (1939); and an exhibition of drawings and lithographs, including the series Mexico in Revolution, Art Institute of Chicago, Chicago, Illinois (1929–30).

Orozco's work has been presented in many group exhibitions, including "Men of Fire: José Clemente Orozco and Jackson Pollock," Hood Museum of Art, Hanover (2012); "Twenty Centuries of Mexican Art," Museum of Modern Art, New York (1940); "Exhibit by Contemporary Mexican Artists and Artists of the Mexican School Presented by Delphic Studios, New York," Junior League, New York (1931); "Mexican Arts," Metropolitan Museum of Art, New York, which traveled to the Museum of Fine Arts, Boston, Massachusetts; Carnegie Institute, Pittsburgh, Pennsylvania; Cleveland Museum of Art, Cleveland, Ohio; Corcoran Gallery of Art, Washington, DC; Milwaukee Art Museum, Milwaukee, Wisconsin; JB Speed Memorial Museum, Louisville, Kentucky; Pan-American Round Table, San Antonio, Texas; and Los Angeles Museum of History, Science and Art, Los Angeles, California (1930–31).

Orozco's work has been featured in numerous publications, including Alma Reed, Orozco (New York: Oxford University Press, 1956); David Elliott, ed., ¡Orozco! 1883–1949 (Oxford: Museum of Modern Art, 1980); Marjorie L. Harth, ed., José Clemente Orozco: Prometheus (Claremont, CA: Pomona College Museum of Art, 2001); Renato González Mello and Diane Miliotes, eds., José Clemente Orozco in the United States 1927–1934 (Hanover, NH, New York, and London: Hood Museum of Art, Dartmouth College, and W.W. Norton & Co., 2002); Renato González Mello, La máquina de pintar: Rivera, Orozco y la invención de un lenguaje emblemas, trofeos y cadáveres (Mexico City: Institute of Aesthetic Research, National Autonomous University of Mexico [UNAM-IIE], 2008); and Miguel Cervantes and Beatriz Eugenia Mackenzie, José Clemente Orozco: Pintura y verdad (Guadalajara, Jalisco, Mexico: Instituto Cultural Cabañas, 2010).

Orozco's work is in many public and private collections, including the Museo de Arte Carrillo Gil, Mexico City; Philadelphia Museum of Art, Philadelphia, Pennsylvania; The Museum of Modern Art, New York; San Francisco Museum of Modern Art, San Francisco, California; Detroit Institute of Arts, Detroit, Michigan; San Diego Museum of Art, San Diego; Hood Museum of Art, Dartmouth College, Hanover; and Instituto Cultural Cabañas, Guadalajara.

Isa Carrillo was born in 1982, in Guadalajara, Jalisco, Mexico, where she continues to live and work. Carrillo earned a degree in visual arts from the University of Guadalajara (2005).

Carrillo's solo exhibitions include "Mano izquierda" ("Left Hand"), Museo Taller José Clemente Orozco, Guadalajara (2015); "La eternidad en una hora" ("Eternity in an Hour"), Centro Cultural Jesús González Gallo, Chapala, Jalisco, Mexico (2014); "Uno obtiene el camino: Fuera de los asuntos del mundo" ("One Finds the Path: Outside of the World's Affairs"), Zapopan Museum of Art, Zapopan, Jalisco, Mexico (2013); "Glosas" ("Glosses"), 5pm Gallery, Zapopan (2007); and "I Wanna Be Pop-Pular," Art and Culture Forum, Guadalajara (2005).

Carrillo has participated in group exhibitions, including the second edition of "Proyectos Unidos Mexicanos, Salón ACME" ("United Mexican Projects, ACME Salon"), Casa Modelo, Mexico City (2016); "Salón ACME No. 4," Archipiélago, Mexico City (2016); "Reconstrucción: un proyecto de Abraham Cruzvillegas" ("Reconstruction: A Project of Abraham Cruzvillegas"), Zapopan Museum of Art, Zapopan (2016); "Imago Muni: Luciano Benetton Collection" ("Image of the World: Luciano Benetton Collection"), Giorgio Cini Foundation, Venice, Italy (2015); "Por qué no lo llamas entropía?" ("Why Not Call It Entropy?"), Tiro al Blanco Gallery, Guadalajara (2015); "Colectiva" ("Collective"), Tiro al Blanco Gallery, Guadalajara (2014); "Tinitus y Fosfenos/ De lo sonoro a lo visual" ("Tinitus and Fosfenos/From Sound to the Visual"), Zapopan Museum of Art, Zapopan (2013); "Paradise Is an Island, So Is Hell," Careyes Art Gallery, Careyes, Jalisco (2013); "Creación en Movimiento 2009–2010" ("Creation in Movement 2009–2010"), Diego Rivera Anahuacalli Museum, Mexico City (2011) and Museum of Painters, Oaxaca, Oaxaca, Mexico (2010); "Salón de Octubre 2011" ("October Salon 2011"), Ex-Convent of Carmen, Guadalajara (2011); and "MIRROR," TRAMA Center, Guadalajara (2011).

Carrillo's work has been included in the following publications: *Estudio abierto 1: Uno obtiene el camino* (Zapopan, Jalisco, Mexico: Zapopan Museum of Art, 2015); *Fuera de los asuntos del mundo* (Jalisco, Mexico: independently published, 2015); and *Mexico: The Future Is Unwritten: Contemporary Artists from Mexico* (Ponzano Veneto, Treviso, Italy: Fabrica, 2015).

Adela Goldbard

Adela Goldbard lives and works in Chicago and Mexico City, where she was born in 1979. Goldbard is a member of the National System of Artistic Creators of Mexico. She received an MFA in studio art from the School of the Art Institute of Chicago (2017), where she was granted the New Artist Society Fellowship. Goldbard received a BA in Hispanic language and literature from the National Autonomous University of Mexico (UNAM), Mexico City (2004).

Goldbard's solo exhibitions include "Paraalegorías" ("Paraallegories"), Casa del Lago Juan José Arreola, Mexico City (2015–16); "COLATERAL" ("Collateral"), Enrique Guerrero Gallery, Mexico City (2013–14); "La Isla de la Fantasía" ("Fantasy Island"), Polyforum Cultural Siqueiros, Mexico City (2013); "En el camino/ On the Road," Aguascalientes Museum of Contemporary Art, Aguascalientes, Aguascalientes, Mexico (2013); "La Quemada Pública" ("The Public Burning"), the No Museum of Contemporary Art (MUNO), Zacatecas, Zacatecas, Mexico (2012); "Non-Reflex," Enrique Guerrero Gallery, Mexico City (2009); "Construcciones improbables" ("Building the Unlikely"), Alianza Francesca Polanco, Mexico City (2009); and "Fábrica Natura" ("Nature Factory"), Mexican Laboratory of Images (LMI) Gallery, Mexico City (2008).

Goldbard has participated in group exhibitions, including "Polvo" ("Dust"), Sonora Museum of Art (MUSAS), Hermosillo, Sonora, Mexico (2014) and Museo de Arte Carrillo Gil, Mexico City (2013); "Statu Quo: La Esmeralda," Museum of Modern Art, Mexico City (2013); "The Marvellous Real: Art from Mexico 1926–2011: FEMSA Collection," Anthropology Museum of the University of British Columbia, Vancouver, Canada (2013); "Mujeres detrás de la lente: 100 años de creación fotográfica en México, 1910–2010" ("Women Behind the Lens: 100 Years of Photographic Creation in Mexico 1910–2010"), Tijuana Cultural Center, Tijuana, Baja California, Mexico (2011); "Beyond the Labyrinth: Latin American Art and the FEMSA Collection," Mexican Cultural Institute, Washington, DC (2011); "Arte emergente" ("Emerging Art"), Polyforum Cultural Siqueiros, Mexico City (2010); New York Photo Festival 2009, Brooklyn, New York; "Behind the Dream: Contemporary Mexican Photography," Museum of Contemporary Art, Ivanova, Russia, and National Center for Contemporary Arts,

Moscow, Russia (2007); and XII Photography Biennial, Image Center, Mexico City (2006).

Her work has been featured in publications, including María Alcocer, "Adela Goldbard: Una realidad simulada," in a special edition of *Architectural Digest* (2011); Adela Goldbard, "En el camino/On the Road," *La membrana* 8 (March 2011); Adela Goldbard, *En el Camino/On the Road*, trans. Rodrigo González (Culiacán, Sinaloa, and Torreón, Coahuila, Mexico: Sinaloan Institute of Culture and Museo Arocena, 2010); Juan José Ochoa, ed., *Actos Mortis* (Mexico: MPC Editors, 2010); "Adela Goldbard: Non-Reflex," *Picnic* (June/July 2010); Ana Elena Mallet et al., "7 promesas de arte contemporáneo," *Chilango* (April 2010); Lolita Castelán, "Mujeres fotógrafas. Haz pedazos tu espejo," *Cuartoscuro* (April 2010); Rodrigo Alonso, ed., *No sabe/No contesta* (Buenos Aires, Argentina: ediciones arte x arte, 2008); and Alejandra Jarillo, "Camino a la fama," *Chilango* (November 2007).

Rita Ponce de León

Rita Ponce de León was born in 1982, in Lima, Peru. She lives and works in Mexico City, Mexico. She studied visual arts at the Pontifical Catholic University of Peru, in Lima (2003) and at the National School of Painting, Sculpture, and Engraving "La Esmeralda" in Mexico City (2008).

Ponce de León's solo exhibitions include "Líneas Aéreas Naturales" ("Natural Air Lines"), 80m2 Livia Benavides Gallery, Lima (2015); "Nuestros nosotros" ("Our Us"), Ignacio Liprandi Contemporary Art, Buenos Aires, Argentina (2015); "Con tus propias manos" ("With Your Own Hands"), ESPAI13, Joan Miró Foundation, Barcelona, Spain (2014); "Endless Openness Produces Circles," Kunsthalle Basel, Basel, Switzerland (2014); "Días enteros con los ojos cerrados" ("Full Days with Closed Eyes"), Casas Riegner Gallery, Bogotá, Colombia (2013); a solo project for Zona Maco Sur, Mexico City (2013); "David," Sala de Arte Público Siqueiros, Mexico City (2012–13); "Cordillera" ("Mountain Range"), 80M2 Livia Benavides Gallery, Lima (2012); "Piso porque creo en el suelo" ("I Step Because I Believe in the Ground"), Museum of Modern Art, Mexico City (2012); "He decidido bifurcarme" ("I Have Decided to Bifurcate"), Border Cultural Center, Mexico City (2011); "Necesito Dormir Cómics" ("I Need to Sleep Comics"), Vertigo, Mexico City (2011); and "Acepto que nada es mío" ("I Accept that Nothing Is Mine"), 80M2 Livia Benavides Gallery, Lima (2010).

Ponce de León has participated in group exhibitions, including "En forma de nosotros" ("In the Shape of Us"), 32nd Biennial, São Paulo, Brazil (2016); "De, desde, en, entre, hacia" ("Of, From, In, Between, To"), On-Site program, Lima Art Museum (MALI), Lima (2016); "Latin American Roaming Art," Museo de Arte Carrillo Gil, Mexico City (2015); "Small."

Drawing Center, New York, New York (2014); "Sights and Sounds: Peru," Jewish Museum, New York (2014); Biennial of Cuenca, Cuenca, Ecuador (2014); "Ultramarine Rumors," Ton de Boer, Amsterdam, Netherlands (2013); "Left Eye, Right Eye," V8 Platform Gallery, Karlsruhe, Germany (2013); Ala Younis's "Tin Soldiers," 9th Gwangju Biennale, Gwangju, South Korea (2012); "The Ungovernables," the second triennial at the New Museum, New York (2012); "Draw," Museum of Mexico City, Mexico City (2010); and "The Misfortunes of Virtue," Co-Lab, Copenhagen, Denmark (2009).

Ponce de León's work has been included in the following publications: Petra Van der Jeught, ed., *Left Eye, Right Eye* (Maastricht, Netherlands: V8 Platform for New Art, 2014); *Youniverse: Chikara Matsumoto and Rita Ponce de León* (Mexico: self-published, 2013); Yilmaz Dziewior and Angelika Nollert, eds., *Utopie Beginnt Im Kleinen-12. Triennale Kleinplastik Fellbach* (Fellbach, Germany: Walter König Bookstore and the Culture Department of Fellbach, 2013); *Vitamin D2* (London: Phaidon Press, 2013); Miguel López, Eliana Otta, and Eungie Joo, eds., *The Ungovernables* (New York: Skira Rizzoli Publications, Inc. and New Museum, 2012); *Cuete* (Peru: Counterculture Editions, 2011); Erik Foss et al., *Draw* (Mexico City: Museum of Mexico City, 2010); *Venus ataca: diez historietistas peruanas* (Peru: Counterculture Editions, 2010); and *Galleta china* (Mexico City: Casa Vecina, 2010).

Naomi Rincón-Gallardo

was born in Raleigh, North Carolina, in 1979; she lives and works in Mexico City, Mexico, and Berlin, Germany. She earned her BA in visual arts from the National School of Painting, Sculpture, and Engraving "La Esmeralda," Mexico City (2007). She received her MA in education: culture, language and identity/cross-sectoral and community arts from Goldsmiths University, London, England (2010). She is currently a PhD candidate in practice at the Academy of Fine Arts Vienna, Vienna, Austria.

Rincón-Gallardo's solo exhibitions include "The Formaldehyde Trip," commissioned by the San Francisco Museum of Modern Art, San Francisco, California (2016–17); "Ocotepec Odyssey," Academy of the Arts of the World, Cologne, Germany (2014); "Monday," as part of the 24 Month Meditation Biennial at The Island, London (2010); and "Ceremonia" ("Ceremony"), in collaboration with Cynthia Yee, presented at The Film House MX and Casa Vecina, Mexico City (2009).

Rincón-Gallardo has participated in group exhibitions, including the X Nicaragua Biennial, presented by the Ortiz Gurdián Foundation, Palace of Culture, Managua, Nicaragua (2016); "Sexo, drogas, y rock & roll: Arte y cultura de masas en México, 1963–1971" ("Sex, Drugs, and Rock & Roll: Art and Mass Culture in Mexico, 1963–1971"), Chopo University

Museum, Mexico City (2014); "Entre Utopía y Desencanto" ("Between Utopia and Disenchantment"), Borda Garden, Cuernavaca, Morelos, Mexico (2014); "México Inside Out: Themes in Art Since 1990," Modern Art Museum of Fort Worth, Fort Worth, Texas (2013); "El incesante ciclo entre la idea y la acción" ("The Endless Cycle of Idea and Action"), Museo de Arte Carrillo Gil, Mexico City (2012); "24 Month Meditation," a two-year project developed by The Island Studio in London and presented in the Fireplace Room of the Church of Santi Cosma e Damiano, Venice, Italy (2010); "Presuntos Culpables" ("Alleged Culprits"), Museum of Modern Art, Mexico City (2009); "Imágenes multimedia para un mundo complejo: Visiones de ambos lados del Atlántico" ("Mult media Images for a Complex World: Visions from Both Sides of the Atlantic"), Multimedia Center of the National Center for the Arts (CENART), Mexico City (2008); III Yucatan Biennial, Center of Visual Arts, Mérida, Yucatan, Mexico (2006); "Apropiaciones" ("Appropriations"), KBK Contemporary Art, Mexico City (2006); and XI Diego Rivera Biennial, Diego Rivera Museum, Guanajuato, Guanajuato, Mexico (2004).

Rincón-Gallardo's work has been featured in publications, including Andrea Karnes, ed., *México Inside Out: Themes in Art Since 1990* (Fort Worth, TX: Modern Art Museum of Fort Worth, 2013); Carmen Cebreros Urzaiz and Andrea Paasch, eds., *El incesante ciclo entre la idea y la acción* (Mexico City: Bancomer BBVA Foundation and Museo de Arte Carrillo Gil, 2012); and Ana Mónica Rodríguez, "Exposición en el MACG coloca al artista como sujeta social de su época," *La Jornada* (Mexico City, February 2012).

Contributors

Mary K. Coffey is an art historian best known for her work on Mexican muralism and the politics of exhibition. Coffey received a BA from Indiana University and an MA and PhD from the University of Illinois at Urbana-Champaign. Her publications span the disciplines of art history, Latin American cultural studies, and museum studies. In 2012, she published *How a Revolutionary Art Became Official Culture: Murals, Museums, and the Mexican State*, an in-depth examination of the relationship between murals and the advent of modern museology in post-revolutionary Mexico. This study won the College Art Association's Charles Rufus Morey Award for a distinguished book in art history. She is currently completing a manuscript on José Clemente Orozco's *Epic of American Civilization*, which is located at Dartmouth College, where Coffey is an associate professor of art history.

Daniel Garza Usabiaga holds a PhD in art history and theory from Essex University in England. He is artistic director of the Zona Maco México Arte Contemporáneo. Previously, Garza Usabiaga was chief curator at Chopo University Museum, in Mexico City, where his projects focused primarily on emerging contemporary artists in Mexico, and curator at the Museum of Modern Art, Mexico City, where he curated multiple exhibitions on Latin American art of the postwar period. Garza Usabiaga's recent publication, *Mathias Goeritz y la arquitectura emocional. Una revisión crítica (1952–1968)*, was awarded the Luis Cardoza y Aragón Prize for Art Criticism.

Terri Geis is director of education and interpretation at the Fowler Museum at the University of California, Los Angeles, and was previously curator of academic programs at the Pomona College Museum of Art. Geis holds a PhD in art history and theory from Essex University, and her research focuses on the art of post-revolutionary Mexico and intersections between Surrealism and the Americas. Recently, Geis has examined Surrealism in the Caribbean, in articles and essays including "Myth, History, and Repetition: André Breton and Vodou in Haiti," in *South Central Review* (2015), and "The Old Horizon Withdraws: Surrealist Connections in Martinique and Haiti—Suzanne Césaire and André Breton, Maya Deren and André Pierre," in *Intersections: Women artists/surrealism/modernism* (Manchester University Press, 2016).

Benjamin Kersten is a doctoral student in visual studies at the State University of New York at Buffalo, where he studies theories of the body and methods of rematerializing queer and feminist theory. He earned a BA in art history at Pomona College, where he received the Louisa Moseley Fine Arts Prize in Art History for his thesis, which examined how art historical discourse on queer sexuality shaped artistic practices and the making of meaning during the AIDS crisis. Kersten curated "Allied Against AIDS: Sue Coe's *AIDS Portfolio*" (2014) for the Pomona College Museum of Art, where he also worked as post-baccalaureate curatorial assistant for the "Prometheus 2017" exhibition.

Rebecca McGrew is senior curator at the Pomona College Museum of Art. Her recent exhibitions include "R.S.V.P. Los Angeles: The Project Series at Pomona" (2015), which celebrated fifty Project Series exhibitions. McGrew's past exhibitions include "Project Series 51: Incendiary Traces" (2017), "Project Series 50: Brenna Youngblood" (2015), "Andrea Bowers: #sweetjane" (2014), and "Project Series 49: Sam Falls: Ferns and Palms" (2014). She has organized many other exhibitions, including "Mowry Baden: Dromedary Mezzanine" (2014), the award-winning and critically acclaimed "It Happened at Pomona: Art at the Edge of Los Angeles 1969–1973" (co-organized with Glenn Phillips, 2011–12), "Steve Roden: when words become forms" (2010), "Hunches, Geometrics, Organics: Paintings by Frederick Hammersley" (2007), "Ed Ruscha/Raymond Pettibon: The Holy Bible and THE END" (2006), and "The 21st Century Odyssey Part II: The Performances of Barbara T. Smith" (2005). Her next exhibition, "Marcia Hafif: A Place Apart," will open in 2018. McGrew is the recipient of a Getty Curatorial Research Fellowship (2007) and Getty Foundation grants under the Pacific Standard Time initiatives in 2009–11 and 2014–15.

Acknowledgments

"Prometheus 2017: Four Artists from Mexico Revisit Orozco" was inspired by the rich legacy of José Clemente Orozco's 1930 mural in Frary Dining Hall on the Pomona College campus. My history—as a Pomona College student eating in Frary Dining Hall for four years and as curator at the Pomona College Museum of Art for the past 20 years—is part of what excited me about this opportunity to contemplate anew *Prometheus* and its impact on our campus, as well as its role as one of the most important artworks in the United States. The exhibition connects life at Pomona College in 2017 with a look back at the early twentieth century, and it unites current students with contemporary artists and scholars.

A project of this scale owes its existence to the good will and efforts of many individuals and institutions. The museum and the college have been extremely fortunate for the assistance we have received throughout the project. In so many ways, this project would not have been realized without the crucial and far-reaching support of the Getty Foundation for the Research and Planning Grant, which was awarded in 2014, and the Exhibition and Implementation Grant, awarded in 2015. Foundation deputy director Joan Weinstein is owed a debt of gratitude for her support of the project from its nascency. Program officer Heather MacDonald and program assistant Selene Preciado provided invaluable support at all stages of both Pacific Standard Time grants. Jodi Chang, Bryan Fair, Sue Kang, Christina Lopez, and Katie Underwood at the Getty Foundation also assisted the project. Gloria Gerace has been of tremendous assistance as managing director of the Pacific Standard Time initiative at the Getty. It has been a pleasure to work with all of them, and Pomona College is eternally grateful to the Getty Foundation for making this project a reality.

I extend deepest gratitude to the artists in the exhibition—Isa Carrillo, Adela Goldbard, Rita Ponce de León, and Naomi Rincón-Gallardo—and José Clemente Orozco. Their work has been the impetus of the project and their generosity has been essential. Many students at the Claremont Colleges have worked with the artists and provided immeasurable assistance with the project: Noor Asif (Scripps College 2016), Ian Byers-Gamber (Pomona College 2014), Nidhi Gandhi (Pomona College 2015), Victoria Hernandez (Pitzer College 2017), Benjamin Kersten (Pomona College 2015), Davis Menard (Pomona College 2017), Jenny Muñiz (Pomona College 2015), Nicolas Orozco-Valdivia (Pomona College 2017), and Romario Quijano Ramirez (Pomona College 2018).

This project would not have been possible without the intellectual generosity and keen scholarly insight of my co-editor Terri Geis, former curator of academic programs at the museum, now director of education and interpretation at the Fowler Museum. Her dedication, from the preliminary research in Mexico through the extensive editorial work, was remarkable. Her extensive knowledge of early twentieth-century Mexican art helped to shape the exhibition and publication. Her development of a lecture series that complimented this effort and her preliminary planning of academic initiatives enriched the project for our colleagues at the Claremont Colleges. For almost four years, she shared the joys and the trials of this project, and I am grateful for her support and camaraderie.

In addition to Geis, team members Mary K. Coffey and Daniel Garza Usabiaga proved vital at all stages of the project, from conception through rigorous scholarly analysis of complicated themes to insightful writing. Coffey has provided crucial guidance, scholarly brilliance, and collegial friendship since 2000, and we are grateful for her deep connection and involvement. Garza Usabiaga likewise provided intellectual guidance on the contemporary themes, and his assistance with negotiating Mexico's numerous and complicated art scenes was invaluable.

Research assistant Audrey Young provided crucial early assistance in researching artists in Mexico and translating their texts, collecting biographical material on artists under consideration, organizing travel plans for research trips to Mexico City and Guadalajara, and assisting with image permission requests. Curatorial assistant Ian Byers-Gamber facilitated all aspects of exhibition management, coordination of artist projects, and oversight of technology needs. Curatorial assistant Benjamin Kersten expertly and patiently worked on a myriad of curatorial and research tasks including researching and compiling the timeline, locating obscure images, and rehousing the College's *Prometheus* archives. Curatorial assistant Nidhi Gandhi proved indispensable at crucial stages of the project management and development, overseeing the collection of image permissions, writing and editing a range of texts, and assisting with overseeing editorial tasks. Program assistant Noor Asif proved instrumental in realizing a broad range of class visits, lectures, and programs.

I would also like to thank numerous other individuals who offered advice and suggestions, who answered research queries, who opened their archives, and who helped in a variety of other ways. In Mexico, we thank scholars Rita Eder, Cuauhtemoc Medina, Renato González Mello, and James Oles. In Los Angeles, we thank Ciara Ennis, Angela Escobar, Rita Gonzalez, Aleca LeBlanc, Mary MacNaughton, Glenn Phillips, and Irene Tsatos. We are grateful to the scholars and curators who participated in the Orozco in Focus lecture series—Alejandro Anreus, Mary K. Coffey, Claudia Garay, Jennifer Josten, and Dafne Cruz Porchini. Their insights and scholarship enriched our understanding of Orozco's work and artistic context.

The publication could not have been realized without the major resources of a large group of creative, hardworking, and dedicated people. Kimberly Varella and her team at Content

Object Design Studio created an elegant record that unifies the complex themes and artists in the exhibition. Many thanks are due to the catalog's contributing authors as well: Mary K. Coffey and Daniel Garza Usabiaga, for major new scholarship, and Benjamin Kersten for the insightful chronology. I thank Nidhi Gandhi for overseeing image collection and permissions and Audrey Young for her thoroughness in transcribing Spanish texts and helping with permissions. Finally, the book would not have been possible without Fredrik Nilsen's stunningly beautiful new photographs of the *Prometheus* mural, which set the tone for a new examination of the mural and its legacy at Pomona College.

Stephanie Emerson seamlessly and skillfully managed the production of this very complex publication. Elizabeth Pulsinelli patiently and painstakingly undertook the enormous process of editing the texts. Ian Byers-Gamber proved an excellent photographer for the majority of new archival images in the book. We thank Getty Publications, in particular Kara Kirk ('85) and Karen Levine, for facilitating the distribution of this publication. In Claremont, we are grateful to Pomona College for allowing many reprints of period images and to Carrie Marsh and Lisa Crane at Special Collections and Libraries, Claremont Colleges Library.

The Pomona College Museum of Art benefits from the ongoing support of dedicated friends of the museum. Their generosity made an ambitious project of this scope possible. Their gifts support internships and post-baccalaureate positions, underwrite publications and programs, and provide crucial support for artists' commissions. We would like to thank Janet Inskeep Benton '79, Louise and John Bryson, Josephine Bump '74, Carlton and Laura Seaver, the Ed and Margaret Phillips Fund for Publications, the Estate of M. Lucille Paris, the Cion Estate Trust, the Michael Asher Foundation, the Merrill Francis Fund for Art in Public Places, the Matson Fund for Exhibitions, and the Rembrandt Club.

This project would not have gotten off the ground without the full support of Pomona College. President David Oxtoby put his support behind it from inception. Vice President for Academic Affairs and Dean of the College Audrey Bilger and former Dean of the College Elizabeth Crighton gave unwavering support. We received essential assistance from Vice President for Advancement Pamela Besnard, Director of Foundation and Corporate Relations Martina Ebert, and Administrative Assistant for Foundation and Strategic Initiatives Kacey Ross. In the office of communications, Vice President and Director of Communications Mary Lou Ferry, Director of News and Strategic Content Mark Kendall, and Associate Director of News and Strategic Content Carla Guerrero recognized the importance of this undertaking and helped in myriad ways to bring this project to new audiences. Faculty colleagues in many academic departments provided encouragement and supported research, and we particularly thank Mark Allen, Lisa Anne Auerbach, Rita Bashaw, George Gorse, Jordan Kirk, April Mayes, Sandeep Mukherjee, Michael O'Malley, Frances Pohl, Christopher van Ginhoven Rey, Miguel Tinker Salas, Tomás Summers Sandoval, Mercedes Teixido, and Hentyle Yapp.

Last, but certainly not least, the staff of the Pomona College Museum of Art tackled this complex project with characteristic enthusiasm and skill. Director Kathleen Howe offered crucial guidance and encouragement throughout the complex stages of exhibition planning, and she provided steadfast support as the project developed. Museum Coordinator Justine Bae skillfully oversaw media relations, web management, Art After Hours programs, and exhibition tours with finesse, efficiency, and good cheer. Barbara Ditlinger ably supported all other elements of the project and was always willing to tackle each new development. Registrar and Associate Director Steve Comba supported this project from its inception and handled the international complexity of the registrarial work with grace. Senior Preparator and Exhibition Designer Gary Murphy planned and supervised the four artist presentations. His expertise in the fabrication of objects and visualization of complex installations is indispensable. I am beyond grateful to them all.

Rebecca McGrew ('85)
Senior Curator
Pomona College Museum of Art

Credits

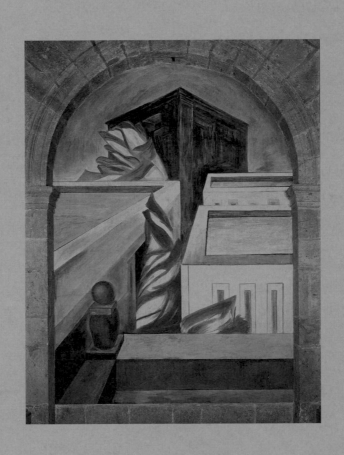